Imagining Illness

IMAGINING ILLNESS

PUBLIC HEALTH AND VISUAL CULTURE

DAVID SERLIN, EDITOR

University of Minnesota Press
Minneapolis
London

Published by the University of Minnesota Press
111 Third Avenue South, Suite 290
Minneapolis, MN 55401-2520
http://www.upress.umn.edu

Library of Congress Cataloging-in-Publication Data

Imagining illness : public health and visual culture / David Serlin, editor.
 p. ; cm.
 Includes bibliographical references and index.
 ISBN 978-0-8166-4822-1 (hc : alk. paper)—ISBN 978-0-8166-4823-8
 (pbk. : alk. paper)
1. Health promotion—Audiovisual aids—History. 2. Health education—
Audiovisual aids—History. 3. Mass media in health education—History.
4. Communication in public health—History. 5. Public health—Marketing—
History. 6. Medical illustration—History. I. Serlin, David Harley.
 [DNLM: 1. Health Promotion—history. 2. Public Health—history.
3. Advertising as Topic—history. 4. Audiovisual Aids—history. 5. History,
19th Century. 6. History, 20th Century. 7. World Health. WA 590 I31 2010]

RA440.55.I43 2919
362.1068'8—dc22

 2010019709

Printed in the United States of America on acid-free paper

The University of Minnesota is an equal-opportunity educator
and employer.

17 16 15 14 13 12 11 10 10 9 8 7 6 5 4 3 2 1

Contents

Part III. Building New Public Spheres for Public Health

Acknowledgments

MOST OF THE ESSAYS COLLECTED IN *Imagining Illness* started as presentations delivered at the William H. Natcher Conference Center on the campus of the National Institutes of Health in Bethesda, Maryland. These presentations were developed for two different public symposia, "Visual Culture and Public Health" (2003) and "Global Health Histories" (2005), which I co-organized with Elizabeth Fee and Paul Theerman of the National Library of Medicine and with Randall Packard of the Johns Hopkins University. Liz, Paul, and Randy were reliable allies, co-conspirators, and lunch partners during the planning and execution stages, and through our shared contacts and pooling of resources we brought together speakers and participants from all over the world for discussion, debate, and dinner. Our implicit goal was always to create opportunities for forging future alliances across institutions, disciplines, and geographies, and I believe that we met and exceeded what we set out to accomplish.

The "Visual Culture and Public Health" and "Global Health Histories" symposia were supported through the generosity of the History of Medicine Division of the National Library of Medicine, the Friends of the National Library of Medicine, the Institute of the History of Medicine at the Johns Hopkins University, the Fogarty International Center of the National Institutes of Health, and the Global Health Histories Initiative of the World Health Organization in Geneva. We were also lucky enough to have colleagues without whose dedication and energy these symposia never would have been possible: Donald A. B. Lindberg, Betsy Humphreys, Becky Lyon, Meghan Attalla, Eric Boyle, Ba Ba Chang, Kathleen Cravedi, Todd Danielson, Kim Dixon, Nancy Dosch, Judy Folkenberg, Greg Pike, K. Walter Hickel, Troy Hill, Jan Lazarus, Robert Logan, Robert Mehnert, Melanie Modlin, Christie Moffatt, Manon Parry, Young Rhee, Nadgy Roey, Vreni Schoenenberger, Sandy Taylor, Michele Tourney, Belle Waring, and Pat Williams.

In helping to transform oral presentations into written essays, I have had the great fortune to work with a group of ace contributors whose analytical sophistication, interpretive ambition, and understanding of the historical and disciplinary

consequences of their scholarship have been not only humbling but also extremely energizing. In short, I could not have dreamed of a better set of authors for this project, and I thank them all for the spectacular essays they produced and for the perseverance they demonstrated throughout the extended editorial process. William Helfand deserves special recognition as a long-time supporter, collector, and independent scholar of the visual culture of public health. Bill's devotion to medical art and ephemera is an object lesson in connoisseurship, and his example illustrates how a single individual's passion can help nurture an emerging area of scholarly inquiry.

Richard Morrison of the University of Minnesota Press saw the potential of this volume from the beginning and encouraged its development. Richard's wise counsel helped to bring this book to fruition, and I hope he agrees with me that it was worth the wait. Sander Gilman, Petra Kuppers, and Marquard Smith delivered incisive comments on early versions of the manuscript and offered equally sharp suggestions for improving it. Kristian Tvedten gave the manuscript his scrupulous attention and expertly oversaw it throughout its last stages of organization and copyediting, while Adam Brunner, Daniel Ochsner, Alicia Sellheim, and Laura Sullivan helped bring all of the production elements together with panache.

For their assistance and cooperation in acquiring and preparing images for the book, I want to thank the following institutions: the Centers for Disease Control and Prevention, Atlanta; Corbis Images, Seattle; the Gran Fury Collection of the New York Public Library; the Prints and Photographs Division of the Library of Congress; the Images and Archives Division of the National Library of Medicine; the National Museum of American History, Smithsonian Institution; the Philadelphia Museum of Art; the San Diego Museum of Art; the University of Iowa Libraries; and the Wellcome Trust Centre for the History of Medicine, London. A faculty grant from the Academic Senate of UC San Diego provided funds that enabled the reproduction of many of these images. David Benin and Lauren Berliner, my research assistants, responded to my arcane requests with dazzling results.

I thank Julie Nagle for permission to reproduce her astonishing painting on the front cover of this volume. Julie's painting deftly captures how public health's ancient iconographies of exposure, vulnerability, and control are perpetually recast and reinterpreted by each new generation of visual artists. Such iconographies continue to refract epidemiological knowledge even as they also produce new forms of epidemiological knowledge in increasingly varied spheres of public health—both those that already exist and those that are in formation.

A final round of thanks goes to colleagues and dear friends without whom this book would have been truly unimaginable: Lisa Cartwright, Giovanna Chesler, Steve Epstein, Elizabeth Fee, Sina Najafi, Joe Masco, Katherine Ott, Marq Smith,

Shawn Michelle Smith, Carol Squiers, Paul Theerman, Robin Veder, and, as always and in all ways, Brian Selznick.

This book is dedicated to the memory and example of Gretchen Worden (1947–2004), the former director of the Mütter Museum of the College of Physicians of Philadelphia, who showed us that the world we live in is illuminated by the one we rarely see.

Introduction: Toward a Visual Culture of Public Health

From Broadside to YouTube

DAVID SERLIN

IN "HPV BOREDOM 2," a one-and-a-half-minute-long video posted in March 2007 on the popular Web site YouTube, an attractive young woman stares at the camera while listening on her cell phone to a passionless electronic voice reciting an enervating litany of facts about the human papillomavirus, the genitally transmitted virus otherwise known as HPV.[1] As one watches the young woman's face, one becomes aware that her eyes—darting nervously, or glazing over, or rolling in their sockets—are the most animated part of the video, while her general affect registers a range of cognitive or emotional changes that are less immediately recognizable.

Is this the future of the public service announcement, in this instance one focused on HPV transmission and prevention, in the form of a video recorded and edited on one's home computer and uploaded directly to the Internet? Or is this an ironic spoof of the public service announcement as a genre—one in which what is communicated to us visually is not prevention but inaction; not education but ennui? Is the video a postfeminist call-to-arms, rebranded through the cool visual language of disaffection? Or does it show the brutal resignation of a young person who, having grown up in a post-AIDS world, acknowledges her body not through the empowerment of individual choice but through the weight of abject fear?

"HPV Boredom 2" is one of a constellation of HPV-related videos that have been uploaded to YouTube following the development of and subsequent controversy surrounding Gardasil, a vaccine promoted by the pharmaceutical giant Merck that targets some but not all strains of the HPV virus linked to cervical cancer in women. The videos feature an array of earnest writer/director/critic/performers framed through different media genres—such as the soapbox rant, the dramatization, the exposé, and the infomercial—that depend on the literacy of a sophisticated viewer to recognize their visual cues. Furthermore, the videos display evidence of a range of different attitudes toward the virus, as well as the current climate in which information about HPV is circulated, through titles like "HPV—The STD Taboo," "[HPV] Vaccine Hoax Exposed," "HPV and Me," "What

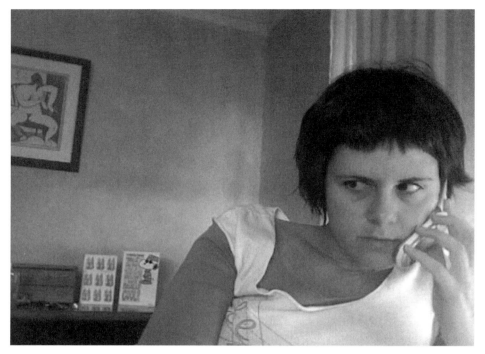

Figure I.1. Video still from "HPV Boredom 2" (2007), the second in a series of three short films by Giovanna Chesler made in response to the marketing of the human papillomavirus (HPV) vaccine to combat high rates of transmission among adolescents and teenagers. Courtesy of Giovanna Chesler.

HPV Does to You," and "HPV Virus: Give Your Little Girl VACCINE if You Are Stupid." Such a profusion of responses suggests that there is no uniform narrative about what HPV is, or what it means, or even how one should treat it. Rather, the YouTube videos represent a set of competing and even contradictory approaches and meanings that, taken together, cast the human papillomavirus as anything but transparent.

YouTube is not alone in its contributions to, and expansion of, the public sphere of health information. Popular Web sites such as Facebook and Wikipedia, as well as millions of blogs, information clearinghouses, clinical trial sites, and consumer advocacy resources, have democratized not so much the delivery or even authority of public health information but, rather, have transformed the public health directive, which traditionally has been an expert-driven, unidirectional system of communication. As *The Economist* observed in a 2007 editorial, "Millions are now logging on to contribute information about topics stretching from avian flu pandemics to the extraction of wisdom teeth or the use of acupuncture to overcome fertility. You could call it user-generated health care, or Health 2.0."[2] The phenomenon of self-diagnosis through Internet research has become so

widespread that the term *cyberchondria* has emerged as one of the signposts of the Internet as it contributes as much to contemporary forms of self-empowerment through knowledge as it does to misinformation, frustration, and cynicism. Ultimately, such a proliferation of "user-generated" discourses about HPV in cyberspace suggests that there is no single story about HPV that one can glean from these sources but, instead, that there are multiple, conflicting, and even contradictory stories for which resolution is virtually impossible. Such a scenario is not unlike that described by sociologist Steven Epstein in *Impure Science,* his classic account of the contested meanings around HIV and AIDS inscribed by biomedical scientists, health administrators, politicians, pharmaceutical companies, and AIDS activists in the 1980s and early 1990s.[3]

HPV is of course only one public health concern whose representation has become part of a national and, increasingly, transnational visual culture readily available for public consumption in the first decade of the twenty-first century. Videos and photographic images captured and uploaded to Internet sites like YouTube by digital cameras, laptop computers, mobile phones, and a host of other lightweight portable devices depict with startling immediacy victims and survivors of infection by recent regional and global outbreaks of anthrax, avian flu, H1N1, "mad cow," swine flu, SARS, tuberculosis, and West Nile virus, as well as those who have endured the devastating effects of hurricanes, tsunamis, war, floods, earthquakes, terrorist attacks, and fires. Such hypermediated events are often unbearable to watch. But it is also true that contemporary public health crises would be literally unimaginable without these visual representations. Indeed, one could argue that such crises are *unknowable* without visual representations. YouTube and its counterparts provide an opening for those who wish to engage public health concerns not through traditional forms of legislative or institutional intervention but through the accessible medium of visual culture, moving public health discussions beyond the clinic or the classroom toward some further uncharted horizon. This has become especially pronounced in an era like ours when the status of health itself—how one defines the concept of health as well as how one defines particular bodies as healthy—has become an epistemological query with its own presuppositions and plot points along which knowledge can be quantified, mapped, and interpreted.

How, then, should we begin to characterize, let alone develop a vocabulary for characterizing, the relationship between public health crises—whether pitched as a local or a global phenomenon—and the highly mediated visual culture that dominates our world? *Imagining Illness* is intended as a critical intervention into the visual culture of public health in the most capacious sense of the phrase. Rather than examine only the most recognizable forms of public health's visual culture, such as images deployed in campaigns for education and prevention against disease, the authors in *Imagining Illness* offer genealogical and taxonomic approaches

to the phrase "visual culture" and its relationship to that which is called "public health" in order to explore what kind(s) of knowledge about health are produced under the auspices of the visual. Campaigns and efforts sponsored by public health agencies, such as the World Health Organization and the Centers for Disease Control, and philanthropic charities such as the Bill and Melinda Gates Foundation and Médecins Sans Frontières, have certainly influenced a core part of what constitutes the visual culture of public health in the late twentieth and early twenty-first centuries. Yet it is important to recognize that the visual culture of public health also includes those productions and practices that, whether created by official agencies or not, sustain public health topics that can be recontextualized, transformed, and disseminated as political and cultural topics as well. The widely circulated photographs, for example, of young men and women in China wearing surgical face masks emblazoned with upscale designer logos during the SARS epidemic in 2003, or during the swine flu epidemic in 2009, are explicit artifacts of public health's visual culture, but they are also implicit (and deeply ironic) artifacts of the hybridizing of campaigns for public health with those of the advertising, mass media, and fashion industries. Indeed, since its appearance in November 2002, the virus responsible for the respiratory condition known as SARS has been a triumph of name-brand marketing, from its first description among a few isolated individuals in Guangdong Province in China to the more than fourteen hundred new cases a week reported internationally at the peak of the epidemic in early May 2003.

Long before the SARS coronavirus—so named because of its intimidating crownlike halo of viral receptors—had been properly identified as the cause of infection, the early arrival of the four-letter acronym "SARS" (intended to resonate both linguistically and epidemiologically with "AIDS" and its distant relation, HIV) confirmed the power of a hypermediated culture to transform a virus into a syndrome and then into a polished sound bite, the public dimension of which made it fall just short of being trademarked. Early visual images related to the SARS epidemic—sick or dying individuals and, later, images of eviscerated civet cats (a regional delicacy sold in many Chinese marketplaces) that were identified as vectors of infection—circulated in the mass media. Quickly, however, the branding of SARS demanded a new set of images that would help distinguish and, arguably, elevate the status of the syndrome from other public health crises. By the beginning of 2003, the iconography of SARS was concretized around images of absence of illness rather than its presence. These absences were broken down into two types that quickly became metonyms for the SARS crisis: crowded urban cityscapes filled with bobbing, anonymous heads wrapped in impenetrable white surgical masks; and haunting, empty commercial spaces such as airports, hotel lobbies, and convention centers.

The emergence of these two distinct categories of images in the visual culture of SARS suggests that there was an effort, deliberate or otherwise, to avoid direct

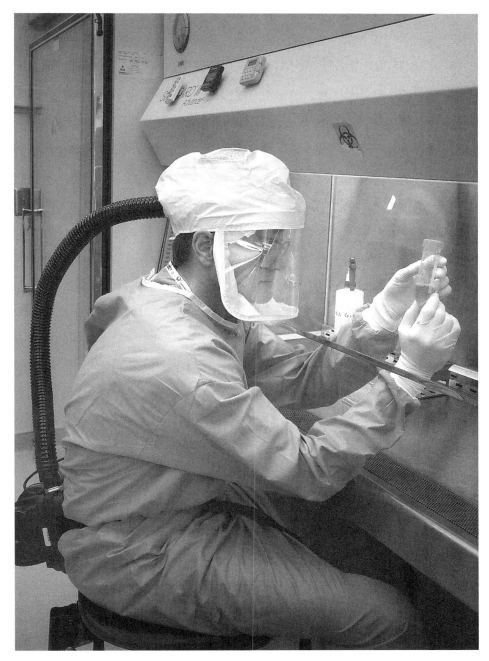

Figure I.2. In this 2005 photograph, microbiologist Dr. Terrence Tumpey examines a vial of the reconstructed 1918 Pandemic Influenza virus. Promotional images like this, created to publicize the efforts of laboratory scientists in order to combat health crises, also demonstrate the iconography of white male heroism that historically has characterized the visual culture of public health. Photograph by James Gathany. Courtesy of the Centers for Disease Control and Prevention, U.S. Department of Health and Human Services.

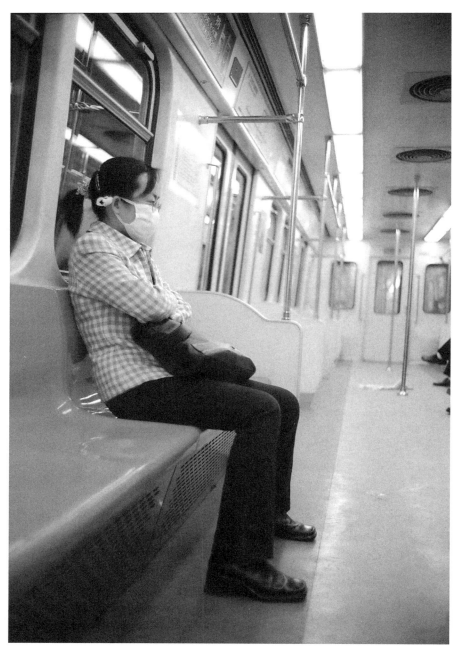

Figure I.3. This photograph of an unidentified female passenger wearing a facemask on the Beijing subway in China captures many of the recurring themes found in photographs documenting Severe Acquired Respiratory Syndrome (SARS) at the height of the pandemic: the isolated, anonymous urban figure in a landscape of epidemiological dangers; the haunted quality of empty zones of transit and tourism; and the vulnerability of the explicitly gendered passenger, as mirrored in her vacant stare, as she makes her way to an uncertain destination. Photograph taken on April 1, 2003, copyright Anaïs Martane/Corbis. Reprinted with permission.

confrontation with illness itself. But as with all aesthetic manipulations of negative space, what the *absence* of actual humans suffering from SARS revealed was the *presence* of other forces at work. Some tracked the absence of traditional images of health crisis—patients lying prostrate in hospital beds, for instance, or children lining up to receive vaccinations—to the Chinese government's unwise decision to conceal information about the SARS epidemic, which enabled the virus to spread around the world under a surgical mask of silence. In May 2003, the World Health Organization openly criticized public health authorities in Guangdong for its inappropriate dissembling over SARS, which apparently included hiding patients in hospitals and ambulances and out of the public view.[4] But the absence of images that were supposed to stand in for SARS instead revealed how deeply intertwined the containment of infectious disease was with the inner logic of contemporary global culture. When virologist Malik Peiris's research team at the University of Hong Kong became the first to isolate and identify the coronavirus that causes SARS in March 2003, scientists around the world seemed to resent his success as they jockeyed for position. "We don't care about press releases, we care about publications," said Christian Drosten of the Bernard Nocht Institute for Tropical Medicine in Hamburg, seeing in the SARS crisis an opportunity for international recognition and career advancement.[5] Meanwhile, photographers documenting the SARS crisis emphasized the eerily vacant interiors of airports and hotel lobbies in international cities like Hong Kong, Singapore, and Toronto, critical nodes of global traffic and international commerce. As images of empty restaurants and convention centers multiplied, economists and policy makers bemoaned the billions of business and tourist dollars lost as fear of SARS-related economic woe spread almost as rapidly as the virus itself. Commercial venues, in other words, were implicitly identified as among the most oppressed victims of SARS, often on a horizontal plane with those infected or dead as a result of the global traffic that helped to spread the virus in the first place. In the summer of 2003, Hong Kong International Airport initiated a campaign featuring an immaculately scrubbed Asian businessman to communicate that the SARS crisis was over. By promising to business people and potential investors that "half the world's population is within 5 hours' flying time," readers learned that neither war, nor virus, nor gloom of impending economic depression would stay these couriers of capital from the swift completion of their appointed rounds.

The attempt to naturalize the race among scientists and the loss of business dollars as emblematic of the epic struggle between man and virus might help to explain why visual images of SARS became so easily exploited by popular culture in the United States and around the world. For many, the outpouring of SARS images, especially those that circulated on the Internet, represented a form of vernacular folk art.[6] The widely circulated Internet image, for example, of a Hong Kong woman wearing a surgical mask constructed from a fashionable scrap

of Burberry tartan plaid was a beautiful example of name branding's potential to achieve vertical integration. Other images, such as the one used by a rock band from Manhattan's Lower East Side of an elegantly dressed Taiwanese bride and groom wearing white surgical masks as an appealing graphic for a forthcoming performance, or artist William Bozarth's notorious "SARS Wars" image of science-fiction villain Darth Vader wearing one mask over another, proved how the SARS epidemic had become cultural fodder to be recontextualized by impertinent twentysomethings for t-shirts and screen savers. Such manipulated images, however, would have been unthinkable for those living with HIV or smallpox or polio. Few would admit authorship to, let alone broadcast, irreverent or manipulated images of a wheelchair-bound FDR or a person with AIDS dying in a hospital bed in the same way that they proudly took credit for the SARS images they created with such ironic aplomb. This suggests that there must have been some inchoate groundswell of disdain, however unarticulated, for the mechanisms at work beneath the branding of SARS by scientific and public health media. The arrival of SARS-inspired satire was, in fact, another kind of grassroots eruption that coincided with other subjects of national and international disrepute. Indeed, one could argue that the spirit in which SARS images were tinkered with mirrored the manipulated images featured in the posters produced by antiwar and antiglobalization movements during the run up to the U.S.'s military invasion of Iraq during the early months of 2003.

Examining histories of public health's visual culture, as the contributors to *Imagining Illness* endeavor to do, means attempting to understand not only what representations mean or how they have changed over time but also how the institutions, agencies, and organizations that are responsible for producing and disseminating the visual culture of public health have changed as well. The mid-twentieth-century rise of Cold War panic and civil defense training, for example, produced different public health images than those fifty years earlier or fifty years later. The "Gilded Age" of late-nineteenth- and early-twentieth-century imperialism and global expansion created the possibilities for thinking about public health not only in terms of promoting modern health practices in far-off populations but also in establishing modern health practices that would supplement military interventions and commercial investments. A century later, in the contemporary era of neoliberal free markets and privatization of formerly public services, health concerns are more often than not addressed by multibillion-dollar conglomerates that have a vested interest in transforming members of the public into a captive audience of medical consumers. In the United States, the promotion of particular forms of health care provision since the mid-1960s such as Medicare and Medicaid—and, since March 2010, the passage of sweeping health insurance reform—has been consistently challenged by for-profit health management organizations (HMOs) and pharmaceutical behemoths that over the

past thirty years have fought to denaturalize any presumptive links between access to medical care and the entitlements of citizenship. All of these changes have had an impact on the visual as well as the institutional character of what is meant by the phrase "public health." Thus, the essays in *Imagining Illness* represent an effort to reckon with the political, economic, and institutional changes that characterize modern health practices while at the same time drawing upon the enormously rich visual culture that shapes and has been shaped by those changes.

Public health's visual culture can be traced long before the era of YouTube or wheat-pasted wall posters to the illuminated manuscripts of East and South Asia, the Middle East, and medieval Europe, in which decorative images graced the pages of hundreds of ancient and modern texts as illustrations of particular principles of healing, natural science, or natural philosophy. While it could be argued that these works were intended to manifest visually the medical and scientific knowledge contained in the texts, their circulation among small groups of scientists, physicians, librarians, and archivists distinguish these works as primarily scholarly and thus reduce the "public" character of their limited impact. The invention of the printing press in the mid-fifteenth century by Johannes Gutenberg of Mainz, Germany, inaugurated the era of printed books, broadsides, posters, and one-sheets that incorporated woodcuts, engravings, dynamic fonts, and other iconic visuals that could be produced in mass quantities, thus shifting the dissemination of information to increasingly larger and more heterogeneous audiences. Public records following the series of plagues that visited the city of London in the seventeenth century, for example, demonstrate that broadsides about dead or contagious bodies in the streets were posted in public squares but were also read aloud for the illiterate and for gathering crowds.[7] Broadsides and other inexpensive printed materials constitute some of the earliest examples of the visual culture of public health in a form that we recognize today.

But public engagement with health and medicine did not reside solely in printed contexts: indeed, one could argue that premodern communities in both Western and non-Western contexts were constantly bombarded by visual signs that were locally mediated and interpreted as revealing social and spiritual phenomena connected to good or ill health, whether configured as balances of energy, bodily fluids, or some combination thereof. As early as the thirteenth century, anatomical dissections in European medical schools were arguably part of the visual culture of public health since autopsies were considered public events regularly attended by physicians and students as well as by the laypersons for whom such events served as both education and entertainment. As media studies scholar José van Dijck has argued, the presentation and viewing of such bodies should never be regarded simply as events or rituals but must always be

historicized as products of a particular historical moment and a particular way of viewing the world.[8]

Throughout the early modern era, visual representations that confirmed evidence of illness and death were an important link between local administrative bodies, universities, health practitioners, and the public. Meanwhile, the reclamation and translation of ancient Greek, Roman, and Islamic medical and scientific texts by Western scholars during the late medieval period helped to precipitate a scientific revolution in which the authority of visual signs was tested against scientific method. The revolutions of seventeenth- and eighteenth-century science helped to shift power and authority away from a visual worldview of open-ended and enigmatic interpretations and toward a more concrete and epistemologically static worldview in which the scientific method was used to distinguish that which could be proven empirically from superstition and folklore. By the eighteenth century, the "natural" world was one that could be known not only through the senses but also could be categorized, mapped, and visually and materially possessed by the dominant European scientific and political powers.

The eighteenth century also established the recognizable relationships between visual culture and public health as we understand those terms today. The development of classification and taxonomic systems for categorizing the visible world according to allegedly natural hierarchies of plants, animals, and humans became the basis for the study of pathology and difference in the bodies of organisms. These were ideal for visual depiction in cabinets of curiosities and museums and, later, in scientific monographs, treatises, and textbooks, many of which were punctuated with hand-tinted color plates and fine engravings that, however stylized by our standards, were treated as authentic distillations of the natural world. The rise of scientific medicine in the nineteenth century, along with important discoveries such as germ theory and the first initiated campaigns to address epidemics such as yellow fever and chronic diseases such as alcoholism, developed at approximately the same historical moment as new printing technologies. Some of these included high-quality engravings and photographs in professional journals, newspapers, and monographs as well as four-color and lithography processes for making art-quality prints and posters that were fast and inexpensive relative to earlier techniques. Nineteenth-century visual materials inspired by contemporaneous health concerns also emerged in tandem with new strategies of distribution and promotion, which were adopted as much by popular and scholarly publishers, professional societies, industrial patent holders, and medical merchandisers as by political parties and promoters of popular entertainments.

The relationship between public health and visual culture found its most potent manifestation in the late nineteenth century, the period in which the

management of epidemics and the implementation of hygiene paradigms became central fixtures of the modern nation-state. The densely populated urban landscapes of capital cities as well as trade centers and colonial outposts on the periphery of the empire convinced many physicians and scientists, in collaboration with local administrators and sanitary officials, to produce easily-understood visual materials that could be printed and circulated on inexpensive paper or affixed to walls, especially in native or immigrant enclaves, in order to educate the lay public about how taking care of one's body was a civic responsibility within dominant regimes of imperial power. Moreover, some of the earliest campaigns for public health were tied intimately to the European and American expansion of the empire from Australia to Africa to Latin America to South Asia to East Asia and the Pacific.[9] The health of colonial subjects was understood as paramount to the business of the empire, and the establishment of colonial hospitals and health bureaus developed concomitantly with infrastructure projects such as digging latrines, creating systems for transporting clean water, and building roads and centers of commerce and networks for long-distance communication. Indeed, the creation of the modern hospital and the deployment of modern medical technologies—especially those of diagnosis and management—became intimately tied to the exigencies of military preparedness during periods of war and geographical expansion of territory.[10]

As a result of geopolitical transformations and military campaigns, the visual culture of public health quickly became dominated by images of altruistic health technicians, beneficent institutional leaders, and smiling natives—images meant to promote the spirit of Western civilization and social progress. Throughout the twentieth century, newspapers and newsreels routinely featured visual depictions in both religious and secular registers: from medical missionary work performed in various non-Western regions to the building of roads, latrines, hospitals, schools, and sterile surgical facilities by research- and policy-oriented charities, such as the Rockefeller Foundation.[11] Yet, as historian of science David Barnes has argued, telling the history of public health as only a succession of political or institutional narratives—heroic scientists saving vulnerable natives from evil viruses or, alternately, heroic peoples resisting the disciplining activities of medical imperialists—ultimately says very little about how public health practices were physically and materially enacted at local levels. Furthermore, such narratives almost certainly do not tell us how the visual field helped to refract, or absorb, the various political and cultural practices that took place at those sites where public health administrators, workers, and caregivers plied their trades.[12]

Public health campaigns—propaganda directed by states and institutions against disease and illness, or narratives that support particular kinds of health practices that Michel Foucault identified as "care of the self"—must be understood as part of the geopolitics of the modern world.[13] But they are also tied

directly to technologies of modern communication and the capacity not only to make health information widely available but also to tailor such information to local, regional, national, and transnational contexts. Just as the invention of the printing press made possible the dissemination of health information (albeit with an initially limited circulation) in sixteenth- and seventeenth-century Europe, the nineteenth- and twentieth-century inventions of photography, telegraphy (and, later, wireless telegraphy, or radio), motion pictures, television, computers, and mobile communication technologies have made the transmission of health information one of the appurtenances that define one's subjective engagement with modern life.[14] The visual culture of public health, then, arguably represents the confluence of two mutually dependent innovations: the emergence of modern medicine's reliance on sophisticated media to represent diagnosis and treatment, and the emergence of modern communication's reliance on sophisticated media to fulfill particular institutional or ideological goals.

Some scholars of visual culture, such as Jonathan Crary, Anne Friedberg, Kevin Hetherington, and Vanessa Schwartz, have argued that the creation of the modern subject in the nineteenth century—that is, the individual whose epistemological position in the world has come to be recognized as fundamentally different from that of his or her predecessors—involved training individuals to see their immediate environments in entirely new ways for the purposes of administrative efficiency and conspicuous consumption.[15] The forces of technological and bureaucratic modernity, according to this body of scholarship, produced a new kind of viewer: not an aloof, existential member of the *flâneur* class (though this is a classic example of an urban figure who both enables and resists modernity) but a new kind of urban subject who was intimately aware of his or her distinctive brand of modernity. For many scholars, such an epistemological worldview was produced by a new relationship to traditional cycles of work and leisure, a result of industrial modernity's fracturing and reconstituting of linear time that enabled the conditions for nostalgia, fantasy, and futurity.

But who, exactly, are these newly defined "modern subjects," as characterized by visual culture studies? Does the phrase refer to a "they," or does it refer to an "us"? It depends on where one looks. From cultural differences based in economics, access to education, gender role, and national politics to physiological differences based in patterns of information reception and cognition, modern subjects who possess something called a "modern" sensibility are individuals who are perceived to be fundamentally, inexorably different from their distant ancestors. Yet one must ask: did modern individuals in 1810 or 1910 perceive visual information the same way as people do in 2010, provided that they were able to perceive visual information at all? Media scholar Stuart Hall has argued that while visual materials (such as public health posters) may exist in the world as tangible, physical artifacts, the contexts in which such materials were created, disseminated,

and received keep shifting as much as the subject position of the individual who is absorbing those materials in the first place.[16] Thus, we can never presume that the meanings attributed to objects of visual culture are static or fixed, no matter how much we wish it were otherwise. Social anthropologist Arjun Appadurai has argued that postcolonial subjects who are part of larger legacies of diaspora and globalization will never be exactly identical to their imperial counterparts; their subjectivity will be shaped by both conventional and nonconventional, or hybridized, forms of technological and cultural practice, what Appadurai has identified as the "ideoscapes" of modern communication and culture.[17] Such distinctions have profound implications for the assumptions one makes about target audiences, demographic groups, and the putatively universal character of public health's visual culture, especially since they overtly challenge the presumption that modern subjects share the same sophisticated repertoire of visual literacy—and the presumption that what defines modern subjects is in fact their visual orientation.

Because of its noncommercial character, the visual culture of public health sometimes has been assumed to operate outside of the visual culture of modern consumerism and, in particular, genres of communication defined by advertising and marketing, commercial photography, cinema, television, and political propaganda. Yet even the most cursory application of semiotics to the visual culture of public health demonstrates that neither the topic of the public-health-directed message nor the individual assumed to be the patron-consumer-subject of the public-health-directed message can be easily defined for one kind of viewer or one kind of genre or one kind of medium. What we call "public health" changes as audiences, media, and the messages they convey are perpetually reinvented and reconstituted; they are transformations that become ever more complex in relation to a given historical era or socioeconomic context or political event. Indeed, the strategy of niche marketing has been as transformative to the visual culture of public health as it has been to the commercial marketplace, stemming from the recognition that it is just as difficult to produce a universal public health message that signifies for audiences across all social and economic levels as it is to produce a message that signifies for audiences across all demographic subgroups or political constituencies.

The virtue of examining public health media through a visual culture approach rather than exclusively through the tools of sociology or anthropology or political science or the history of medicine is that public health's visual culture consists by definition not only of images drawn from biomedicine but also from the vast web of media forms with which public health intersects. Public health projects, for example, such as the consciousness-raising campaigns for urban hygiene, maternal and infant care, and sexually transmitted diseases produced by artists and designers for the Federal Art Project of the Works Progress Administration (WPA)

in the United States during the mid- to late-1930s, have been considered by some art historians and scholars of medicine as the apogee of public health's visual culture. For all of their power, however, one could argue that these iconic images were created with a putatively universal message and neutral viewer in mind, and that their creators were optimistic about or simply oblivious to potential cultural or political differences of subjective interpretation. The WPA producers of such images included artists, writers, and designers who were born or who had come of age in the nineteenth and early twentieth centuries; like the audiences for whom they directed their artwork, they were literate in the generic and iconographic vocabularies that comprised the public health campaigns of the Progressive Era, the Great War, and the Roaring Twenties.

By contrast, consider the campaigns of Gran Fury, a graphic design collective inspired by the performative dimensions of the AIDS Coalition to Unleash Power

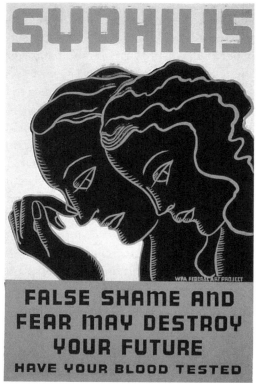

Figure I.4. Two-color poster (circa 1937), created by Erik Hans Krause for the Federal Art Project of the Works Progress Administration, uses bold, highly stylized German woodblock and Soviet graphic design elements to encourage viewers—as embodied in two pensive male and female figures—to get tested for syphilis and therefore to transcend moralistic narratives of shame and humiliation characteristically attached to nonprocreative, pleasure-driven sexual practices. Courtesy of the Prints and Photographs Division, Library of Congress.

(ACT UP), an influential activist group that emerged out of the AIDS crisis in New York City during the late 1980s. Gran Fury's artists and instigators, who were born and came of age in the 1960s and 1970s, used graphic design elements and framing devices drawn from the post-Warholian worlds of commercial advertising, underground journalism, avant-garde cinema, and the pop music industry as well as from contemporary practitioners such as American feminist artists like Jenny Holzer and Barbara Kruger.[18] One could argue that Gran Fury, unlike the WPA artists, imagined a particular kind of viewer—one whose aesthetic sensibilities encompassed and appreciated the political (as well as camp) value of representational categories of racial, ethnic, gendered, economic, and sexual difference. Such a deployment of identity politics was critical for ACT UP and its constituencies, which sought to antagonize both institutional and ideological power structures in order to advocate for funding for HIV/AIDS research in the face of willful silence and systemic homophobia. While the WPA's public health projects deliberately imagined a viewer who would be inspired to social responsibility by seeking help from a medical professional or local health care provider, the Gran Fury posters deliberately imagined a viewer who would be inspired to social responsibility by challenging medical professionals, including pharmaceutical scientists, government bureaucrats, Wall Street investors, and public health officials whose reputations were tainted by their collective failures and individual decisions such as withholding experimental AIDS medications from those in need.[19]

In this sense, both the public health images produced by the WPA and those produced by Gran Fury should be regarded as dramatic artifacts of what visual culture scholars call *intertextuality*—that is, the process of borrowing and recycling from a broad variety of sources that may have nothing to do with the immediate context of public health but that enables public health information to appear in settings and contexts where it might not otherwise circulate. Some intertextual images rely on conventions of art-historical categories—echoes of famous examples of post-Renaissance painting, sculpture, photography, and so forth—whereas others rely on the less highbrow but no less influential visual languages of advertising, political propaganda, children's culture, and mass media forms such as cinema, magazines, television, and Internet blogs. Intertextuality, as an aesthetic strategy, takes for granted that images that may have initially provoked anxiety or fear in an earlier generation will fade into the mist as their meanings are transmuted over time into the distant, the subversive, or the ironic. This implies that the creators of health care education campaigns often treat prospective audiences like marketing niches or control groups to whom particular messages should be pitched with ever-increasing levels of visual sophistication. This is a far cry from the earnest conventions typically associated with public health's visual culture, which historically have assumed that their creators were exploiting universal themes of panic, expertise, and intervention to frame their health

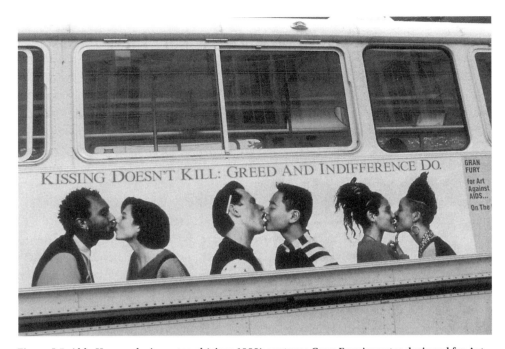

Figure I.5. Aldo Hernandez's postcard (circa 1989) captures Gran Fury's poster designed for Art against AIDS as it appeared in situ on the side-advertising panel of a New York City bus. The poster, depicting three friendly, osculating couples in late 1980s color-blocked geometrical knit-wear, challenges contemporary misperceptions of HIV transmission by disentangling eroticism (especially same-sex and cross-racial eroticism) from the kinds of shame narratives produced by many early twentieth-century public health messages as well as late twentieth-century homo-phobic panic. Courtesy of the Grand Fury Collection, New York Public Library.

messages. Examining the visual culture of public health from within multiple systems of meaning-making relocates the analysis of images beyond simple aes-thetic or interpretive claims to focus on how certain health practices are deeply embedded in larger networks of visual practices and the interrelated genealogies of visual media. Such practices, in turn, are shaped in large part not only by *what* they depict but also *how* and *where* they are depicted as well as in what contexts they initially emerge and to what contexts they ultimately flow.

Critical studies of science, technology, and medicine have provided much of the intellectual and disciplinary scaffolding for the essays in *Imagining Illness,* as they have for studying the visual culture of public health in general. Studies of visual representations within medical science as well as the sciences more generally represent a relatively new field that emerged in the 1980s from interrogating the role that the visual plays in producing (and naturalizing) truth claims within scientific knowledge and legitimating (and naturalizing) methodologies within scientific practice. Scholars of science and medicine, such as Peter Galison,

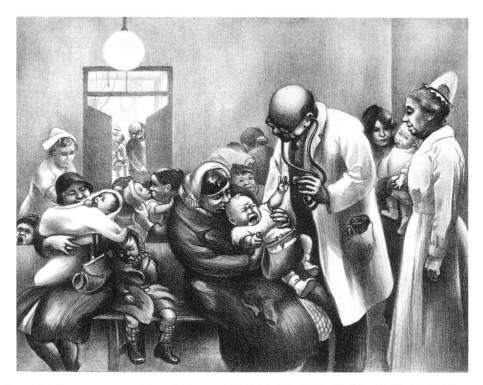

Figure I.6. By turns cartoonish and ethnographic, Mabel Dwight's "Children's Clinic" (1936) conveys the chaotic atmosphere of a public health center during a historical moment in which the Roosevelt administration endeavored to provide health care, especially for the most vulnerable, as a right of democratic citizenship. Dwight's drawing suggestively links the stylistic conventions of public art produced by the WPA to the stylistic conventions of proletarian art produced by the American Left during the interwar period. Reproduced with permission of the San Diego Museum of Art (Gift of Mr. Herbert Lerner).

Bettyann Holtzmann Kevles, Michael Lynch, Gregg Mitman (one of the contributors to this volume), and Steve Woolgar, began to examine and interpret visual technologies, illustrations, diagrams, photographs, films, and the performative character of laboratory experiments in order to reconstruct institutional histories of science as well as the epistemological investments that such visual texts represent.[20] Mitman, for example, demonstrates how curators in natural history museums prepare visual displays to accompany popular science and anthropology exhibits in order to show how seemingly neutral visual technologies were deployed to corroborate the "objectivity" of scientific methodology. Many feminist scholars of science and medicine in the 1990s, such as Lisa Cartwright (also in this volume), Ludmilla Jordanova, and Rayna Rapp, built upon this critique by arguing that the assumptions to scientific "objectivity" that dominate scientific practice are generated and reproduced in the authoritative male "gaze"

put into motion by such visual-oriented media as microphotography, sonography, and a wide variety of other diagnostic technologies of gynecological and reproductive health care.[21]

Developing an approach to the visual culture of public health builds upon these theoretical and methodological precedents, but it also gains substantially from the tools of art history, cinema studies, television and media studies, and cultural studies, out of which have grown annual conferences, academic departments, and several significant journals.[22] Art historians such as Jonathan Crary and Barbara Stafford, for two foundational examples, have contributed much to visual culture's theoretical sophistication whereby the visual is deployed as a form of social authority, and claims to expertise that are instantiated by the visual play a key role in sustaining this authority.[23] How we understand the visual culture of public health depends, however, not only on criteria for analyzing artifacts of visual culture or public health respectively; it also depends on where artifacts of public health are found or located, how they are framed or situated, and to what degree they reflect the increasingly diffuse set of cultural and political influences out of which such artifacts are created and constituted. As media scholars such as Anna McCarthy have shown, *where* visual culture takes place is often as important, if not more important, than *what* the content of an image is itself.[24]

By focusing on the social, institutional, and infrastructural dimensions of visual culture that inform representations of public health, we move the object of analysis beyond an existing image or immediate field of vision constructed to produce an image to examine the multiple contexts in which an image has appeared: from the hospital or clinic, to the national or local government administrative office, to the drafting table of a design department or the advertising agency, to the billboard or poster adorning the wall of a building or a classroom, to the public service announcement broadcast on a radio or television or shown on the Internet, to the message affixed to a consumer product, to the slogan silk-screened onto a t-shirt. And this, ultimately, is what makes looking at the contextual variances of visual culture so much more provocative than looking exclusively at a static image adorning a poster or embedded in a textbook. How we reckon with the deliberate publicity of such images is crucial to the reconstruction of the possible meanings embedded not only in an artifact itself but also in the infinite range of spaces, networks, and subjectivities through which an artifact travels.

Each of the essays in *Imagining Illness* is engaged with the visual culture of public health in one way or another as a system of reconstituting public knowledge and, in the process, reconstituting the social relations that are produced through that knowledge. Though the authors may have arrived at this perspective by using different theoretical and methodological tools, all of them share a profound commitment to unpacking visual materials as part of structures of

NATIONAL
NEGRO HEALTH WEEK

TWENTY-SEVENTH OBSERVANCE
MARCH 30 — APRIL 6, 1941

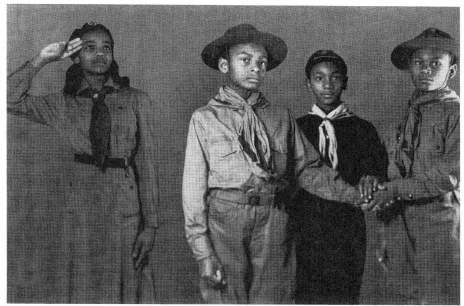

Courtesy of Sixth Division, National Capital Area Council, Boy Scouts of America, and Girl Scouts, Incorporated, District Seven, Washington, D.

"Semper Paratus" — Always Prepared

"I pledge allegiance to the flag of the United States of America and to the Republic for which it stands . . . "

SPECIAL OBJECTIVE FOR THE YEAR 1941:
Personal Hygiene and First Aid Preparedness

For other information write National Negro Health Week Committee
United States Public Health Service, Washington, D. C.

Figure I.7. Cover of the publicity packet for the twenty-seventh annual "National Negro Health Week" held in Washington, D.C. Given the dearth of adequate health resources available to African Americans in the historical lead-up to civil rights activism of the late 1950s, one could argue that this photograph's attempt to equate community health awareness with spirited patriotism is belied by the apprehensive, perhaps even ironic, facial expressions and physical gestures of the Boy Scout in the center and his saluting female counterpart. Records of Sydenham Hospital (Baltimore, Maryland), MSC 243, Box 83, History of Medicine Division, U.S. National Library of Medicine.

meaning-making and hierarchies of power that are dynamic artifacts of the historical, political, and economic contexts in which those materials originally circulated. These authors demonstrate that the visual culture of public health, in effect, is always produced in relation to the prospect of creating new publics.

In Part I, "Tracing the Visual Culture of Public Health Campaigns," cultural anthropologist and historian of medicine Lenore Manderson examines the hookworm campaigns of the International Health Board of the Rockefeller Foundation, initiated in British Guyana in 1914 and extended over the next decade to other parts of the Caribbean and Central America, to Australia, Southeast and South Asia, and the Pacific. Manderson argues that the campaigns provided the Rockefeller Foundation with a means not only to reduce disease that in some areas had profound economic and social impact but also to test various approaches to disease eradication, health services development, and public and private sector collaboration. Manderson draws upon the files of Wilbur Augustus Sawyer, who was sent to Australia by the Rockefeller Foundation to run its hookworm campaign. Sawyer was a serious amateur photographer and diarist, and his collection includes letters, diaries, memorabilia, and photographs. Such ephemeral images, as Manderson reads them, provide a glimpse into the mechanisms at work by those who imagined public health as a tool of political control and an extension of the civilizing mission of colonial powers.

Similarly, historian Liping Bu examines the work of W. W. Peter, an American in China who, like Sawyer, was commissioned to implement public health campaigns during the early decades of the twentieth century. Bu moves across a range of visual media—from maternal and infant care exhibits installed in local markets to public demonstrations of men carrying signs or wearing sandwich boards announcing methods for keeping the household sanitary—in order to show how Peter transformed the content of otherwise banal and even reductive messages for local audiences in rural China and, in the process, transformed the methods by which public health information was delivered. Bu, a specialist in the history of medicine in modern China, makes a significant contribution to the visual culture of public health as much of this growing body of scholarship, in the present volume and elsewhere, is often hampered by its focus on Western narratives and visual sources.[25]

In his essay, Gregg Mitman, a historian and pioneering scholar in the visual culture of science and medicine, examines the work of Otto Neurath, the Austrian sociologist, political economist, and philosopher, who developed, in conjunction with the National Tuberculosis Association, a visual language for health education meant to reach across borders of geography, race, and class. Neurath's efforts to establish the *isotype* as an international picture language accorded well with his socialist beliefs and aspirations for a unified science. But, as Mitman describes, the isotype did not match the economic, political, and social realities

of a segregated America. Through an exploration of visual materials—Christmas seals, posters, and films—produced over three decades of campaigning for health, Mitman explores how voluntary health agencies addressed issues of racial integration and segregation and became an important, yet largely unrecognized, site of activism and change in the struggles leading up to the Civil Rights Act of 1964.

The essay that concludes this section, by film studies and visual culture scholar Kirsten Ostherr, compares the ideological work done by two public health films—one produced by the Firestone Corporation in the 1950s, the other by the World Health Organization in the 1970s—shot in the African nation of Liberia. Ostherr, whose previous historical work on public health films comprises a groundbreaking monograph on the subject, takes the reader step-by-step through both films to unpack the complex visual and audio messages with which both films engage, always mindful of the original historical and political contexts—one during the period of European colonial rule, the other in the era of African independence—in which the films were produced and screened.

In Part II, "Mapping a Visual Genealogy of Public Health," Katherine Ott, a historian and senior curator of medicine at the Smithsonian, follows the nineteenth-century visual fortunes of two public health problems that affected skin, scabies and favus, as both public health and dermatology came to terms with the professional issues of classification, language, concept formation, and descriptive thought. Using a variety of visual materials, Ott suggests that modern dermatology has been perhaps the most visual of all medical subspecialties, and few texts present as dramatic and unsettling a display of color and form as the nineteenth-century dermatological atlas. Where the post-Enlightenment compulsion to classify fell short with words, as was often the case with skin disorders, the copper plate, chromo-lithograph, and photograph filled the gap. Looking at the skin and the wonders to be found there, Ott argues, was crucial to understanding how and why some conditions spread contagiously through communities and others did not.

Traveling from somatic sites of infection to spatial sites of infection, Mark Monmonier, a professor of geography and author of the acclaimed *How to Lie with Maps*, examines the role of maps in visualizing public health: from John Snow's map of the infamous Broad (now Broadwick) Street pump in London's Soho, first created during the cholera epidemic of 1854, to epidemiological maps used by government agencies in the early twenty-first century. Monmonier argues that Snow's map was largely buried in the epidemiological literature until the 1930s when Johns Hopkins epidemiologist Wade Hampton Frost touted it as a prototype of bacteriological thinking as well as an emblem of medical geography. Maps ostensibly intended to describe public health facilities or summarize programs of disease surveillance have a dual role that is at least partly persuasive. In examining the role of maps in public health, Monmonier argues that maps are inherently more effective, if not more common, as persuasive graphics than as

research tools. Indeed, as Monmonier argues, any graphic that attracts viewers' attention to a threat or campaign is propaganda insofar as it contributes to height-ened concern or increased resolve.

William Helfand, an independent scholar and veteran collector of the visual culture of public health, puts into historical context development of the public health poster as a genre, from its late-nineteenth-century art-historical European origins to its most forward-thinking iterations during the AIDS pandemic of the 1980s. Helfand focuses on the aesthetic qualities imparted to early public health posters, which incorporated the work of professionally trained fine art painters, illustrators, and engravers, and how changing understandings of public health inspired these artists to employ new aesthetic criteria and graphic techniques in their work. The resulting trajectory, Helfand argues, provides traditional art his-torians with a subset of images that they have often neglected to incorporate into canonical studies of nineteenth- and twentieth-century art.

Rounding out this section, Shawn Michelle Smith, a leading scholar of visual culture studies as well as an accomplished photographic artist, explores visual representations of public health nurses who belonged to the National Organiza-tion for Public Health Nursing (NOPHN) in the 1930s, and examines how the work of these women was quite literally "envisioned." First taking stock of the NOPHN's marked interest in visual education in this period, Smith then studies how new nursing uniforms worked symbolically to signal the nurse's modernity. The second part of the essay investigates two of the most often-reproduced iconic images of public health nurses—the visiting nurse arriving at someone's home, and the nurse within the home tending to a newborn. Assessing these oft-repeated scenes, Smith argues that the public health nurse was positioned as a link, or mediator, between public and private institutions—a new kind of modern, mobile, independent young woman charged with securing the health of the nation.

In Part III, "Building New Public Spheres for Public Health," historians of medicine Roger Cooter and Claudia Stein examine the changing character of the visual culture of epidemics across the twentieth century to chart the rise, and fall, of medical authority through a close reading of a controversial photograph, adapted in 1992 by the Benetton clothing empire, of a family agonizing over a young man with full-blown AIDS on his deathbed. Cooter and Stein suggest that photograph's subversion of religious iconography—the source of its controversy and subsequent censorship in many European countries—parallels AIDS's sub-version of the traditional iconography associated with the visual culture of public health as well as the certainty with which medicine and its practitioners could claim success over previous public health crises. Cooter and Stein characterize the Benetton image as emblematic of a profound professional and representa-tional shift that has taken shape in the visual culture of public health over the past half-century. They argue, finally, that what is ultimately at stake in contemporary

public health images requires an ontological reconciliation between what we thought we reliably knew and what we are told that we need to know.

In her exploration of the evolution of childhood trauma as a public health issue, visual communication and science studies scholar Lisa Cartwright considers the place of visual analysis and documentation of infants and children in psychoanalysis in Britain and the United States after World War Two. This was a period during which mental health concerns for orphans, widows, and survivors of war began to receive critical attention from the clinical psychiatric community. Cartwright focuses on the use of film to document the work of René Spitz and James and Joyce Robertson, the latter group of whom worked with psychiatrist John Bowlby in England. Cartwright considers how these professionals and their peers responded to images of children in circumstances that included deprivation and grief in order to understand the place of visual knowledge in the branch of psychoanalysis devoted to infants and children.

Moving from postwar film studies to postwar television studies, cultural historian David Serlin traces the broadcast history of live surgery in the United States, from its first appearance on network television in the late 1940s through its contemporary manifestations on the Internet. Distinguishing programs depicting documentaries that included live surgery from contemporary fictional dramas (called "stethoscope operas") of the early 1960s such as *Ben Casey, M.D.* and *Dr. Kildare,* Serlin also distinguishes live display from other types of medical diagnostics or imaging techniques in order to show that, in promoting the often conflicting goals of public health, live surgery broadcast in the immediate postwar era was more like the Internet than we might expect, especially for the ways it sustained corporate sponsorship while promoting medical services to an increasingly prosperous clientele eager to purchase health services as consumer amenities.

Finally, cultural anthropologist Emily Martin explores the ways in which those psychological states classified under the rubric of "mood disorders" have been treated as a public health problem from the eighteenth century onward. Martin uses historical and contemporary examples from images and films that are designed to teach us what mood disorders are, how to identify them, and why they are a health concern. Over the last several decades, Martin argues, mood disorders have come to signify different meanings for individuals and groups with different ethnic and class backgrounds. The essay offers an array of visual materials produced by the pharmaceutical industry as well as public health agencies in order to trace the cultural and linguistic links between motivation and mood, and thence the links between mood disorders and social and economic productivity, the gold standards of normalization in the contemporary world.

The essays in *Imagining Illness* prove beyond a doubt that the visual culture of public health proliferates within multiple aesthetic, scientific, and political traditions. But the visual culture of public health has been and remains a complex and

variegated landscape, encompassing materials as different as circulars, broad-sides, posters, photographs, magazine and newspaper advertisements, billboards, films, documentaries, lithographs, and cartoons, to name just some of the most recognizable forms. Likewise, these forms have taken shape in an equally complex landscape of spaces and geographies beyond those of print media, providing a palpable and often tactile presence at information fairs held in educational auditoriums, civic centers, and church basements; health exhibits installed in museums and on university campuses; dioramas displayed at eugenics conferences and World's Fair pavilions; and public service announcements broadcast on radio, TV, and the Internet. The histories of these media forms and landscapes have only just begun to be written and documented. Furthermore, popular and professional discourses about what constitutes the healthy body, conveyed through visual means that do not necessarily preclude engagements with the auditory, tactile, and olfactory, communicate a range of competing and often contradictory messages about the triumphs (and failures) of scientific medicine, public health and personal hygiene, and representations of physical and cultural normativity. These histories also have only just begun to be written, and it is the profound hope of the authors in *Imagining Illness* that the essays in this volume will inspire more research, scholarship, and debate in these areas.

The visual culture of public health relies, often problematically so, on the need to forge a collective understanding of something identifiable as "public" through which particular kinds of images may be valorized, appropriated, or subverted. Surely exploring the visual and cultural meanings attached to magnetic resonance imaging (MRI) of the human body or the ultrasound image of a fetus in utero is part of the process of educating patient-citizens, and is arguably one of the core, if implicit, responsibilities undertaken by public health professionals and their allies.[26] But such mediated productions are not designed for universal access or legibility; indeed, they literally require mediation in the form of a skilled technician who will translate and interpret such images as medical information for patients. By contrast, many other visual culture forms, such as textbook graphics, wall posters, promotional films, or even videos for HPV featured on YouTube, are designed from the ground up as public artifacts that will be consumed by the broadest possible audience. This does not mean that such quotidian forms are more simple and thus more "straightforward" than their technoscientific counterparts. It simply means that the public dimensions of such forms—where they appear, what they're made of, and who sees them—must be factored into any analysis that might be provided. And this, ultimately, is one of the fundamental generic characteristics enjoyed by the visual culture of public health that distinguishes it from the visual culture of science: the visual culture of public health, by definition, constitutes a form of public knowledge that is regularly mediated and contested not because of what it says or how it says it but by virtue of its very

existence. The essays in *Imagining Illness* move us closer to understanding the mechanisms by which the publicity of what we call "public health" is never merely an incidental feature but instead an essential prerequisite for reckoning with the power of the visual in the public sphere.

Notes

1. "HPV Boredom 2," short film by Giovanna Chesler, posted on YouTube at http://www.youtube.com/watch?v=gQb3VzquHNc (last accessed August 19, 2010).

2. "Health 2.0," *The Economist: Technology Quarterly* (September 8, 2007): 16.

3. See Steven Epstein, *Impure Science: AIDS, Activism, and the Politics of Knowledge* (Berkeley: University of California Press, 1996).

4. Martin Enserink, "WHO Wants 21st-Century Reporting Regs," *Science* 300 (May 2, 2003): 717–18.

5. Dennis Normile, "Up Close and Personal with SARS," *Science* 300 (May 9, 2003), 886–87.

6. See Amy Harmon, "Digital Artists Find a Muse in SARS (and Each Other on the Internet)," *New York Times*, June 15, 2003.

7. See Stephen Greenberg, "Plague, the Printing Press, and Public Health in Seventeenth-Century London," *Huntington Library Quarterly* 67, no. 4 (December 2004): 508–27.

8. See José van Dijck, *The Transparent Body: A Cultural Analysis of Medical Imaging* (Seattle: University of Washington Press, 2006); see also Michael Sappol, *A Traffic of Dead Bodies: Anatomy and Embodied Social Identity in Nineteenth-Century America* (Princeton, N.J.: Princeton University Press, 2004).

9. There is substantial literature on public health and colonialism; for a significant sampling, see Alison Bashford, *Imperial Hygiene: A Critical History of Colonialism, Nationalism, and Public Health* (New York: Palgrave Macmillan, 2004); Mark Harrison, *Public Health in British India: Anglo-Indian Preventive Medicine, 1859–1914* (New York: Cambridge University Press, 1994); Deborah Lupton, *The Imperative of Health: Public Health and the Regulated Body* (Thousand Oaks, Calif.: Sage Publications, 1995), especially chapters 1 and 2; Lenore Manderson, *Sickness and the State: Health and Illness in Colonial Malaya, 1870–1940* (New York: Cambridge University Press, 2002); Shula Marks, "What Is Colonial about Colonial Medicine? And What Has Happened to Imperialism and Health?" *Society for the Social History of Medicine* 10. no. 2 (1997): 205–19; Steven Paul Palmer, *From Popular Medicine to Medical Populism: Doctors, Healers, and Public Power in Costa Rica, 1800–1940* (Durham, N.C.: Duke University Press, 2003); Ruth Rogaski, *Hygienic Modernity: Meanings of Health and Disease in Treaty-Port China* (Berkeley: University of California Press, 2004); and Kalinga Tudor Silva, "'Public Health' for Whose Benefit? Multiple Discourse on Malaria in Sri Lanka," *Medical Anthropology* 17, no. 3 (1997): 255–78.

10. See, for example, Vincent Cirillo, *Bullets and Bacilli: The Spanish-American War and Military Medicine* (New Brunswick, N.J.: Rutgers University Press, 2004), and Ken De Bevoise, "The Compromised Host: The Epidemiological Context of the Philippine-American War" (PhD diss., University of Oregon, 1986).

11. The Rockefeller Foundation's extensive commitment to public health in Latin America during the twentieth century has inspired a significant amount of historical research on the relationship between the Rockefeller's philanthropic interests and its exploitation of its financial power and political influence. See, for example, Anne-Emanuelle Birn, "Public Health or Public Menace? The Rockefeller Foundation and Public Health in Mexico, 1920–1950,"

Voluntas 7, no. 1 (1996): 35–56; Steven Paul Palmer, "Central American Encounters with Rockefeller Public Health, 1914–1921," in *Close Encounters of Empire: Writing the Cultural History of U.S.–Latin American Relations*, ed. Gilbert M. Joseph (Durham, N.C.: Duke University Press, 1998), 311–22; and Steven C. Williams, "Nationalism and Public Health: The Convergence of Rockefeller Foundation Technique and Brazilian Federal Authority during the Time of Yellow Fever, 1925–1930," in *Missionaries of Science: The Rockefeller Foundation and Latin America*, ed. Marcos Cueto (Bloomington: Indiana University Press, 1994), 23–51.

12. David Barnes, *The Great Stink of Paris and the Nineteenth-Century Struggle against Filth and Germs* (Baltimore: The Johns Hopkins University Press, 2006), 14.

13. See Michel Foucault, *The History of Sexuality, Vol. 3: The Care of the Self*, trans. Robert Hurley (New York: Vintage, 1988).

14. See Paul Starr, *The Creation of the Media: Political Origins of Modern Communication* (New York: Basic Books, 2004). For an excellent examination of the changing relationship of the medium of photography to public health topics, see Carol Squiers, *The Body at Risk: Photography of Disorder, Illness, and Healing* (Berkeley: University of California Press, 2005).

15. See Jonathan Crary, *Suspensions of Perception: Attention, Spectacle, and Modern Culture* (Cambridge, Mass.: MIT Press, 2001); Anne Friedberg, *Window Shopping: Cinema and the Postmodern* (Berkeley: University of California Press, 1994); Kevin Hetherington, *Capitalism's Eye: Cultural Spaces of the Commodity* (New York: Routledge, 2006); and Vanessa Schwartz, *Spectacular Realities: Early Mass Culture in Fin-de-Siècle Paris* (Berkeley: University of California Press, 1999). See also Donald Lowe, *A History of Bourgeois Perception* (Chicago: University of Chicago Press, 1983), and Susan Buck-Morss, *The Dialectics of Seeing: Walter Benjamin and the Arcades Project* (Cambridge, Mass.: MIT Press, 1991).

16. See Stuart Hall, "The Work of Representation," in *Representation: Cultural Representations and Signifying Practices*, ed. Stuart Hall (Thousand Oaks, Calif.: Sage Publications, 1994), 13–74.

17. See Arjun Appadurai, *Modernity at Large: Cultural Dimensions of Globalization* (Minneapolis: University of Minnesota Press, 1996).

18. The iconic "Silence=Death" graphic, incorporating stark white lettering floating over the sharp edges of a pink triangle (the symbol gay men and lesbians during the Nazi regime were required to wear as an identifying marker), is arguably the most enduring design of AIDS activism in the 1980s, but it was not created by Gran Fury. It was created by the Silence=Death Collective in 1987.

19. The best and most compelling discussion of Gran Fury's work remains Douglas Crimp and Adam Rolston, *AIDS/Demo/Graphics* (Seattle: Bay Press, 1990).

20. For some of the most influential works in the disciplinary development of visualization within science and technology studies, see Michael Lynch and Steve Woolgar, eds., *Representation in Scientific Practice* (Cambridge, Mass.: MIT Press, 1988); Gregg Mitman, "Cinematic Nature: Hollywood Technology, Popular Culture, and the American Museum of Natural History," *Isis* 84 (1993), 637–61; Peter Galison, *Image and Logic: A Material Culture of Microphysics* (Chicago: University of Chicago Press, 1997); and Bettyann Holtzmann Kevles, *Naked to the Bone: Medical Imaging in the Twentieth Century* (New York: Basic Books, 1998). For a more recent addition to this literature see Luc Pauwels, ed., *Visual Cultures of Science: Rethinking Representational Practices in Knowledge Building and Science Communication* (Hanover, N.H.: Dartmouth College Press/University Press of New England, 2006).

21. See Lisa Cartwright, *Screening the Body: Tracing Medicine's Visual Culture* (Minneapolis: University of Minnesota Press, 1995); Rayna Rapp, *Testing Women, Testing the Fetus: The Social Impact of Amniocentesis in America* (New York: Routledge, 2000); and Ludmilla

Jordanova, "Medicine and Genres of Display," in *Visual Display: Culture Beyond Appearances,* ed. Lynne Cooke and Peter Wollen (Seattle: Bay Press, 1995), 202–17.

22. Some key texts in contemporary visual culture studies include Lisa Cartwright and Marita Sturken, eds., *Practices of Looking: An Introduction to Visual Culture* (New York: Oxford University Press, 2001); Jessica Evans and Stuart Hall, eds., *Visual Culture: The Reader* (Thousand Oaks, Calif.: Sage Publications, 1999); Nicholas Mirzoeff, ed., *The Visual Culture Reader* (New York: Routledge, 2002); and W. J. T. Mitchell, *What Do Pictures Want? The Lives and Loves of Images* (Chicago: University of Chicago Press, 2006). For an excellent overview of the field, including interviews with some of its intellectual and disciplinary proponents, see Marquard Smith, ed., *Visual Culture Studies* (Thousand Oaks, Calif.: Sage Publications, 2008).

23. See Jonathan Crary, *Techniques of the Observer: On Vision and Modernity in the Nineteenth Century* (Cambridge, Mass.: MIT Press, 1992), and Barbara Maria Stafford, *Good Looking: Essays on the Virtue of Images* (Cambridge, Mass.: MIT Press, 1996).

24. See Anna McCarthy, *Ambient Television: Visual Culture and Public Space* (Durham, N.C.: Duke University Press, 2000). See also Lynn Spigel and Jan Olsson, eds., *Television after TV: Essays on a Medium in Transition* (Durham, N.C.: Duke University Press, 2004).

25. An important exception is work represented in the field of visual anthropology; see, for example, Christopher Pinney and Nicolas Peterson, eds., *Photography's Other Histories* (Durham, N.C.: Duke University Press, 2004).

26. See Sarah Franklin and Helena Ragone, eds., *Reproducing Reproduction: Kinship, Power, and Technological Innovation* (Philadelphia: University of Pennsylvania Press, 1997); Paula Treichler, Lisa Cartwright, and Constance Penley, eds., *The Visible Woman: Imaging Technologies, Gender, and Science* (New York: New York University Press, 1998); and Valerie Hartouni, *Cultural Conceptions: On Reproductive Technologies and the Remaking of Life* (Minneapolis: University of Minnesota Press, 1997).

*Tracing the Visual Culture
of Public Health Campaigns*

1. *Image and the Imaginary in Early Health Education*

Wilbur Augustus Sawyer and the Hookworm Campaigns
of Australia and Asia

LENORE MANDERSON

THE HOOKWORM CAMPAIGNS CONDUCTED by the Rockefeller Foundation in the
early twentieth century were among the earliest public health education cam-
paigns that incorporated fundamental principles still used in twenty-first-century
public health. The foundation, and specifically the International Health Board
(IHB), used an intersectoral approach, bringing together different departments
(education, health, agriculture), supporting public–private partnerships, encour-
aging community involvement and local ownership of health interventions, using
mixed media presented in culturally appropriate contexts, and establishing sys-
tems and structures to ensure sustainable behavioral change and disease control.
The visionary nature of these campaigns, and the premises of those who shaped
them in relation to the epidemiology of the disease and the political economics of
its control, make for extraordinary reading, and provide argument enough to
revisit this historical moment.

In this essay, I focus on the use of imagery in the IHB's advocacy of hookworm
control at government, professional, and community levels. In so doing, I concen-
trate on the activities of the IHB in Australia and South and Southeast Asia, draw-
ing for the visual record from the photographs and ephemera of Wilbur Augustus
Sawyer as well as his letters, diaries, memorabilia, and from photographs of
Australia, Siam, the Federated Malay States, Ceylon, and India between 1919 and
1924.[1] Sawyer, an earnest amateur photographer and diarist, went to Australia to
run its hookworm campaign in 1919, remained until late 1923 as an advisor to
the Australian government, then took on the role of supervising the activities of
the Rockefeller Foundation in Asia.

My aims in this essay are several. First, I explore the use of imagery by public
health advocates, such as Sawyer and his colleagues, to encourage public health
interventions that promised economic, social, and aesthetic outcomes to those
in positions of authority at both local and national levels. In this context, I am
interested in the combination of text and photography to argue for health educa-
tion and the critical role of language to construct images in reports and other

documents. I consider the use of images in public health education material and the early use of mixed materials for representational and educational purposes. I explore the content and structure of health educational campaigns in different cultural and social contexts in Australia and Asia, and examine the use of the visual to represent the etiology and natural history of hookworm disease, hence facilitating the imagination of the unseen. I analyze the representation of disease control through key health education materials of the period, and reflect on how health education was presented in visual and written records. Prior to pursuing these areas of discussion, however, I summarize briefly the early work of the IHB and introduce Wilbur Sawyer, the central character of the chronicle that provides the frame for this essay.

Hookworm and the Rockefeller Foundation, 1909–1925

At the time of Rockefeller's interest in the parasitic infection, hookworm disease was known also as uncinariasis or ankylostomiasis (or anchylostomiasis), or as dochmiosis, tropical chlorosis or anemia, Egyptian chlorosis, brickmaker's anemia, miner's cachexia, tunnel anemia, dirt-eater's anemia, mountain anemia, and in the United States, cotton-mill anemia, resulting in the "typical" profoundly stunted "cotton-mill child."[2] The disease had already been well described by parasitologists. Hookworm larvae penetrate the skin and migrate through the bloodstream to the intestine. There, matured, the blood-sucking worms pair and mate; eggs are released, and most are passed out in feces. The eggs hatch, and assuming human-larvae contact, the cycle begins again. The nematode, *Agchylostoma duodenale*, was first described by Angelo Dubini in 1838; classed as a *strongyloidae* by Edward Caspar Jakob Von Siebold in 1845; identified as causing anemia by Guido Wücherer in Brazil in 1866; and diagnosed by identifying ova in stools (by Giovanni Battista Grassi and colleagues in Italy) in 1877.[3] Attention to the disease increased in the late nineteenth century, however, with a series of major epidemics: among Italian laborers working on the Saint Gotthard tunnel in Switzerland from 1880 until 1882, and among miners, brickmakers, and rice farmers in Italy and elsewhere in Europe a decade later. W. L. Blickhahn reported a case of hookworm in St. Louis, Missouri, in 1893; subsequently cases of hookworm anemia were identified primarily in the southern United States. In 1898, Looss, working in a laboratory in Cairo, self-infected and consequently established that hookworm was transmitted transdermally, and he is accredited with fully identifying the route of infection and life cycle of hookworm. By the early twentieth century, thymol treatment for infection was being supplemented by sanitary interventions and sanitation laws in Central, Western, and Southern Europe. In 1902, Charles Wardell Stiles described the vector prevalent in U.S. and various former Spanish colonies annexed by American expansion in 1899 as a new

species: *necator americanus*. In 1911, Looss published his "monumental volume" on hookworm,[4] a compilation of his and others' work on the life cycle of the worm, and the etiology, effects, treatment, and prevention of the disease. Hookworm and hookworm disease were so well studied, in fact, that in 1922 the Rockefeller Foundation was able to publish a bound bibliography of 5680 items dealing with its social, economic, biological, and clinical aspects.

Despite these extraordinary advances, there was considerable controversy in relation to the disease, its perceived contribution to anemia, and methods to control its transmission. In the United States, controversy related to the right of federal government authorities to examine school children for possible infection, its use in schools of "medical propaganda that finds its profit in frightening children," and in relation to a particular "revolting spectacle," a film on sanitation and a souvenir program that was deemed "offensive . . . the gratuitous exhibition of the horrors it advertised was disgusting."[5] The debate went further. Newspaper journalists and members of the U.S. Senate questioned the motives of the American Medical Association, the John D. Rockefeller Foundation, and other organizations to promote the germ theory of disease: "[T]hey have no right to use public institutions and public servants in conducting a crusade for the establishment of their highly speculative theories."[6] Others were less suspicious of science but regarded the association of hookworm and poor health to be grossly exaggerated. For instance, Malcolm Watson, a central figure in malaria prevention in the Federated Malay States, claimed that "the worm does little harm to the labor force" and that there was no evidence that Tamil coolies in colonial Malaya were "even seriously handicapped" by hookworm.[7] His primary purpose appears to have been to minimize hookworm to ensure adequate resources for malaria control, and while he acknowledged other reasons for sanitary provisions on estates he also argued that "[t]he real difficulty, and not a small one, is to get the coolie to use them [latrines]."[8] In Central America, he argued, sanitation was a "bottomless pit for money" with little impact, given the "failure of sanitary measures to control many of the most important diseases in the tropics."[9] Washburn, who oversaw hookworm control for the foundation in Trinidad in 1915, remarked also on the "uncertainty" of planters and physicians of the seriousness of hookworm, and the value of research to convince governments reluctant to commit funds for its control rather than for control of malaria.[10] Yet this skepticism was not universal: from the turn of the century, for instance, Ashford was working in Puerto Rico on hookworm eradication, and he and his colleagues were adamant that lethargy, confusion, and poor work capacity of laborers were all due to hookworm disease.[11]

In 1909, John D. Rockefeller allocated one million dollars for a period of five years to eradicate hookworm in the southern United States and established the Rural Sanitation Commission. The work of the commission drew on the recommendations

of earlier inquiries and reports on conditions in the south, mandated by an Act of Congress on January 27, 1907. Activities included intensive community and dispensary work with microscopic examination of the total population of target areas; treatment, weekly reexaminations, and retreatment of all people identified to be infected until they were cured; the inspection of privy conditions of every home and the construction of new or improvement of old privies until all homes had at least one privy of a type able to prevent soil pollution and the transmission of hookworm.[12]

While the early focus of the Rockefeller Foundation was therefore on conditions in the United States, there was emerging interest within the foundation and beyond that America had an obligation to support other, poorer countries. A number of American scientists were deeply committed to the eradication of tropical disease and the moral imperative to do so. Jackson,[13] for instance, in a tropical medicine and hygiene textbook directed toward doctors who would work in American colonies, maintained that there were "great problems of investigation and administration to be solved" in the tropics and that

> Americans are confronted by obligation and opportunity. Without volition on our part, we have become responsible for the government and education of millions of men and women in distant parts of the world, who differ from us in race, traditions and civilizations. Without doubt the most important part of this work of education is that touching the physical well-being of these people. Very decidedly, we are the "keepers" of our brethren, black, brown, yellow and white.

In May 1913, the International Sanitary Commission (subsequently referred to as the International Health Board, or IHB) of the Rockefeller Foundation was organized to broaden its public health work to foreign countries. The first activity—one of the first public health campaigns involving multiple government departments—was an extension of the hookworm work to tropical colonies of the British Empire.[14] Early in 1914, the general director of the Sanitary Commission made a tour of Egypt, Ceylon, the Philippines, and the Federated Malay States, visiting estates and examining two thousand coolies in the latter colony.[15] The same year, the commission commenced a pilot project in British Guiana, in the context of which the "intensive method" was tested. In June 1915, the director general went to London to offer the services of the foundation to the empire on a more extensive basis, and hookworm eradication programs were introduced to the British colonies of the Caribbean and Central America, then to Southeast Asia (including Siam, not a colony), South Asia, and Australia. The International Sanitary Commission agreed to finance case detection and treatment, with treatment undertaken through the appropriate government agencies and campaigns directed by English medical men with local subordinate staff. The foundation would provide some expertise and would deposit funds on a quarterly basis for dispensation by the local colonial

government treasury departments. At the same time, the local government was to direct its resources, at its own expense, into a system of sanitation that would prevent reinfection and break the cycle of transmission. Hence the Rockefeller Foundation established, at a very early date, the mechanisms for the devolution of power and responsibility. The campaigns provided the foundation with a means not only to reduce disease that in some areas had profound economic and social impact but also to test various approaches to disease eradication, health services development, and public and private sector collaboration. Many of the fundamentals of health promotion were rehearsed under these auspices.

Wilbur Augustus Sawyer in Australia and Asia, 1919–1924

Wilbur Sawyer was born on August 7, 1879, in Appleton, Wisconsin, into an old New England family, although he took great pride in claiming himself as a thirty-third generation descendent of King Alfred the Great.[16] He joined the staff of the University of California at Los Angeles in 1908, and in 1916 was appointed Clinical Professor of Preventive Medicine. In 1910, he was also appointed director of the State Hygiene Laboratory, and from 1915 to 1918, concurrent with his work at the University of California, Sawyer was Secretary, California State Board of Health. At the State Hygiene Laboratory, he met and later married Margaret Henderson, a bacteriology instructor.

In 1918, Sawyer accepted a commission as major in the U.S. Army Medical Corps, with responsibility for venereal disease control, and he moved with his wife and three young daughters to Washington, D.C. In November 1918, when undertaking a survey for the American Social Hygiene Association and traveling routinely from Washington to New York, Sawyer met with Ernest Myer of the Rockefeller Foundation and subsequently dined with Victor Heiser, director for the East of the IHB of the Foundation. Two months later, on February 6, 1919, Heiser and Edwin R. Embree, secretary of the IHB, asked Sawyer if he would represent the board in Australia. A number of meetings followed, and salary and conditions of service were finalized (matters always noted by Sawyer). On June 1, 1919, Sawyer joined the International Health Board of the Rockefeller Foundation, and on July 9, with his young family, he sailed from San Francisco for Australia on the *S.S. Moana* to take up appointment as the director of the Hookworm Campaign.

Hookworm was prevalent in the silver, lead, and zinc mines in Broken Hill, New South Wales,[17] and the gold mines at Bendigo, Victoria.[18] It was also a health problem among miners and cane-field laborers, and in indigenous communities, in Queensland. Consequently, Sawyer and family were based in Brisbane, the state capital, in southeast Queensland. On arrival, he established the Hookworm Campaign Office at a temporary site, and then moved into a substantial two-story building in College Road adjacent to the boys' grammar school (Figure 1.1).

From this base, on October 1, 1919, the Hookworm Campaign of Australia was launched. From Brisbane, Sawyer routinely traveled to the far north, coastal, and western parts of the state, and from Brisbane south to New South Wales, South Australia, and Victoria, visiting state government counterparts in Sydney and Adelaide, participating as a member of the Technical Commission of Enquiry into Miners Disease at Broken Hill, and meeting state and federal government officers in Victoria.[19] At the same time, he made supervisory visits to the mines and cane fields, visited quarantine stations, and met with politicians at all levels. A year later, on October 27, 1920, Sawyer sailed for Papua and former German New Guinea to investigate hookworm in those colonies, touring around the coastline and to a number of provinces. On December 13, he presented a hookworm plan to the Australian governor in Port Moresby. At his insistence, Sawyer deleted a statement to the effect that hookworm infection was heavy in Papua. His plan, involving the creation of a regulation requiring employers to treat native laborers twice a year and to appropriate £150 per year toward the work, was presented to the Executive Council that afternoon. Sawyer returned to Brisbane on December 21, just in time for Christmas.

Heiser, Director for the East of the IHB, joined Sawyer in Sydney in early January 1921, and the two went on to Melbourne. On October 5, 1920, Sawyer had

Figure 1.1. January 1920, W. A. Sawyer, Director, Hookworm Campaign Office, College Road, Brisbane.

had, with the Federal Minister for Home and Territories, an "animated 15-minute discussion" with Prime Minister Billy Hughes regarding the possibility of a federal ministry of health and plans to extend health functions to the commonwealth by starting laboratories in tropical Queensland and territories. John Howard Lidgett Cumpston, then Director for Quarantine for the commonwealth, and Sawyer followed this meeting up with a memorandum to allow Hughes to bring the proposal for laboratories before the Cabinet. On January 19, Cumpston, Sawyer, and Heiser met again with Hughes to discuss an offer from the Rockefeller Foundation to loan to Australia three experts in hookworm eradication, grant two fellowships in public health, and broaden the function of the Hookworm Campaign, provided that "a separate Ministry of Health be at once established."[20] Hughes guaranteed to take the matter to cabinet "shortly," and the establishment of a federal Department of Health was approved on February 3.[21] Sawyer and Heiser were advised of this the following day, via a ship radio, as they sailed for Singapore and a supervisory visit of hookworm control in Siam, Ceylon, and India. In Sawyer's absence, Margaret gave birth to their fourth child and only son, also named Wilbur.[22]

The high point of the visit to Siam was the observation of a health education lecture in a *wat* in Chiangmai, but Heiser and Sawyer made other strides in public health: handing over sanitation functions from the Siamese Red Cross to the Ministry of Health; making plans for public health and medical training including a medical school in Siam; and establishing strategies for plague and cholera control. In Ceylon, they inspected the lines (laborers' accommodation) of rubber and tea plantations; visited Rockefeller Foundation projects that combined intensive health education, treatment, and the provision of latrines; and met with the officer-in-charge of the Ankylostomiasis Inquiry conducted in Madras Residency. They then went to Madras to inspect the conditions of the quarantine station and explore the possibility of treating laborers prior to their immigration to Ceylon.

In June 1922, Heiser first wrote to Cumpston from the Rockefeller Foundation head office in New York suggesting that Sawyer be reassigned to support the establishment of a federal department of health in Australia, while the two other Rockefeller advisers, Dr. Lanza and Colonel Longley, continued to work in Queensland on the Hookworm Campaign. In November 1922, with this transfer in effect, the Sawyers moved to Melbourne. Wilbur Sawyer received notification on December 16 from the IHB of his appointment as Assistant Regional Director for the East, for the year 1923 and, two days later, the family took up a year's tenancy of a house in what is now the very gracious suburb of Camberwell. From this base, Sawyer continued to supervise aspects of the Hookworm Campaign in Australia, visit local control programs and "hookworm families" in highly infected areas, and inspect night soil incinerators, hospitals, orphanages, and quarantine stations. He explored potential sites for commonwealth laboratories, planned a demonstration unit of a rural health service, and gave public lectures and professional

talks in Australia and overseas. He also participated in various Australian professional associations, including the one he established, the Australasian Public Health Association (Figure 1.2). For much of 1923, he edited both its quarterly journal *Health Forum* and the monthly *Bulletin*. [23] On January 4, 1924, as planned, the three advisers left Australia, Lanza and Longley directly returning to the United States, and Sawyer returning via a three-month supervisory visit in Ceylon and travel through India, Palestine, and Europe.[24] On January 1, 1925, back in New York, he took up appointment as Director of Laboratories of the IHB.[25] In 1927, he was made Associate Director of the division, and in 1935 succeeded General William Russell as its director.[26]

Imagery and the Imagined in Public Health Advocacy

During his trips within Australia and beyond, Sawyer took great pleasure in his camera, sending snapshots back as supplements to his letters to his wife and children. His letters and diaries provide detailed and impressionistic accounts of his travels and of his family and their leisure activities, and these often provide details of photographs taken at the time. On weekends, he would spend time updating his diary and annotating the photographs. Sawyer also had a keen naturalist's eye, took copious notes of fauna and flora, and made the most of his access to natural environments—on weekends he might, often with his wife and eldest daughter, Peggy, walk ten or more miles for pleasure. Sawyer was pernickety for detail, recording his and his wife's weight and height, and his salary adjustments, with the same detail as he would record information of a shrub or a bird.

Given these insights, it comes as no surprise that in 1915 he discovered that the polio virus could be detected in stools, nor that he was the first to develop a successful vaccine against yellow fever. What was impressive was his visionary understanding of the big picture of public health as well as its microscopy,

Figure 1.2. Founding members of the Public Health Association of Australasia on the roof of Myers store, Melbourne, September 8, 1921.

literally and metaphorically. Sawyer and his colleagues used text and visuals to promote public health ideas to those in positions of authority at both local and national levels, in order to encourage public health interventions that promised economic, social, and aesthetic outcomes. Text and photographs were combined to argue for health education and reflect on the critical role of language in constructing images in reports and other documents. As noted, hookworm disease and its effects were documented earlier, and it was largely the written rather than the visual that provided the graphic imagery intended to galvanize governmental sympathy and corral resources for public health interventions. Jackson's description of Puerto Rico, preceding Rockefeller's interest in the eradication of the disease, serves as a case in point:

> In valley, mountain and coast, alike, is found a ghastly population dragging out a miserable existence, and with a death rate which has shocked all who have occasion to learn of it. The number of children who have lost parents and most of their relatives is very large, and these pick up a living as best they can. Men who should be supporting their families are chronic invalids and the families, also infected by the disease, are in a condition of misery beyond description.[27]

With the establishment of hospitals, Jackson continues, people came in scores, willing to take advantage of effective medication and health education: "They are cured, taught how to prevent reinfection and return home, well and happy, to spread the good news." Stiles's accounts from Central America are equally graphic,[28] as they describe to the reader unfamiliar with the disease the clinical appearance of individuals with infection: anemic appearance, tallow complexion, dry parchment-like skin, dry hemplike hair, peculiar dull "hookworm stare," anxious and hopeless expression, cervical pulsation, winged shoulder blades, prominent abdomen, presence of ground itch, tibial ulcers or scars, and underdevelopment. Individuals might report "legs swelling," "buzzing in the ears," "swimming in the head," "dizziness," "fluttering in the heart," "indigestion," and difficulty breathing; a more detailed medical history typically indicated constipation and, postadolescence, the absence of auxiliary and pubic hairs, undeveloped genitalia, and, among girls, failure to menstruate. Here, Stiles draws on lay descriptions of disease and simple descriptions of bodily states to capture the clinical profile of stunting and arrested development, and to enable the reader to translate edema, nausea, vertigo, and tachicardia into visceral experience.

The physical environment in which people are exposed to hookworm and various other health risks is more easily illustrated. Chalmers,[29] for instance, in his *Report of the Enquiry into Hygiene and Sanitation in Colombo* conducted in 1906, extensively uses photographs, maps, and plans. Although he notes an efficiency of text when supplemented by visual material, some of his most dramatic

illustrations of the importance of hygiene and sanitation are not from pictures of tenements, latrines, and cesspits but from his descriptive text:

> Night soil consists of urine and feces. In an Indian community it is estimated that 8 ounces of fecal matter will be produced per head per diem by a mixed population of races, sexes, and ages. If the population of Colombo is assumed to be 160,000, this amount of fecal matter would be 80,000 lb or more than 35 tons per diem. The urine is estimated to be 40 fluid ounces, which in Colombo would mean 40,000 gallons per diem.[30]

Night soil, he explains, is treated in cesspits infested by cockroaches and "vile-smelling" dry-earth privies, private conservancy with pails, and government, municipal, and military latrines "often left for days without being emptied"; he provides vivid descriptions of toilets and drains and their swarms of flies;[31] many drains, he notes, stink vilely as they pass along the sides of eating-houses, shops, and boutiques.[32]

A selection of photographs was published with the report. The photographs—a latrine "showing urine flowing onto floor"; a public latrine with stalls divided by concrete, two men visible, one face clear and looking at camera; a night soil depot showing method of trenching, coolies standing in (empty) drains; the exteriors and interiors of an aerated water factory, a sweetmeat factory, a bakery, and a sherbert factory, dilapidated and with rubbish strewn on the ground—make sense only because of the explanatory texts to the photographs and elsewhere in the report. Without the written text, we do not know what we are meant to see. The photograph of tenements in Hunupitiya is difficult to interpret without the commentary: "Note how nearly the roofs of the houses on each side of the passage approach each other," hence rain would flood the drain running down the center of the path between the rows of houses, a drain which, we know from elsewhere, carries night soil and household waste from the houses. Similarly, without text, the photographs of wells and latrines are difficult to interpret. But we understand from what we read: the photograph of Beira Latrine is annotated, "Note persons washing themselves in the lake close to the latrine." Only one photograph, entitled "Probable additions to the infantile mortality," needs no gloss: a photograph of three naked and emaciated infant girls, the "N.B.—These children were alive" is intentionally a shocking annotation.

Generally speaking, the photographic record for sanitation is unremarkable. Latrines and what one sanitation expert refers to as "excrementitious matter"[33] do not make good subjects for the camera. The variety of drains, sewers, latrines, urinals, and house connections, and the different methods for the disposal and treatment of sewage, surface water, and subsoil drainage, are of technical interest, but they have limited visual interest. As a public health expert as well as a photographer, Sawyer took few photographs of sewers and latrines in his early days in

Australia, paying far more attention to the context. Thus, when he turned his camera from his family, Sawyer's photographs are often of scenic or cultural interest: the photograph of the camel train at Broken Hill, for example; women carrying sand from the seashore at Kankesnaturai; or dhobis doing laundry in the river bed in Madras. During his visit to Singapore and the Federated Malay States in 1923, however, he began to use the camera to record sanitary measures (Figure 1.3). While based in Ceylon, he paid more attention to sanitary infrastructure as photographic subjects when on the road, using photographs as adjunct data to his diary notes. For example, on January 28, 1924, on the road in Ceylon, he noted that

> [f]urther on we went through the Heneratgoda area (the part on the Kandy Road) where Dr Hampton had worked. Photographed latrine, said to be 2 ½ years old. Took 2nd photo of latrine with door propped open . . . Stopped at Veyangoda. "Sanitated" about a year ago. High floor in latrine on account of high ground-water level? Built about a year ago and part of the Heneratgoda area. Saw also three latrines near together, one of concrete and very elaborate, one of wattle and mid and breaking down at top.[34]

So Sawyer's diary notes often provide more information than the photographic record. On January 30, he met the superintendent of North Matate Estate. The language is terse, and yet the picture is quite clear: "It was raining, but we made a round of inspections nevertheless. Saw the incinerators and the latrines for men and women, designated by picture on the doorways as well as words. The lines

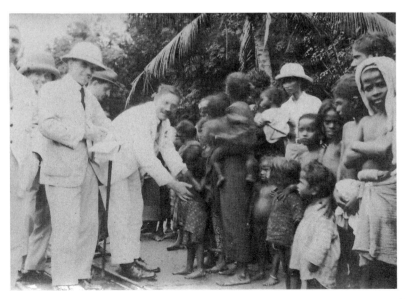

Figure 1.3. Col. Cristophers examining for enlarged spleens on Carey Island, Major Russell keeping tally. Major Cunningham behind him. Half of Malcolm Watson on the border. September 11, 1923.

were old and had been ordered replaced by Dr Bridger's department,[35] but they were surrounded by a level drained area of chiseled stone. The vegetation is to be cut back as a preventive of malaria and hookworm. The coolies definitely use the latrines under these conditions, although some may not."[36]

Although Sawyer's inspections were punctuated with photographs, few of these made it into his personal photo albums, and some that did have been removed. Those that remain allow us to share his view, as captured by the camera lens, but also to reflect on imagery and subject: pictures of latrines often include individuals, but these are human interest additions, nameless and without commentary, a decision related to the composition of the photographs in question, or perhaps included to emphasize the public health concerns for sanitation (Figures 1.4, 1.5, and 1.6). Sawyer does not explain his reasons.

Images and Approaches in Public Health Education

I want to follow this discussion of the role of the visual in public health education material and the use of visuals to represent the etiology and natural history of hookworm disease, by reflecting on how such images facilitate what I will call the imagination of the unseen. I am interested in the mix of materials for representational and educational purposes in campaigns in Australia and Asia, and in changes in the content and structure of health educational campaigns in different cultural and social contexts. But it is important to emphasize that the publicity and educational measures used by the Rockefeller Foundation in the hookworm

Figure 1.4. Cadjan fences so characteristic of Jaffna and an old pit latrine of brick. February 20, 1924.

Figure 1.5. Close to insanitary coolie lines on the Scrubs Estate near Nurvara Eliya. Man cutting stone for new lines. February 26, 1924.

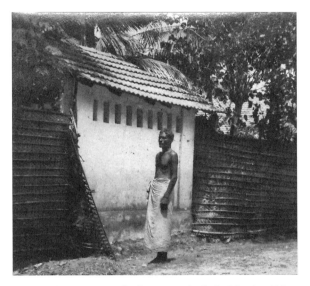

Figure 1.6. Old coolie lines on Dessford Estate, Dimbula District, February 27, 1924.

campaigns were clearly articulated as critical to the intensive methods used to teach people about public health. As one foundation pamphlet described it,

> Among the natives in many tropical countries, the story must be presented in direct and concrete terms. Here the medical directors rely upon word of mouth: and as they tell the story they illustrate its details by lantern slides, photographs and objects. They use typical cases as object lessons; they point out the gross clinical symptoms, which

the people soon learn to recognize; they get specimens of the patients' stools and ex-
hibit the eggs of the parasite under the microscope; they show the parasites that have
been expelled by the treatment administered; and by means of the microscope they
exhibit the living, squirming embryos that live by teeming thousands in the soil that
has been befouled by an infected person and that are ready to infect any person with
whose bare skin they come into contact. The recovery that follows treatment and cure
tells its own story, both to the patient and to his friends and neighbors.[37]

Publicity and education began, it was argued, as soon as the intervention area had
been selected, and both had to be sustained throughout the campaign to ensure
that people were sufficiently committed to a regimen of submitting specimens,
accepting treatment, and installing and using household latrines. Accordingly, the
foundation specified, "every possible influence" should be brought to bear, with an
opening lecture night including slides, attended by "government officials, village
officials, clergymen, schoolmasters, heads of societies, health officers, members of
mission boards and of clubs, local representatives of the press, and officials of
planters' or agricultural organizations."[38] The talk, it was specified, should include
not only information about hookworm but also information regarding the origin
of activities to be undertaken, the source of funding for the work, the need for
cooperation from the population, the benefits of cooperation to the population
individually and collectively, and the importance of sanitation. Pamphlets and
posters, simply worded in the vernacular, were also to be distributed. According to
reports, these steps were observed wherever the foundation operated.

Sawyer routinely relied on a mix of the spoken word, models, and poster
displays, using lantern slides, charts, and three-dimensional models (Figures 1.7
and 1.8). He used patients to demonstrate the impact of problems of public heath,
issuing press releases and inviting the press to meetings, undertook outreach vis-
its to communities where hookworm was prevalent, and routinely met with fellow
scientists, doctors, senior politicians, and government officials. In May 1920, for
example, Sawyer was traveling in Queensland. On August 18, he went to an
Aboriginal settlement near Murgon (probably Cherbourg settlement), and the fol-
lowing day he addressed an outdoor meeting of Aboriginal men at the settlement
on the subject of hookworm. From August 23–27, 1920, Sawyer attended the
Australasian Medical Congress at the University of Queensland, where he gave a
paper entitled "Team Work in Sanitation" in the section on public health and state
medicine on August 24 and a second paper on "Hookworm in Australia" in the
same section the following day. A day later, he held a clinic at the children's hos-
pital, using hookworm patients from Nambour to demonstrate to his colleagues
the clinical signs of hookworm infection, and on August 27, he facilitated a discus-
sion at the congress on tropical health and the need for a public health association
of Australasia. His staff maintained an exhibition of the work of the Hookworm
Campaign for the duration of the congress, which he subsequently wrote up for

Figure 1.7. Hookworm exhibit, Australasian Medical Congress, September 1923.

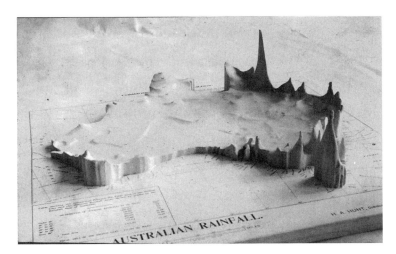

Figure 1.8. Rainfall and hookworm model, Australasian Medical Congress, September 1923.

the *Medical Journal of Australia*. Three weeks later (September 22), Sawyer gave a lecture on "the control of hookworm in Australia" at Albert Hall, Brisbane, one of a series of popular lectures held under the auspices of the University of Queensland in which he used lantern slides to project images of tiny hookworm larvae on the screen. Sawyer noted good attendance of around 150 people, including the state Attorney General, Mr. Robertson, and noted a positive report in the local papers.[39]

Sawyer gave interviews with the press and routinely gave public lectures on a wide variety of public health matters other than hookworm: in 1921, for instance, in response to other health threats, Sawyer spoke on plague on "Health Sunday," and arranged for placards warning against the risk of plague to be placed on trams (cable cars) in Melbourne.

In using a mix of methods and materials, Sawyer and his colleagues were surprisingly sensitive to the importance of context and local endorsement. Meeting with Aboriginal elders in Cherbourg, therefore, was arguably no accident. When Sawyer and Heiser visited Barnes's pilot project for hookworm control in Chiengmai, for instance, Sawyer wrote:

> We went . . . to the wat (temple) which was packed with an audience of 200 men and a few women waiting for a hookworm lecture. Dr Heiser and I sat in chairs at the feet of the great gilded Buddha [original gloss].
>
> Coming in as strangers from the heat and glare of the tropic sun we noticed first the refreshing shade and coolness of the dimly lighted temple, the great image of Buddha, the tall pillars, the pictures of soldiers and elephants, and the reverent audience in their quaint *penungs*—the whole scene impressively oriental and pervaded with a spirit of satisfaction with things as they are. Then the eye fell on a most discordant element— hanging on the front of the pulpit was the Meyer hookworm chart, and on a small table were models showing how latrines could be made from native materials.
>
> This is the picture which we came upon when Dr. Barnes took us to the opening meeting of his hookworm campaign in Amphur Sansai during our visit in March. This amphur, or township, is situated near the old walled city of Chieng Mai, far in the north of Siam and three days journey from Bangkok. The temple of an ancient religion has been made available for a meeting to initiate a most modern moment. The meeting was just a first step in one of the many unique methods devised by the field men of the International Health Board to separate the hookworm from its food supply and popularize sanitation by precept and demonstration.[40]

Barnes spoke in Lao, according to Sawyer, for two hours. Clearly, people approved:

> They seemed to be ready to attempt the control of the parasite that was sapping their strength and holding back their prosperity. They were more than ready to follow his leadership in an attempt to secure for themselves, through better sanitation, another of the blessings of modern civilization.

Barnes was followed by Major Boriracksha, a medical officer in the Siamese Army. According to Sawyer,

> [Barnes] waxed eloquently and used the chart and models freely. It was obvious from his gestures that he was enthusiastic. He gave the dramatic story of the hookworm's

life from the egg to the adult—from the soil to the intestine. His explanations of the specifications for latrines were so graphic we could follow him in general without understanding a word. At the end of his talk the audience was shown the eggs and living larvae under the microscope. This was the final touch in demonstrating the reality of hookworm and creating an intense eagerness to eject this unwelcome boarder and keep him out.

At the end of the lecture, Sawyer reported in a letter to his wife, the participants "were told to sit still to have their pictures taken, and I went back to the doorway, the only source of light of any consequences, and took three time exposures of 40 seconds each. After the meeting there was a microscopic demonstration outside. We returned to headquarters, where we visited with the staff and discussed methods."

The visit, Sawyer and Heiser concluded, gave them the opportunity to see that "the hookworm work had been successful in spite of the reputed conservatism of the Siamese, and that the time was opportune for extending it to other parts of Siam and making the project truly national." They concluded, "Of all the mental pictures that we carried away from Siam, the one that stays most vividly is the sea of eager faces at the hookworm meeting in Wat Sansai. It was symbolic of a national movement for better health, which we confidently believe will expand to meet the needs of the people."[41]

This use of local setting and the advocacy implicit in so doing was not atypical. On his extended visit to Ceylon in 1924, Sawyer reported a dispensary in a Muslim "(Moorish) village at the house of a headman," and in Pannipitiya in the Homagama area, again, a dispensary at the headman's house because of the central importance of the headman in inducing people to come for treatment.[42] In Magammana, where dispensaries were conducted at the headman's house for three consecutive days per week, native physician *vederalas*[43] had been recruited to help by taking treatment themselves and by bringing people to the dispensary. Here, circulars were distributed in Sinhalese, Tamil, and English; in Madras, India, they were distributed in Tamil, Telegu, and English. Sawyer describes a lecture, with lantern slide images projected onto a sheet on the wall of a house in front of Hindu Temple, given (in Tamil) by the subassistant surgeon, Mahamad Ali, to several hundred people, around 70 percent of whom indicated by show of hands that they had already been treated.[44] In Madras, the subassistant surgeon lectured at schools with lantern slides and identified those who needed treatment every day at dusk, and provided treatment at 7:00 AM the next day for all students, with the aim of covering the seven hundred schools in the city over two years.[45] The lantern slides were enduring novelties, as Sawyer noted in a letter to Margaret at the conclusion of his 1924 visit to India: "Toward evening we went by car to a village and I heard a lecture in Telugu on the usual subject of hookworm disease. The tom-tom beater was very much in evidence and a good crowd had gathered.

The lecturer used lantern slides, which are still a drawing card among these peo-
ple who see so few pictures of any kind."[46]

These were not unusual stories. The general pattern for Rockefeller-supported
activities in Thailand, Ceylon, and India included lectures that used lantern slides
and Meyer charts to explain the life cycle of the hookworm, the importance of
therapy, and the collection of stools, diagnosis, and treatment. Concurrently,
attention was given to ensuring the regular supply of drugs, countering occa-
sional complaints of toxic side effects from the drugs and complaints about the
treatment of children without parental authorization, and working with the local
administration to improve sanitation—removing unsanitary latrines, as in north-
ern Thailand where they original emptied into the town river and water supply,
and improving the collection and safe disposal of night soil. Reluctant colonial
administrators and inept estate managers were as much a problem as recalcitrant
or superstitious villagers.

Neither the Meyer chart, showing the life cycle of hookworm, nor the lantern
slides appear to be extant. But in 1920, the film *Unhooking the Hookworm* was
produced, and copies still exist. The film was rapidly distributed to all Interna-
tional Health Board intervention sites to supplement other public health educa-
tion campaign materials. In Australia, its first screening appears to have been on
April 13, 1922, as part of a lecture on hookworm at Australian Museum in Sydney.
The film was shown in conjunction with lantern slides on July 22 at Goodna,
Queensland, which then as now included an Aboriginal population.[47] Increas-
ingly, it was to feature in public health education in Australia and in Asia.

Imagining the Invisible

During the period when the Rockefeller Foundation was most active in eradicat-
ing hookworm, the public health poster as we know it, widely distributed to
attract public attention and encourage changes in perception or practice, barely
existed. Instead, in the colonies of Australia and Ceylon, the Federated Malay
States and Indonesia, and in the independent state of Siam, textual leaflets, trans-
lated into the vernacular, were distributed, persuading people to wear shoes and
use latrines. These did not include illustrative material; there were no pictures of
folks squatting over neat, unsoiled, and fly-free trenches, the ground at their feet
dry and clean. The subject was not picturesque, and visual metaphors were elu-
sive. But also, pictographic material was still expensive to reproduce and was used
in a limited fashion, hence the particular novelty of the lantern slides and *Unhook-
ing the Hookworm* for educational purposes, as well as the use of displays in aca-
demic settings. Moreover, as illustrated by Sawyer's photograph albums, even for
a personal record of travel, latrines do not make for great photographs and Sawyer
was parsimonious as a photographer.

The gaze of the camera, as Susan Sontag argued in her early essay, is revealing. The captions to Sawyer's photographs of the public health work of the Rockefeller Foundation are annotative, concerned to explain and supplement the images of latrines, unsanitary settlements, decay, risk, illness, and health practices. The more dramatic images of disease, and the arguments for public health interventions, are those in the written text: as I have illustrated, language was often used to dramatize the urgent need for disease prevention and control, and professionals such as Sawyer took advantage of extended travel time to maintain in diaries and both personal and work-related letters rich written accounts of their work. But the photographs typically include human subjects—a woman with four infants and small children, a laborer, a crowd of plantation workers. While they remain nameless, their presence asks us to consider their health, and to relate this to the conditions of everyday living. A photograph, like a text, history like anthropology, asks us therefore to consider what is almost always outside of the frame: to ask why the photograph was taken, to consider the multiple stories that it might tell—the caption and the written text in publications point to only one possible direction of analysis and interpretation.

Notes

1. All references to the Wilbur Augustus Sawyer Papers (1899–1952), MSC 69 (hereafter cited as W. A. Sawyer Papers), especially Series I (Personal and Biographical), Series III (Diary Books), and Series V (Photographs and Motion Pictures), found in the Archives and Modern Manuscripts Program, History of Medicine Division, National Library of Medicine, Bethesda, Maryland.

2. Charles Wardell Stiles, *Report on Condition of Woman and Child Wage-Earners in the United States* (Washington, D.C.: Government Printing Office, 1912), 9.

3. See Rockefeller Foundation, *Bibliography of Hookworm Disease* (New York: International Health Board, Rockefeller Foundation, 1922).

4. Arthur Looss, *The Anatomy and Life History of Agchylostoma duodenale* (Cairo: National Printing Department, 1911).

5. *Rural Sanitation in the Health Service: Hearings before the Committee on Public Health and National Quarantine, Sixty-Fourth Congress. First Session on S.2215, The Bill to Provide Divisions of Mental Hygiene and Rural Sanitation in the United States* (Washington, DC: Government Printing Office, 1916), 62, quoting *Los Angeles Tribune*, June 1912, n.d.

6. See *Rural Sanitation in the Health Service* See also Rockefeller Foundation, *Bibliography of Hookworm Disease.*

7. See Sir Malcolm Watson, *Rural Sanitation in the Tropics: Being Notes and Observations in the Malay Archipelago, Panama, and Other Lands* (London: John Murray, 1915).

8. Ibid., 72.

9. Ibid., 119.

10. See Benjamin E. Washburn, *As I Recall: The Hookworm Campaigns Initiated by the Rockefeller Sanitary Commission and the Rockefeller Foundation in the Southern United States and Tropical America* (New York: The Rockefeller Foundation, 1960).

11. See Bailey Kelly Ashford and Pedro Gutiérrez Igaravidez, *Uncinariasis (Hookworm Disease) in Porto [sic] Rico: A Medical and Economic Problem* (Washington, D.C.: Government Printing Office, 1911).

12. See Stiles, *Report on Condition of Woman and Child Wage-Earners in the United States.*

13. See Thomas Wright Jackson, *Tropical Medicine, with Special Reference to the West Indies, Central Amrica, Hawaii, and the Philippines, Including a General Consideration of Tropical Hygiene* (Philadelphia: P. Blakiston's Son & Co., 1907).

14. Washburn, *As I Recall,* 53–64.

15. See Samuel Taylor Darling, Marshall A. Barber, and Henry P. Hacker, *Hookworm and Malaria Research in Malaya, Java, and the Fiji Islands: Report of Uncinariasis Commission to the Orient 1915–1917* (New York: International Health Board, Rockefeller Foundation, 1920).

16. W. A. Sawyer Papers, Series III, Box 6, XV (November 14, 1918–December 31, 1921), 256–57.

17. Broken Hill was Australia's and one of the world's largest mines. Deposits of lead and silver were found in the area in 1883. Two years later the Broken Hill Proprietary Mining Company Limited (BHP) was established; additional subsidiary and independent companies were established largely over the next two decades. By 1906, some 7,500 men were working in the mines and the town had a population of 39,000 and 58 hotels; in 1907 the number of miners employed had jumped to 9,000 with increased prices in lead. In December 2009, the estimated population was 21,314, with mining still contributing to the local economy.

18. Gold was discovered in Bendigo in 1848 and by the early 1850s was a center of the Australian gold rush. Mining expanded underground from the early 1880s, and flooding created a perpetual problem in the deepest mines. In part for this reason, mining had slowed down by about 1914, and Sawyer's involvement related as much to general public health interests as to mining in this area. Sewerage was laid in Bendigo in 1922 as part of an effort to attract other industries, and although this did not occur, there was a brief revival in the 1930s.

19. W. A. Sawyer Papers, Series III, Box 6, XV (November 14, 1918–December 31, 1921), 133.

20. Sawyer had met with Hughes in September of the previous year, commenting on his deafness and the fact that he used an electrical apparatus. See W. A. Sawyer Papers, Series III, Box 6, XV (November 14, 1918–December 31, 1921), 176.

21. See W. A. Sawyer Papers, Series III, Box 6, XVI (January 8, 1921–October 19, 1922).

22. Margaret's rather pithy cable, received by Sawyer when he arrived in Colombo on March 28, advised: "Son born. Well. Your father died January." See W. A. Sawyer Papers, Series III, Box 6, XVI (January 8, 1921–October 19, 1922), 89. The boy was born on March 23; Sawyer first saw him on his return to Brisbane from this trip on May 3. See W. A. Sawyer Papers, Series III, Box 6, XVI (January 8, 1921–October 19, 1922), 137.

23. Sawyer notes, in a letter to his wife dated January 15, 1921: "We organized the Public Health Association of Australasia yesterday" with Cumpston as president. See W. A. Sawyer Papers, Series I, Box 4. Sawyer gave extraordinary effort to this task the previous year and subsequently in the early life of the association. Again, this is a subject for another paper.

24. See W. A. Sawyer Papers, Series III, Box 6, XVIII (January 8, 1924–April 5, 1924) and XIX (April 5, 1924–October 10, 1924).

25. See W. A. Sawyer Papers, Series III, XX (October 8, 1924–November 12, 1926).

26. Sawyer held this position until his retirement in 1944 at age 65, when he became Director of Health for the United Nations Relief and Rehabilitation Administration. He died November 12, 1951; his obituaries published at the time credit him with controlling disease in the postwar era and preventing the kind of outbreak that characterized the end of World War One. Among his many achievements, he developed the first viable—but not commercially viable—vaccine for yellow fever, using his son as one of the volunteers (he was immune). Under Sawyer's

directorship of the Division, Max Theiler continued this work, and developed a commercially viable vaccine, for which he was awarded the Nobel Prize in Physiology or Medicine in 1951.

27. Jackson, *Tropical Medicine*, 374–75.

28. Stiles, *Report on Condition of Woman and Child Wage-Earners in the United States.*

29. Albert John Chalmers, *Report of the Sanitation of Colombo and the Causes of Abnormal Incidence of Specific Diseases in 1906* (Colombo, Sri Lanka: Government Printer, 1907).

30. Ibid., 8.

31. Ibid., 10.

32. Ibid., 19.

33. C. Carkeet James, *Oriental Drainage: A Guide to the Collection, Removal, and Disposal of Sewage in Eastern Cities, with a Glossary of Sanitary and Engineering Terms* (Bombay: Times of India Press, 1902), 1.

34. W. A. Sawyer Papers, Series III, Box 6, XVIII (January 8, 1924–April 5, 1924), 14.

35. Dr. Bridger was the Sanitary Commissioner in Ceylon.

36. W. A. Sawyer Papers, Series III, Box 6, XVIII (January 8, 1924–April 5, 1924), 20.

37. Hector Holdbrook Howard, *The Control of Hookworm Disease by the Intensive Method* (New York: International Health Board, Rockefeller Foundation, 1919), 31–32.

38. Ibid., 33–34.

39. W. A. Sawyer Papers, Series III, Box 6, XV (November 14, 1918–December 31, 1921), 165, 232.

40. See W. A. Sawyer Papers, Series I, Box 4. See also M. E. Barnes, *Final Report on the First Treatment Campaigns for the Relief and Control of Hookworm Infection in Changwats Chienmai and Lampoon, Monthol Bayap* (Bangkok: International Health Board, Rockefeller Foundation, 1923), and M.E. Barnes et al., *Final Report on Hookworm Survey and Health Propaganda Work in the Kingdom of Siam* (Bangkok: International Health Board, Rockefeller Foundation, 1924). See also Wilbur Sawyer to Margaret Sawyer, March 11, 1921, in the W. A. Sawyer Papers, Series III, Box 6, XVI (January 8, 1921–October 19, 1922), 1–2.

41. Victor G. Heiser and Wilbur A. Sawyer, "Wats and Worms," *Bulletin of the International Health Board* 2 (1921): 21–29. See also Kai Khiun Liew, "Wats & Worms: The Activities of the Rockefeller Foundation's International Health Board in Southeast Asia (1913–1930)" (unpublished manuscript, Wellcome Trust Centre for the History of Medicine, University College London, 2006).

42. W. A. Sawyer Papers, Series III, Box 6, XVIII (January 8, 1924–April 5, 1924), 16, 28.

43. Ibid., 29.

44. Ibid., 182–85.

45. Ibid., 171.

46. Wilbur Sawyer to Margaret Sawyer, April 1, 1924, in W. A. Sawyer Papers, Series I, Box 4.

47. Goodna is roughly midway between Brisbane and Ipswich, and would have been relatively rural in the 1920s. Today Goodna is part of the City of Brisbane.

2. *Cultural Communication in Picturing Health*
W. W. Peter and Public Health Campaigns in China, 1912–1926

LIPING BU

THE EVOLUTION OF MODERN PUBLIC HEALTH EDUCATION took place in China when the country was undergoing a difficult process of transformation from a traditional society into a modern nation. The pioneering effort of national public health education was initiated in 1910 by the Joint Council on Public Health Education, which was composed of Western-trained Chinese physicians and Christian medical missionaries. The Chinese nationals in modern medicine were searching for national sovereignty and modernity through the public health movement, whereas the missionaries were seeking Christian evangelism. Although these two groups came from drastically different cultural backgrounds and aspired to different larger goals in their public health efforts, they both promoted Western medicine and public health in the name of progress and modernization of China. They emphasized the scientific nature of Western medicine and simultaneously dismissed Chinese traditional medicine as nonscientific superstition. They believed that their work would help legitimize and expand Western medicine in the Chinese society where the populace still adhered to Chinese traditional medicine. In transferring Western medical knowledge to a Chinese audience, they also conveyed Western cultural values and practices. The Chinese audience at first showed indifference to the health lectures delivered to them in the style of missionary preaching. Thoughtful organizers of public health campaigns such as W. W. Peter gradually adapted to Chinese culture and concerns to make health education more acceptable and attractive to the Chinese audience, even though the council achieved limited successes in the long run.

The public health education campaigns of the council were a phenomenal movement in early twentieth-century Chinese cities. And yet, this major effort of public health education has not been studied by scholars. In the extensive literature on missionary enterprises and China's modern medicine and public health, there is only brief mention of the events by historians such as Shirley Garrett, Mary Bullock, and Ka-che Yip. In fact, Chinese public health education as a field of study lacks scholarly investigation, though it is increasingly gaining scholarly

attention. This study contributes to the scholarship on Chinese modern medicine and health with a detailed examination of the first modern public health education movement in China. It concentrates on cultural communication in the dissemination of modern medical and health knowledge from the West to China, and it illuminates the cultural challenge of such an endeavor. Drawing upon traditional archival materials and nontraditional and nontextual sources such as posters and photographs, the article delineates the efforts of public health and analyzes how the communication of medical and health information was embedded with particular cultural values and practices and why the first major effort of the public health education movement in China failed to achieve many of its goals.

Western modern medicine was first brought to China by missionaries in their evangelical mission to convert Chinese people to Christianity. The missionaries found that medical services and teachings were effective means to attract local people and open up the society. Scholars have pointed out the role of medicine in the Western imperialist conquest of diverse societies in Africa and Asia.[1] Louis-Hubert Lyautey, a French colonial administrator and marshal of France, once commented revealingly about medical service in colonial conquest: "La seule excuse de la colonization, c'est la médicine."[2] Since the mid-nineteenth century, Western missionaries in China emphasized the backwardness and ill health of the Chinese people in their reports about China to the outside world. They depicted the Chinese people as an exotic but deformed people and therefore helped create a peculiar perception of the Chinese people in the Western imagination.[3] Additionally, the emphasis on the ill health of Chinese people helped the missionaries effectively solicit donations from their homelands to support their evangelical cause abroad. Moreover, missionaries' approach toward ill health as an external manifestation of internal moral degradation helped justify their self-appointed moral leadership and presumption of cultural superiority through the use of scientific medicine to "civilize" and "save" others. Such moral justification of their evangelical mission provided the missionaries with self-righteousness to impose their religious beliefs and cultural practices as the right way for the Chinese people to make the transition from traditional "backwardness" to modern "progressiveness."

With the influence of germ and sanitation theories, the medical missionaries in China began to emphasize personal hygiene and community sanitation as ways to prevent diseases. They started with school hygiene and distributed information on epidemic diseases to school students. In 1910, the China Medical Missionary Association appointed a Committee of Medical Propaganda to take charge of public health education, but little was done due to the death of two key committee members and the outbreak of the 1911 Revolution in China.[4] In the midst of the Chinese Revolution arrived William Wesley Peter (known as W. W. Peter), an American medical missionary sent by the Mission Board of the Evangelical Association. He and his wife, Eleanor Elizabeth Whipple, sailed from San Francisco in

October 1911 and reached Shanghai a month later.[5] Peter had just finished his medical training at Rush Medical College in Chicago the previous year, but did not have experience of medical practice in America. Shortly after his arrival, Peter was posted at a missionary hospital in Wuchang of Hubei province in central China. Like the rest of the medical missionaries in China, Peter worked at the hospital to serve two main purposes: to heal the body, but more importantly, to save the soul by converting the patient to Christianity.

While working at the Wuchang hospital, Peter became interested in public health education in China, arguing that the hospital treatment of patients was too slow and could not meet the health needs of millions of Chinese who suffered from such epidemic diseases as tuberculosis, plague, cholera, and smallpox. His interaction with the Chinese patients, who usually came from the illiterate social classes, convinced him that "[i]n China there is no common knowledge regarding tuberculosis except that it is caused by devils, spirits and revengeful gods, and hastened by night, and especially cold, air *[sic]*."[6] Chinese people's understanding of illnesses and their belief in Chinese traditional medicine were integral parts of Chinese culture, which Peter had to learn to understand during the next fifteen years he spent in China. The Chinese population was suspicious of Western medicine, whose surgery, dissection, and autopsy were not only culturally alien but also frightening to them. Most of those who sought treatment in missionary hospitals were destitute and illiterate, and did so as a last resort. Peter believed that the significance of preventive medicine in a country of large population like China could not be neglected, realizing that public health education could be a great opportunity to carve out a new professional career for himself. The work at the Wuchang missionary hospital offered little prospect of specializing in surgery, but the new public health field was full of needs and opportunities. Peter wrote about his new ambition to "become a sanatarian *[sic]*, an expert on hygiene, a director of public health."[7]

In seeking the potential channel to accomplish the plan of public health education, Peter turned his attention to the YMCA in China, which had been engaging in promoting public health in its social services and reform programs.[8] The YMCA had delivered lectures on public health and distributed health literature to educate the public about tuberculosis and cholera. The Shanghai YMCA even created an antituberculosis story calendar that was distributed to individual homes.[9] The YMCA also published health articles in Chinese newspapers to discuss diseases that took heavy death tolls during different seasons, namely smallpox in winter and dysentery and cholera during the summer. The YMCA leaders were receptive to the suggestion of launching a public health education program when Peter discussed it with them. In July 1913 Peter was formally released from the Missionary Society of the Evangelical Association, and he joined the International Committee of the YMCA.[10] Late that year the China YMCA created a Health

Division under the Lecture Department, where Peter began his career as a YMCA secretary in charge of public health education.

In 1914, the China Medical Missionary Association asked Peter to help construct a public health exhibit. Inspired by the traveling health exhibits that were developed by the American Medical Association (AMA) in the United States, Peter purchased exhibition materials from the AMA's illustrated catalogue and adapted them for the Chinese audience. In February 1915, Peter's health exhibit was displayed at the national conference of the China Medical Missionary Association in Shanghai. It occupied more than two thousand square feet of space and included maps, charts, diagrams, cartoons, paintings, pictures, placards, tracts, and epigrams, as well as lantern slides and large mechanical and electrical devices that Peter and his staff created to illustrate deaths from tuberculosis and smallpox.[11] At the conference, Wu Liande (Wu Lien-teh), the Cambridge University-trained Chinese doctor in modern biomedicine who led the Manchurian Plague Prevention Service, also displayed an "Exhibit on the Manchurian Plague."[12] Wu's exhibit represented the pubic health education of the Chinese government, whereas Peter's represented the missionaries' program. These two exhibits, which were intended to publicize health knowledge among the general audience as well as the professionals, were so popular that requests came from different groups across the provinces to inquire about the use of the exhibits to launch health campaigns.

The local interest in the health exhibits provided the YMCA with great opportunities to organize public health campaigns as an integral part of their evangelical mission in China. The YMCA and the China Medical Missionary Association (CMMA) collaborated closely in coordinating these public health campaigns as means to further penetrate Chinese society. Often the sites of the health campaigns were chosen with the strategic consideration that evangelical campaigns were to follow immediately so as to capitalize on the enthusiasm of the people who had gathered to see the health campaigns.[13] Peter believed that this collaboration served as a step "to unite the C.M.M.A. and local Y.M.C.A. on a common program of work."[14] As a demonstration of its commitment to the public health program, the CMMA created a Council on Public Health at the 1915 Shanghai conference and allocated half of its budget (about $600) for the council's work. Members of the council included key figures in modern medicine such as Henry S. Houghton of Harvard Medical School of China in Shanghai, who served as chairman;[15] W. W. Peter, who served as secretary; Yan Fuqing (F. C. Yen) of Hunan-Yale Medical School;[16] Ida Kahn of the Methodist Women's Hospital in Nanchang of Jiangxi province; F. C. Tooker of the Presbyterian Hospital in Xiangtan of Hunan province; and H. J. Smyly of Peking Union Medical School.[17] The newly founded National Medical Association of Chinese Physicians joined the Missionary Association's Council on Public Health to form the Joint Council on Public Health Education in March 1916.[18] Thus, these two groups

became a main force in public health education under the organizational umbrella of the new Joint Council. The evangelical agenda in public health campaigns was subdued with the Chinese nationals' participation, but the Christian message continued due to the dominance of medical missionaries.[19]

Major health campaigns were conducted in 1915 and 1916 in cities such as Shanghai, Changsha, Xiangtan, Nanjing, Kaifeng, Hangzhou, Xiamen, Shantou, Fuzhou, Beijing, and Tianjin, where local YMCAs, missionary groups, and Chinese government officials, businessmen, educators, and students were mobilized to cooperate with the Joint Council's health team. Posters and bulletins were distributed in the city wherever the campaign was held, with the hope of making the epidemic diseases of plague, cholera, malaria, and smallpox the chief topic of conversation in the entire city. Although the campaigns targeted the local Chinese population, much of the health information provided by the council had a distinctly American flavor. In Figure 2.1, for example, the text description and the high chair depicted in the poster are infused with cultural relativism: the American expression "play pen" and the high chair were rarely used among Chinese families. The only specific change made to this poster that seemed to address the Chinese audience was the energy exerted to make the boy Chinese-looking and wearing Chinese clothes and shoes. But the text message on the poster was a direct translation from the original English. As many materials

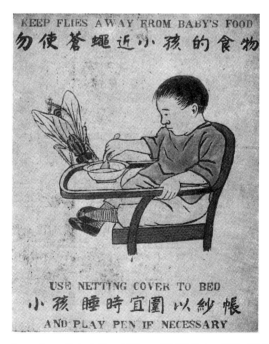

Figure 2.1. "Keep Flies Away from Baby's Food," from W. W. Peter, "The Field and Methods of Public Health Work in Missionary Enterprise," *China Medical Journal* 40 (March 1926), 223.

presented at the health exhibit and campaign were things purchased from America, some visitors who were newly exposed to modern public health campaigns did not relate the items closely to China. For instance, during a health campaign in Kaifeng of Henan province in October 1915, a group of women (mostly wives of local officials) went to the health exhibit and saw a picture of a magnified common house fly. According to Peter, one of them cried out: "Is that the kind of flies you have in America? No wonder you are afraid of them! If we had flies as big as that here in China we would have to be afraid of them too."[20]

Typically, the health campaigns lasted for a week and had three major components—exhibits, lectures, and slide and film shows. The exhibit materials and illustration devices formed such a large collection that Peter had to hire Chinese laborers to carry the exhibit materials on wheelbarrows when the council's health team was on the road. The laborers, often called coolies, tended to chant to amuse themselves when pushing the wheelbarrows on the street. Seeing this, Peter lost no time in turning them into live advertisements. He asked the laborers, who were extremely talented in incorporating new materials of health shows in their songs and intermittent chorus, to chant verses about the health campaigns coming in town.[21] Moreover, Peter sometimes recruited urban residents to help stage public health parades to raise the public's awareness of how flies and mosquitoes could kill people as agents carrying germs to spread diseases. At one city Peter used these "sandwichmen"—so called because of the use of the American commercial tactic of wearing sandwich boards—to publicize the health campaign meetings (see Figure 2.2). This publicity strategy of sandwichmen was deemed culturally inappropriate in the Chinese setting, as it reminded many Chinese people of the parade of the execution of criminals, or the bodyguard with a Chinese character *yong* (勇, brave) on his back and front. Nonetheless, this publicity tactic was quite effective in making the health campaign *the* conversation on streets and in tea houses.[22]

The health campaigns were intended as visual displays of modern scientific knowledge and strategies for improving public health. But the specific goals that

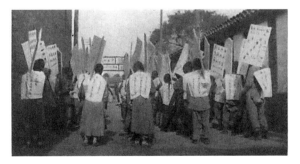

Figure 2.2. Public Health Campaign Parade, E. C. Routzahn, *The Health Show Comes to Town* (New York: Russell Sage Foundation, 1920), 11.

such campaigns tried to achieve and the materials that they used to communicate those goals were extremely diverse. In fact, the campaign had to encompass the interests of at least three groups of audiences: the missionary/YMCA evangelical cause, the American business and health interests, and the Chinese personal and national health interests. To justify the health campaign for American interests, Peter pondered: "China, plague-ridden and cholera-infested, is a distrinct [sic] menace to the health of America. China, handicapped by existing bad health conditions and therefore bearing more than the usual economic load due to high death rate and incapacity of wage-earners on account of preventable diseases, is to that extent less able to buy from America."[23] Peter concluded that "[a] sick nation is a backward nation commercially," and his work "ought to appeal to medical and business men" alike, for they were important to the missionary cause and the health campaigns as potential donors and partners. Such commercial appeals were also intended for the Chinese audience as well, especially those in the business and modern medical circles. But how, and in what ways, would the church benefit from these health campaigns? Peter recognized that missionaries constantly faced two problems in China: one was "[h]ow to develop contacts with previously inaccessible people so that they may be influenced toward the Kingdom [of Christ]" and the other was "[h]ow to enlist those not yet in the Kingdom in service for others." "The solution of these problems," Peter argued, "lies in the direction of finding some enterprise in which all classes in a city are interested. There are many who are not interested in education or religion with whom missionary workers have longed to get in contact. But everybody is interested in the health question, and a Health Education Campaign is one way in which the above problems may be solved."[24]

Peter popularized the economic argument of public health in folksy language to emphasize the financial gains of individuals in having good health. Visitors to the exhibits and lectures saw a big banner hanging above the lecture platform: "卫生能生利" with its English equivalent "Health Pays Dividends" below the Chinese characters. The very idea of "Health Pays Dividends" came from American commercial business culture and characterized the whole health campaign to appeal to people's fundamental desire to know the personal benefits of good health. Peter explained that good health not only offered "self-protection" for your life but also brought in "dollars and cents," for when you were healthy you were productive to make money, but when you were sick you had to spend money to see doctors. However, the notion of "dividends," derived from the stock market operation in the West, was a new and culturally alien concept for Chinese people, who traditionally interpreted "good health" in terms of prolonging life to enjoy life, not in terms of financial gains.

Ultimately, Peter felt that the appeal of economic gains of good health was not enough to attract diverse social groups of merchants, students, soldiers, scholars, and government officials. As an evangelist, Peter never forgot that "our objective

is not only four hundred million bodies, but four hundred million souls" and that the public health program "is a mighty weapon for extending the Kingdom [of Christ] in China."[25] But Peter was aware that the Chinese people were generally not interested in evangelical preaching. In order to attract Chinese of all classes to the health campaigns, Peter tried to adapt to the Chinese cultural and political needs by linking public health to the Chinese concerns of national survival and strength. During his years in China, Peter had met Chinese from a wide social spectrum—laborers, merchants, students, teachers, army officers, and government officials of all levels. He found them invariably concerned first and foremost with the fate of their country in the face of the increasing dominance of foreign powers. Consequently, he titled his health lectures "The Relation between National Health and National Strength," in which he elaborated on the relations between national health and national economic, educational, and moral strengths. Such a linkage proved effective, for previously when he explained in pure scientific terms that large numbers of Chinese were dying each year from diseases and poor sanitation, his Chinese audiences were not impressed. They simply retorted that there were too many people in China anyway and deaths somehow kept people from being pushed into the sea. Their indifference to Peter's health lectures demonstrated their suspicion and boredom with the usual missionary preaching about the backwardness of China. When Peter made the linkage of national health and national strength, the Chinese audience sat up and listened to his explanation of how the health of a population contributed to national power as demonstrated in the low death rates among strong countries such as America and England and the high death rates among weak countries such as India and Egypt.[26] The Chinese audience particularly wanted to know the death rate of Japan in comparison to that of China. Despite a lack of reliable statistics, Peter estimated China's death rate at 40 per 1000, whereas Japan's death rate was set at 25 per 1000.[27]

The positive response to the lecture on national health and national strength led Peter to highlighting it as a key component of the health campaign. Additionally, Peter and his associates believed that women, who were eager attendants at the health campaigns, had their "special needs" that had to be taken care of. On women's day, which was usually the last day of the week-long campaign, health talks were held exclusively for women with the title, "The Care of Your Baby." These talks emphasized baby care and home hygiene with detailed demonstration of proper clothes for baby, methods of dressing and undressing, giving baths, preparing packaged commercial food, and demonstrating the proper bed for good baby sleep. This approach suggested the health campaign's complicity with the separate domestic space for women and public roles for men that fit Chinese traditional gender expectations. Moreover, the talks on women's day further demonstrated the transfer of American middle-class values of domesticity to Chinese women during the public health education campaigns. Chinese mothers breastfed their

babies and slept with their babies. In the high fashion of seeking modernity in the early twentieth century, only very few rich families—mostly modern Chinese merchants—tried commercial baby food or used separate beds for their babies. The talks of baby care during the health campaigns actually introduced Chinese women to American middle-class ways of raising children and actively promoted American commercial products in China.

The health campaign attracted tens of thousands of people in each city; many were curious onlookers who passed through the exhibit hall and the lectures. One major challenge for the Joint Council on Public Health Education was to get enough qualified health instructors to give health lectures and explain the exhibit items to the large crowds from morning through evening. After several experiments with recruiting local students of modern medicine, YMCA members, and businessmen to work as "health faculty," the council set up a routine to train a few key recruits first and then designate them as captains and lieutenants to train the rest. The size of the health faculty ran from a few dozen to a few hundred, depending on the crowds at the health shows. In Tianjin, for instance, the council trained 450 men as health faculty, and each health session would have a different group of health instructors to explain the exhibits. In Changsha, however, the council trained 75 men to cover all sessions of health meetings and exhibits, which entertained about 30,000 people who passed through the exhibition hall. More importantly, these 75 men, equipped with thorough understanding of the subjects of the health exhibits, became the informed public health experts, who worked with local organizations on health matters after the health campaign had left town.[28]

The public health campaign often turned out to be a great social occasion for local people, who were curious and eager to join the crowds. Groups with widely divergent interests exploited the occasion for their own benefit. Missionaries, who were often active participants in the organization of the health campaign, enthusiastically rode on the wave of the campaigns to further their evangelical cause. Shrewd merchants also took advantage of the occasion to advertise their products and sell their drugs. During the health campaign in Changsha in May 1915, for example, people received free copies of a little booklet called "Hygiene and Sanitation Indispensible [sic]," which wasn't distributed by the health campaign organizers. The booklet contained good health information, but ended by saying: "Now the way to secure all the advantages of hygiene and sanitation mentioned in this book is to buy Dr. Williams Pink Pills for Pale People *in large quantities.*"[29]

W. W. Peter went on furlough in 1917–1918 and then worked in France with Chinese laborers through the end of World War I. During Peter's absence, the Joint Council was run by Hu Xuan-ming (S. M. Woo), who had received medical and public health training at the Johns Hopkins Medical School and the Harvard-MIT School of Public Health. Hu Xuan-ming initiated the "National Health Essay Contest" in 1917 to increase the awareness of public health among Chinese students

and devoted much energy to translating health pamphlets from English into Chinese for distribution in cities across China. The council's efforts to disseminate public health knowledge through literature and campaigns attracted support from other organizations. In 1920 the YWCA, the Chinese Christian Education Association, and the Nurses' Association of China joined the Joint Council to strengthen the public health education movement in China. With these new forces as sponsoring organizations, the Joint Council was reorganized and renamed as the Council on Health Education. Its mission also shifted to concentrate on public health education apart from evangelical purposes. Peter was elected as the director of the newly reorganized Council on Health Education after his return to China in early 1920, and he began to discuss the need for public health education in China from a perspective typical of the health professionals of the United States.[30] He pointed out that as a nation "China has not as yet followed the example of other great nations in establishing national, provincial, and city Boards of Health. Nothing is being done in an adequate way to decrease the prevalence of the many communicable diseases, which each year cause the loss of many lives. There are no vital statistics and there is no public opinion as yet to bring about modern health-conserving work."[31] Hence, public health education appeared to be the most urgent need for both Chinese officials and the masses. Peter served as the director of the Council on Health Education until 1926, when he returned to the United States for good.[32]

The Council on Health Education functioned as the umbrella organization for the different sponsoring organizations that formed the important force in promoting modern public health education in China. Major work of the council included preparing and distributing "health literature such as bulletins, leaflets, cartoons, posters, lecture charts and books with lantern slides and film shows and exhibit material," and participating in "local health programs such as health conferences, campaigns, better baby weeks, vision conservation and health examination in schools."[33] In 1920 the council sold more than 132,000 copies of health bulletins across China and delivered hundreds of health shows, which included lectures, slide and film demonstrations, and exhibition displays that emphasized clean water and sanitation, keeping flies away from food, using mosquito nets, and killing rats.[34] The council also made health tours of campaigns, lectures, and exhibits to publicize the prevention of infectious diseases such as cholera, tuberculosis, plague, smallpox, venereal diseases, and malaria. The objectives of the health tour in each city were defined according to that city's particular circumstances and needs. The health tours provided the foundational steps for creating public health programs, organizing local public health societies, and promoting vaccination for smallpox.

By the 1920s, health literature had become more adapted to Chinese culture and life. In Figure 2.3, which was part of a series of posters designed to illustrate Chinese

Figure 2.3. "Do Not Share Towels among Family Members," from W. W. Peter, "The Field and Methods of Public Health Work in Missionary Enterprise," *China Medical Journal* 40 (March 1926): 221.

domestic life, the depiction of a grandmother washing her grandson's face authentically captured the lifestyle of a typical Chinese family, as grandmothers usually performed this task in a family where three (or more) generations lived together. The health messages of such posters aimed to reduce the spread of diseases among family members, but the practicality of the posters was not as effective as their creators expected, for they neglected to consider the socioeconomic dimensions of the actual life of the people as well as the challenge it posed to Chinese cultural customs. For instance, the poster in Figure 2.3 admonishes people not to share a towel among family members, an unrealistic ideal at that time when the majority of the population lived at the subsistence level. This health message, however, was gradually put into practice during the later decades when Chinese society had undergone fundamental socioeconomic advances and is now practiced in almost every urban household. In Figure 2.4, the poster on eating habits encourages people not to share food and to use different pairs of chopsticks, spoons, and dishes when taking food from shared bowls and plates. The health message of this poster poses the same challenges as that of Figure 2.3, for it requires not only changing traditional eating habits but also a considerable increase of living standards of the Chinese families before they could possibly afford to follow the health instruction. The fact that today's visitors to China notice the use of separate bowls and plates and extra pairs of chopsticks and spoons by people in restaurants and increasingly in private homes suggests the willingness to change certain traditional eating habits for the sake of health when they can afford to do so.

Figure 2.4. "Do Not Share Food," from W. W. Peter, "The Field and Methods of Public Health Work in Missionary Enterprise," *China Medical Journal* 40 (March 1926): 222.

In addition to disseminating health information, the council was often called upon to launch a new health campaign when an epidemic hit a particular region. The Anti-Cholera Campaign in the city of Fuzhou in June 1920 was such a campaign when cholera broke out in that region. The council provided the professional leadership of the campaign while the Fuzhou Health and Sanitation Committee, which was made up of local leaders, sponsored the campaign. According to Peter, more than 2,380 volunteers worked as assistants for the daily health parades, lectures, and a large outdoor health exhibit about cholera. The parades covered 90 percent of Fuzhou city streets with an audience of 220,000 people. The campaign proved so effective in educating people in the prevention of the disease that when cholera hit the region again, Fuzhou basically remained cholera free.[35]

Smallpox was another epidemic devastating many communities in China. Once the city of Wuhu of Anhui province suffered from an outbreak of smallpox, the council was called upon to send over a team to hold health meetings and conduct over 5000 vaccinations in one week with the help of local medical doctors and nurses. On another occasion when a Shanghai factory with about 1000 employees suffered from smallpox, the council was asked to come and give vaccines, deliver health lectures, and distribute health literature in a two-day campaign.[36] In order to help people understand the possibility of preventing smallpox, the council printed and distributed posters of smallpox vaccination in many urban areas. The poster depicted in Figure 2.5 best exemplifies the vast improvement that the council had made in printing and distributing effective health imagery. This poster uses the popular Chinese term *tianhua* (天花, heavenly flowers) instead of the medical term *zhengzi* (疹子) to describe smallpox. In doing so, it immediately captured the

Figure 2.5. "Smallpox Vaccination" from W. W. Peter, *Broadcasting Health in China: The Field and Methods of Public Health Work in the Missionary Enterprise* (Printed by the Presbyterian Mission Press, Shanghai, 1926): 62.

attention of the audience, who saw the health message together with the image of a cute young baby boy that any Chinese parent might dream of as their own son, pointing towards the vaccine scars on his arm and declaring: "Get a quick vaccine if you don't want smallpox." This poster effectively communicated a serious health problem and its easy prevention by projecting a beautiful and healthy young Chinese boy. But there was one mistake in the poster: the boy shows the right arm instead of the left arm. In China, left-handed was and still is vigilantly guarded against by parents and teachers from early childhood; therefore the overwhelming majority of children are right-handed. In the inoculation of vaccines, children were asked to offer their left arms.

The council played a key role in disseminating popular knowledge of public health in many cities across the provinces of China, working with local governments, businesses, schools, and the military to generate support and interest in public health programs such as health essay contests, antituberculosis and anti-cholera campaigns, better baby weeks, vision conservation, smallpox vaccination, and health examination in schools. Its major programs included the preparation and distribution of health literature, the health exhibits and campaigns,

the health lectures, and the lantern slide and film shows. Many of these programs, however, did not take root in the local communities as the council had initially predicted. Several factors contributed to the failure of the council's efforts in the long run. First of all, the council did not invest adequately in coordinating follow-up programs with local health organizations that would continue necessary medical and public health services after the council's health campaigns were over. Second, while the council helped to establish a few local public health societies in different cities, there was no national network to encourage mutual cooperation and collaboration. The health campaign was often Peter's show, and little was done to ensure the transition of leadership of the council's work to the Chinese health professionals. Third, many Chinese local officials, who offered support for the public health campaigns, remained deeply in their hearts suspicious of the strong evangelical motivations that helped originate the program in the first place. Still, in the process of developing public health education through the popular methods of exhibits, campaigns, and lectures, W. W. Peter and his associates learned to adapt to Chinese culture and concerns in the designs of health lectures as well as posters and other visual devices in order to better communicate with the Chinese audience.

The novelty of modern health campaigns gradually became a popular propaganda format that the urban Chinese learned to participate in and to use for different purposes. Although it was created as part of the evangelical scheme originally, the health campaigns of the council shifted its mission from evangelical goals to professional dissemination of health knowledge, and the council carried out this pioneering movement of public health education with increased support of other organizations. Despite the fact that the public health education campaign did not retain its momentum after Peter's departure, it nonetheless offered a model for the public health campaigns that the Nationalist government launched.

Notes

1. David Arnold, ed., *Imperial Medicine and Indigenous Societies* (Manchester, UK: Manchester University Press, 1988); Roy MacLeod and Milton Lewis, eds., *Disease, Medicine, and Empire: Perspectives on Western Medicine and Experience of European Expansion* (New York and London: Routledge, 1988); Ma Boying, Gao Xi, and Hong Zhongli, *The History of Intercultural Medicine Communication between China and Foreign Countries* [Zhongwai yixue wenhua jiaoliu shi] (Shanghai: Wenhui chubanshe, 1993).

2. Quoted in Ruth Rogaski, *Hygienic Modernity: Meanings of Health and Disease in Treaty-Port China* (Berkeley: University of California Press, 2004), 165.

3. Some scholars pointed out that clinical photographs in the mid-nineteenth century frequently concentrated on "people suffering from extraordinary physical illness or disabilities." (Daniel M. Fox and Christopher Lawrence, *Photographing Medicine: Images and Power in Britain and America since 1840* [Westport, Conn.: Greenwood Press, 1988] 25.) In China, a camera was rare in the nineteenth century, and missionary doctors used

paintings to represent the deformity and illness. See Larissa N. Heinrich, "Handmaids to the Gospel: Lam Qua's Medical Portraiture," in *Tokens of Exchange*, ed. Lydia Liu (Durham, N.C.: Duke University Press, 1999), 239–75.

4. Ibid., 564–65.

5. Eleanor E. Whipple as Mrs. Peter received her education at the University of Chicago (B.S., 1907) and Rush Medical College (M.D., 1911). They were married in May 1911 shortly before their journey to China. Eleanor did not hold any official missionary position, but she served on the YWCA's Physical Education Committee and taught at YWCA schools. (W. W. Peter, "Biographical File," Kautz Family YMCA Archives, Andersen Library, University of Minnesota Libraries) (hereafter cited as YMCA Archives).

6. W. W. Peter, "Annual Report for the Year Ending September 30, 1914," (hereafter cited as "Annual Report 1914"), YMCA Archives, 3.

7. In his 1914 annual report, Peter mentioned that "to help me to reach this goal [of becoming an expert of hygiene] is my wife who had had a better premedical and medical training than myself. When we are called back to America [on furlough], we hope for some time for study and visitation with just this object in view." (Peter, "Annual Report 1914," 6.) Peter eventually earned his doctorate in public health from Yale University in 1927.

8. The YMCA's social reform programs in China have been studied by various scholars. See Shirley S. Garrett, *Social Reformers in Urban China: The Chinese Y.M.C.A., 1895–1926* (Cambridge, Mass.: Harvard University Press, 1970); Jun Xing, *Baptized in the Fire of Revolution: The American Social Gospel and the YMCA in China: 1919–1937* (Bethlehem, Pa.: Lehigh University Press, 1996); Charles Keller, "Making Model Citizens: The Chinese YMCA, Social Activism, and Internationalism in Republican China, 1919–1937" (PhD diss., University of Kansas, 1996); Kimberly Ann Risedorph, "Reformers, Athletics, and Students: The YMCA in China, 1895–1935" (thesis, Washington University, 1994); and Xing Wenjun, "Social Gospel, Social Economics, and the YMCA: Sidney D. Gamble and Princeton-in-Peking" (PhD diss., University of Massachusetts, 1992).

9. When the Council on Public Health was created in 1915, it bought the plate of the antituberculosis story calendar from the Shanghai YMCA and made a million copies of it to distribute across the country with the help of the Christian Literature Society. (W. W. Peter, "Annual Report for the Year Ending September 30, 1915" [hereafter "Annual Report 1915"], YMCA Archives, 9, 10, 17).

10. Peter, "Annual Report 1914," 2.

11. W. W. Peter, "The Public Health Exhibit," Appendix 2 to "Quarterly Report, January–March, 1915," YMCA Archives, 3; and letter, "W. W. Peter to F. S. Brockman, July 29, 1914," Appendix to Peter, "Annual Report 1914," 9.

12. Peter, "Annual Report 1915," 11.

13. W. W. Peter, "Report for Quarter Ending June 30, 1915," YMCA Archives, 2.

14. Ibid.

15. Houghton later served as director of Peking Union Medical College.

16. Yan Fuqing was president of the National Medical Association of China and had received medical training at Yale University. He was brother of Yan Huiqing, a diplomat who held Chinese government positions as Vice-Minister of Foreign Affairs in 1912, Foreign Minister in 1920, and a short term as Prime Minister in 1922 under Li Yuanhong.

17. Peter, "Annual Report 1915," 2–3.

18. The National Medical Association of China was organized at the 1915 Shanghai conference of the China Medical Missionary Association when a group of twenty-one Western-trained Chinese doctors, including Yan Fuqing, and Diao Xinde (E. S. Tyau), Yu Fengbin (C. V. Yui),

Ida Kahn, and Wu Liande, gathered at a dinner and voted to officially form their own medical association to distinguish from the association of the medical missionaries. They immediately set up a publication of their own professional journal, *National Medical Journal of China*, with Wu Liande as editor and sections in both English and Chinese languages.

19. Some of the Chinese members on the Joint Council were also Christians, such as Yan Fuqing and Ida Kahn.

20. W. W. Peter, "Report for Quarter Ending December 31, 1915," YMCA Archives, 4.

21. Peter, "Annual Report 1914," 9, 11.

22. Peter, "Annual Report 1915," 2.

23. Peter, "Annual Report 1914," 6.

24. Ibid., 7.

25. Ibid.

26. E. C. Routzahn, *The Health Show Comes to Town* (New York: Russell Sage Foundation, 1920), 16–19.

27. Chinese health professionals estimated the death rate of China at 30 per 1000 in the 1920s. According to John B. Grant, Japan had a very high infant mortality of 168 per 1000. The high infant mortality and low death rate were ascribed to two factors: public health in Japan was largely hygienic by rote, law, and regulation, but was little practiced in true preventive medicine, in addition to socioenvironmental conditions. See *The Reminiscences of Dr. John B. Grant*, Columbia University Oral History Project (Oral History Research Office, Columbia University, 1961), 397.

28. Routzahn, *Health Show*, 24–27. This pamphlet was based on Peter's report where Peter used rounded figures.

29. Peter, "Annual Report 1915," 6. Chinese newspapers such as *Shenbao* also carried the advertisement of "Dr. Williams Pink Pills" in the 1910s to 1920s.

30. Peter studied at Harvard-MIT School of Public Health and received a Certificate of Public Health in 1918. During the 1920s, Peter also served as chairman of the Sanitation Board and Chinese and Foreign Famine Relief Committee. He was a member of the Huai Valley Conservancy Board from 1923 to 1926. He founded and edited *Health Magazine* in 1924, but the magazine did not last long. In addition, he lectured on public health at St. Johns University in Shanghai during 1920–1926 while contributing articles on public health in medical journals and newspapers. In recognizing Peter's contribution to China, the Chinese government decorated him with a medal (jiahou wu ji) in 1924. (Peter, "Biographical File.")

31. W. W. Peter, "The Work of the Council of Health Education," *The National Medical Journal* 6, no. 4 (1920): 235.

32. After he returned to the United States, Peter obtained a doctorate in public health from Yale University in 1927 and became engaged in public health work in America. In the 1930s, Peter worked for the United States Indian Service as Medical Director at Navajo Areas, Window Rock, Arizona. (See YMCA "World Service Fellowship Questionnaire" filled out by Peter on Sept. 28, 1938, together with the letter "E. O. Jacob to W. W. Peter, June 6, 1938" in Peter, "Biographical File.")

33. Peter, "The Work of the Council of Health Education," 234.

34. Ibid.

35. Ibid, 234–35.

36. Peter, "The Field and Methods of Public Health Work in the Missionary Enterprise," *China Medical Journal* 40 (March 1926): 226, 230.

3. *The Color of Money*
Campaigning for Health in Black and White America

GREGG MITMAN

In 1936, the National Tuberculosis Association (NTA) commissioned the Austrian sociologist, poiitical economist, and philosopher Otto Neurath to design a traveling exhibit to educate Americans on the causes and prevention of tuberculosis. Part of a national NTA campaign launched under the slogan, "No Home Is Safe until All Homes Are Safe," "Fighting Tuberculosis Successfully" needed to carry its message of TB prevention to all age, economic, and racial groups in the United States. Neurath appeared a logical choice to accomplish this mission in mass education. Ten years earlier, while director of the Museum of Economy and Society in Red Vienna, he invented the International System of Typographical Picture Education, otherwise known as Isotype. Designed to convey statistics on economic and social life in visually simple forms, these pictograms were initially developed by Neurath to explain and disseminate the reformist ideas of Vienna's Social Democrats to the working classes, whose political support had brought their party to municipal power. Over the next decade, Neurath and his collaborators at the International Foundation for Visual Education greatly expanded these pictograms into the International Picture Language, a dictionary that contained over two thousand isotype symbols as well as a grammar of visual language.[1] Under the motto "Words Divide, Pictures Unite," Neurath envisioned a "universal medium of communication" that would "reach all people, rich and poor, sick and well, educated and uneducated."[2]

The building block of "Fighting Tuberculosis Successfully," the isotype embodied a particular symbol of universality. Details that added complicated, layered, and hidden meanings had been stripped away. Any mark of difference—of ethnicity, education, class, culture, or nation—were purposefully erased on the pictograms of universal man and woman (Figure 3.1). Shades of meaning could be added (the isotype for man multiplied became a population), but the symbol's effectiveness relied upon its ability to narrate a story simply, without words. A sign and its meaning needed to be transparent to "the educated man and the pre-school child alike."[3] In what he regarded as "the Century of the Eye," Neurath aimed to create a "visual lingua franca"

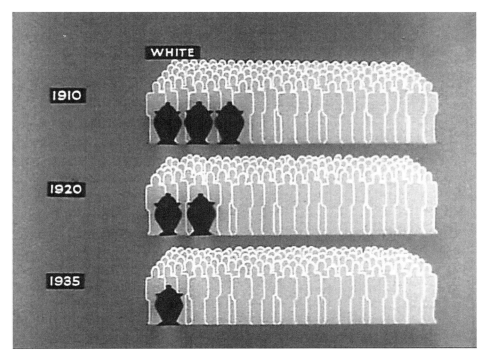

Figure 3.1. Grouping of Otto Neurath's isotype for universal man becomes a population, used to visually display the decreasing mortality rate of tuberculosis among whites in the National Tuberculosis Association film, *On the Firing Line*. Note the urn, symbolizing death, is black. Courtesy of National Library of Medicine.

that embraced socialist and democratic ideals, a basis of communication that would cut across lines of expertise, politics, education, and class.[4] Duplicated and exhibited over five thousand times, Neurath's tuberculosis display seemingly met with great success in the United States. But the eye could readily deceive.

Neurath's efforts to establish the isotype as an international picture language accorded well with his socialist beliefs and aspirations for a unified science, but they did not match the economic, political, and social realities of a segregated America. Neurath and the NTA may have believed that pictures unite, but to disenfranchised communities that the NTA sought to reach, and particularly African-American communities, pictures could just as easily reinforce the deep economic and racial divides in America as words could. From the late 1930s through the 1950s, leading national voluntary health agencies in the United States including the NTA and the National Foundation for Infantile Paralysis struggled with the issue of how to design visual materials for their public health campaigns that would reach across the color line in America. Although the initial impetus behind such efforts was motivated by the perceived threat that higher rates of diseases like tuberculosis among blacks posed to white Americans, making no

home safe until every home was safe, by the 1940s the buying power of blacks in American society had become an economic reality that leading voluntary health agencies like the National Foundation for Infantile Paralysis, as well as advertisers in general, could not afford to ignore.[5]

The problems an idealized universal visual language posed for voluntary health agencies were complex and brought into sharp relief the challenges that such agencies faced as they increasingly sought to capitalize on a market of health care and consumerism long segregated in America. Places of consumer culture, whether downtown shopping districts or country general stores, were important spaces where the color line in America's south appeared most visible and solid, but also where cracks in the black-and-white racial ordering of segregation first came into view.[6] The marketplace served as an important site for civil rights activism; this was no less true for health than it was for other service sectors of the economy, where lunch counters and public buses became a testing ground for change in the late 1950s. Contested visions, grounded in the politics of race and class, shaped the visual campaign materials of leading voluntary health agencies as they produced informational and fund-raising materials for African Americans and other minorities previously believed to be on the economic margins of American society. Neurath's exhibit for the NTA offered a vision of liberalism that whitewashed the politics of disease and race in America; the isotype idealized and homogenized people across race, ethnicity, and class. But bodies had never been universal, either in the history of American public health or in the history of American consumer culture. Other enterprising individuals during the period, such as Edgar Ulmer and Charles Bynum, offered a different vision of health and consumerism, playing upon the possibilities of a segregated America that would build a new sense of community, not through universality, but through difference. Through their efforts, health and consumerism combined in ways that gave African Americans an increasingly significant role and voice in the campaigns of voluntary health organizations, which in turn offered an early, experimental foray into the push for integration within American society at large.[7]

This essay charts the changing visual culture of race in the disease campaigns of the NTA and the National Foundation for Infantile Paralysis in the period before the 1954 Supreme Court decision in *Brown v. Board of Education of Topeka* that declared segregation in the public schools unconstitutional and ushered in an era of civil rights activism in the United States. In the fight against tuberculosis and polio, the NTA and the National Foundation for Infantile Paralysis came to confront and eventually challenge—in posters, brochures, photographs, and films—the visual iconography of racism in black and white America. Public health campaigns, I argue, occupied an important site in linking consumer activism and health in ways that used the power of images and the power of a dime to protest racial discrimination and achieve greater equality for blacks at a time when the

fight for economic, political, and social justice in the Civil Rights Movement had only just begun.

The Color of Germs and Giving

In the late 1930s, the NTA, the first voluntary national society to direct its activity at a single disease, could boast of unparalleled financial and medical success in its efforts to combat tuberculosis. In the thirty-five years since the establishment of the NTA in 1904, the national death rate had plummeted from 188 per 100,000 to 45 per 100,000. Aggregate statistics, however, were sometimes misleading.[8] The uneven geography of the disease in relation to locale, race, and occupational group meant that the battle against tuberculosis had hardly been won. Rural areas, particularly in the South and the Southwest, where some states had death rates in excess of 60 per 100,000, became a focus of concern as the NTA began to channel more resources and community organizing efforts to neglected geographical areas before the war intervened.

Educating the American public on the importance of early detection and treatment in the prevention of TB relied upon the mass media. From its head-quarters in New York City, the NTA mobilized newspapers, motion pictures, radio, touring exhibits, and the annual Christmas Seal campaign to good effect. But mass communication, like statistics, could be deceptive in its portrait of the average American reader, listener, or viewer. Films made by the NTA, such as *On the Firing Line*, a 1939 travelogue to places in the fight against tuberculosis, were aimed at white audiences. From the dominant images on screen to the venues in which they were shown, health education films of the era projected whiteness. When films did address issues of color, black was usually the chosen shade to signify "undesirable." In *On the Firing Line*, a speeding train of hope, which began its journey in Washington, D.C., and gathered momentum in northeast-ern and Midwestern states, slows to a cautionary speed when it reaches the black South: a "sore spot on the optimistic picture" in the battle against tuber-culosis. The camera pans the street of a southern black town and, in the most intimate close-up of the film, zooms in on the face and hands of an old, poor African-American man, destitute and disheveled in appearance (Figure 3.2), while the voice-over informs the audience: "Certain racial groups such as Negroes, Mexicans, and Indians suffer heavy losses from tuberculosis. The death rate among Negroes is three times as high among whites, not only in the southland but also in the northern industrial centers. Poverty, bad housing, and a depressed scale of living seem to be largely responsible." Camera shots in *On the Firing Line* capture whites in a multitude of scenes—rural and urban, office and factory, home and school—but the camera's aperture reduces the picture of black American life to a single-framed image of poverty, disease, and despair.

Figure 3.2. The NTA film, *On the Firing Line,* narrowed the frame of black culture and life to a single image of poverty, disease, and despair. Courtesy of National Library of Medicine.

"Tuberculosis threatens every doorstep," the narrator concludes the film, "making no home safe until every home is safe," but there is no doubt in the film about where the most dangerous homes lie.[9]

Whites viewed the high rates of tuberculosis among blacks with trepidation and fear. Johns Hopkins University physician Wade Hampton Frost, among others, believed such rates could be explained on the basis of inherited biological differences, a view grounded in deep-seated beliefs about black racial inferiority. Prominent black leaders, such as W. E. B. Du Bois and Charles Spurgeon Johnson, argued that the observed health disparity was due more to "economic than biological" factors. Regardless of the explanation favored, the two and one-half times difference in mortality rates from tuberculosis between the black and white populations in the United States was cause for alarm.[10] Blacks moved in and out of white society as cooks, maids, and laundresses—service jobs that brought them into the homes of whites. Segregation offered no protection from disease. Recognition that "germs have no color line" elicited whites to focus a modest amount of attention on black health care out of self-interest and a sense of danger. And African-American leaders such as Du Bois and Johnson played upon white fear of color-blind bacilli to push for improving the economic, educational, and social needs of blacks.[11]

In 1931, the NTA, with the aid of a $50,000 grant from the Julius Rosenwald Fund, launched a five-year study by the Committee on Tuberculosis among Negroes to address the tuberculosis problem among African Americans. While its initial aims were epidemiological, inadequate funds led the committee to concentrate its efforts on the study and promotion of methods for tuberculosis control within black communities. Health education became a primary focus of the committee, as members remained at odds over whether environmental or racial susceptibility offered the most compelling explanation for the high mortality rates of tuberculosis observed in the black population.[12] Charles S. Johnson, a prominent Fisk University sociologist and founder of the National Urban League's journal *Opportunity*, used his position on the committee, along with the support of NTA staff member Cameron St. Clair Guild and Howard University physician Paul Cornely, to direct resources of the NTA toward health education activities targeted at African-American communities, including essay contests on tuberculosis for students in black colleges and high schools, the creation of two graduate fellowships for the training of black public health nurses, and postgraduate seminars and clinical experience for black physicians.[13] Recognizing the "need for the story of health to be told in the language and terms of the people whom it is designed to help," the Committee channeled funds into the production of pamphlets, posters, and health columns written and illustrated by African-American authors and artists. But the most interesting experiment the NTA embarked upon, which stood in stark contrast to Neurath's vision of an international picture language, was a film series aimed at African-American, Latino, and Native-American audiences.[14]

From 1937 through 1940, the NTA contracted with independent filmmaker Edgar Ulmer to produce eight films as part of their health education campaign. Born in Vienna in 1904, Ulmer's path took him in a quite different direction in visual language than that embarked upon by Neurath in the 1920s. Working as a set designer with luminary European directors such as F. W. Murnau and Fritz Lang, Ulmer emigrated to Hollywood in the early 1930s, where he directed the acclaimed Universal Studio's horror film *The Black Cat*, starring Bela Lugosi and Boris Karloff. What started as a promising Hollywood career came to an abrupt end when a love affair between Ulmer and Shirley Kassler Alexander, who was at the time married to the nephew of Universal executive Carl Laemmle, effectively exiled Ulmer from Hollywood. He and his new wife Shirley moved to New York City, where Ulmer began making films for specialized ethnic audiences, from Yiddish films like *Green Fields* to Ukranian films like *Cossacks in Exile*, to African-American features like *Moon over Harlem*.[15]

Ulmer's ethnographic sensibilities carried through in the films he made for the NTA, and his 1938 production, *Let My People Live*, in particular, offered a touching expression of human compassion, dignity, and respect for black culture and

institutions rarely found in Hollywood cinema of the day. The film's title echoed the refrain, "Let my people go," from "Go Down, Moses," an African-American spiritual sung as a song of faith, inspiration, and protest by enslaved blacks in the nineteenth century and later adopted by freedom fighters during the Civil Rights Movement. Filmed at the Tuskegee Institute and the surrounding fields of Alabama, *Let My People Live* opens with the Tuskegee choir singing "I Know the Lord Has Laid His Hands on Me," with the credits superimposed on the exterior view of the chapel and a statue of Booker T. Washington. The prominence of the church throughout the film, both through the use of African-American spirituals for the musical score, as well as the role of the minister, emphasized Johnson's belief in the powerful role that church leaders within the African-American community could play in health education. The minister in *Let My People Live* provided a role model for the "frequently backward but powerful leadership" Johnson used to describe the place of black ministers in health preservation. It is the reverend who advises Mary to seek professional medical help rather than the folk remedies touted by her friend Minnie, when she confides in him about her fears that she has contracted tuberculosis from her mother, who recently died from the disease.

The film's opening at the Tuskegee Institute and the sermon delivered by Dr. Gordon for National Negro Health Week also linked the film closely to the politics of accommodation and self-help initiated by Washington, whose footsteps Du Bois accused Johnson of following in. From the platform of Tuskegee, Washington preached the gospel of self-help to the black community. Improvement of the conditions for blacks in American society, he argued, was best achieved, not through "the agitation of questions of social equality," but through the furtherance of education, personal hygiene, and moral character. Individual responsibility and self-betterment were the paths Washington advocated to lift African Americans up out of their plight of poor health and economic despair. Some black leaders like Johnson followed Washington's example, believing that better health care for blacks could be more easily obtained through compromise rather than a challenge to the racial ordering of black and white America. Voluntary health associations and philanthropic organizations would help provide better training and services within the black community. In exchange, blacks would limit demands for equal access to the same hospitals, physicians, and health care services enjoyed by whites.[16] *Let My People Live* followed this approach and avoided addressing politically and racially charged issues regarding the segregation of health care in American society. Mary is eventually admitted into a tuberculosis sanatorium, heartened by her prospects of getting well; however, restricted access to tuberculosis sanatoriums, particularly in southern states where fewer than two thousand beds in a thirteen-state region were available for tubercular blacks, is invisible in the film.[17] Film scenes, from Dr. Gordon's public health sermon preaching the value of early detection, to Mary's initiative in

seeking medical advice, to the education of her brother George in the causes and prevention of TB, to the film's finale where Mary listens with pride to the radio broadcast of George's graduation ceremony at Tuskegee, reinforce the image of education, self-reliance, and independence that structured the NTA's policies toward tuberculosis work with blacks.

Although *Let My People Live* did little to visually subvert segregation, it did reject the derogatory racial stereotypes of toms, coons, and mammies into which Hollywood cast black actors in the 1930s.[18] Unlike *On the Firing Line*, this NTA film scripted many roles for African Americans—sharecroppers, ministers, nurses, educators, and physicians—that reflected the actual diversity of economic and social positions held by blacks within American society. And although Johnson did not embrace the path of militant civil rights activism later taken up by Du Bois, he nevertheless viewed health as an important means for bringing about social change. "There is less racial resistance to effecting broad social changes aimed at health improvement than, perhaps, with any other set of problems," Johnson wrote.[19] In *Let My People Live*, Dr. Gordon, played by the Hollywood actor and Northwestern University medical school graduate Rex Ingram, delivers a message in keeping with Johnson's view that tuberculosis was an economic and social problem, despite the opinion of powerful members of the NTA's Committee on Tuberculosis among Negroes who adhered to a theory of innate racial difference.[20] Johnson was hardly "the complacent black man" Du Bois once accused him of being.[21] Accommodation and compromise went only so far.

While the NTA made *Let My People Live* for African-American audiences, it tried to expand the film's viewership, suggesting that "the scientific facts apply equally well to white people and Negroes" and that "Rex Ingram's work in *Green Pastures* and *Haiti* is probably admired by a greater number of white people than Negroes."[22] But the ending of *Let My People Live* illustrates the multiple layers of segregation at work in the health campaigns of the NTA, even as it sought to develop visual health education materials to reach a diverse audience. The ending of *Let My People Live* contrasts with that of *On the Firing Line*, where happy, white, middle-class parents with their child are shown promoting the purchase of Christmas seals. No such charitable appeal ends *Let My People Live*, even though middle-class blacks with the means to give appear in the film. African Americans were considered to be too far on the economic margins of American society to merit fund-raising attention by the NTA, despite the role that Modjeska Simkins, a woman health activist, played in assisting state chapters such as the South Carolina Anti-Tuberculosis Association in mobilizing black support for the annual Christmas Seal campaign.[23] This attitude, steeped in racial stereotypes, extended to other voluntary health agencies as well as advertisers in general. Don Gudakunst, medical director of the National Foundation for Infantile Paralysis, for example, remarked in the early 1940s that "there is little that is more uncertain

than a colored man and his money," a view echoed by fund-raising director D. Walker Wear, who similarly remarked that "the average Negro is not charitably inclined."[24] Despite books such as *The Southern Negro as a Consumer,* written by Fisk economist Paul Edwards with the encouragement of Johnson, that demonstrated the collective spending power of African Americans in the South's seventeen largest cities in 1929 stood at $308 million, few companies, let alone voluntary health agencies, sought to tap into the buying power of the national black community. Kellogg Company's campaign to attract black consumers to buy Kellogg's Corn Flakes in the 1930s through non-derogatory advertisements placed in the black press was one of the first such national campaigns.[25]

The NTA had behind it a savvy public relations department that had turned its Christmas Seal Sale into a hugely successful marketing campaign that grew from $3,000 in 1907 to more than $5 million in gross revenues by 1939. Needing to "keep in step with the best practices in the field of advertising and public relations," the NTA saw its health campaigns as embodying all the "elements of good merchandising."[26] As in any principle advertising campaign, brand familiarity was important, and the NTA used its Christmas Seal Sale and the double-barred cross as a symbol of its corporate product. But the NTA also needed to establish an emotional relationship to its market audience, and it did so through its use of children and Christmas in the iconography and design of its stamps. By the 1930s, it also began to add slogans, in keeping with the latest trends in advertising to add subject value to the product. The traditional "Buy Christmas Seals, Fight Tuberculosis," evolved to changing slogans such as "Protect Your Home from Tuberculosis," further adding a sense of family values to the campaign and targeting women as caretakers, consumers, and organizers of the annual Christmas Seal campaign (Figure 3.3).

The values and economics that the NTA capitalized on were located solely in white, middle-class, Christian family homes for whom white children and the holiday of Christmas evoked childhood nostalgia and a sense of giving. The Christmas Seal Sale was firmly rooted in whiteness, what historian Grace Hale has described as the "homogenizing ground of the American mass market."[27] Walter Christmas, founding member of the Harlem Writers Guild, commented negatively in 1949 on this distorted picture that the iconography of American advertising promoted, and which the Christmas Seal campaign participated in:

> The inhabitants of this world are so-called average Americans. They are tall, blonde, God-like creatures, well-proportioned and happy. They smell of fragrant soaps and seductive perfumes, live in well-appointed, sun-filled homes with frigidaires, space-saving, stainless steel kitchens. The children, smaller editions of the adults, mature on vitamin-filled packaged foods and sleep on air-foam mattresses under electrically-heated blankets.

"Every day," Christmas noted, "two million dollars are spent to maintain our belief in and acceptance of this world," a world that denied the "Negro's proportionate

Figure 3.3. Children and Christmas were two symbols of giving the National Tuberculosis Association successfully used to pull on the emotions and purse strings of the American public in its fund-raising efforts. Courtesy of National Library of Medicine.

existence in our society."[28] There was never a black family or child, let alone a black Santa Claus, featured on a Christmas Seal stamp. Although "germs have no color line," apparently money did, at least until companies like Lucky Strike, Philip Morris, and Pepsi-Cola began after the Second World War to recognize the potential of the

black consumer market in their products and advertising. Following the latest in advertising trends, voluntary health agencies, in particular, the National Foundation for Infantile Paralysis, would adopt and expand upon the successful marketing strategies initiated by the NTA in ways that began to challenge the racialized visual iconography of giving that had become the trademark of public health campaigns.

The Power of a Dime

No voluntary health agency developed the fund-raising strategies of the NTA more successfully, taking advertising and public relations in the campaign for health to new heights, than the National Foundation for Infantile Paralysis. Established in 1938 by President Franklin Delano Roosevelt, the National Foundation grew into a $20 million annual fund-raising voluntary health organization through its close ties to radio and Hollywood. Comedian Eddie Cantor, playing off the popular newsreel feature "The March of Time," coined the phrase the March of Dimes during a Hollywood fund-raiser for the National Foundation in November of 1937, urging radio listeners to send their dimes directly to the White House.[29] By the 1940s, the March of Dimes had grown into an annual national media event, orchestrated by well-honed public relations and radio, TV, and motion picture departments that provided local chapters with slick campaign guides on the latest in organizational techniques and publicity strategies, from sample newspaper stories to departmental window displays to billboards to construction plans for the building of wishing wells and the "Mile O' Dimes stand." Beginning in 1946, the centerpiece of the campaign was the March of Dimes poster child, carefully selected by the National Foundation based on nominations from local and state chapters. Although the use of poster children would later be criticized by organizations like the American Coalition of Citizens with Disabilities, the emotional appeal of a child with crutches and braces built upon the Christmas Seal campaign and proved itself to be far more successful. In 1949, when the National Foundation conducted a survey of leading advertising and public relations firms to inquire how they might improve upon their annual campaign, all responded that the use of a recovered polio child was the greatest success story in the history of fundraising and that to make any change would be foolhardy.[30]

The National Foundation for Infantile Paralysis was a pioneer on other advertising fronts as well. Concerned about the potential decrease in annual giving because of the war, Marvin Eckford wrote to foundation head Basil O'Connor in 1943 pointing out that a $2 billion market existed, "a nation within a nation," that had been largely untouched by the March of Dimes campaign. Citing statistics from the U.S. Department of Commerce on black business and home ownership, Eckford believed that contributions by blacks to the March of Dimes campaign could increase 300 percent, given the right marketing strategy. One year

later, the foundation hired Charles Bynum, a former assistant to the president of Tuskegee University, as Director of Interracial Relations to organize publicity and make contacts among African-American communities throughout the country, as well as advise the Foundation on interracial relations. During the 1940s, few white companies in America employed what became known as "Negro market specialists" to promote their corporations in the black community. The most notable exception was the Pepsi Cola Company, which hired African-American Edward Boyd in the late 1940s to enhance the visibility and appeal of their soft drink to African Americans. By the early 1950s, a number of companies sought to emulate the success of Pepsi Cola's advertising campaign by hiring black trailblazers in corporate America who organized themselves into the National Association of Market Developers. Bynum, a founding member of the organization, had put the National Foundation well ahead of the corporate advertising curve.[31]

When the National Foundation for Infantile Paralysis launched its poster child in 1946, Bynum urged foundation officers to have a separate black poster child and separate fund-raising materials for black communities to broaden the appeal of the March of Dimes campaign. "Present practice is to use one child," Bynum noted, but "to give significance to the appeal in Negro schools the poster should indicate that our services include the Negro child." Bynum argued, "The poster should not be considered as a special appeal to a racial group. . . . Recognition of a special population group is necessary not because of race but because it is impossible to demonstrate the validity of our pledge and the reliability of our staff without visual evidence."[32] Both the publications committee and fund-raising division rejected Bynum's plan. The National Foundation had made a pledge to serve American communities "without regard for race, creed, or color." Separate campaign materials targeted at blacks, foundation officers argued, would undermine this pledge of equality by creating "a situation that would result in two campaigns—one for Negroes and the other for whites."[33] Bynum knew, however, that such color-blind policies hardly prevented discrimination in practice. The National Foundation was a case in point. Despite the pretense of universal care, visible signs of discrimination, both blatant and subtle, could be seen in the facilities for polio treatment sponsored and supported by the National Foundation and in the local organizational efforts of the March of Dimes campaign. Bynum was a brilliant pragmatist in using these discrepancies between policy and practice to his advantage, building upon a strategy of separateness to achieve integration. The segregated treatment of polio patients at Warms Springs, Georgia, was but one glaring example that Bynum continually invoked in memos to foundation officers as he pushed for greater services for medical training and treatment of African Americans.[34] Similarly, in the early 1940s, local chapters of the March of Dimes in southern states followed the segregated pattern that

existed within other voluntary health agencies such as the NTA, where separate fund-raising committees—all-white and all-black—were established in local communities. This, too, Bynum helped to change.

Bynum's argument of the need for separate visual materials targeted at black communities won out, and in 1947 a separate black poster child was created. Demand for such posters escalated from three thousand in 1947 to fifty thousand by 1950.[35] The National Foundation also began the production of separate brochures for circulation in African-American neighborhoods. Bynum himself had separate Foundation stationary printed with photos of black polio patients receiving care that he used in correspondence with twenty-one thousand people from black organizations, agencies, institutions, newspapers, and magazines that filled his Rolodex file, indexed by cities, in the early 1950s. Through personal contacts and word-of-mouth, he aimed to win the trust and support of the African-American community, improve facilities for the treatment of black polio patients, create greater opportunities for blacks in the health care professions, and increase black participation at the local, state, and national levels in the organization and leadership of the March of Dimes campaign.

Words alone, however, could not win the support of black communities nor help institute change in a segregated nation. Bynum continually felt an "urgent need of pictures of Negro polio patients receiving treatment," "volunteers working in various capacities," and "Negro professional workers in hospital situations" to be used in his publicity and outreach efforts.[36] In 1954, the National Foundation, at Bynum's request, produced a 16mm, eight-minute, sound newsreel-type film that focused on the place of African Americans in the service programs of the National Foundation. Inspired by *Let My People Live,* which Bynum saw at a meeting of the Virginia Federation of Colored Women's Clubs, *Dime Power* offered a visual celebration of and tribute to African Americans who, with the support of the National Foundation, were helping the nation, black and white, to win the fight against polio.

The opening scene of *Dime Power* visually disrupts the dominant image of the white, male, lab-coated research scientist prominent in both documentary and fiction film of the 1950s and racist attitudes toward blacks in the professional world of science and medicine. We are witness to the usual scene of a scientific research laboratory, filled with racks of test tubes and scientific equipment. But this time the lab is staffed, not by white males, but by "spirited [black] men and women of medical science working earnestly in laboratories across the country" for whom "disease is a frontier of the mind to be conquered by knowledge" (Figure 3.4). The film then takes the viewer on a tour of how their (read African-American) contributions to the March of Dimes campaign are helping to advance research on a polio vaccine. But these contributions entail far more than dimes; they are contributions in scientific research, experimental medicine, and state-of-the-art medical care, professional realms that blacks had long been denied access to in white America.[37]

Figure 3.4. *Dime Power* challenged racial stereotypes about the place of blacks in the profes-
sional world of science and medicine. Courtesy of the March of Dimes Birth Defects Foundation.

The laboratory in *Dime Power*'s opening scene was most likely the HeLa produc-
tion laboratory of Russell Brown, Director of the Carver Research Foundation at
Tuskegee, who, along with James Henderson, Norma Gaillard, and other scientists
and research technicians, worked round-the-clock in helping develop the first polio
vaccine. With support from the National Foundation for Infantile Paralysis, Jonas
Salk, a research scientist at the University of Pittsburgh Medical School, had devel-
oped a prototype polio vaccine in 1952 using killed strains of the poliomyelitis
virus. Initial experiments with the vaccine proved promising, and the foundation
moved ahead to undertake a massive clinical trial. To ensure safety of the vaccine,
however, researchers needed to measure the amount of antibodies produced by the
vaccine's three types of poliovirus antigen. African Americans gave their sweat,
labor, and knowledge to advance the cure for polio; they also gave their tissue and
blood. HeLa cells, the first human cell line to be established in pure cell cultures,
were chosen as the host cell to measure antibody activity. The HeLa cell line had
come from Henrietta Lacks, a Baltimore housewife who died of cervical cancer in
1951 after seeking treatment at the Johns Hopkins University Hospital. Although
not public knowledge at the time, Lacks was black. At Tuskegee, Brown and his col-
leagues produced over six hundred thousand HeLa cell cultures in two short years,
shipped to twenty-three evaluation laboratories across the United States.[38]

African-American children, along with 1.6 million other kids from the first,
second, and third grades in 272 counties and 44 states, also donated themselves
to the "largest field trial ever undertaken in the history of medicine" in the spring
of 1954.[39] In this massive clinical trial of the Salk vaccine, children—black, white,
and Latino—as *Dime Power* proudly shows, waited in line to be injected with
either a placebo or the killed polio virus. Twenty years later, when the atrocities of
the Tuskegee Syphilis Experiment came to light, it would be difficult to see *Dime
Power* in the same way Bynum had intended. Images of children as experimental
subjects and knowledge that HeLa cells were procured from Lacks without
her knowledge link the film today to the long and troubled history of human

experimentation and the violation of ethical principles, justice, and informed consent in medical research, particularly in relation to disadvantaged and minority populations.[40] But in 1954, images of African-American scientists at work in the laboratory, black children alongside white in a heroic medical experiment, and black health care professionals, trained and supported through National Foundation fellowship programs, working with disabled children, visually conveyed a sense of pride in the professional, financial, and experimental contributions the black community had made in winning the war against polio.[41] Unlike *Let My People Live*, *Dime Power* ended with an appeal to African Americans to contribute to the March of Dimes. Bynum effectively worked the power of pictures to enhance the power of a dime.

In 1951, Bynum could proudly boast of the enviable position the National Foundation enjoyed as a result of his public relations efforts. "More Negro organizations, agencies, institutions, and people work in the March of Dimes than in any other organization, excepting only the community chests," he wrote. "And proportionately more money is given by Negroes in the March of Dimes than in any other campaign excepting none."[42] A member of both the NAACP and the National Urban League, Bynum leveraged the power of the black consumer in pushing for civil rights both within the National Foundation and in society at large. He regarded better public relations between the National Foundation and the black community as creating new and "widespread ramifications in and implications for general public relations, because the American dilemma is but one way of expressing the fundamental belief of all Americans in a great ideal and their bumbling strivings toward attainment of the ideal."[43]

Like other civil rights activists of the 1950s, Bynum knew the power of consumer activism as a potent nonviolent strategy African Americans could employ to achieve greater equality. Throughout the late forties and fifties, he used the financial contributions of African-Americans to help break down the barriers of segregation found within local chapters of the March of Dimes. As a black man raised in North Carolina and educated in the north at the University of Pennsylvania and the University of Minnesota, who later became a dean of a college in Texas, Bynum knew there were "no standard patterns of segregation" in America.[44] Each community, each region, required its own tactics and strategies to break down the color barrier. Through exhaustive travel schedules—he averaged over one hundred thousand miles per year—that included meetings with newspaper editors, school principals, ministers, and businessmen, as well as women's auxiliaries, Chambers of Commerce, and other community organizations, particularly in the deep South, Bynum worked tirelessly at pushing for the integration of blacks on the executive committees of state and local chapters. In five years, for example, he had increased the number of blacks on the Arkansas–Texas Miller–Bowie County executive committee from one in 1943 to nine in 1948 as it

realized its service program and fundraising would be improved through wider chapter representation. By 1949, the black poster child was integrated into the March of Dimes Campaign guide distributed to virtually every local county chapter of the National Foundation throughout the United States. In campaigning for health, it was the color of money that began to unseat the physically and visually segregated landscape of health care in America.

While the separate black poster child participated in the culture of segregation, it simultaneously unhinged the categories of race and class that previously had been blurred and that had led voluntary health agencies to ignore an important market in their midst. As voluntary health agencies like the National Foundation tapped into the pocketbooks of the black middle class, the visible signs of economic difference trumped those of racial difference. Within the African-American community, skin color could also be a cultural sign of economic advantage, and the National Foundation played upon this knowledge in its fund-raising campaigns. The light skin tone of many African-American children chosen as the March of Dimes Poster Child, and their dress in middle-class attire, even when the families of poster children—either white or black—could not afford such clothes, created an image that conformed to that of both middle-class whites and African Americans (Figure 3.5). Passing as a mixed-race lifestyle had throughout the twentieth century disrupted the black-and-white image of a segregated America. Light skin, embraced as an escape from social and economic inferiority, became equated with power and economic privilege within the African-American community. In Harlem, for example, the neighborhoods of Strivers' Row and Sugar Hill were the preferred neighborhoods of Harlem's black upper class, where "light-skinned doctors, lawyers, ministers, journalists, teachers, and other professionals" lived and socialized. Dark-skinned African Americans, as Harlem Congressman Adam Clayton Powell, Sr., noted, were often shunned when attending social functions in the neighborhood. Skin color as a mark of class within the African-American community shaped the visual landscape of the National Foundation's campaign efforts as well.[45]

One of the first successful integrated March of Dimes campaigns, held up by the National Foundation for Infantile Paralysis as a model for future efforts, was the 1950 Phoenix Mothers' March on Polio. The campaign, which raised $44,890 for Maricopa County, almost double that of the proceeds earned in its 1946 drive, owed its success to a combination of astute advertising, the emotional appeal of a disabled child, and a broad-reach integrated effort. The campaign slogan "Turn Your Porch Light on Polio Tonight" was used to reach out across all communities in the greater Phoenix area, "whether you live[d] in the finest home with an electric porch light—or in the humblest dwelling lighted only with a candle in a bottle." Four women served as district leaders of the campaign, with Mrs. W. J. Sutter as head of the southwest region, a predominately African-American and Latino neighborhood of Phoenix.[46]

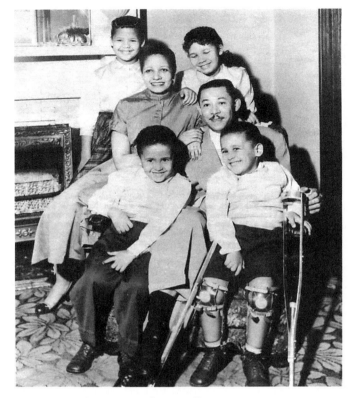

"Calvin was born too soon for the Salk Vaccine...

. . . But we made sure that our three other children got their polio vaccinations as
soon as the vaccine was available," says Mrs. Raymond Mayfield of Cleveland,
Ohio, mother of four-year-old Calvin Mayfield, 1957 March of Dimes Poster Boy.
 "And now that there's enough vaccine for everybody, my husband and I have
had our shots, too. It's a mistake to think polio is only a children's disease—about
40 per cent of all polio victims are teenagers and adults."

Figure 3.5. Creating an image that conformed to middle-class values—both black and white—
was an important strategy in the marketing of the March of Dimes Poster Child. The home fur-
nishings, dress, and light skin color of the Mayfield family were clear markers of class in this
photograph featuring Calvin Mayfield, the 1957 March of Dimes Poster Boy. Courtesy of the
March of Dimes Birth Defects Foundation.

The light skin complexion of Mrs. Sutter and Mrs. David Solomon, member of
the March of Dimes Special Events Committee and wife of an African-American
physician, elucidated the subtle ways in which color and class came together in this
integrated campaign effort.[47] It was economic status that gave African-American
women a seat at the table of leadership in the Phoenix Mothers' March. Integration
occurred through a shared feeling about charitable giving among middle-class
blacks and whites. Campaign organizers could no longer afford to write off city
districts with large minority populations on the assumption that racial identity and

economic inferiority went hand-in-hand. Phoenix organizers purposely refrained from publicizing total amounts given by neighborhood, fearing that such statistics might hurt "the pride of less-income groups" and inadvertently reinforce stereotypes about poverty and race in America. Black no longer signified the object of charity and the inability to give. Seen through the prism of class, black as a color dispersed into multiple shades of gray.[48]

Conclusion

In 1963, reflecting on the success and future challenges of the National Foundation for Infantile Paralysis, Bynum commented that the "image of ONE organization validating its service pledge was unique in the experience of the Negro public." Bynum grew concerned, however, about declining membership and participation by blacks as the National Foundation ceased its fellowships for black scholars and as terminal grants to black institutions removed a "strong compensating factor."[49] In the period before *Brown v. Board of Education of Topeka,* Bynum had adopted a strategy of visual segregation as a means toward economic empowerment and racial integration in the National Foundation's campaigns for health. By 1963, the time had come, Bynum argued, to alter the course. "I suggest that future materials reflect a gradually accelerated project of awareness of the increased importance of all market publics," he wrote. Two strategies were needed. No materials omitting blacks as a part of the subject should be produced by the National Foundation, and increased use of black subject matter should be included in the Foundation's national advertising and publicity efforts.[50] It was a strategy in keeping with the Congress of Racial Equality's civil rights demand in the early 1960s that U.S. corporations use African-American models in their print and television advertising campaigns. The color of money could equally be that of black or white.

White had been the color of purity, of science, of wealth in segregated America. Black was the color of danger, ignorance, and despair. In their campaigns for health, both the NTA and the National Foundation confronted these stereotypes as they sought to cross America's color line. Neurath's strategy of a visual Esperanto based upon the universality of science failed to appreciate how deeply ingrained medicine and science were in the pattern of black and white America. Science and medicine had long been complicit in reinforcing, rather than dismantling, America's racial divide. No level of abstraction could undo that pattern.

Ulmer and Bynum charted a different path in educating and enlisting the support of African Americans in campaigns for health. They projected not a color-blind America but a country greatly enriched by both black and white. The absence of color was an aesthetic in which the politics of whiteness prevailed. To subvert that aesthetic, they used black as a color in ways that Americans had rarely seen on the motion picture screen until Sidney Poitier rose to stardom in

the late 1950s and early 1960s as a "hero for an integrationist age." In their hands black became the color of money, education, and racial pride.[51]

Notes

My thanks to the extremely helpful and generous staff of the History of Medicine Division at the National Library of Medicine and particularly Paul Theerman, Nancy Dosch, and Jan Lazarus for the help in locating and providing copies of audiovisual materials. Special thanks also go to David Rose at the March of Dimes for his assistance with the remarkable archival collection of the National Foundation of Infantile Paralysis and to Arienné Ulmer Cipes of the Edgar G. Ulmer Preservation Corporation for sharing information on Edgar Ulmer. Evelynn Hammonds, Michelle Murphy, David Serlin, and participants at the Visual Culture of Public Health conference sponsored by the National Library of Medicine offered invaluable comments and guidance on previous drafts. Research for this article was supported by a grant from the National Library of Medicine.

1. Otto Neurath, *International Picture Language* (London: Kegan Paul, 1936).

2. Nancy Cartwright, Jordi Cat, Lola Fleck, and Thomas E. Uebel, *Otto Neurath: Philosophy between Science and Politics* (Cambridge: Cambridge University Press, 1996), 65. Otto Neurath and H. E. Kleinschmidt, *Health Education by Isotype* (New York: American Public Health Association, 1939), 20.

3. Neurath and Kleinschmidt, *Health Education by Isotype*, 6.

4. See Sybilla Nikolow, "Planning, Democratization, and Popularization with Isotype, ca. 1945: A Study of Otto Neurath's Pictorial Statistics on the Example of Bilston, England," in "Induction and Deduction in the Sciences," ed. Friedrich Stadtler, *Vienna Circle Yearbook* (Dordrecht: Kluwer Academic Publishers) 11 (2003): 299–329; R. Kinross, "Blind Eyes, Innuendo, and the Politics of Design," *Visible Language* 28 (1994): 68–78.

5. On the history of black consumerism, see Robert E. Weems, Jr., *Desegregating the Dollar: African-American Consumerism in the Twentieth Century* (New York: New York University Press, 1998) and Lizabeth Cohen, *A Consumers' Republic: The Politics of Mass Consumption in Postwar America* (New York: Alfred A. Knopf, 2003), 41–52.

6. See, e.g., Grace Elizabeth Hale, *Making Whiteness: The Culture of Segregation in the South, 1890–1940* (New York: Vintage, 1998).

7. For an insightful analysis of the history of consumer culture and health care that touches briefly upon racial inequalities, see Nancy Tomes, "Merchants of Health: Medicine and Consumer Culture in the United States, 1900–1940," *Journal of American History* 88 (2001): 519–547.

8. On the history of the NTA, see Richard Harrison Shryock, *National Tuberculosis Association, 1904–1954: A Study of the Voluntary Health Movement in the United States* (New York: National Tuberculosis Association, 1957).

9. *On the Firing Line: A Travel-Tour to Scenes of the Fight against Tuberculosis* (New York: National Tuberculosis Association/Courier Productions, 1939), 20 min. From the National Library of Medicine.

10. Willis D. Weatherford and Charles S. Johnson, *Race Relations: Adjustment of Whites and Negroes in the United States* (New York: Negro Universities Press, 1934), 372. On the history of medical theories of racial susceptibility and TB, see Marion M. Torchia, "Tuberculosis

among American Negroes: Medical Research on a Racial Disease, 1830–1950," *Bulletin of the History of Medicine* 32 (1977): 252–79.

11. Vanessa Northington Gamble, *Germs Have No Color Line: Blacks and American Medicine, 1900–1940* (New York: Garland Publishing, Inc., 1989); Marion Torchia, "The Tuberculosis Movement and the Race Question, 1890–1950," *Bulletin of the History of Medicine* 49 (1975): 152–68.

12. *Report of the Committee on Tuberculosis among Negroes* (New York: National Tuberculosis Association, 1937).

13. See, e.g., Charles S. Johnson, *The Negro in American Civilization: A Study of Negro Life and Race Relations in the Light of Social Research* (New York: Henry Holt and Co., 1930). On Johnson, see Richard Robbins, *Sidelines Activist: Charles S. Johnson and the Struggle for Civil Rights* (Jackson: University Press of Mississippi, 1996).

14. *Report of the Committee on Tuberculosis among Negroes*, 54. The films were *Let My People Live* (1939), *Cloud in the Sky* (1940), and *Another to Conquer* (1941).

15. On Ulmer, see Kinsley Canham, *The Hollywood Professionals* (London: Tantivy Press, 1973), 149–80; Myron Meisel, "Edgar G. Ulmer; the Primacy of the Visual," in *Kings of the B's: Working within the Hollywood System: An Anthology of Film History and Criticism*, ed. Todd McCarthy and Charles Flynn (New York: E. P. Dutton, 1975), 147–52; Peter Bogdanovich, *Who the Devil Made It?* (New York: Knopf, 1997), 558–604.

16. Torchia, "The Tuberculosis Movement and the Race Question," 160; David McBride, "The Henry Phipps Institute, 1903–1937: Pioneering Tuberculosis Work with an Urban Minority," *Bulletin of the History of Medicine* 61 (1987): 78–97.

17. These statistics are from the *Report of the Committee on Tuberculosis among Negroes*, 32.

18. See, e.g., Donald Bogle, *Toms, Coons, Mulattoes, Mammies, & Bucks: An Interpretive History of Blacks in American Films*, 3rd ed. (New York: Continuum, 1994).

19. Quoted in Philip P. Jacobs, *The Control of Tuberculosis in the United States* (New York: National Tuberculosis Association, 1940), 208.

20. On Igram, see Bogle, *Toms, Coons, Mulattoes, Mammies, & Bucks*, 69–71.

21. Robbins, *Sidelines Activist*, 209.

22. This is from a National Tuberculosis Association flyer kindly given to me by Arianne Ulmer Cipes of the Edgar G. Ulmer Preservation Corp.

23. On Simkins, see Edward H. Beardsley, *A History of Neglect: Health Care for Blacks and Mill Workers in the Twentieth-Century South* (Knoxville: University of Tennessee Press, 1987), 108–12; P. Preston Reynolds, "Hospitals and Civil Rights, 1945–1963: The Case of *Simkins v. Moses H. Cone Memorial Hospital*," *Annals of Internal Medicine* 126 (1997): 898–906. On black women's health activism in general, see Susan L. Smith, *Sick and Tired of Being Sick and Tired: Black Women's Health Activism in America, 1890–1950* (Philadelphia: University of Pennsylvania Press, 1995).

24. Quoted in Chapter VIII of *National Administration and Policies of the National Foundation for Infantile Paralysis: 1944–1953*, 33 (Typescript), March of Dimes archives (hereafter MOD). Courtesy of David Rose.

25. See Weems, *Desegregating the Dollar* and Cohen, *A Consumers' Republic*.

26. Jacobs, *The Control of Tuberculosis in the United States*, 35

27. Hale, *Making Whiteness*, 168.

28. Walter Christmas, "Negroes in the Ads," *Negro Digest* 8 (1949): 70–71.

29. See Jane S. Smith, *Patenting the Sun: Polio and the Salk Vaccine* (New York: William Morrow, 1990). On the history of poliomyelitis in the United States, see Naomi Rogers, *Dirt and Disease: Polio before FDR* (New Brunswick, N.J.: Rutgers University Press, 1992).

30. La Porte to O'Connor, 29 April 1949, Poster Children Tour, 1950, Fund Raising Records. Series 4. Poster Children, 1946–2003. Box 7. MOD (hereafter MOD).

31. Weems, *Desegregating the Dollar.* For information on Bynum, see Charles H. Bynum, Medical Program Records. Series 14. MOD.

32. Bynum to Savage, 19 July 1946, Inter-Racial & Inter-Group Activities and Relations, 1946–1947. Medical Program Records. Series 14. Poliomyelitis. Box 13. MOD.

33. LaPorte to Bynum, 24 July 1946, Inter-Racial & Inter-Group Activities and Relations, 1946–1947. Medical Program Records. Series 14. Poliomyelitis. Box 13. MOD.

34. See, e.g., Bynum to Ducas, 15 June 1951, Inter-Racial & Inter-Group Activities and Relations, 1948–1951. Medical Program Records. Series 14. Poliomyelitis. Box 13. MOD. On segregation at Warm Springs, see Richard Thayer Goldberg, *The Making of Franklin D. Roosevelt: Triumph over Disability* (Cambridge, Mass.: Abt Books, 1981).

35. Bynum to Savage, 4 February 1949, Inter-Racial & Inter-Group Activities and Relations, 1948–1951. Medical Program Records. Series 14. Poliomyelitis. Box 13. MOD.

36. Bynam to Ducas, 25 August 1952, "Inter-Racial and Inter-Group Activity and Relations, 1952–1963," Medical Program Records Series. Series 14. Poliomyelitis. Box 13. MOD.

37. *Dime Power* (White Plains, N.Y.: March of Dimes, 1954), film. MOD.

38. On the HeLa cell line, see Rebecca Skloot, "Cells That Save Lives Are a Mother's Legacy," *New York Times,* November 17, 2001, A15–A17, and Rebecca Skloot, *The Immortal Life of Henrietta Lacks* (New York: Crown, 2010). See also Hannah Landecker, "Immortality, In Vitro: A History of the HeLa Cell Line," in *Biotechnology and Culture: Bodies, Anxieties, Ethics,* ed. Paul E. Brodwin (Bloomington: Indiana University Press, 2000), 53–74; R. W. Brown and J. H. Henderson, "The Mass Production and Distribution of HeLa Cells at Tuskegee Institute, 1953–1955," *Journal of the History of Medicine and Allied Sciences* 38 (1983): 415–31.

39. *Dime Power.* See also Marcia Meldrum, "'A Calculated Risk': the Salk Polio Vaccine Field Trials of 1954," *British Medical Journal* 317 (1998): 1233–36.

40. James H. Jones, *Bad Blood: The Tuskegee Syphilis Experiment,* 2nd ed. (New York: Free Press, 1993); Susan Lederer, *Subjected to Science: Human Experimentation in America before the Second World War* (Baltimore: The Johns Hopkins University Press, 1995).

41. See, e.g., Bynum to O'Connor, 1 November 1948, and "Miscellaneous Facts: 1941–1951," Inter-Racial & Inter-Group Activities and Relations, 1948–1951. Medical Program Records. Series 14. Poliomyelitis. Box 13. MOD.

42. Bynum to Ducas, 15 June 1951.

43. Bynum to LaPorte, 28 February 1946, InterRacial & Inter-Group Activities and Relations, 1946–1947. Medical Program Records. Series 14. Poliomyelitis. Box 13. MOD.

44. Bynum to JLL, 18 January 1945, Inter-Racial & Inter-Group Activities, 1942–1945. Medical Program Records. Series 14. Poliomyelitis. Box 13. MOD.

45. Kathy Russell, et al., *The Color Complex: The Politics of Skin Color among African-Americans* (New York: Harcourt Brace Jovanovich, 1992), 26. For an insightful memoir on the subject, see Eugene Robinson, *Coal to Cream: A Black Man's Journey beyond Color to an Affirmation of Race* (New York: Free Press, 1999). See, also, Kathy Peiss, *Hope in a Jar: The Making of America's Beauty Culture* (New York: Holt, 1999).

46. "1950 Mothers March on Polio," Fund Raising Records. Series 5. Box 8. MOD.

47. See, e.g., "Women Plan Polio March Meeting," *Phoenix Gazette,* January 2, 1950.

48. "1950 Mothers March on Polio."

49. Bynum to Voss, 22 April 1963, "Inter-Racial and Inter-Group Activity and Relations, 1952–1963," Medical Program Records. Series 14. Poliomyelitis. Box 13. MOD.

50. Bynum to Franck, 21 June 1963, "Inter-Racial and Inter-Group Activity and Relations, 1952–1963," Medical Program Records. Series 14. Poliomyelitis. Box 13. MOD.

51. Bogle, *Toms, Coons, Mulattoes, Mammies, & Bucks,* 175. As Bogle points out, Poitier was the first black actor to appeal to middle-class Americans, both black and white.

4. *Empathy and Objectivity*
Health Education through Corporate Publicity Films

KIRSTEN OSTHERR

THE PURSUIT OF PUBLIC HEALTH has been a pursuit of the public's attention since the first efforts were made to provide medical treatment to the masses. This desire for a mechanism of mass publicity, coupled with an early focus on the spread of communicable diseases, meant that public health required an educational medium that could capture both movement through space and change over time; for these reasons, the spatial and temporal attributes of contagion had an obvious affinity for motion pictures and, later, video.[1] With its additional ability to represent organisms that are invisible to the naked eye, film appealed to scientists who saw the medium as a promising new research technology.[2] Moreover, the mechanical reproducibility of film, its public exhibition context, and its minimal demands on audience literacy offered a clear opportunity for mass education. Recognizing these qualities, public health organizations promoted the motion picture as a favored pedagogical tool, thus ensuring that major innovations in the treatment and prevention of disease would not languish in isolation of the laboratory.

While motion pictures thus seemed to promise an unprecedented ease of communication, achieving universal comprehensibility proved to be an insurmountably difficult task. The dual challenge of explaining the vast scale of global migrations while also explaining the microscopic scale of bacteria, parasites, and viruses led public health films to employ imprecise means of creating images of disease. These representations had to be socially legible to effectively train a population to avoid infection or participate in a vaccination campaign. Consequently, the techniques for visually representing invisible contagions attempted to balance the appeal to popular—and often oversimplified—imaging conventions with the explanation of complex and unfamiliar medical and scientific principles. Not surprisingly, these competing demands produced unintended results. The paths of contagion that early public health films were meant to represent always seemed to elude documentation. Instead,

these films often presented vectors of contamination as sources of pathology themselves.

Despite vast technological advances, the depictions of disease outbreaks in public health media haven't changed much over the years. In the early twentieth century as well as in the early twenty-first, invisible pathogens produce widespread anxieties about universal contagion, resulting in a proliferation of images of contamination. These films share an approach that I characterize as "representational inoculation": if one can *see* the contaminant, then one can avoid infection. By attempting to visually represent invisible contagions in order to fix the location of the ever-elusive pathogens that continue to cause disease outbreaks around the world, mapping disease-ridden areas of the globe amounts to a form of containment. Consequently, the historical continuities among mass-mediated responses to transnational contagions often promote an amnesiac visual culture of global disease founded upon unacknowledged forms of social stigma. Consider, for example, the widespread public avoidance of restaurants in New York's and San Francisco's Chinatowns during the Severe Acute Respiratory Syndrome (SARS) outbreak in 2003, despite the fact that no cases had been confirmed anywhere within United States borders.[3] This logic of disease prevention through social quarantine is based on the conflation of national and racial difference with pathology, which leads to the association of Chinese food with contagious degeneracy. As I have discussed elsewhere, this logic of avoidance has frequently characterized the health education imagery employed to combat outbreaks of communicable disease.[4] For instance, in *The Silent Invader,* a 1957 telecast produced to train American audiences to avoid Asian influenza, the path of contagion is displayed on world maps to highlight the national specificity of the virus, and images of unidentified "Asians" are presented to demonstrate its racial provenance. While the ostensible goal of the production is to prevent an epidemic within United States borders, its methods for visualizing the threat rely on historically entrenched patterns of stigmatization that align racial and geographic outsiders with pathology.

Such xenophobic representations may be predictable in this example, considering the military animosities toward Japan and Korea in the 1940s and 1950s, and therefore it might seem redundant to fault the mass media for espousing sensationalistic clichés that map world health according to national or racial typologies.[5] But the history of public health promotion is full of iconography that carries more than symbolic weight. Despite the fact that film and television are clearly commercial media, they also function in multiple contexts as educational media, as early public health promoters had recognized.[6] More recently, scholars in film, media, and visual culture studies have approached the interpretation of motion pictures, television programs, and advertisements through a wide range of methods, including approaches that address the unique properties of audiovisual texts,

such as editing and sound.[7] Public health researchers have also analyzed these texts, emphasizing their impact on viewers' behavior, particularly in connection with their mental and physical well-being. As scholars in both fields have shown, the representation of both patently offensive and seemingly benign stereotypes in film, television, and other media can have an enduringly negative impact on the perception and treatment of minority groups, often leading to the perpetuation of social inequalities.[8] Moreover, as numerous historians of medicine have shown, the proliferation of such stereotypes can contribute to poor health outcomes, particularly for already disenfranchised groups.[9]

While visual theorists have met instrumentalist arguments about the "effects" of mass media with skepticism, arguing for the importance of more nuanced approaches to the varied forms of media reception,[10] health specialists increasingly utilize imaging technologies in clinical settings. And yet, the methodologies that govern interpretation in these disparate realms rarely meet, to the detriment of both humanists and scientists. But an opportunity for constructive dialogue is emerging. Because the content of public health films can have concrete and serious consequences, medical education researchers have begun to argue for the importance of media literacy training for pediatricians whose young patients are increasingly seen as suffering from maladies, such as obesity, that they argue are indirectly caused by exposure to mass media.[11] Most of the underlying issues— poor exercise, eating habits, and body image—are viewed as consequences of excessive indulgence in the visual media of distraction,[12] such as television viewing and video game playing, not film viewing, and yet, the most common approach to this issue in the growing field of medical humanities focuses on the motion picture as a tool for clinical and pedagogical intervention. Indeed, a recent volume summarizing the research in the field, *Cinemeducation: A Comprehensive Guide to Using Film in Medical Education* (2005), explains the rationale thus: "Films can be experienced with immediacy, permitting a broad experience that would otherwise be difficult to achieve in the usually limited time available, and almost every learner possesses enough critical capacity to gain meaningful insights through the experience of watching films."[13] The curriculum focuses exclusively on the uses of film for developing "narrative competence," and thus emphasizes story and character over the visual and auditory elements that comprise the medium's unique appeal (in contrast to text-based media).

Such a limited understanding of media literacy, however, tends to revive an outdated dichotomy between form and content, misleading viewers into focusing on one level of media "effects" while ignoring another. Emphasizing this sort of narrowly defined content alone provides an inadequate understanding of the processes by which meaning is created in these films. Instead, as scholars of visual culture have long argued, we need to examine representation itself as an integral component of "content"; analysis based solely on the narrative of *The Silent*

Invader would miss entirely the xenophobic underpinnings of the film's approach to public health. While narrative analysis may be sufficient to reveal the presence of some damaging media stereotypes and to generate group discussion about social issues related to clinical practice, it cannot access the more fundamental issue of how the ostensible "immediacy" of audiovisual media depends upon and generates particular "ways of seeing" that profoundly shape medical research and practice.[14] By comparing the explicit narrative subject matter of a film with the techniques used to convey that material, we can begin to address the complex and often contradictory pedagogical functions of mass media technologies in the realms of medicine and public health.[15]

In the remainder of this essay, I will examine the different ways of seeing that health films have promoted in the latter half of the twentieth century in order to highlight the tensions among the various messages the films espouse. Focusing primarily on two films that were produced to serve the dual functions of corporate publicity and medical education will provide a case study of how health films have resolved the competing demands of addressing both general and expert viewers simultaneously. Comparing these commercial endeavors with a film produced by a nongovernmental organization will reveal how the techniques for presenting health education change over time to reflect the ideals of the producers and evolving theories of visual pedagogy. As we will see, these films use varied means to accomplish the goal of training viewers in particular forms of clinical perception: editing establishes visual analogies, microcinematography affirms the scientific quality of the image, and music and voiceover techniques offer a preferred interpretation of the image. And yet, the presentation often seems to contradict the film's stated aims, thus creating ways of seeing that alternately emphasize visual and auditory perceptions as privileged but conflicting forms of sensory information that undermine the ostensibly educational and empathetic objectives of the film.

Corporate Benevolence: *Medicine in the Tropics*

Medicine in the Tropics was produced in 1948 by Lewis Sound Films for the Firestone Plantations Company, a subsidiary of the Firestone Tire and Rubber Company.[16] The film presents health issues related to workers on the Firestone rubber plantation in Liberia, and is, in all relevant respects, a typical postwar public health film.[17] The promotional films of a transnational corporation advertising its accomplishments in the realm of tropical medicine raise complex questions about how "appropriate" content and style are determined for presenting scientific advances to different audiences, how to define the "public" whose health is being preserved, and what role "science" plays in establishing the boundaries between experts and the public. Moreover, *Medicine in the Tropics* was

reviewed in the *Journal of the American Medical Association,* and this review provides valuable insight into contemporary perceptions of the film's function and success.[18]

Opening with an animated map of Africa accompanied by a broad description of the climate and customs of Liberia, the film moves into a discussion of the diseases typical of the region. Over documentary footage of Liberians engaged in varied sorts of physical labor, and intercut with shots of palm trees, rubber trees, and flowering bushes swaying in the breeze, the voiceover sets the scene: "Most Liberians are tribes-people, who work and live very simply. Their daily activities are devoted largely to taking care of their immediate needs. In these respects they are typical of native inhabitants of many tropical climates." Thus far, the film seems merely to present objective facts as relevant background. Indeed, the *Journal of the American Medical Association* praised this approach: "This film is especially well done; it is artistic and the photography is superb. The geography of Liberia and the customs of its people are well portrayed. Natives tapping drums form a fitting introduction."[19] Viewers are primed to understand the lives and medical problems of Liberian workers as "simple" and therefore less evolved than the white physicians who provide their care. But viewers also come to regard the workers as anthropologically interesting in their exoticism, and this perspective helps frame the film's investigation of Liberian rubber plantation workers as a threat that can be scientifically explained and contained. Intense, rhythmic drumming during the opening sequence establishes a theme of menacing, uncontrolled nature through association with the diseases of the native inhabitants of Liberia; by contrast, calming orchestral music, associated with the cures provided by Western medicine, enables an alternate theme to emerge.

This opening sequence uses techniques common to many films of the period; by cutting from maps to documentary footage of diseased bodies, postwar public health films could visually isolate contaminated locales and thereby provide viewers with the imaginary security of representational inoculation. Thus, in the process of creating a visual iconography of disease, these films produce an epidemiological map of the world that presents the inhabitants of regions afflicted with endemic diseases as the most visually recognizable faces of disease. The success of this technique depends on the film's ability to convincingly display scientific evidence of the isomorphic relationship between exotic, distant lands and contaminated bodies. Importantly, this relationship is not inherent in the film's narrative.

Following along with the mood set in the opening sequence, the film carefully pursues a tone of corporate benevolence that is never overtly critical of the "natives" but is nonetheless inherently patronizing. In order to be worthy of medical care, the natives must not be capable of caring for themselves. On the other hand, they must be capable of learning and self-improvement with the

assistance of their superiors. And yet, they must not be capable of becoming equals, or they wouldn't deserve to live in such squalid, primitive conditions, or to endure such back-breaking labor on the plantations. Thus, viewers are meant to hold a contradictory attitude of humanitarian condescension toward the film's subjects, an attitude that is maintained by balancing the counterposing values of the audio and visual tracks of the film.

One of the crucial tensions in *Medicine in the Tropics* arises from the film's refusal to acknowledge the role of the sponsor—the Firestone Company—in creating any of the problems that its medical researchers ultimately solve. A voiceover, for instance, jovially explains that "[a]griculture is inherently easy because of the soil's fertility, and the fact that crops are not severely restricted to seasons. Even on casual inspection of the landscape, it is evident that here, almost anything will grow." This commentary is accompanied by cheerful string music softly filling the background, which abruptly shifts its tone to a deep mix of brass and timpani that surges to the aural foreground when microbes appear on screen, dramatically enhancing the narrative of danger: "On the one hand, this lush productivity, resulting from the climate and rainfall, is a blessing. On the other, it is a threat, a menace, and a liability. For the same conditions that make for an abundance of vegetables, forest products, and flowers are also favorable to the growth and development of the microorganisms that cause ruinous diseases." Here, the sequence that initiated with the animated map of Africa, followed by images of the inhabitants of Liberia, cuts to a microcinematographic image of an unidentified, squirming microorganism.

It is important to note the lack of an explanation for the microcinematography sequence. This absence follows a broader pattern of editing typical of postwar public health films: the narration moves from a shot of a map to a documentary image of an unidentified locale or, as in this case, to an unidentified shot of a microorganism. In both cases, the film relies on the voiceover to assert the logical connection between the two images, regardless of their actual interrelation, and despite major explanatory gaps. By accessing scientific authority in this way, the film presumes its status as a document of neutrality and objectivity. Distorted depictions of labor and living conditions become little more than documentary images of the unvarnished truth, and Firestone's heroic efforts toward modernization are celebrated rather than scrutinized or critiqued.

In another interesting juxtaposition, *Medicine in the Tropics* jumps from the microbe to documentary footage of native women filling buckets in a muddy stream while children play nearby in the same water. To underscore the presence of an invisible menace lurking within the seemingly innocent landscape, the voiceover continues: "For example, while some of Liberia's streams are pure, others play a grim role as carriers of malicious dysenteries and many other water-borne diseases." The voiceover interpretation of this scene as evidence of native ignorance

promptly gives way to a scene of corporate instruction and improvement: a medium shot of two barefoot African men in white shirts and shorts, digging out a stream bed, is intercut with a medium close-up of a muddy waterway. The voiceover establishes the preferred interpretation: "Before the advent of the Firestone rubber plantations, swamplands and stagnant pools provided ideal breeding places for Anopheline mosquitoes, the carriers of malaria. Today, with a broad medical and sanitation program in progress, this stagnant water is methodically drained, to prevent the formation of larvae breeding pools." The scene fades out, and the intended moral is clear. But considering the long history of slavery and environmental destruction in the service of empire, one might view these images differently. Indeed, the presumption of dependence that enables this paternalistic interpretation of exploited labor ultimately serves the corporation, not the "natives." Moreover, the impact of rubber farming on the human and ecological landscape should raise serious questions about this project of modernization. However, the voiceover articulates a different meaning—a point of view that cannot be captured by the images alone.

The film's underlying theme of corporate benevolence is developed most fully in an elaborate sequence that documents a case study of an ailing worker, which also serves as a means of promoting the hospital facilities on the plantation. The man depicted is shown suffering from amebic abscess of the liver, and the film recreates the sequence of events that lead him to undergo the appropriate treatment, including visiting a dresser station staffed by native orderlies who provide him with a written note that secures his transport and admission to the hospital. A melodramatic tone is set through the lyrical musical accompaniment of plaintive violins. The selection of this type of background music elicits viewer engagement with the storyline; instead of distanced observation of an appalling scene, as in the microbe sequence, the film encourages the viewer to become emotionally involved and to care about this patient's outcome. But it soon becomes clear that this patient, who remains anonymous throughout the film, is important not as an individual but as a case study in medical and pedagogical intervention.

Moreover, this patient's status as a "native" is repeatedly presented as central to the viewer's understanding of the course of treatment; the voiceover thereby encourages interpretation of racial difference as indicative of evolutionary difference. Inside the hospital, the patient is examined by a black nurse and a white doctor, and the voiceover explains, "The native medical personnel on the Firestone plantations are about one hundred in number. All of them have been trained by American doctors and nurses, who direct the hospital staff." As the patient is admitted to the hospital for surgical treatment, the narrator elaborates upon the racial dynamics at play: "In the early part of the medical program, natives were dubious of what they termed 'foreign doctors.' But their doubts and fears were dispelled as a result of cures affected and the obvious efficiency of modern medical techniques and equipment." Just as this film depicts the training and conversion of

the Liberian workers into modern subjects, it also trains viewers to understand themselves as possessing an inherently superior pedagogical capacity, precisely because of their position as observers of—rather than participants in—the "obvious efficiency" of modern biomedical treatments.

Following the patient's course of treatment, the film cuts to a tracking shot of a long row of beds on the surgical ward. We see an African orderly collecting samples at the patient's bedside, then examining the specimens at a microscope in the laboratory. The voiceover proclaims, "The blood tests themselves are made in the hospital laboratory by skilled native technicians. The laboratory facilities in the Firestone hospital in Liberia are completely modern in all respects." To confirm this claim, we next see the patient in the X-ray room, attended by a white orderly, while a white doctor reads the X-ray in the background of the shot. This sequence could be seen as evidence of the generous, egalitarian attitude of the Firestone Corporation; after all, the voiceover describes the natives as "skilled technicians," and we see them performing important tasks related to the patient's medical care. Indeed, cutting from shots of a native hospital worker to shots of a white hospital worker might prompt viewers to interpret these scenes as equivalent—African and American medical technicians working together for the greater good. The natives are beneficiaries of the same high-tech diagnostic imaging technologies as the Western viewers watching the film.

The voiceover's anxious insistence on the "modernity" of the facilities, however, belies such an easy interpretation. By emphasizing the sophistication of the laboratory immediately following the announcement that this lab is run by "natives," the voiceover subtly reveals—and endorses—the anticipated bias of the audience. The expected reaction of shock or skepticism upon seeing the images of natives at the microscope is subdued by the assurance that although the workers on the plantation might be primitive, the technology responsible for Firestone's corporate identity as medical philanthropist is not. Moreover, by cutting from the lab scene to footage of a white American doctor working with the more complex and sophisticated technology of radiology, the film assures viewers that one can expect normative social hierarchies to remain firmly in place. Many films from the postwar era of "medical miracles" are heavily invested in maintaining clear, insurmountable distinctions between health specialists and their patients, but as this sequence demonstrates, maintaining the hierarchy can be hard work, for Firestone is clearly dependent on the African laborers, both on the plantation and in the hospital.[20]

Anxiety about the feasibility and legitimacy of practicing modern medicine in a primitive setting permeates *Medicine in the Tropics*.[21] The stakes are high; as the film notes early on, a healthy work force is vital to the successful operation of the plantation. Implicit in this recognition is the broader historical context: with the postwar boom in automobile sales in the United States, corporate profits and market dominance of the Firestone tire company depend heavily on the

productivity of the rubber plantation. Thus, the expansive modernization of American consumer culture contributes to the disingenuous treatment of Liberian workers in this film, since a frank acknowledgment of the mutual dependence of these two countries' economies would place Firestone in the ethically untenable position of recognizing as equals its population of virtually enslaved laborers.[22] Instead, the film continually vacillates between an attitude of medical empathy and a posture of scientific superiority. Indeed, the very next sequence takes place in an operating room filled with busy white medical personnel in scrubs, and the voiceover notes, "Equipment, sterilization, and medical skills attendant upon surgery in the Firestone hospital compare favorably with those existing anywhere. The extremely high percentage of successful surgery attests to the validity of modern medical techniques in primitive surroundings."

By examining the pedagogical strategies employed by this film, we can see that *Medicine in the Tropics* depicts more than the techniques involved in developing clinical medical practices in a tropical climate. In fact, one could argue that the mode of representation tells us far more about the promotional function of medicine for multinational corporations, the role of both tropical medicine and documentary film in defining "Africa" and "America" during the postwar era, and the uses of film as a scientifically legitimated educational tool than it does anything else. The possibility of reforming and modernizing Africans so that they can function as workers for Western corporations such as Firestone is cast as evidence of the altruistic behavior of multinational corporations. Doing business in the developing world contributes to global modernization and the pursuit of world health. Thus, the voiceover compares the hospital in Liberia to those in the United States while simultaneously insisting on a hierarchical relationship: "After surgery, the patient is removed to the convalescent ward, where the care he receives differs little from that offered in hospitals in Des Moines, Hartford, Tucson, Portland, New Orleans, or San Diego. The plantation hospital is staffed by American doctors and nurses, and is supplemented by native personnel, most of whom have learned readily and function devotedly at a highly competent level."

"Unsuitable for Lay Audiences"

The mode of address used in *Medicine in the Tropics* seems general enough to serve as a vehicle of corporate promotion for a wide range of audiences—after all, the film was perpetually on loan from Firestone's Department of Public Relations, in addition to the more conventional route of rental through a New York–based film distribution company called Association Films.[23] At the same time, the film's self-presentation as technical and scientific—no mere publicity tool—is affirmed not only by the opening credits sequence, prominently listing a physician, K. H. Franz, M.D., as technical adviser, but also by the positive review of the film

in the pages of the *Journal of the American Medical Association* (hereafter *JAMA*) in 1949. The *JAMA* review focuses on the educational value of the documentary film footage for American audiences who would not otherwise have direct experience with diseases with low prevalence in their communities. Highlighting this pedagogical function subtly reminds the audience of its privileged viewing position; the isolation of the United States from many of the developing world's worst diseases ostensibly authorizes the viewer's gaze as benign medical interest rather than prurient voyeurism: "There are three cases of smallpox shown which make an excellent clinical demonstration. For medical students in the United States these smallpox cases alone make the picture worthwhile."[24] But since the film is not directed solely toward a specialist audience, its attempts to address multiple types of viewers suggest some answers to the questions we started with: how to define "appropriate" content and style of presentation for different audiences, and how to define the role of "science" in establishing the boundaries between experts and the public.

The film's valorization of African bodies as sources of clinical evidence obscures their larger function: affirming that visible disease is an intrinsic quality of the third world. By analyzing this film closely, we can see that the content of the "clinical demonstration" is far from a purely scientific spectacle. Although *JAMA*'s review might suggest that the film's extensive depiction of smallpox patients, for example, simply reflects the disease distribution in Liberia, the setting of these shots, their musical soundtrack, and the style of camerawork all provide evidence of more than a clinical presentation of smallpox.

In fact, the *JAMA* review hints at the film's potential for unintended effects. For instance, the reviewer critically observes, "A patient with elephantiasis of the scrotum is demonstrated but neither the causative agent nor the vector is shown."[25] Indeed, the segment does seem to fulfill a voyeuristic rather than an educational function. In the elephantiasis sequence, a white doctor and an African nurse move from bed to bed, displaying each patient's visible symptoms to the accompaniment of voiceover explanation, while the camera cuts between a medium long shot that takes in multiple beds on the long, open ward, and medium close-ups of the specific condition being exhibited. At each bedside, the doctor unceremoniously pulls down the covers to reveal a naked body (though one female patient holds a small cloth over her genitals). When the physician exposes a naked man and examines his dramatically enlarged scrotum, the voiceover explains, "Elephantiasis, a complication of filariasis, is an almost exclusively tropical disease. This elephantoid scrotum, weighing 42 pounds, was successfully removed by surgery, and the patient discharged mentally and physically improved." The close-up focuses on the scrotum and the doctor's palpating hands; when the examination is completed, the film cuts back to the medium long shot while the doctor replaces the bed covering, then pans right to show the patient in the next bed. We never see the

elephantiasis patient's face in close-up, and the film does not show any verbal communication between the physician and patient (Figure 4.1).

While the concluding paragraph of the *JAMA* review acknowledges at least one problematic aspect of this depiction, namely the indelicate exposure of the patients' bodies, it locates the overall negative effect not in the representation itself, but rather in the audience: "The film would be suitable for first and second year medical students and groups of nurses. The demonstration of nude patients makes it unsuitable for lay audiences. The main portion of this film could be used as a basis for two separate pictures, one for the laity and one for the medical profession. For the first film simply omit the nude patients. For the medical profession some revision along the lines suggested would convert it into a valuable scientific contribution."[26] The *JAMA* review clearly recognizes that these bodies are handled inappropriately for a general audience, but one could argue that the film's broader pedagogical function depends on precisely this form of mistreatment.

Interestingly, the producers of the film seem to have taken the *JAMA* recommendations quite seriously. In 1957, a revised version of the film was released under the same title.[27] Instead of integrating the display of tropical diseases with the narrative, as in the earlier version of *Medicine in the Tropics,* the 1957 update visually introduces and consequently isolates each new pathology with the assistance of fade-outs and intertitles. Additionally, following the *JAMA* reviewer's recommendation, this 1957 version is divided into two different segments, one for a lay audience and one for medical professionals. Although the internal division of the film is not explicitly announced to the viewer, a significant shift in tone marks the break on several levels. First, the voiceover summarizes the discussion, in the first half of the film, of the industrial economics of health in the tropics, casting it as background information for the closer medical investigation to follow: "Numerous villages serve as laboratories of treatment and control, and throughout Liberia, the [Liberian Institute of the American Foundation for

Figure 4.1. A doctor palpates the patient's dramatically enlarged scrotum. *Medicine in the Tropics.* Prod. Lewis Sound Films/Firestone Plantations Company/Association Films, 1948. Courtesy of the National Library of Medicine.

Tropical Medicine] carries out collaborative projects with such groups as American universities, the World Health Organization, and the United States Public Health Service. In view of the variety and density of tropical disease, all of Liberia is available for medical study." As the narration draws to a close, an aerial long shot of the rubber plantation zooms in on the village where this study takes place. Finally, the musical soundtrack and the image fade out, and an intertitle appears on a black screen announcing: "Typical Tropical Diseases in Liberia."

The split between "lay" and "professional" sections is not so sharply marked that the two halves of the film cannot function as a cohesive whole; nonetheless, the specific strategies used to indicate the transition suggest the producers' revised views on appropriate modes of address for different audiences. After the voiceover sums up all of the ethnographic and environmental factors in tropical medicine, a new narrator's voice takes over. Compared to the highly expressive and wide-ranging voice range of the first narrator, the second narrator's tone is flatter, less animated, and so precise that many sequences contain notably long silences. The narrator of the first half of the film clearly strives for a mood of generous cultural relativism, even as his tone of voice reveals incredulity at the primitivism he describes. By contrast, the second narrator provides no audible embellishment beyond presenting the basic etiological facts of a given pathological specimen. Moreover, since the second half of the film contains no musical accompaniment, the deliberate minimalism of this sequence is clearly meant to register as "scientific," particularly in contrast with the previous mode of address. In this second section, pathologies are presented individually, each with a representative Liberian body manifesting the disease, rotating before the camera like a display in a museum of medical oddities.[28] One sequence opens with a medium shot from the waist down of the backside of a naked African man with an elephantoid scrotum. Promptly a subtitle is superimposed to further specify the condition as "Filarial Elephantiasis." The man slowly turns to face the camera, shifting ninety degrees at a time to provide ample opportunity for viewers to examine his anatomical anomaly. The voiceover translates the visuals: "Bancroft's filariasis is due to a filarial worm parasite, *Wuchereria bancrofti*, which invades the lymphatic system. It is transmitted by a number of mosquito species very prevalent in Liberia. It is this parasite that gives rise to elephantiasis" (Figure 4.2).

Does the mode of representing disease in the 1957 version of *Medicine in the Tropics* attain the desired level of objectivity, freed from the perceived emotional biases of the 1948 film? And is the revised film's fundamental assumption—that objectivity defines the most effective pedagogy—a tenable claim? On the one hand, these sequences serve a scientific, instructional, and arguably humanitarian purpose; improving the health of Liberians is an indisputably legitimate and laudable goal. On the other hand, these sequences objectify living human beings as laboratory specimens in front of the camera, and the primary purpose served by this

Figure 4.2. Display of the elephantoid scrotum. *Medicine in the Tropics.* Prod. Vogue Wright/ Firestone Plantation Company, 1957. Courtesy of the National Library of Medicine.

investment in tropical medicine is to provide a healthy work force for the rubber plantation. Then again, one could argue for the educational benefit of showing rare diseases on film, but such representations can easily give the impression, as this film does, that all African bodies are monstrous. Furthermore, the cumulative effect of the representational techniques in both versions of *Medicine in the Tropics* suggests that, in the United States, you can't actually "see" disease, whereas in the Third World disease is visible all around you. While it may be true that some particularly gruesome visuals are available in the hospitals of the developing world, this assumption belies the widespread prevalence in this period of tuberculosis, polio, and other diseases that spread in the United States and abroad precisely through their invisibility. While the visual culture of global health associates Africa with manifestations of bodily horror, such diseases in the United States remain largely invisible.[29]

Conclusion: Cinema of Liberation?

The representational strategies deployed in films such as *Medicine in the Tropics* raise difficult questions. On the level of content, the information presented in these films was not medically inaccurate at the time of production; on this basic level, the films are "true." Furthermore, smallpox continued to exist in Africa long after it had been eradicated from the United States, and many other diseases unfamiliar to the Western world exist, often uniquely, in the tropics and when left untreated, do in fact manifest themselves in dramatic ways. Yet, as we have seen, the techniques used to present information in these films create representational distortions that not only obscure medical objectivity but also—and perhaps most importantly—infuse public perceptions of health and disease with imagery of racial degeneracy.[30] This problem partially results from the effort simultaneously to address expert and lay audiences; the varied levels of understanding amongst such viewers prompt the filmmakers to oscillate between complex technical instruction and broad generalizations. However, this approach does not lead

simply to a clear segmentation of the film into "professional" sequences that function in isolation from the "popular" sequences. On the contrary, the aura of expertise conveyed through the film's scientific mode of address bleeds into the rest of the film, endowing the generalizations about "African diseases" with expert legitimacy. In turn, the connotations of racial degeneracy in the popular segments infuse the scientific sequences with the aura of racialized national superiority. But what mode of representation might avoid creating such problems, particularly when, intentionally or not, instructional media often—perhaps always—are engaged in multiple pedagogical functions, for multiple and sometimes competing audiences, all at once?

A film produced in 1978 for the World Health Organization (WHO) called *Medicine of Liberation: Aspects of Primary Health Care in Mozambique* might contain some answers.[31] This film recounts the history of the Frente de Libertação de Moçambique (Mozambique Liberation Front), or FRELIMO, in the armed struggle against Portuguese colonialism as well as the role of medicine in the fight for self-determination and the development of a "new type of health personnel" to care for people living in postcolonial communal villages. Mozambique achieved independence from Portugal in 1975 after a decade of armed struggle; when the vast majority of Portuguese settlers departed, most of the trained professionals in the country, including physicians, also left. The loss of health and education resources previously controlled by the colonial power left a gap that the Marxist opposition group FRELIMO attempted to fill, and *Medicine of Liberation* narrates the early stages of this process.[32]

In the opening sequence of the film, shot on location with direct sound, a group of Mozambican "natives" is gathered in a shady grove, and a man addresses the crowd: "When the people of Mozambique began armed struggle against colonialism, under the leadership of FRELIMO, it was decided also to have a health campaign to fight disease, because only with good health are we strong enough to build up our country." We hear these words, in English, through the voiceover of a translator; the sound of the man's original speech remains low in the postproduction mix. During this sequence, the camera moves around the gathering, at times showing the faces of children in the crowd in medium close-up with a wobbly, handheld camera, then cutting back to long shots of the speaker standing in the midst of the seated crowd. Unlike *Medicine in the Tropics, Medicine of Liberation* embraces the techniques of direct cinema, thereby creating an intimate, immediate tone that contrasts strongly with the presumptions to objectivity that characterized earlier periods in documentary film. By using a telephoto lens, the cinematographer gives the impression of shooting the scene from within, being a participant rather than a distanced observer. Moreover, by incorporating location sound—not just the words of the speaker, but the background noise of an outdoor gathering, this sequence can claim to document a messy moment of spontaneous

reality rather than a clean, highly orchestrated artifact of corporate postproduction techniques.

Of course, part of this difference can be attributed to the technological developments—lightweight cameras, high-speed film, and synchronized sound—that allowed the direct cinema movement to become a global phenomenon in the late 1950s and 1960s.[33] As Paul Arthur has discussed, the qualities associated with these technologies, such as immediacy, presence, and authenticity, were easily manipulated effects that strategically produced a sense of immersion in "reality" regardless of what was "really" going on.[34] Nonetheless, the relative absence of extrafilmic techniques—no animation, no mapping, no microcinematography—combined with the rejection of a tripod in favor of handheld camera work and the use of location sound rather than nondiegetic voiceover and music, eliminates the observational distance that, in the earlier films, enabled the scientific detachment of the narrator and the treatment of the film's subjects as diseased lab specimens. In many postwar public health films, cinematography, editing, and sound conspire to authorize an attitude of racialized evolutionary superiority that was intrinsically linked to a presumption of scientific objectivity. But in *Medicine of Liberation,* the very same techniques are used to counter these historical tendencies. For instance, the nondiegetic "native drumming" that was used to insidious effect in *Medicine in the Tropics* is replaced by the singing of young Mozambican men and women who have been selected by their villages to become *agentes polyvalentes alimentaires,* or village health workers. Instead of functioning as exotic, incomprehensible, and menacing mood music, the lyrics of their songs about fighting disease in Mozambique are brought to the foreground through translation.

Similarly, while the audible presence of an omniscient, off-screen narrator still provides the preferred interpretation of the visual footage in *Medicine of Liberation,* the bodily presence of the interlocutor just barely out of frame is made clear through the conversational mode of onscreen interviewees, whose own bodily positioning plainly indicates that they are answering questions posed to them from behind the camera (Figure 4.3). Moreover, while the absence of direct sound in the earlier films endowed the narrator with exclusive and total interpretive power, the intermittent function of translation, when coupled with summarization, disperses the power to describe and define amongst a variety of voices. Thus, the voiceover in *Medicine of Liberation* plays a dramatically different role than it does in *Medicine in the Tropics.* Indeed, the use of the interview format alone distinguishes *Medicine of Liberation* from the earlier films. By engaging the film's subjects and permitting them to address the camera directly, this film gives depth to bodies that had formerly registered only as one-dimensional bearers of disease. Perhaps even more significantly, we see Africans practicing medicine (albeit rudimentary) on each other without recourse to images of bodily disfigurement, nudity, or grotesque pathological specimens.

Figure 4.3. Direct address to the camera. *Medicine of Liberation: Aspects of Primary Health Care in Mozambique.* Dir. Peter Krieg and Heidi Knott. Prod. TELDOK/World Health Organization. 1978. Courtesy of the National Library of Medicine.

Above all else, however, the film makes clear the linkage between representational techniques and the ideology of anticolonial struggle. Self-governance requires direct expression of the will of the people, and the sense of minimal intervention produced by this film's approach to cinematography and sound offers an aesthetic support for the ideology of independence. This emphasis on self-reliance allows *Medicine of Liberation* to avoid many of the problematic power dynamics inherent in the relations of dependence we saw in the earlier films. The film's meaning, however, is not reducible merely to formal considerations. In all of the films discussed, it is the interplay between form and content that creates the opportunity for complex and often contradictory forms of pedagogical intervention to take place. Just as the 1948 and 1957 versions of *Medicine in the Tropics* typified some of the dominant professional and political perspectives of their times, *Medicine of Liberation*, too, is a historical relic. The celebration of socialized medicine in that film was a challenge to colonial policies and their authoritarian regimes of bodily governance. In contrast to the forced imposition of colonial regulations directed toward systematic oppression of Mozambicans whose minimal access to education and health care enabled their continued exploitation, FRELIMO espoused collective labor aimed toward self-directed community uplift.

The years since *Medicine of Liberation* was produced have seen the collapse of a wide range of collectivist governments, including that of Mozambique. Just as the trend toward foundling democracies governed by free-market principles has characterized late-twentieth-century global politics, so too has international public health shifted from grassroots activism to the worldwide dominance of commercialized medicine, typified by Big Pharma and direct-to-consumer (DTC) advertising.[35] DTC advertising was legalized in 1997 as a result of a U.S. Food and Drug Administration ruling, and a new genre of health education was born, leading promptly to a barrage of print, radio, Internet, and television advertisements that circumvent the traditional authority of the prescribing physician by appealing directly to consumers' health care concerns.

The difficulties of conveying complex information through a popular medium that characterized postwar public health films return with DTC advertising, as do the underlying assumptions about the practice of medicine in modern and developing countries. Interestingly, the authoritative presence of the expert scientist continues to inform the mode of address in DTC advertising, despite the widespread critiques of these ads by physicians who view them as spreading misinformation leading to inaccurate self-diagnosis by consumers. While this technique might be seen as undermining the status of the physician as the ultimate source of knowledge about health, pharmaceutical companies defend the practice as befitting sophisticated health care in an advanced democracy.[36] That is, DTC advertisements claim to popularize expert information with the goal of elevating the overall health of American consumers (albeit exclusively through prescription drugs); the unstated corollary to this logic is that only through the combined efforts of high-tech media and high-tech medicine can such individualized power over medical decisions be attained. Since this celebrated form of individual power through consumer choice is not available in the poorest countries of the world, access to pharmaceuticals through DTC advertising is the latest sign of the privileges of modernization and the superiority of scientific medicine. Missing from these representations is the fact that most pharmaceutical drugs are manufactured in the developing world, in precisely the areas where access to the advanced medical care promised by these products is not available to the general public.[37]

The image of American exceptionalism promoted through the conflation of freedom of information and advanced medical care in DTC advertising found confirmation in media coverage of the SARS outbreak in China in 2003. In contrast to the purported open access to scientific expertise in DTC advertisements, the SARS epidemic was characterized by repressive, authoritarian censorship in China, with its public denials of SARS in the face of clear evidence to the contrary, delays in permitting WHO teams access to the affected areas, and silencing of emerging theories to explain the disease by the Ministry of Health.[38] While the belated and highly propagandistic government response to SARS in China serves as more recent proof of the function of mass media in manipulating scientific evidence, the visual association of rural Chinese farmers with bestiality in the Western media coverage of avian influenza highlights the continued linkage of unfamiliar diseases with primitive medicine, national underdevelopment, and racial degeneracy. The depictions of Liberian laborers in *Medicine in the Tropics* are shaped by conflicts between the corporate image of benevolence and the uneasy recognition of exploitative work conditions. The representations of Chinese peasants arise from the tensions between paternalistic sympathy toward exploited laborers and anxiety about national economic dependence on workers whose very bodily suffering is seen as evidence of their evolutionary inferiority. Within this logic, national access to DTC advertising implicitly guarantees

protection from the primitive public health infrastructure that the disease out-breaks in China have revealed.

As both of these outbreaks have shown, the project of global health surveil-lance is critically dependent upon the effective monitoring and tracking of dis-ease outbreaks around the world. While problems can arise due to lack of funding or inadequate information networks, one persistent problem almost always remains, even under the best of circumstances: the problem of detection. In the most literal sense, the term "surveillance" means "observation," and thus, suc-cessful surveillance would seem to require the visual recognition of the object under investigation. But the invisibility of viruses and bacteria to the naked eye can make this act quite difficult to accomplish, and this poses a conundrum for the practice and promotion of public health. And yet, the history of public health film shows that, under certain circumstances, some diseases can be made visible. The association of different media styles with different relations of power suggests the continued importance of closely watching and responding to the images that form public understanding of issues in global health. We must continue to ask: which diseases can we see, and how are we trained to see them?

Notes

1. For an overview of the historical shift from 16mm film to video, see Anthony Slide, *Before Video: A History of the Non-Theatrical Film* (New York: Greenwood, 1992), 123–36.

2. On the early development of film as a scientific research tool see Hannah Landecker, "Micro-cinematography and the History of Science and Film," *Isis* 97 (2006): 121–32.

3. Dean E. Murphy, "The SARS Epidemic: Economic Fallout; Market for Chinese-American Delicacy Plummets." *New York Times,* May 23, 2003, A8.

4. See Kirsten Ostherr, *Cinematic Prophylaxis: Globalization and Contagion in the Discourse of World Health* (Durham, N.C.: Duke University Press, 2005), 18–24, 135–48.

5. For other examples of xenophobic imagery in the context of health and international rela-tions, see Lisa Cartwright and Brian Goldfarb, "Cultural Contagion: On Disney's Health Education Films for Latin America," in Disney Discourse, ed. Eric Smoodin (New York: Routledge, 1994), 169–80.

6. For a discussion of the proactive uses of television to convey "positive" health messages at the Centers for Disease Control and Prevention (CDC), see http://www.cdc.gov/communication/healthsoap.htm. See also Arvind Singhal et al., eds., *Entertainment-Education and Social Change: History, Research, and Practice* (Mahwah, N.J.: Lawrence Erlbaum Associates, 2004), 21–38. For a cultural studies perspective, see Brian Goldfarb, *Visual Pedagogy: Media Cultures in and beyond the Classroom* (Durham, N.C.: Duke University Press, 2002), 25–56.

7. For good introductions to the range of methodologies, see David Bordwell and Kristin Thompson, *Film Art,* 9th ed. (New York: McGraw-Hill, 2010), 223–311; Jeremy G. Butler, *Television: Critical Methods and Applications,* 3rd ed. (Mahwah, N.J.: Lawrence Erlbaum Associates, 2007), 204–70; and Marita Sturken and Lisa Cartwright, *Practices of Looking,* 2nd ed. (New York: Oxford University Press, 2009), 9–48.

8. The body of scholarship on the topic of media stereotypes is too vast to include here, but for good overviews, see Ed Guerrero, *Framing Blackness: the African American Image in Film* (Philadelphia, Pa.: Temple University Press, 1993); and Ella Shohat and Robert Stam, *Unthinking Eurocentrism: Multiculturalism and the Media* (New York: Routledge, 1994), 178–219.

9. See Thomas A. LaVeist, ed., *Race, Ethnicity, and Health: A Public Health Reader* (San Francisco: Jossey-Bass, 2002), 161–210; and Alan Kraut, *Silent Travelers: Germs, Genes and the 'Immigrant Menace'* (New York: BasicBooks, 1994).

10. For a concise overview of the debates about media effects and violence, see J. David Slocum, "Violence and American Cinema: Notes for an Investigation," in *Violence and American Cinema,* ed. David Slocum (New York: Routledge, 2001), 1–36.

11. See Michael Rich and Miriam Bar-on, "Child Health in the Information Age: Media Education of Pediatricians," *Pediatrics* 107 (2001): 156–62; Elizabeth Thoman and Tessa Jolls, "Media Literacy: A National Priority for a Changing World," *American Behavioral Scientist* 48, no. 1 (2004): 18–29; V. Susan Villani, Cheryl K. Olson, and Michael S. Jellinek, "Media Literacy for Clinicians and Parents," *Child and Adolescent Psychiatric Clinics in North America* 14 (2005): 523–53.

12. For theories of "distraction" in postmodern media, see Jean-François Lyotard, *The Postmodern Condition: A Report on Knowledge,* trans. Geoff Bennington and Brian Massumi (Minneapolis: University of Minnesota Press, 1984); and Fredric Jameson, *Postmodernism; or, The Cultural Logic of Late Capitalism* (Durham, N.C.: Duke University Press, 1991), 1–54.

13. Matthew Alexander et al., eds., *Cinemeducation: A Comprehensive Guide to Using Film in Medical Education* (Oxford, UK: Radcliffe, 2005), 11.

14. The phrase "ways of seeing" was popularized by John Berger in his influential text, based on an eponymous BBC television series, *Ways of Seeing* (London: Pelican, 1972).

15. For a foundational account of "miscommunication" in mass media, see Stuart Hall, "Encoding/Decoding" in *The Cultural Studies Reader,* ed. Simon During (London: Routledge, 1993), 90–103.

16. *Medicine in the Tropics.* Prod. Lewis Sound Films, Firestone Plantations Company, Association Films, 1948.

17. The extensive production of health, medicine, and science films in the postwar period covered a wide range of topics, and many of these films targeted specific audiences. However, notwithstanding the technical content of some films, a review of hundreds of these films has convinced the author that the overall mode of representation remained remarkably consistent across different fields. For more on this topic, see Ostherr, *Cinematic Prophylaxis*; Lisa Cartwright, *Screening the Body: Tracing Medicine's Visual Culture* (Minneapolis: University of Minnesota Press, 1995), 143–70; Robert Eberwein, *Sex Ed: Film, Video, and the Framework of Desire* (New Brunswick, N.J.: Rutgers University Press, 1999), 63–149; and Lester Friedman, ed., *Cultural Sutures: Medicine and Media* (Durham, N.C.: Duke University Press, 2004), 280–314.

18. While the *JAMA* review provides a useful perspective on this film's reception by a specific type of viewer, the record is unfortunately silent on the many other possible responses that *Medicine in the Tropics* might have generated. As is often the case with educational and instructional films from this era, most archival holdings do not include paper records documenting a given film's production, distribution, exhibition, or reception. Tellingly described as "ephemeral" or "orphan" films by contemporary researchers, this body of film production was not seen as worthy of historical preservation until relatively recently, and in the intervening years, many important ancillary materials, not to mention many actual films, have

been irrecoverably lost. Consequently, many important questions—such as who saw this film and how was it received?—can only receive partial answers, often based on indirect evidence.

19. American Medical Association, "Medicine in the Tropics," *Reviews of Medical Motion Pictures* (Chicago: American Medical Association, 1949): 71.

20. On the hierarchical relations between health specialists and patients, see Paul Starr, *The Social Transformation of American Medicine* (New York: Basic Books, 1982), 3–29.

21. For a historical perspective on the development of the field of tropical medicine in the context of colonialism, see Cindy Patton, *Globalizing AIDS* (Minneapolis: University of Minnesota Press, 2002), 27–50.

22. In fact, in a report published on 10 February 2006, the United Nations Integrated Regional Information Networks (IRIN) news organization (of the UN Office for the Coordination of Humanitarian Affairs) reported that 6,000 workers on the Bridgestone/Firestone rubber plantation in Liberia had gone on strike to demand better living conditions and wages. The report referred to a lawsuit filed in the United States in December 2005 by a group of Liberian human rights groups in partnership with the United States–based International Labor Rights Fund (ILRF), alleging that "thousands of workers, including minors, toil in virtual slavery at Bridgestone/Firestone rubber plantation in Liberia." "Liberia: Rubber Plantation Workers Strike Over Conditions, Pay, Child Labour," IRIN News (February 10, 2006), http://www.irinnews.org/Report.aspx?ReportId-58109 (last accessed September 13, 2010).

23. American Medical Association, "Medicine in the Tropics," 70.

24. Ibid., 71.

25. Ibid.

26. The suggested revisions included providing more technical details in the presentation of medical conditions, such as showing the "causative agent" and the "vector" of elephantiasis. American Medical Association, "Medicine in the Tropics," 71.

27. *Medicine in the Tropics.* Prod. Vogue Wright, Firestone Plantation Company, 1957.

28. For studies of an earlier historical example of this form of medicalized racial display, embodied in the "Hottentot Venus," see Sander Gilman, "The Hottentot and the Prostitute: Toward an Iconography of Female Sexuality" in *Difference and Pathology: Stereotypes of Sexuality, Race, and Madness* (Ithaca, N.Y.: Cornell University Press, 1985), 76–108; Anne Fausto-Sterling, "Gender, Race and Nation: The Comparative Anatomy of 'Hottentot' Women in Europe, 1815–1817," in *Deviant Bodies: Critical Perspectives on Difference in Science and Popular Culture,* eds. Jennifer Terry and Jacqueline Urla (Bloomingon: Indiana University Press, 1995), 19–48.

29. One major, though complex, contemporary exception to this rule is the current representation of the "obesity epidemic" in the United States. While the condition has been somewhat medicalized, and functions precisely through its visibility, the noncontagious quality of this public health issue places it in a categorically different realm from the representation of visible disease in Africa. See Charlotte Biltekoff, "Hidden Hunger: Eating and Citizenship from Domestic Science to the Fat Epidemic" (PhD dissertation, Brown University, 2005), 179–233, especially chapter 4, "The Terror Within: Citizenship and Self Control in the 'Fat Epidemic.'"

30. *Medicine of Liberation: Aspects of Primary Health Care in Mozambique.* Dir. Peter Krieg & Heidi Knott. Prod. TELDOK/World Health Organization. 1978.

31. See Alice Dinerman, *Revolution, Counter-Revolution and Revisionism in Postcolonial Africa* (New York: Routledge, 2006), 32–89.

32. On the technological developments that enabled the direct cinema movement to take place, see Brian Winston, *Technologies of Seeing: Photography, Cinematography and Television* (London: British Film Institute, 1996), 58–87.

33. See Paul Arthur, "Jargons of Authenticity (Three American Moments)" in *Theorizing Documentary*, ed. Michael Renov (New York: Routledge, 1993), 108–34.

34. See Adriana Petryna, *When Experiments Travel: Clinical Trials and the Global Search for Human Subjects* (Princeton, N.J.: Princeton University Press, 2009); Adriana Petryna, Andrew Lakoff, and Arthur Kleinman, eds., *Global Pharmaceuticals: Ethics, Markets, Practices* (Durham, N.C.: Duke University Press, 2006), 1–84.

35. For examples of the rhetoric of direct-to-consumer advertising, see the Web site for PhRMA (Pharmaceutical Research and Manufacturers of America), an advocacy group for the pharmaceutical industry, at http://www.phrma.org/dtc. Accessed September 13, 2010.

36. James Thuo Gathii, "Third World Perspectives on Global Pharmaceutical Access," in *Ethics and the Pharmaceutical Industry*, eds. Michael A. Santoro and Thomas M. Gorrie (New York: Cambridge University Press, 2005), 336–51.

37. On the role of government secrecy in the narrowly averted disaster of SARS, see the WHO's Western Pacific Regional Office (WPRO) publication *SARS: How a Global Epidemic Was Stopped* (Geneva: WHO, 2006), 73–85; Martin Enserink, "SARS in China: China's Missed Chance," *Science* 301, no. 5631 (2003): 294–96.

Mapping a Visual Genealogy of Public Health

5. Contagion, Public Health, and the Visual Culture of Nineteenth-Century Skin

KATHERINE OTT

IN THE BEGINNING WAS THE ITCH. Then there was the scratch, and a wheal that became a bleb, the yuke, the crust, and the squirmy tingling psora. In the end, there was sulfur. But what happened in between the first sign of disorder and the subduing of it? For a person to get to the point where she or he was asked to bathe in sulfur in order to relieve suffering involved many incremental steps that are deeply intertwined with historical forces. Looking at skin, and the wonders to be found there, was crucial to understanding how and why some conditions spread contagiously through communities and others did not. Many threats to the public health such as measles, variola, pellagra, smallpox, and rubella appeared as a rash, and a quick determination of the nature of the malady was a physician's best defense. Practitioners confronted both the need to measure and classify what was observed and how to train the eye to diagnose. How, then, did nineteenth-century physicians comprehend what they observed? What, after all, was the difference between a wheal, a bleb, and a bulla, and how did you know one when you saw it?[1]

This chapter examines a corner of public health as it related to contagious, nonfatal—and, often, merely annoying—disease. It chronicles the looking, sorting, and presenting of information in the decades in which medicine and public health were forming the knowledge base and tools that would guide those developing professions: the parallel dermatological universe to nineteenth-century public health. Rather than present a blow-by-blow of the doctors and their discoveries, the history presented in this essay is recovered through the images they created. The long nineteenth century saw the rise of professional public health officers who first counted and, later, plotted cases of epidemic disease. During the course of the century, officers also expanded their focus. They started with epidemics such as yellow fever and cholera with corollary attention to public water supplies, waste disposal, and the management of public thoroughfares clogged with animals (both dead and alive), manure, night soil, and garbage. They then moved on to recognize a growing number of other debilitating diseases that

circulated in communities by being passed from person to person. Scabies and favus, two itchy and contagious skin eruptions, will serve as the vehicles for recounting this dermatological tale since both were widespread and particularly bothersome in the nineteenth century. Both diseases eventually became important public health targets in the early twentieth century.

From its beginnings, dermatology has been perhaps the most visual of all medical subspecialties. Dermatologists started by looking first at the lesion, then at the rest of the skin, and then at the whole person. But the manner of understanding what was seen was embedded in a visual history that began to take shape around the turn of the nineteenth century. The earliest texts by physicians such as Robert Willan, Thomas Bateman, and Jean-Louis Alibert, included lavish color plates that attempted to capture what they saw so that others might learn from it. Although dermatology continues to share a heavy reliance upon visual representation with other fields such as anatomy and microscopy, few texts present as dramatic and unsettling a display of color and form as the nineteenth-century dermatological atlas. Where the post-Enlightenment compulsion to classify fell short with words, as was often the case with skin disorders, the copperplate, chromolithograph, and, later, the photograph filled the gap.

The history of dermatology is a relatively unexplored field, especially in comparison with the cottage industries that have developed around epidemic diseases like cholera, smallpox, tuberculosis, and AIDS. With the exceptions of venereal disease and leprosy (and, recently, cosmetic surgery), histories of skin have been poorly represented in the pages of the *Bulletin of the History of Medicine* and the *Journal of the History of Medicine and Allied Sciences*.[2] This may reflect a historical lack of interest in the field by physicians; few nineteenth-century medical textbooks, for example, include substantial sections on skin disorders. Physicians who wanted to make their reputation had better luck with promoting surgery than with treating rashes and blemishes. In addition, treatment was not often successful. Writing in the 1860s, one skin specialist explained that "medical men are in the habit of excusing their inability to remove these maladies by explaining to the patient that they form a safety valve, an outlet to the system."[3] In presenting that view, physicians hoped patients would find it easier to accept the blebs in light of a more dramatic alternative. Certainly, patients with skin disorders have never been at the top of the triage list. For example, in 1872, James Clarke White's skin ward at Massachusetts General Hospital closed after only two years because critics complained that ambulatory patients should not take up beds or resources in a manner "disproportionate to their suffering."[4] Yet the systemization of dermatology, which began in the late eighteenth century with attempts to classify all the peculiar and itchy conditions that patients asked medical practitioners to treat, was significant both for the development of medical practice in general and for public health in particular. Dermatologists realized early on the need to come to

terms with the professional issues of classification, language, concept formation, and descriptive thought.

Dermatology, as a specialization with self-identified practitioners, was one of the first subject areas to emerge within medicine. Not long after barbers and surgeons rejected each other on the heels of the French Revolution, a few physicians spent their intellectual energies contemplating and classifying all of the things they saw happening to the skin of the people that passed through their clinics. In an era when bathing, using soap, and changing one's clothes were rare and, among some social classes, nearly unknown, peoples' skin blossomed with bumps, crusts, crevices, and lesions in a palette of colors that rivaled the works of Vincent Van Gogh and Jasper Johns. Most of these eruptions are seldom, if ever, seen by physicians today, but throughout the nineteenth century the study of the skin was as exciting and adventuresome as a journey around the world. Indeed, skin specialists came to rely upon large elephant folios of illustrations to find their way in the same way that mariners used gazettes and atlases to navigate the oceans.

Skin atlases, resplendent with copperplate engravings, chromolithographs, and, later, with photographs, large and lovingly detailed, follow the traditions of bodily representation established by Andreas Vesalius and the other great sixteenth- and seventeenth-century anatomists as well as those of cartographic atlases meant to map the limits of geographical knowledge and of eighteenth-century natural history illustrated volumes.[5] But skin atlases are different in presentation: there is no backdrop, habitat, or landscape in the background, no props in the field of view. The images are not packed with visual symbols and information. Nor are they pictorial philosophy and religion.[6] What these genres share, reflected in their size, vivid color, and careful detail, is the visual pleasure that derives from the act of looking.

Medical practitioners viewed diseases and people as cartographic material almost from the beginning of the history of illustrated texts. Illustrators borrowed their style and intellectual framework from Gerhard Mercator's first modern atlas in the seventeenth century. Atlases, such as the one shown in Figure 5.1, authored by Louis Duhring, the first American dermatologist of note, encompassed the universe of the possible.[7] The entry point to these images for the modern viewer is the assumption that the skin is a place to discover conceptions about health and society; analyses of bodies and skin must not be separated from the context of social practices. This is not a particularly innovative idea—using the skin as a metaphor for something else. The difference with the approach at hand is that a strictly cultural analysis might use the conception of the skin as border and boundary and never move from the interpretive abstract to the physical object. As visual aids for medicine, the images feature form and physical location. Such skin atlases are remnants of an era of exploration when adventurers mapped Africa and North America as a prelude to conquering. As copious and alluring as the

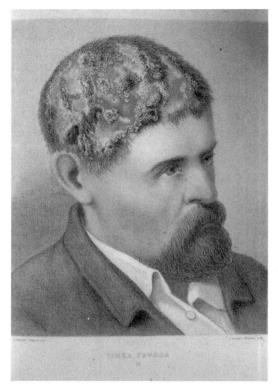

Figure 5.1. "Tinea Favosa," from Louis Adolphus Duhring, *Atlas of Skin Diseases* (Philadelphia: Lippincott, 1876), Plate O.

world seemed, so did the bodies on view among the plates, and equally in need of mastery.

An approach from the history of medicine operates from the idea of the skin as the largest organ of the body, so that understanding the skin's anatomy and the physiology of lesions, classification of diseases, control of contagion, and the like are the real bread-and-butter issues, rather than skin as a bodyscape that dermatologists pore over. Accordingly, the pathological leitmotif for this essay is composed of two common nineteenth-century disorders: scabies and favus.[8] Scabies is caused by a tiny insect that burrows under the skin, while favus originates in the reaction of the skin to the spreading presence of a vegetable parasite, a particularly fierce ringworm, which dines on material that composes the base of hair follicles. Both scabies and favus are common public health problems, even though their stock had lost most of its value by the late twentieth century. These unique diseases were visually delineated within the developing disciplines of nineteenth-century dermatology and public health. In dermatology, the main professional struggles throughout the nineteenth century revolved around figuring out what they were

looking at, that is, classification and nomenclature. In public health, on the other hand, the professional labor was for legitimacy and respect, power and authority.[9]

Nineteenth-Century Public Health

Although the U.S. Public Health service was established in 1798, organized efforts to promote public health were haphazard and largely reactive during most of the following century. Most cities had public works ordinances of various sorts by the end of the eighteenth century but, in responding to disease and natural forces, crisis management prevailed. Laws about disposing of trash, offal, waste water, and manure in the streets were well-known and accepted, although not strictly enforced and generally undermined by the nonexistence of services and utilities. After the middle of the nineteenth century, as water, gas, and then electricity grids spread across cities, the regulation of public health became more rational and real.[10] Indeed, most historians of medicine generally agree that the nineteenth century (until about World War I) was an intense period of public health activity as it became systematized along with the modern industrial state.

But skin, as a public entity, has never been as manageable as sewage or charnel houses or prostitutes. Skin is a conduit for numerous animal and vegetable rogues and the site of first appearance of viral and bacterial scourges like measles, bubonic plague, yellow fever, and chicken pox. Skin will not yield to curfews or quarantines. It covers the bodies of individuals, not the surface of streets or the counters of saloons. Public nuisances were far easier to identify and quantify than pustules passed between strangers sharing a bed while traveling. In the case of scabies and favus, one important variable was that they were contagious diseases spread by contaminated bodies and textiles. Standards of cleanliness one hundred and fifty years ago were based upon a daily life without regular bathing or washing of clothes and bed linens. Filth diseases were widespread and intractable because they were endemic.[11] Class did not figure significantly in cultural connotations of the skin disorders until much later because everyone was pretty much in the same dirty boat. Class figured more prominently in descriptions of household decor and behaviors.

The big epidemic diseases, such as cholera, smallpox, tuberculosis, yellow fever, and malaria, were the foci of public containment for most of the eighteenth and nineteenth centuries. And since not much was reliably effective in preventing epidemics or treating those afflicted by them, public health was low on the list of expenditures and even lower on the ladder of social priorities. The grand diseases that preoccupied dermatologists in these eras were smallpox, leprosy, and, most importantly, syphilis. To be sure, there were skin manifestations in almost all epidemic diseases, but the big push in dermatology was to figure out how to classify and differentiate among the common skin disorders, not fight epidemics.

Generally, environmental explanations of epidemics (miasma and its variations of sanitary movement initiatives) were more acceptable than contagion (germ theory) until later in the century.[12] Despite periodic sanitary commission reports, surveys of filth and infection, and monitoring of prostitutes and other sex workers, it is not until the early twentieth century that most of the components and professional groups associated with modern public health—such as publicly funded laboratories, public health nurses, public water and sewage systems, universal standards of compiling vital statistics, hygiene education carried out through schools, and the formation of federal food and drug and public health services—were put in place. The laboratories established in the 1890s concentrated on epidemic problems and milk contamination. Skin disorders never made the trifecta.

The reputation of public health officers improved over the course of the nineteenth century with the development of better microscopes, more accurate statistical methods, and cheaper printing techniques that allowed easier circulation of information. City inspectors eventually ceased to report through police departments. And beginning in the late 1870s, there was a growing belief that national, rather than local, strategies were needed to safeguard citizens' health. Bear in mind that throughout the nineteenth century, vital statistics were spotty, inconsistent, and generally unusable.[13] Getting good numbers was not a priority. John Shaw Billings finally got the attention of Congress in 1880, which resulted in the inclusion of vital statistics in census reporting. But health inspection of children on a regular basis by and large did not begin until the early twentieth century.[14]

Dermatology in the Nineteenth Century

Everyone in the late eighteenth century was itching, stinking, or shedding something or other from their bodies—or, at least, they would have been seen that way by today's standards. But these circumstances provided dermatology with the terminology and constancy in identification of disorders, without which developing dermatology as a coherent and teachable subspecialty was impossible. Consequently, most of the first ink expended on dermatology was related to classification and how to look at skin. Physicians disagreed about the relation of skin eruptions to internal disease states and to the character of the person in whom eruptions were occurring. There were sporadic and heated exchanges about etiology, with predictably nationalistic overtones. In general, there was a need for scientific comprehension and the steps to get there took decades.[15]

There were competing and elaborate systems on how to differentiate disorders. Some physicians, following Daniel Turner in England, favored a topographical approach, preferring to differentiate by the location on the body where the disorder was most apparent. The revered Galen of Pergamon introduced this method in the second century AD. Galen simplistically divided the body into skin

disorders of the head, and everywhere else. This had obvious limitations. Over the centuries, physicians added more sectional detail. American Noah Worcester, though indebted to Willan, looked at the big picture. He divided the disorders in his dermatological volume, the first published in America, into two large groups: moist and dry. Scabies and favus were both moist diseases.[16] Physicians also employed a vast array of contradictory nomenclature.[17] Erasmus Wilson, a giant in the discipline in the mid-nineteenth century, pointed to the "multitude of terms" that contributed to the confusion and compared it to putting the names of the various diseases into a bag, shaking them up, and dumping them onto a chessboard, "so that several names should fall indiscriminately on each square."[18] Old and obsolete terms were still in circulation, like scalled head, milk crusts, salt rheum, and dry herpes. Until well past midcentury, physicians disagreed about the role of a person's constitution or predisposition, called diathesis, in skin eruptions.[19] Likewise, physicians argued over whether scabies sprang from within the body in spontaneous generation or came from without.

In Britain, Willan built a system around identifying the essential lesion at the height of disease (Figure 5.2). Willan's masterwork was first presented to

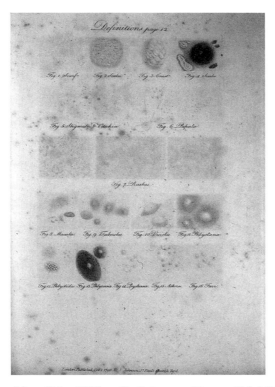

Figure 5.2. "Definitions" from Robert Willan, *On Cutaneous Diseases. Vol. I. Containing Ord. I. Papulae. Ord. II. Squamae. Ord. III. Exanthemata. Ord. IV. Bullae* (London: Johnson, 1808), vol. 1.

colleagues in 1790 and then published much later with thirty-three hand-colored copperplate engravings. This 1808 image of "Definitions" of lesions is a landmark graphic, though for content rather than visual style.[20] Willan's volume has few images of whole heads or bodies. He preferred isolated arms, forearms, and detached skin sections. For Willanists, who came to dominate dermatology in the first half of the century, the lesion's appearance (morphology) was the basis for classification.[21] Willan described 8 disorders and 119 diseases. By way of comparison, today there are over 2100 separate skin diseases.[22] His system revolutionized dermatology—or, more accurately, it created dermatology, because he was the first to impose an order (albeit an inaccurate one) that could be replicated and used by other physicians.

By the mid-nineteenth century, with better microscopes and the development of pathology and knowledge of etiology, physicians realized that lesions that looked alike might not have anything else in common. Moreover, a disorder might fit into several different classes because the lesions changed as the disease progressed. Consequently, classification based on pathological anatomy began to rival Willan's system. Wilson was a great proponent of physiological classification and drew attention to the layer of skin that was disturbed.[23] The drawback to Wilson's schema, however, was that a physician needed to know a lot of science and be trained in that style of medicine to be able to diagnose using his method. It was more accurate than Willan's, but much harder to use if uninitiated. There was also the problem, found in every classification scheme, that several microstructures—and not just one—might be involved. In Vienna, Ferdinand von Hebra (1816–1880), another giant in nineteenth-century dermatology, also classified disorders according to their pathological anatomy, and trained numerous international students.

The main contemporary rival to Willan's system, and one that only two or three scientists ever truly embraced because it was virtually impossible to use, was that of Jean-Louis Alibert (1766–1837), a skin specialist at the l'Hopital Saint-Louis in Paris.[24] Using what he called a "Natural System," Alibert began by grouping all skin disorders into one large category, called dermatoses. He then identified twelve branches or subgroups to his dermatoses tree. In explaining the logic behind his system, he compared his "natural" method to the organic action of plants; plants reach into different places and are as dispersed as the leaves on a tree. Alibert had a brilliant eye for observation and apparently exhibited an unparalleled lecture room showmanship. The problem was that his system was so uniquely his own, grounded in his personal quirks and preferences, that his colleagues and students were unable to use it with much success. He described disorders vividly and accurately, but they slid from category to category. His classifications reflected a streaming process of discernment, not a particular, codified system.[25]

Most dermatologists, too practical to be distracted by dogmatism, appropriated aspects from all of these competing and overlapping systems. Today, dermatologists have settled upon a comingled system in which several factors are considered: the location of the lesion on the patient; where the lesion originates within the structure of the skin; the lesion's etiology; and how the lesion appears through superficial observation. Around 1970, the acronym TEMF was introduced as a way to remember the critical aspects of topography, etiology, morphology, and function. Exactitude is still somewhat elusive, and, more than other subspecialties, dermatologists seem to accept the paradox that every case is both unique and yet also falls within a predictable set of epidermal possibilities.

Frameworks for Viewing

The physicians who studied favus and scabies and those who diagnosed them labored within the ambiguous circumstances of dermatology and public health described so far. A closer look at these two different and distinctly identifiable diseases through their graphic record reveals how physicians employed visual understanding in times of rapid change and uncertain transition. Favus is a striking (in both sight and smell) and contagious disease that has largely disappeared from first-world countries. Scabies is a highly contagious disease that is still a relevant public health problem, especially in poorer countries, nursing homes, and schools.

More than merely the prevalence of scabies and favus has changed over the last two hundred years. Visual cues and comprehension of medical images have shifted, too. Artists, under the direction of dermatologists, created images for textbooks during a time when people did not experience either the skin or their bodies in the same way as people do today. For one thing, these images were made in the years before skin was breeched for therapeutic or cosmetic alteration. Even successful restoration of injured body parts was decades away. The people inhabiting the skin in the illustrations never thought to protect their skin from aging, sunlight, pollution, or the elements. Nor was skin part of a vast consumer marketplace; a little arsenic was all a lady needed. Surgery was for wounds and other basic repairs. Otherwise, practitioners roamed only the skin's surface.

Diagnosis was the all-important mechanism of producing order, and observation was the most critical step in the diagnostic procedure. Practitioners approached diagnosis as both science and art.[26] By midcentury, they had a smattering of instruments, such as clinical thermometers, specific gravity bottles, an occasional hypodermic syringe and stethoscope, and microscopes. Besides using atlases and fugitive photographs, physicians drew upon a variety of methods to study skin diseases. Some universities had research collections with specimens, plaster and wax casts, tactile models, and drawings. Wilson, for instance,

frequented the Hunterian Collection, opened in 1869 at the Royal College of Surgeons in London, and employed its resources to examine scabies mites mounted for the microscope, dermatological watercolors, and plaster casts of infected hands.[27] But the senses still reigned in the art of diagnosis. Practitioners relied upon touch, smell, hearing, and sight. The new technologies were designed to assist the senses in their work. Skin diseases activated the diagnosticians' senses like the food that excited the patricians' senses at a Roman feast. The viscous crusts of favus, for example, smelled to high heaven. Physicians likened the odor to cat urine or mice nests. A limitation of the images was how they flattened the sensual surround in which physician and patient interacted. The smells are even further removed from viewers in the antiseptic twenty-first century. Modern viewers study the plates in climate-controlled libraries and other aesthetic environments filled with floral-scented room fresheners and the odor of cleanliness.

These images help to capture the training in observation that all physicians constantly sought. For example, in writing about general symptoms, Duhring, the first full-fledged American dermatologist and professor of diseases of the skin at the University of Pennsylvania, described what students needed to notice about what he called "eruptions." He first explained that eruptions referred to all the lesions present in a case, and that they could be uniform, multiform, isolated (that is, discrete), or confluent. Duhring then drew attention to the form of the lesions, which could be the size of a pinhead, and either pointed or shaped like a pea or bean.[28] Because descriptions such as Duhring's required illustrators to capture that level of detail, physicians often made their own drawings and photographs or worked closely with an artist and printer.

Atlases are unusual because they present the surface of the skin and an actual patient rather than a close-up or microscopic view of the eruption or patch in isolation. At the diagnostic level, nineteenth-century skin doctors wanted to understand what they observed with their eyes rather than with a microscope (although by the 1880s most were using microscopes to examine skin sections), and the large atlases served that purpose best. For these reasons, color played a central role in understanding the eruptions. Most authors monitored the meticulous coloring of the plates.[29] Each plate represented the decision of the physician-author about which stage of the disease to depict. The color of an eruption varied with the stage of the pathological process (Duhring found inflammations the "most striking").[30] The color might originate in the crust or the epidermis or be affected by heat, irritation, or treatment. Blue one day might become vermillion the next and crimson an hour later.

Since the images represented a step in the diagnostic process, their intended audience was small and highly selective. Laypersons and the general public never saw them. The illustrated volumes were produced during a time when information did not circulate freely; professions did not intermingle at the textbook level.

The images were a method to share what was seen and used as a strategy to create agreement about it. Consequently, the images were used by physicians alone, unlike today when anyone with a library card or Internet access can view them. The volumes were large (two feet by one and a half feet and more) and expensive, which also limited their availability. Authors swapped images with one another, sometimes never having seen an actual case of the disease themselves. Willan's beautiful hand-colored copperplate engraved illustrations appeared with modifications and slowly disappearing details in many other publications. For example, Worcester's octavo volume, the first American dermatology text, contained sixty color plates that he culled and edited from Willan and Bateman, Alibert, Ricord, and others. Worcester taught at the Medical School of Ohio and was not a skin specialist. This may explain why his images, such as the one in Figure 5.3, were more economical than von Hebra's or Alibert's. The patches of skin in the plate show little individuality, and it is likely that the details of his images were as inscrutable to many viewers in their day as electron microscope images are in ours. The circulation of plates and images, sometimes across

Figure 5.3. Scabies, acne, and other disorders from Noah Worcester, *A Synopsis of the Symptoms, Diagnosis, and Treatment of the More Common and Important Diseases of the Skin* (Philadelphia: Thomas Cowperthwait, 1845), Plate II.

decades, adds another caution to historians hoping to understand the relationship among image-maker, subject, and viewer.[31]

Lastly, for most of the century, the images were created to clarify classification. Elite physicians, such as Willan, Alibert, and von Hebra, were consumed by the formal classification of skin disorders. Accordingly, each illustration was intended to exist within an orderly universe and through relationship to large and small groupings (Linnaeus was the benevolent, if distant, godfather of their collective work). As soon as they saw a patient, however, most physicians witnessed the order used by any particular author fall apart. And the more one tried to reconcile systems, the more inscrutable things became. A. R. Robinson, a late-nineteenth-century skin specialist at the New York Polyclinic, complained that the classification "adopted by the American Dermatological Association was decided by balloting, and never should have seen the light of day."[32]

The disarray created by the competing classification systems was reflected in the different forms and styles that illustrators adopted to create medical images. Since there were no conventions specifically coded to the visual language of dermatology, the conventions used in the illustrations were those of art painting and engraving. Dermatology was not a rigid visual regimen, so the images vary in techniques of foregrounding, the addition of details not to scale (for example, a much-enlarged itch mite might appear beside a disembodied arm), and the presence of clothing (some wear outer garments, some have undergarments—today, patients depicted in medical illustrations are virtually all unclothed). For these dermatologists, art—and not medical science—laid the visual ground rules.

A closer look at images of scabies reveals the visual and medical forces at work. Scabies has gone by several names: the Greeks called it "psora," while in France it was known as "la gale." Wilson in England called it "the Gentle Stranger." Most knew it simply as "the itch." The itch mite is not the same as lice (also known as crabs or pediculosis) or chiggers, ticks, fleas, or bedbugs. Scabies is a skin disorder caused by an infestation of *acarus scabiei,* also called sarcoptes.[33] When the itch mite burrows into the skin, it produces a tiny papule or vesicle where it enters.[34] The distinctive thing about scabies is the itch, which is especially bad at night when warm in bed. Wilson claimed the scabies itch was not as bad as other prurigos. In fact, he claimed that "it is so far bearable, that a royal authority, James the First, is said to have remarked that the itch was fitted only for kings, the scratching being so exquisite an enjoyment."[35] With respect to its prevalence in the mid-nineteenth century, von Hebra reported that most of the disorders he saw at the skin clinic in Vienna were scabies cases. In his first year there, he saw 2700, of whom 2200 were scabies cases.[36] At the Philadelphia Dispensary for Skin Diseases, 9 percent of the people who sought help from the clinic in 1891 were treated for scabies.[37]

Many dermatologists have been interested in scabies, and its history is well documented.[38] Two chroniclers described its history as a "tale in which talented men located the mite and inept successors mislaid it."[39] Practitioners had much to figure out: did the disorder arise from within the body, for example, or from without? What role did the itch mite play in the affliction? How did one differentiate the pustule from the mite and the scratches of the afflicted? Was the mite in the vesicle or somewhere else? How was it passed along? And was the mite a cause or an effect? For much of its existence, observers had noted that mothers and old women—especially if Corsican—were adept at removing the pinhead-size mite from under the skin with a needle. But the significance of the mite remained disputed. Many writers conflated scabies and *pediculi* (lice) and occasionally mistook blackheads for scabies. Others thought they were produced by syphilis.[40] Confusion and disagreement continued until the 1830s.[41] Figure 5.4 depicts the life cycle of the mite, and is interesting for several reasons. The artist drew the mites with precision, using order and symmetry to place them around the central burrow drawing. Within the burrow, however, disorder reigns as the female cuts her ragged way along a meandering path, dropping eggs and feces in her wake. Inside the burrow, there is barely containable activity; outside, there is fixity and assurance. The burrow tableau is excerpted from its human location, depicted within a patch of skin in isolation. The well-defined life cycle reinforces the belief that knowledge produced through scientific study yields certainty and control.

Once the acarus was shown to precipitate scabies rather than be a mere camp follower of the lesions, it achieved widespread fame and scientific adulation.

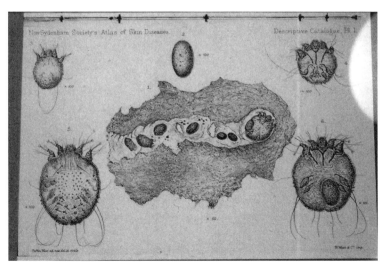

Figure 5.4. The itch mite and its burrow from Jonathan Hutchinson, The New Sydenham Society, 1869. *A Descriptive Catalogue of the New Sydenham Society's Atlas of Portraits of Diseases of the Skin. Pts. I and II* (London: New Sydenham Society), part 2, plate 1.

Wilson wrote a passage about the beauty and elegance of their "marvelous feet" that would have made a Freudian's pencil fly across the page.[42] The artist included a close-up detail of the suckers at the tip. Wilson noted that the itch mite had caused so "much inkshed *[sic]* throughout the civilized world," that she was "like another Helen."[43] Wilson maintained his anthropomorphic rhapsody to the scabies mite through much of his writing, calling it a "little brigand," and a "little marauder."[44]

Scabies has been typically understood as a disease of intimacy. Today it is considered one of the sexually transmitted diseases. Since the mites get particularly active when their environment is warm, pressing the flesh is a bugle call to arms. Alexander Squire circulated a photograph of the hand of a twenty-year-old girl who caught it from sleeping with another girl.[45] Duhring included a plate of a sixteen-year-old rope-maker who got it from a boy with whom he had slept. The youth had it on his arms, legs, trunk, penis, and scrotum.[46] Henry Piffard recommended that, in diagnosing scabies, the physician look at the hands first and then the penis, belt line, and axilla. The attending physician should also inquire whether others have slept with the patient or worn his clothes, a trail that would surely lead to more eruptions.[47] Remember, too, that these were syphilis doctors who looked at the skin and its visitors, human and other. The easy intimacy among strangers and acquaintances throughout the nineteenth century was different from our sense of personal space and etiquette. In the nineteenth century, convenience, not intimacy or acquaintance, was the prerequisite for sharing a bed for sleep or donning soiled clothes.

Figure 5.5 shows a plate from von Hebra's 1875 *Atlas*. Von Hebra was a member of the New Vienna School, known for its faculty who opposed humoral theory and who were pioneers in pathological anatomy. Von Hebra preferred lesions and skin sections viewed under the microscope. According to his son-in-law, Moritz Kaposi, the man for whom the sarcoma lesion is named, von Hebra's hours of squinting paid off handsomely when he once observed through the microscope a male and female itch mite copulating, thereby making him a uniquely privileged observer. The story also reinforced his prowess with a lens.[48]

Favus, another contagious disease, further illuminates the issues of representation and medicine presented by scabies. It was also known to the ancients. It is a type of *tinea capitis* (also known as porrigo, scall head, teigne, and *tinea tonsurans*) or ringworm of the scalp, caused by one of several trichomycoses. It has never been very common in North America but was once widespread in Europe. Today, it is mostly found in South Africa and the Middle Eastern countries. It is similar in presentation to impetigo, ecthyma, and crusted scabies.[49] It has a unique yellow sulphur color and cup-shaped crust. When the crusts mass together they look like honeycombs and are very uncomfortable. Alibert reported, however, that his patients enjoyed a "voluptuous pleasure in scratching their hair with their nails."[50] Favus has a distinctive, disgusting odor, reminiscent of wet mice,

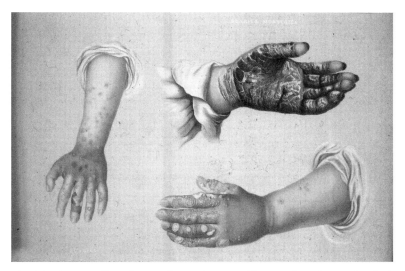

Figure 5.5. Scabies from Ferdinand von Hebra and Anton Elfinger, *Atlas of Portraits of Diseases of the Skin* (London, 1860–1875), plate XXVII.

damp straw, or cat urine. When left untreated, the disorder can become chronic and last for years or a lifetime. In the nineteenth century, it usually began in childhood and was associated with poverty, and in the United States, with "foreigners."[51] When the parasite was discovered in 1839, it was the first cryptogam (fungus) found that caused disease.[52] Until the second half of the nineteenth century, *tinea favosa* was thought to be intractable once it reached an advanced stage. Today it is easily treated with the antifungal drug, griseofulvin. As with scabies, having favus could exempt a person from certain obligations and duties. For example, French draft dodgers reportedly put nitric acid on their scalps to mimic the crusty yellow lesions and avoid military service.[53] In the 1910s and 1920s, students were excluded from class who had either scabies or favus.[54]

Willan in 1814 wrote that although the Arabic term "tinea" was often used, he preferred the more familiar Latin, "porrigo."[55] Willan also explained that the sores eventually covered the head and "when the coverings or dressings of the head are removed, a sour, rancid, vapour is exhaled, which affects very disagreeably, both the eyes, and the organs of smell and taste, in persons who examine or dress the patient."[56] Decades later, although Willan's descriptions remained accurate, his drawing did not. In 1877, Tillbury Fox reworked Bateman and Willan's 1840 volume. Fox was an obstetrician turned dermatologist who, along with Wilson, dominated British dermatology. He used many of the plates from Bateman and Willan's original volume but made changes that reflected newer understandings. For example, he changed the name of one plate from *porrigo favus* to *impetigo rodens* (a severe ulceration), noting that he believed that Bateman had never actually seen a case of ulceration and that is why he had mistaken it for favus of the face.[57]

Alibert, using his Natural System, described two kinds of favus: vulgaire or urceole (urn-shaped), seen in Figure 5.6; and scutiform or cup-shaped.[58] Duhring described the case, seen in Figure 5.1, of a thirty-year-old laborer, "small stature, spare and frail, and is dull of comprehension, patient has had scalp condition all of his life. About 10 years ago, it spread to his thighs, legs, arms, hands. His scalp has a musty odor like stale straw or mice."[59]

Figures 5.1, 5.6, and 5.7 also illustrate yet another riddle of these portraits. What are modern viewers to make of the facial expressions depicted? Barbara Maria Stafford has pointed out the serenity of the subjects of these portraits.[60] She interprets the tranquility of the subjects' expressions as imitations of religious portraits of suffering. Their expressions might also be read as sardonic, clenched in pain, or averted by shame. But they can also be read as showing no visible demonstration of emotion. The physiognomic significance of the human face was certainly known to these physicians. Interior psychological life had a strong place within middle-class culture, and it was popularly believed that it was expressed though physiognomy. Until the mid-1800s, physicians on their part, believed the

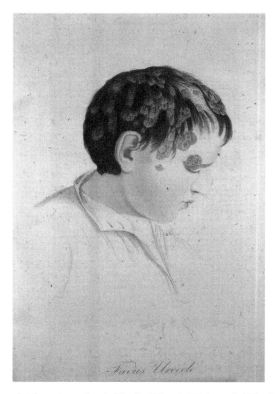

Figure 5.6. "Favus urceole" from Jean-Louis-Marie Alibert, *Clinique de l'Hopital Saint-Louis; ou, Traite complet des maladies de la peau, contenant la description de ces maladies et leurs meilleurs modes de traitement* (Paris: Cormon et Blanc, 1833), plate 17.

majority of skin diseases to be the result of dyscrasis, that is, a disordered internal humoral balance, producing such things as impurities in the blood (laxatives and antimony were popular treatments). Diathetic concepts of disease etiology—that is, the idea that constitutional tendencies or pre-dispositions were activated by external forces—had not yet been supplanted by germ theory. The cause of disorder could be food, grief, anxiety, filth, heredity, or contagion. In 1829, Samuel Plumbe emphatically rejected the idea that *porrigo favus* was an external disease.[61] Since he believed that it was caused by "deranged digestive organs" and was always constitutional, it required internal remedies. Worcester likewise treated skin afflictions with bleeding and cathartics as well as dressings and sulphur baths.[62] The idea that skin eruptions, ulcers, and such were due to impurities in the blood dominated for decades—indeed, von Hebra was one of the first to question and then reject constitutional explanations. What external impression did these internal states produce?

These portraits of patients capture the intangible relationship between surface and depth, inside and outside, accessible only through the indirect means of art. Perhaps they reflect no more than the human exhaustion and resignation of enduring the crusty masses and an itchy state of affairs. Or the physicians may have wished to capture a phase of the disease, depicting the frozen moment through a motionless expression on the patient's face. They are people with disease, co-habiting the visual space. The foregrounding of pathology and the disintegration of the person's individuality into a "case" is still a couple of generations away. Certainly, their expressions allow us to impute a variety of explanations and

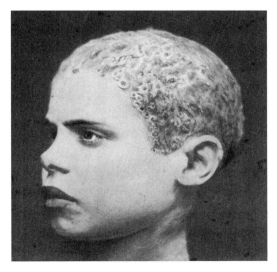

Figure 5.7. "Favus," from Alexander Balmanno Squire, *Photographs, Colored from Life, of the Diseases of the Skin* (London: J. Churchill, 1865), p. 7.

interior states to them.[63] But in the end, the portraits are enigmas. For these physicians, the skin was an integument or covering that "completely invests the body,"[64] the "exterior investment of the body, which it serves to cover and protect."[65] They used descriptive language to create order out of the chaos they observed on a patient's skin. The magnificent atlases were testaments to the futility of their words. The atlases they created overpowered their words and put the whole body on view. Their purpose was both to create knowledge where there was none and to provide a means for physicians to compare their experiences with those of others. Duhring put it simply: "To know cutaneous diseases it is necessary to see them."[66]

Notes

1. Readers need not be kept in suspense. A wheal, also called pomphi, is a primary lesion, usually temporary, and also hot and tingling, such as in a bug bite, hives, or a lash with a whip, or, as Louis Duhring explained, "elevations of a fugitive or ephemeral character." Louis Duhring, *Cutaneous Medicine: A Systematic Treatise on the Diseases of the Skin* (Philadelphia: Lippincott, 1895), 79.

 Blebs, also called bullae, are primary lesions a bit more involved than wheals. Blebs have transparent fluid inside, such as in blisters. Yuke and psora are variations of itches. Eczema, probably the most common skin disease of the nineteenth century, was called psora, for example.

2. The standard overviews of the field are by Crissey and Parish, to whom I owe an enormous debt for their lucidity about issues that seemed incomprehensible as I began to read through primary sources; John Crissey and Lawrence Parish, *The Dermatology and Syphilology of the Nineteenth Century* (New York: Praeger, 1981); John Crissey, Lawrence Parish, and K. Holubar, *Historical Atlas of Dermatology and Dermatologists* (Boca Raton, Fla.: Parthenon Publishing Group, 2002). See also Herman Goodman, *Notable Contributions to the Knowledge of Dermatology* (New York: Medical Lay Press, 1953).

3. S. C. Griffith, *A Short Dissertation on Skin Disease* (London: Saunders Bros, 1861), 3.

4. Michael Albert and Bonnie Mackool, "A Dermatology Ward at the Beginning of the Twentieth Century," *Journal of the American Academy of Dermatology* 42 (2000): 113.

5. See for examples, Andreas Vesalius, *De Humani corporis fabrica* (1543), Gerardus Mercator, Atlas of Europe (c. 1570), and John James Audubon, *Ornithological Biography, or an Account of the Habits of the Birds of the United States of America* (Philadelphia: E. L. Carey and A. Hart, 1832).

6. Barbara Maria Stafford places Alibert's graphic masterwork within the context of the theology of the fall from grace, grounded in his Catholicism and elite connections as king's physician for several years. See Barbara Maria Stafford, *Body Criticism: Imaging the Unseen in Enlightenment Art and Medicine* (Cambridge, Mass: MIT Press, 1991), 302.

7. Louis Duhring (1845–1913) practiced in Philadelphia starting in 1876, after studying for a time in Europe under Ferdinand von Hebra and others. For more on Duhring, see Lawrence Parish and Donald Pillsbury, *Louis Duhring, M.D.: Pathfinder for Dermatology* (Springfield, Ill.: Charles C. Thomas, 1967).

8. The term *scabies* comes from the Latin word for digging, scab, and mange. In France, the disease was called gale, from the Latin word meaning to cover with a helmet. Eczema and

psoriasis were other types of gale. Scabies was also a kind of porrigo, again from the Latin, meaning stretching out and extending. The Latin origin of favus is the word for honeycomb, because of its cup shape and yellow color. Favus was also called tinea (from the Latin for grub or worm) and sometimes porrigo, too. See Robley Dunglison, *A Dictionary of Medical Science* (Philadelphia: Blanchard and Lea, 1860), 377 ("Favus"), 822 ("Scabies").

The terms for these and other diseases were fluid throughout the first half of the nineteenth century, causing consternation among many practitioners. An exasperated Erasmus Wilson complained that "porrigo" was used for so many contradictory conditions that the term should be discarded completely. See Erasmus Wilson, *A Practical and Theoretical Treatise on the Diagnosis, Pathology, and Treatment of Diseases of the Skin* (London: John Churchill, 1842), 178.

In older French texts, the term *dartres* is used in conjunction with both scabies and favus. *Dartres* referred to a general, chronic skin disease, but the term disappeared from the medical literature in the 1830s.

9. This discussion of nineteenth-century public health is based largely upon Martin Melosi, *The Sanitary City: Urban Infrastructure in America from Colonial Times to the Present* (Baltimore: The Johns Hopkins University Press, 2000); Ralph Chester Williams, *The United States Public Health Service, 1798–1950* (Washington, D.C.: Commissioned Officers Association of the United States Public Health Service, 1951); James Tobey, *The National Government and Public Health* (Baltimore: The Johns Hopkins University Press, 1926); George Rosen, *A History of Public Health* (New York: Publications, 1958); Mazyck Ravenel, ed., *A Half Century of Public Health* (New York: American Public Health Association, 1921); Wilson Smillie, *Public Health: Its Promise for the Future* (New York: Macmillan, 1955); Barbara Rosenkrantz, *Public Health and the State: Changing Views in Massachusetts, 1842–1936* (Cambridge, Mass.: Harvard University Press, 1972); Bess Furman, *A Profile of the United States Public Health Service, 1798–1948* (Bethesda, Md.: National Library of Medicine, 1973).

10. For example, in 1840, there were only fifty city waterworks in the United States. Brooklyn built sewers in 1857. See Maureen Ogle, *All the Modern Conveniences* (Baltimore: The Johns Hopkins University Press, 1996), 10.

11. See for example, Edwin Chadwick's influential *Report on the Sanitary Condition of the Labouring Population of Great Britain, 1842*, ed. M. W. Flinn (Edinburgh: University Press, 1965) or John H. Griscom's *Sanitary Condition of the Labouring Class of New York, 1845* (New York: Arno Press, 1970).

12. Miasma was the theory that disease was produced by decaying animal and vegetable matter; miasma resulted from particularly ripe atmospheric conditions, or it percolated up from the ground. As the idea of contagion and then germ theory and bacteriology displaced miasma, the emphasis of public health shifted from control of the environment to control of specific diseases, through isolation, immunization, and disinfection.

13. Massachusetts had the only continuous, reliable state statistics before 1900. Edward Meeker, "The Improving Health of the United States, 1850–1915," *Explorations in Economic History* 9 (1972): 355.

14. Milestones in public health, for context, include Edwin Chadwick's ground-breaking 1848 Public Health Act in Britain; Lemuel Shattuck's collection of vital statistics in Boston in the 1840s followed in 1851 with his Boston Sanitary Report; U.S. Sanitary Commission activities during the Civil War; Mary Livermore's 1863 Chicago Sanitary Fair; the Metropolitan Health Law in New York City in 1866; the founding of the American Public Health Association in 1872; and establishment of the National Board of Health in 1878 in wake of a yellow fever epidemic (its duties were transferred to Marine Hospital Service in 1893, and it eventually

became the U.S. Public Health Service). But also note that the variety of what today is considered public health work was not consolidated until the creation of the Department of Health, Education, and Welfare under Eisenhower in 1953.

15. Some nineteenth-century reference points in the history of American dermatology include: opening of the New York Infirmary for Diseases of the Skin in 1836; New York's Broome Street Infirmary for Diseases of the Skin opened the following year (1837); Noah Worcester authored the first American textbook on skin diseases in 1845; James Clark White became the first lecturer in skin disease in 1863 (at Harvard); the *American Journal of Syphilography and Dermatology* began in 1870; Louis Duhring's dispensary opened in Philadelphia in 1871; the *Archives of Dermatology* started in 1874; the American Dermatological Association was founded in Philadelphia in 1876, the same year that Duhring published his *Atlas of Skin Diseases;* and finally, in 1887, the American Medical Association created a section on dermatology.

16. Noah Worcester, A *Synopsis of the Symptoms, Diagnosis, and Treatment of the More Common and Important Diseases of the Skin* (Philadelphia: Thomas Cowperthwait, 1845), 1–10.

17. From the vantage point of the end of the century, one observer characterized the early 1800s as "a maze of irreconcilable nomenclature." See Isaac Edmondson Atkinson, "President's Address, delivered before the American Dermatological Association at its twelfth annual meeting" (Boston, 1888), seven-page reprint distributed by American Dermatological Association, Boston, 1888. Crissey and Parish describe the years 1776–1850 as an era of classification and bringing order to the chaos. See Crissey, Parish, and Holubar, *Historical Atlas,* x–xx.

18. Erasmus Wilson, *Healthy Skin: A Popular Treatise on the Skin and Hair, Their Preservation and Management* (Philadelphia: Blanchard and Lea, 1854), 200–201.

19. Edwin Payne explained in his *Skin Diseases and Their Cure by Diathetical Treatment* (London: Henry Renshaw, 1862), 2, that local treatment of skin disorders was ineffective until the grasp of the diathesis was "unclenched."

20. Robert Willan, *On Cutaneous Diseases. Vol. I. Containing Ord. I. Papulae. Ord. II. Squamae. Ord. III. Exanthemata. Ord. IV. Bullae* (London: Johnson, 1808). Much credit should also be given to Willan's student, Thomas Bateman, who saw Willan's work through to publication and kept the Willanist torch lit long after the master's death.

21. Pre-Willan followers of this system included Riolanus (early seventeenth century) and Joseph Plenck (late eighteenth century) who identified 14 classes, with 115 disorders.

22. Robert Helmer, *Skin Deep* (Los Angeles: Nash Publishing, 1971), 2.

23. Jean Astruc (1684–1766) was one of the first to suggest this approach.

24. For more on Alibert, see Société des amis de Villefranche et du Bas-Rouergue, *Jean-Louis Alibert, 1768–1837: fondateur de la dermatologie française, médecin-chef de l'hôpital Saint-Louis, premier médecin ordinaire des rois Louis XVIII et Charles X, membre de l'Academie de médecine* (Villefranche-de-Rouergue: Société des amis de Villefranche et du Bas-Rouergue, 1987). See also Crissey and Parish, *Dermatology and Syphilology,* 40–47; Stafford, *Body Criticism,* 300–304.

25. Jean-Louis-Marie Alibert, *Monographie des dermatoses; ou, Précis théorique pratiques des maladies de la peau.* (Paris: Daynac, 1832), 1:lxii. Alibert began his career as a priest but had to find a new vocation when religious orders were outlawed in 1792. For modern nomenclature and classification, see Crawford S. Brown, ed., *SNODERM (Systematized Nomenclature of Dermatology),* (Washington, D.C.: American Academy of Dermatology and Syntex Laboratories, 1977).

26. A good presentation of this medical worldview is J. M. DaCosta, *Medical Diagnosis with Special Reference to Practical Medicine* (Philadelphia: J. B. Lippincott, 1864).

27. See Erasmus Wilson, *Descriptive Catalogue of the Dermatological Specimens Contained in the Museum of the Royal College of Surgeons of England Museum* (London: Taylor and Francis, 1875), v–vi.

28. Each shape had its own name: pin-headed was miliaris, pointed was acuminatus, and pea was lenticularis. Duhring, *Cutaneous Medicine*, 87.

29. Sadly, the vivid colors are lost in the black-and-white reproductions in this volume, but a less diluted sense of the originals can be found at the National Library of Medicine's graphics database: www.ihm.nlm.nih.gov.

30. Nearly all authors of general textbooks discoursed about color and diagnosis. Duhring's remark is from *Cutaneous Medicine*, 87.

31. For example, Robert Taylor thanks Squire, Hutchinson, von Hebra, Kaposi, and several others for their plates, in the preface to his *A Clinical Atlas of Venereal and Skin Diseases* (Philadelphia: Lea, 1889), i.

32. A. R. Robinson, *A Manual of Dermatology* (New York: D. Appleton and Company, 1885), 51.

33. For centuries, the genus of the mite was known as acarus. In 1831, French zoologist Pierre Latreille (1762–1833) renamed it Sarcoptes scabiei, after the Greek word for flesh-cutting. Many physicians resisted the new name, claiming that the mite bore rather than cut. See Herman Goodman, *Notable Contributions*, 119.

 The acarus, which can only live on human skin, is a tiny, whitish mite, the size of a pin-head, and travels by skin-to-skin contact, producing a pruritus, or itching. A dozen or so female mites burrow around the body, laying dozens of eggs apiece. There may be as many as one million mites in a rare crusted scabies infestation. The burrow is visible under the skin (through the epidermis and into the mucous layer) as a straight or zigzag elevation, up to 1/2 inch long. Multiform eruptions may exist, with scratch marks, pustules, eruptions, and crusts, making it sometimes hard to diagnose. The female burrows and lays eggs and leaves specks of excrement along the tract, to which the body continuously reacts.

34. For modern descriptions, see Thomas B. Fitzpatrick et al., eds., *Color Atlas and Synopsis of Clinical Dermatology: Common and Serious Diseases* (New York: McGraw-Hill, Medical Pub. Division, 2001), 834–41; and several chapters on scabies by various authors in Milton Orkin and Howard Maibach, eds., *Cutaneous Infestations and Insect Bites* (New York: Dekker, 1985).

35. Wilson, *Healthy Skin*, 214.

36. Ralph Major, *History of Medicine* 11 (Springfield, Ill.: Chas. C. Thomas, 1954), 783–84. William Pusey reports von Hebra's numbers as 2197 scabies cases out of 2723; William Allen Pusey, *The History of Dermatology* (Springfield, Ill.: Charles C. Thomas, 1933), 44.

37. Noted in Reuben Friedman, *A History of Dermatology in Philadelphia* (Fort Pierce Beach, Fla.: Froben Press, Inc., 1955), 229.

38. Herman Goodman did a survey of historical texts in dermatology and noted 114 writers who attempted to explain some aspect of scabies (Herman Goodman, *Notable Contributions*, 102). Reuben Friedman, the Boswell of scabies, wrote several books and many articles about the little itch mite and its history. See for example, Reuben Friedman, *Biology of Acarus Scabiei* (New York: Froben Press, 1942); Reuben Friedman, *The Emperor's Itch: The Legend Concerning Napoleon's Affliction with Scabies* (New York: Froben Press, 1940); Reuben Friedman, *Scabies, Civil and Military: Its Prevalence, Prevention, and Treatment* (New York: Froben Press, 1941); Reuben Friedman, *The Story of Scabies* (New York: Froben Press, 1947).

39. Crissey and Parish, *Dermatology and Syphilology*, 60.

40. Herman Goodman, *Notable Contributions*, 118.

41. Giovanni Bonomo (1663–1696) was probably the first to describe the mite, in a 1687 letter to the entomologist/physician Francesco Redi (1626–1694) For more on this, see Daniele Ghesquier, "A Gallic Affair: The Case of the Missing Itch-Mite in French Medicine in the Early Nineteenth Century," *Medical History 43* (1999): 26–54.

 In 1824, Alibert assigned one of his students, Jean Crysanthe Gales, to study the scabies mite. Gales claimed to be able to extract the mite with unfailing success, further proof of the mite's role in the disorder. A commission was appointed to study the assertion and found that the mite was truly there, and drawings were circulated of the creature. Problems quickly arose when others were unable to replicate Gales's demonstration. Furthermore, the image of the mite that accompanied Gales's work seemed identical to the familiar cheese mite and bore little resemblance to the acarus drawn by Baron De Geer in 1788. Accusations flew about fraud and manipulation. Gales did not respond and after counterdemonstrations and much theatrics, the mite lost favor as the cause of scabies—no one could recover it from within the lesion where Gales said it dwelled. The presence and importance of the mite was finally settled (for all but a few starchy geezers and a handful of spontaneous generation enthusiasts) in 1834, when Francois Renucci, another student of Alibert and native of Corsica, repeatedly demonstrated the extraction of the mite from the hands of a young woman. Renucci claimed to have learned the technique from observing peasant women doing the same with needles. Ernest Bazin (1807–1878) did a detailed study of the mite and determined it could be found all over the body and treated with sulphur ointment—radically improving hospital care of scabies patients.

42. Wilson, *Healthy Skin,* 214.

43. Wilson, *Practical and Theoretical Treatise,* xviii.

44. Wilson, *Healthy Skin,* 212–15.

45. Alexander Balmanno Squire, *Photographs, Colored from Life, of the Diseases of the Skin* (London: Churchill, 1865), scabies plate.

46. Louis Adolphus Duhring, *Atlas of Skin Diseases* (Philadelphia: Lippincott, 1876), plate Q.

47. Henry Granger Piffard and Robert M. Fuller, *A Practical Treatise on Diseases of the Skin* (New York: Appleton, 1891), 109.

48. For this anecdote, see Moritz Kaposi, *Pathology and Treatment of Diseases of the Skin: For Practitioners and Students,* translation of the last German edition under the supervision of James C. Johnston (London: Bailliere, Tindall and Cox, 1895), 652.

49. Fitzpatrick et al., *Color Atlas and Synopsis,* 700–705.

50. Jean-Louis-Marie Alibert, *Description des maladies de la peau: observées a l'Hôpital Saint-Louis, et exposition des meilleures méthodes suivies pour leur traitement* (Paris: Chez Barrois l'aine et fils, 1806), 2. Translation by the author.

51. Jay Schamberg, *A Compend of Diseases of the Skin* (Philadelphia: P. Blakiston's Son and Co., 1905), 146.

52. Agostino Bassi (1773–1857) an early experimenter in bacteriology who worked on vegetable parasites, helped point the way to discovery of the *Achorion schoenleinii* in 1839. See Herman Goodman, *Notable Contributions,* 125.

 Dermatophytes are a group of fungi that stay on the surface of the skin and do not cause systemic infection. They are epidermotropic, meaning that they need skin and its append-ages, such as hair, for survival. There are three genera, Microsporum, Trichophyton, and Epidermophyton. Johann Lukas Schönlein found the first one in 1839, which caused favus, and it was named for him in 1845: *Achorion schoenleinii.* By the 1950s, genera *Achorion* had been folded into the genus *Trichophyton* (which had twelve species, including *T. tonsurans, and T. schoenleinii).* See Rene Dubos, ed., *Bacterial and Mycotic Infections of Man* (Philadelphia:

J. B. Lippincott Co., 1958), 614. See also Lucille Katherine Georg, *Animal Ringworm in Public Health: Diagnosis and Nature* (Washington, D.C.: U.S. Communicable Disease Center, 1960), Public Health Service publication no. 727, 2.

53. Crissey and Parish, *Dermatology and Syphilology*, 96.

54. Alan Kraut, *Silent Travelers: Germs, Genes, and the "Immgrant Menave"* (New York: Basic Books, 1994), 241, 273. U.S. immigration inspection officers were on the lookout for favus, too. According to their 1903 manual, *Book of Instructions for the Medical Inspection of Immigrants,* there was mandatory exclusion of Class A "loathesome diseases," which included favus, syphilis, gonorrhea, and leprosy.

55. Robert Willan (posthumous), *A Practical Treatise on Porrigo, or Scalled Head, and on Impetigo, the Humid, or Running*, ed. Ashby Smith (London: Cox, 1814), 3.

56. Willan, *Practical Treatise on Porrigo*, 24.

57. Tilbury Fox, *Atlas of Skin Diseases, Consisting of a Series of Coloured Illustrations Together with Descriptive Text and Notes upon Treatment* (London: Churchill, 1877), 35.

58. Jean-Louis-Marie Alibert, *Clinique de l'Hôpital Saint-Louis; ou, Traité complet des maladies de la peau, contenant la description de ces maladies et leurs meilleurs modes de traitement* (Paris: Cormon et Blanc, 1833), 2–3.

59. Duhring explained that the crusts (friable crusts) can be raised from their bed without difficulty because they are superficially seated. Louis Adolphus Duhring, *A Practical Treatise on Diseases of the Skin* (Philadelphia: Lippincott, 1877), 529–31.

60. Stafford, *Body Criticism*, 93, 283. See also Sander Gilman, *Disease and Representation: Images of Illness from Madness to AIDS* (Ithaca, N.Y.: Cornell University Press, 1988), 2–3.

61. Samuel Plumbe, *A Practical Treatise on the Diseases of the Skin, Arranged with a View to Their Constitutional Causes and Local Characters; and Including the Substance of the Essay on These Subjects to which the Royal College of Surgeons Awarded the Jacksonian Prize* (London: Nimmo, 1829), 158–59.

62. Worcester, *Synopsis*, 24.

63. Note also that the subjects usually wear street clothes or undershirts (patient gowns were decades in the future), suggesting both autonomy and that the image was captured in the midst of the person's daily life, a life in which visiting the doctor was a fleeting experience.

64. Duhring, *Cutaneous Medicine*, 1.

65. Wilson, *Practical and Theoretical Treatise*, 1.

66. Louis Duhring, *Atlas of Skin Diseases*, ii.

6. *Maps as Graphic Propaganda for Public Health*

MARK MONMONIER

SCHOLARLY TREATMENTS OF THE USE OF MAPS in medicine and public health typically focus on the map's role as an exploratory or confirmatory tool for scientific research.[1] The classic example, heavily promoted in epidemiology and geography, is John Snow's map of cholera cases clustered around London's infamous Broad Street Pump during the epidemic of 1854 (Figure 6.1).[2] According to medical (and geographic) folklore, Snow suspected waterborne transmission of the disease but

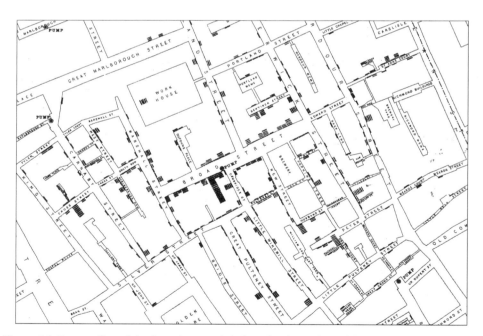

Figure 6.1. Excerpt from John Snow's map of cholera deaths in the Golden Square area in Soho during the London cholera epidemic of 1854. From John Snow, *On the Mode of Communication of Cholera* (London: J. Churchill, 1855), map between 44 and 45. History of Medicine book collection, National Library of Medicine.

lacked proof until he made a detailed plot of victims' residences. With his map as evidence, the good doctor convinced local officials to remove the pump handle, thereby halting the epidemic.[3] Skeptics of the myth point out that the epidemic had largely run its course by the time the pump was disabled, and that Snow made his fabled map for the second edition of a 1849 book laying out his thesis on waterborne transmission.[4] What's more, the map was largely buried in the epidemiological literature until the 1930s, when Wade Hampton Frost, who taught epidemiology at Johns Hopkins, promoted the book's reprinting and touted Snow's methodology as a prototype of bacteriological thinking.[5] Ostensibly crafted as a tool for pattern analysis, the cholera map became an instrument of cartographic propaganda.

In examining the role of maps in public health, this essay argues that maps are inherently more effective, if not more common, as persuasive graphics than as research tools.[6] As I will demonstrate, even when authors of disease maps assert an exploratory or scientific intent, their maps and atlases serve to promote an organization, a particular viewpoint, or (more broadly) public awareness.[7] Moreover, even those maps ostensibly intended to describe public health facilities or summarize programs of disease surveillance have a dual role that is at least partly persuasive. Indeed, any graphic that attracts viewers' attention with the likely result of making them more aware of a threat or a campaign is propaganda insofar as it contributes to an increased awareness or resolve that might ultimately trickle down to local officials and the public.

A case in point is the large-scale frontispiece map accompanying a fourteen-page booklet in which physicians William Berry and F. C. Wilson describe an 1873 cholera episode that killed thirty-three people in Lancaster, Kentucky. The authors characterize the town's "sanitary condition" as "wretched"; note that streets, alleys, stables, and privies were not properly cleaned; and use numbers on the map to identify victims' residences.[8] Although the spatial pattern is not as clustered and convincing as Snow's, the map clarifies the narrative and at least indirectly promotes awareness of poor sanitation as a contributing factor.

Another, even earlier disease map is the detailed plot of yellow-fever deaths during an 1819 outbreak in New York City (Figure 6.2). Titled "A Map of [the] Old Slip and Infected Vicinity," and compiled by Félix Pascalis-Ouvière, a local physician working for the Board of Health, the map identifies victims' homes by number, shows a sewer line contributing to the pollution around the "Old Slip," and pinpoints four gates or barriers controlling access to the area from which vessels were to be removed, houses inspected for contamination, and lots cleansed with quicklime.[9] Although map and book presage John Snow's systematic approach, neither received lasting recognition. Pascalis-Ouvière had used a map to demonstrate spatial concentration, but he attributed the deaths to miasma (bad air), an obsolete theory embarrassing to twentieth-century epidemiologists.

Figure 6.2. Map of "The Old Slip." Félix Pascalis-Ouvière, *A Statement of the Occurrences during Malignant Yellow Fever, in the City of New York, in the Summer and Autumnal Months of 1819, and of the Check Given to Its Progress, by the Measures Adopted by the Board of Health* (New York: William A. Mercein, 1819), folded map bound in opposite the title page. History of Medicine book collection, National Library of Medicine.

Arguments for the importance of propaganda maps in public health must distinguish between external propaganda, intended for the general public, and internal propaganda, intended for health practitioners, administrators, and other insiders. Whether a propaganda map is principally internal or external is usually apparent in its design and mode of publication. All three maps previously cited were intended for informed citizens, not the public at large, and are thus internal. Only Snow's map attained wider recognition as an emblem of methodologically precise epidemiology and socially effective graphic analysis.[10] And in this role, it was typically simplified and condensed into a page-width dot map.[11]

Noteworthy examples of maps intended to promote insider awareness include the various disease atlases produced by the Public Health Service and the National Institutes of Health using county-unit data and computer-assisted cartography. The first was the *Atlas of Cancer Mortality for U.S. Counties: 1950–1969,* by the National Cancer Institute.[12] To minimize sources of variation, the authors focused on the white population, produced separate maps for males and females, and adjusted mortality rates for geographic differences in age structure.[13] To dampen temporal noise they calculated twenty-year averages, and to reduce the problematic effects of small numbers they incorporated a test for statistical

significance in their classification and mapped less common diseases using state economic areas (SEAs), which have larger populations than counties and yield more reliable rates for less common categories. Although the introduction opined that "the maps should serve to identify counties, or clusters of counties, with elevated cancer rates which in turn may provide etiological clues," there were few epidemiological revelations, largely because even site-specific cancers are highly complex.[14] The most notable hotspots apparent in the atlas are areas like coastal Georgia, which had relatively high rates of lung cancer among males, believed to be related to the employment during World War II of large numbers of local residents in shipyards, where poorly ventilated work spaces were often laden with asbestos fibers, and areas like central North Carolina, which had high rates of oral cancer among women, plausibly related to "snuff dipping."[15]

A more recent development is the *Atlas of United States Mortality* published by the Centers for Disease Control and Prevention (CDC) in 1996.[16] The authors' use of hospital service areas rather than counties not only acknowledges the causal role of health care but also makes the cartography more meaningful to health administrators. A noteworthy collateral benefit is the cartographic research of geographer Cynthia Brewer, a consultant on the project who developed a widely used series of subject-tested color schemes for statistical maps as well as useful insights on classification techniques appropriate for integrated series of statistical maps.[17]

Among physicians who used maps to explore diseases and promote wider awareness, the best known among geographers (after Snow) is Jacques May, a physician-scholar focusing on tropical medicine, who headed a postwar medical geography department at the American Geographical Society.[18] Between 1948 and 1960, May produced a series of maps collectively known as the "Atlas of Diseases." He also wrote numerous monographs on disease and malnutrition. His *Ecology of Human Disease* is noteworthy for its dearth of whole-world maps, in preference to country-by-country description and a few single-country multifactor maps relating disease rates to climate, soil, and vegetation.[19]

An even earlier model of descriptive medical geography is the three-volume *Global Epidemiology: A Geography of Disease and Sanitation* initiated during World War II by James Stevens Simmons and numerous co-authors and collaborators.[20] Simmons was a brigadier general in the U.S. Army, which sponsored the work, and chief of the Army's Preventive Medicine Service. Focused on the tropics, *Global Epidemiology* enhanced a country-by-country survey of diseases and public health conditions with cartographic summaries like the world map of yaws and bejel, compiled by the Preventive Medicine Division's Medical Intelligence Service.[21] Unlike May, who used maps to explain regionally relevant causal relationships for the few areas with suitably detailed data, Simmons offered a broad-brush approach appropriate to his focus on global patterns of prevention and control.

Few medical geographers are likely to have heard of Maurice Crowther Hall, a parasite-control expert affiliated with the U.S. Bureau of Animal Industry and later with the U.S. Public Health Service. A photograph in the historical collections of the National Library of Medicine shows Hall, who held a PhD in zoology as well as a doctorate in veterinary medicine, examining a U.S. map of trichinosis at the Public Health Service laboratories. Although posed, the portrait underscores his use of maps for disease monitoring and risk communication. Surveillance was important to Hall, who considered parasites an enemy to be watched, intercepted, and defeated. His 1936 textbook *Control of Animal Parasites* highlighted the importance of propaganda graphics in this metaphorical war. Hall's schematic "War Map of Campaigns against Parasites" outlines a general strategy based on sixteen "weapons" strategically positioned along potential pathways from an old host to a new one.[22] Other diagrammatic "war maps" describe the "major units" of "parasite forces" and outline the "terrain of enemy action and broad lines of communication."[23]

Although most of Hall's war maps are only metaphorically cartographic, he used a crudely drawn geographical map to describe "the War against the Piroplasms and the Cattle Fever Tick" as of December 1919 (Figure 6.3).[24] That veterinarians were

WAR AGAINST TICKS AND PIROPLASMS 51

Map of the War against the Piroplasms and the Cattle Fever Tick, showing the status of the war in December, 1919. The area bounded by the Atlantic and Pacific Oceans, the Gulf of Mexico, and the heavy black line to the north, is the area held by the enemy at the beginning of the war in 1906. Within this area, the black areas are those still held by the enemy, and the white areas are those taken by us up to December, 1919. In 1933, the enemy held positions only in Texas, Louisiana and Florida.

Figure 6.3. Maurice C. Hall's cartographic description of the "War against Ticks and Piroplasms." From Maurice C. Hall, *Control of Animal Parasites: General Principles and Their Application* (Evanston, Ill.: North American Veterinarian, 1936), 51. General book collection, National Library of Medicine.

slowly winning the war is apparent in the enemy's retreat southward from the heavy line marking the front in 1906 to the black area occupied in 1919. For health workers, the taste of victory, communicated convincingly with map graphics, can be energizing and flattering.

While persuasive intent is difficult to determine without knowing a map's context, the author's use of symbols and type might suggest an interest in attracting the viewer's attention or at least registering a strong impression. A case in point is the map of "Animal Plague in the United States, 1902–1950" in the historic prints collection at the National Library of Medicine (Figure 6.4). The archived copy has no provenance aside from a note indicating that it was deposited in 1983 by the Centers for Disease Control and probably created in the 1950s. A companion map describes human plague for the same time period. A propaganda motive is plausible because the maps exaggerate the spatial impact of plague by painting large counties solid black on the basis of a single case—by contrast, dots or graduated circles would present a more balanced, more spatially reliable picture of relative density.[25] Moreover, the map author made the display ever more ominous by including a half century of incidents on a single map.

A pair of smaller maps, similar in content if not identical in appearance, provides a reason for a persuasive design. These page-width maps illustrate Vernon Bennett's 1955 Public Health Monograph on the history of plague in the United States.[26] Although the CDC plague study might not have produced the larger

Figure 6.4. Animal Plague in the United States, 1902–1950. History of Medicine prints collection, National Library of Medicine.

maps, their smaller counterparts underscore the observation, in the foreword, by the head medical officer at the Communicable Disease Center, that plague, described as "one of the world's greatest killers, has forced the spending of large amounts of money on efforts to keep it out of this country."[27] Moreover, the map of animal plague supports Bennett's point that because of "no marked tendency in recent years for plague to spread eastward in North Dakota, Kansas, Oklahoma, and Texas," the CDC was justified "in its decision to discontinue the annual surveys and to use those funds to establish one field station to study the ecology of plague in wild rodents."[28] In neither case, though, did the author direct the reader to the relevant maps, consigned to the end of the monograph in an appendix.

In promoting the public health agenda, persuasive maps were especially useful in calling attention to geographic differences in sanitation. An early example is the highly detailed "Sanitary and Topographic Map of the City and Island of New York prepared for the Council of Hygiene and Public Health of the Citizens Association."[29] Printed in 1865 at a scale of 1:12,000 and laid out with north to the right, the color lithograph is nearly two feet (45 cm) tall and five feet (157 cm) wide, and thus suitable for a wall display at eye level. The cartographer was Egbert L. Vielé, a Union Army general and West Point graduate who was the city's chief engineer and author of *The Topography and Hydrology of New York,* published the same year.[30] Colored pattern symbols divide the island into marsh, made land, and meadow; hachures provide a pictorial view of terrain that exaggerates slope; and heavy black lines following street centerlines represent sewers. Sewers, relying on gravity and discharging directly, without treatment, into the Hudson and East Rivers, promoted public health by keeping fecal matter out of the water supply. In 1865 sewers served most streets in lower Manhattan but were comparatively sparse in Midtown. And in some neighborhoods gravity flow was less than ideal.

Although the Citizens' Association report made no specific mention of Vielé's cartography,[31] his map was the subject of a lengthy *New York Herald* story, apparently triggered by publication of the general's book, which examined the relationship between disease and drainage, natural as well as artificial.[32] According to the *Herald*:

> General Egbert L. Vielé has published a very interesting work, together with a valuable map, showing the topography and hydrology of the city of New York, and defining the healthy and unhealthy sections of the metropolis. It will prove of great value to persons about purchasing residences or building sites upon which to erect the same. . . .
>
> This map shows the water courses, streams, meadows, marshes, ponds, ditches, canals, &tc., that existed and now exist upon the site upon which New York is built. General Vielé asserts the remarkable fact that when the cholera, yellow fever, intermittent, typhoid and other fevers, fever and ague and all similar complaints have prevailed in the city they have been most general and virulent within or near the lines of these water course districts.

The article concluded, under the heading "General Viele's Remedy," with a call for expediting the flow of sewage, storm water, and traffic.

> The remedy to be applied in the lower part of the city is to widen the narrow streets and to raise the grade where the streets pass through the original depression of the surface. Narrow streets, under any circumstances, are a curse to a city. They are generally the abodes of vice and crime. In them an ordinary sickness spreads into a pestilence, and a fire into a conflagration. By constructing lateral drains along the slope of the depressions in the lower part of the city, and connecting them with the sewers, they will intercept the water in its descent and prevent accumulation in the original basins; and then raising the grade, at the same time widening the streets, and perhaps discontinuing some of the short and insignificant streets in the Sixth ward, the health of the city will be improved one hundred percent.

An editorial in the same issue cited the map in condemning "the general hygienic welfare of the city" and calling for "a thorough and radical improvement in our system of drainage and sewerage."[33] In addition to describing the city's sanitary infrastructure, Vielé's map helped journalists, city officials, and other citizens visualize the effect of natural topography on disease.

Public health historians attribute the landmark New York Metropolitan Health Bill of 1866 to an extensive sanitary survey summarized in the Citizens' Association report. Association officials divided the city into twenty-nine sanitary districts, each explored by a young physician who served as the district's sanitary inspector. Although Vielé's cartography no doubt played a key role in their efforts, available accounts of the house-to-house survey ignore his contribution, which was eclipsed in his obituary, four decades later, by other notable accomplishments.[34]

Few examples of cartographic propaganda are as pointed as the maps used by the American Social Hygiene Association in its campaign against prostitution and venereal disease. Founded in 1914, the association published the *Journal of Social Hygiene* and produced booklets with titles like "Case against Prostitution" and "Good Laws Are Strong Weapons."[35] In the early 1940s efforts to control sexually transmitted diseases in the military bolstered the association's legislative agenda, readily apparent in its 1942 map reporting the status of state laws requiring premarital health examinations.[36] The principal title, "Protecting Marriage from Syphilis," leaves no doubt about the seriousness of the effort. In this case solid black, instead of alluding to death or doom, dominates the display in highlighting states in which both bride and groom must submit to a medical examination that includes a blood test. By contrast, in symbolizing the least desirable of the four categories, states that "grant marriage licenses without regard to venereal disease infection," the map uses solid white, which is readily associated with emptiness or absence. An updated map published two years later reports the addition of five states to the most desirable category and the movement of three states out of the

least desirable group[37] (Figure 6.5). Three sentences below the 1944 map address pointed questions to citizens and association members:

How does your state stand?

When does your legislature meet?

What plans are there to improve the legal status of premarital health examinations in your state?

In contrast to the small, page-width maps in the *Journal*, larger maps on letter-size paper in the historic prints collection of the National Library of Medicine were apparently intended for posting or mailing to legislators.

Another 1944 map addresses a prime source of infection, prostitution.[38] Eighteen states are in the most desirable group, portrayed in black, while the two states outlawing only the "activities of exploiters of prostitutes" (Arizona and Nevada) are shown in solid white. As for blood tests and premarital exams, three equally incisive questions at the bottom underscore the map's message.

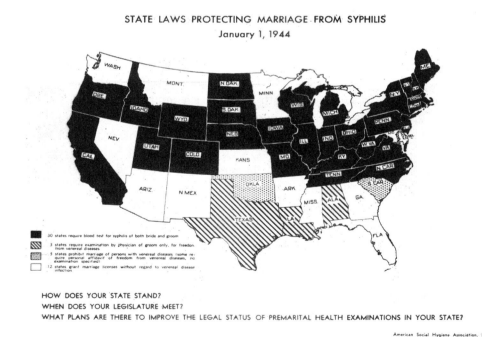

Figures 6.5. The American Social Hygiene Association lobbied state legislators with this 1944 U.S. map showing the status of "State Laws Protecting Marriage from Syphilis." History of Medicine prints collection, National Library of Medicine.

How does your state stand?

When does your legislature meet?

What plans are there to improve your laws against prostitution?

Cartographic propaganda also played a persuasive role in health-care delivery, particularly in securing public funding for hospitals in poor, remote areas. A noteworthy example is the large folded map accompanying a 1943 issue of the magazine *Hospital Management*.[39] Compiled by the journal's physician editor, Thomas Ritchie Ponton, the map describes local and regional differences in access to hospitals approved by the American College of Surgeons or registered with the American Medical Association. White areas are within fifty miles of a hospital approved by both organizations, and other symbols describe areas either more than fifty miles away or served by a facility not vetted by one or both of these organizations. According to an accompanying article in the magazine, the map was intended for hospital administrators so that they might "present the national hospital service picture with a great deal more clarity and accuracy."[40] Titled "Survey Reveals Need for Increased General Hospital Service in U.S.," the article pointed out the many areas lacking easy access to hospital care, especially in the western states. Although the map's impact is difficult to assess, it no doubt contributed, at least indirectly, to passage of the Hill-Burton Act, also known as the Hospital Survey and Construction Act of 1946.[41] Although the law focused on poverty as an impediment to health care, nonmetropolitan regions without an approved hospital usually qualified for Hill-Burton assistance.

Another noteworthy persuasive map is the self-congratulatory, three-part cartographic narrative reporting the eradication of smallpox in the 1970s.[42] Supplementary text in the final panel, in the 1977 map at the bottom, highlights "the last case of *Variola minor* in the world." Designed as a poster, a flyer, or a single-page advertisement, the map sends the message "Vaccination works" and indirectly praises World Health Organization eradication efforts.

Persuasion is readily apparent in the map of female breast cancer rates embedded in the two-foot by three-foot (60 x 90 cm) poster "Europe against Cancer" produced by the World Health Organization's International Agency for Research on Cancer.[43] A generalized outline of a woman and a red spot representing a breast tumor complement a colored seven-category map of mortality rates aggregated at the provincial (subnational) level and adjusted for differences in age structure. High rates in red, low rates in green, and intermediate rates in yellow and orange invoke the traffic-light metaphor common to environmental maps.[44]

As one of the poster's key elements, the map relies on the objective authority of numerical data to get the attention of northern Europeans. After noting the incidence of high rates in Britain, Ireland, Denmark, and Holland, the poster

suggests obesity and saturated fats as an explanation and advises women to watch their weight.

> Among the reasons given are excessive weight and a diet too rich in animal fats. However,
> these hypotheses need to be confirmed.
> Conclusion: avoid being overweight.

This interpretation would probably puzzle American viewers, conditioned to warnings about the importance of self-examination and professional check-ups. In this instance a map added visibility if not credibility to a questionable theory.[45]

Among the more prominent examples of propaganda maps in environmental health is the Environmental Protection Agency's radon map, promulgated in a variety of formats, including a large (28 x 24 inch, 71 x 61 cm) poster (Figure 6.6).[46] Chief among the map's persuasive elements are a heavy reliance on danger-mongering colors and a vague key identifying the three categories as merely Zone 1, Zone 2, and Zone 3. Rather than employing a stop-light (red-amber-green) color sequence, the map favors the warm side of the visible spectrum with a sequence

Figure 6.6. EPA Map of Radon Zones. The 1993 map accompanied a brief explanation, issued as EPA document 402-R-93-071. Collection of the author.

of progressively more ominous hues advancing from yellow to orange to red, thereby avoiding more placid, less ominous greens or blues. This design supports the EPA's effort to promote home testing, a worthy goal blurred by strong, unpredictable local contrasts in indoor radon levels related to geology, home construction, and the life styles of the occupants.[47] Although counties shown in red have generally higher concentrations of indoor radon, most homes here do not require remediation, while some residences in the yellow and orange areas do. As graphic propaganda, the map indirectly supports the EPA's action level of 4 pCi/l (pico-Curies per liter), which is based on questionable assumptions used to estimate the lethal dose of this colorless, odorless gas.[48]

Maps designed to frighten the public are also prominent in the work of the late Peter Gould, a geographer concerned with the AIDS pandemic. In addition to writing a book-length essay on the spread of AIDS, Gould developed a video animation describing the diffusion of the disease from Pennsylvania's metropolitan centers into the state's most remote townships.[49] Although his data were based on questionable projections, he wanted the sequence's spreading red symbols to send a clear warning that the disease would quickly move outward from metropolitan centers to their rural hinterlands. As the developers who designed the maps noted, the animation was largely rhetorical, intended to scare both teenagers and health practitioners.[50] A national version of his "map movie" was so compelling that *Time* magazine, *Forbes,* and *Playboy* reproduced a series of snapshots from the animation.[51]

Cartography can be a powerful tool for publicizing problems and suggesting solutions. By drawing on common perceptions that maps are factual representations of reality, map authors can attract the attention of medical authorities and private citizens alike, and even reify dubious relationships such as cancer clusters, which typically prove spurious upon close investigation.[52] It is thus not surprising that environmental health is nearly as fertile an arena for cartographic propaganda as geopolitics, in which maps assert nationhood, objectify boundaries, exaggerate threats, and seek sympathy for victims. Maps help us find our way, we trust them, and map authors can exploit that trust for diverse purposes.[53]

Notes

1. For a recent example, see Andrew B. Lawson and Fiona L. R. Williams, *An Introductory Guide to Disease Mapping* (Chichester, U.K.: John Wiley and Sons, 2001). Lawson and Williams point out the role of maps in public health surveillance, particularly by describing both incidence and prevalence. They also argue that spatial patterns can help public health officials understand the origin of infectious diseases and develop hypotheses for noninfectious diseases. For older examples of works promoting disease mapping, see Howard C. Hopps et al., *Computerized Mapping of Disease and Environmental Data: Report of the Mapping of Disease (MOD) Project* (Washington, D.C.: Geographic Pathology Division, Armed Forces

Institute of Pathology, 1969), and Neil D. McGlashan, ed., *Medical Geography: Techniques and Field Studies* (London: Methuen, 1972). Disease mapping received a substantial impetus from the development of computer-assisted cartography, starting in the 1960s. More recent works promote geographic information systems and spatial statistics as promising tools; for examples, see Donald P. Albert, Wilbert M. Gesler, and Barbara Levergood, eds., *Spatial Analysis, GIS and Remote Sensing: Applications in the Health Sciences* (Chelsea, Mich.: Ann Arbor Press, 2000); Anthony G. Gatrell and Markku Löytönen, eds., *GIS and Health* (London: Taylor and Francis, 1998); and Alan L. Melnick, *Introduction to Geographic Information Systems in Public Health* (Gaithersburg, Md.: Aspen Publishers, 2002). According to geographer Frank Barrett, in 1792 Leonard Ludwig Finke (1747–1837), a German physician, produced the first world map of disease. Drawn by hand and never reproduced, Finke's map survived only in an oblique published reference to its existence; see Frank A. Barrett, "Finke's 1792 Map of Human Diseases: The First World Disease Map?" *Social Science and Medicine* 50 (2000): 915–21.

2. For the initial publication of the map, see John Snow, *On the Mode of Communication of Cholera* (London: J. Churchill, 1855), the folded map tipped in between pages 44 and 45. It is one of two maps; the other describes boundaries of public health and water supply boundaries in south London. A short table of illustrations (page viii) describes the cholera map: "Map 1. Showing the deaths from cholera in Broad Street, Golden Square, and the neighbourhood, from 19th August to 30th September 1854. A black mark or bar for each death is placed in the situation of the house in which the fatal attack took place. The situation of the Broad Street Pump is also indicated, as well as that of all the surrounding Pumps to which the public had access."

3. See, for example, L. Dudley Stamp, *The Geography of Life and Death* (Ithaca, N.Y.: Cornell University Press, 1965), 34–35. According to Stamp, "On 8th September, 1854 the handle of the pump was removed at Snow's request and new cases ceased almost miraculously. His theory was proved: contaminated drinking water." Not all promoters of Snow show or cite his map. In a study of cholera in Russia, Roderick McGrew refers to Snow's "researches on the cholera in Broad Street" as well as "his equally important work" on London water companies. According to McGrew, "In both instances Snow proved that the cholera could be traced to contaminated water supplies, and his work has become classic. [Even so] Snow's proofs . . . were not accepted at once, and the papers which he submitted to the French Academy went unpublished." See Roderick E. McGrew, *Russia and the Cholera, 1823–1832* (Madison: University of Wisconsin Press, 1965), 9.

4. Kari S. McLeod, "Our Sense of Snow: The Myth of John Snow in Medical Geography," *Social Science and Medicine* 50 (2000): 923–35. Also see Wade Hampton Frost, "Epidemiology," in *Papers of Wade Hampton Frost, M.D.: A Contribution to Epidemiological Method*, ed. Kenneth F. Maxcy (New York: Commonwealth Fund, 1941), 493–542. In 1849 Snow published a shorter edition of the book, mentioned earlier (Snow, *On the Mode of Communication of Cholera*).

5. J. P. Vandenbroucke, H. M. Eelkman Rooda, and H. Beukers, "Who Made John Snow a Hero?" *American Journal of Epidemiology* 133 (1991): 967–73. Also see John Snow, *Snow on Cholera, Being a Reprint of Two Papers by John Snow, M D., together with a Biographical Memoir by B. W. Richardson, M.D., and an Introduction by Wade Hampton Frost, M.D.* (New York and London: The Commonwealth Fund and the Oxford University Press, 1936). Frost has praised "John Snow's masterly analysis of the epidemiology of cholera" in an essay on epidemiology published in 1927 in a Nelson Loose-Leaf System book on Public Health—Preventive Medicine; see Frost, "Epidemiology," 493–542, quotation on 532. Although the Vandenbroucke essay rightly credits Frost with promoting Snow's methodical approach, and by extension

his map, a 1902 book by a member of the MIT sanitary science and public health faculty provided a smaller, generalized version of Snow's map that was no doubt attractive to later writers; see William T. Sedgwick, *Principles of Sanitary Science and the Public Health, with Special Reference to the Causation and Prevention of Infectious Diseases* (New York: Macmillan, 1902), map between 174 and 175.

6. Because propaganda has pejorative connotations, some cartographic scholars prefer the term *persuasive maps*; see, for example, Judith A. Tyner, "Persuasive Cartography," *Journal of Geography* 81 (1982): 140–44.

7. The literature on propaganda cartography focuses largely on maps in the political or geopolitical area, where the propaganda motive is clear or can readily be inferred. For examples, see Derek R. Hall, "A Geographical Approach to Propaganda," *Political Studies from Spatial Perspectives,* eds. Alan D. Burnett and Peter J. Taylor (Chichester, U.K.: John Wiley and Sons, 1981): 313–30; J. B. Harley, "Maps, Knowledge, and Power," in *The Iconography of Landscape: Essays on the Symbolic Representation, Design and Use of Past Environments,* Cambridge Studies in Historical Geography 9, eds. Denis Cosgrove and Stephen Daniels (Cambridge: Cambridge University Press, 1988), 277–312; Alan K. Henrikson, "Maps, Globes, and the 'Cold War,'" *Special Libraries* 65 (1974): 445–54; Guntram H. Herb, *Under the Map of Germany: Nationalism and Propaganda 1918–1945* (London: Routledge, 1997); John Pickles, "Texts, Hermeneutics, and Propaganda Maps," in *Writing Worlds: Discourse, Text, and Metaphor in the Representation of Landscape ,* eds. Trevor J. Barnes and James S. Duncan (London: Routledge, 1992), 193–230; and Hans Speier, "Magic Geography," *Social Research* 8 (1941): 310–30. Other, less prominent arenas for cartographic propaganda include advertising and environmental controversies; see Paul D. McDermott, "Cartography in Advertising," *Canadian Cartographer* 6 (1969): 149–55; and Mark Monmonier, "The Three R's of GIS-Based Site Selection: Representation, Resistance, and Ridicule," in *Policy Issues in Modern Cartography,* ed. D. R. Fraser Taylor (Kidlington, Oxford: Pergamon, 1998), 233–47.

8. William Berry and F. C. Wilson, *A History of Cholera at Lancaster Ky., in 1873* (Louisville, Ky.: John P. Morton and Co., 1873), quotation on 3.

9. Félix Pascalis-Ouvière, *A Statement of the Occurrences during Malignant Yellow Fever, in the City of New York, in the Summer and Autumnal Months of 1819, and of the Check Given to Its Progress, by the Measures Adopted by the Board of Health* (New York: William A. Mercein, 1819).

10. For example, graphics guru Edward Tufte in a widely read celebration of visual communication acclaimed Snow's map. See Edward R. Tufte, *The Visual Display of Quantitative Information* (Cheshire, Conn.: Graphics Press, 1983), 24.

11. See, for example, the version in Stamp, *The Geography of Life and Death,* 35.

12. Thomas J. Mason et al., *Atlas of Cancer Mortality for U.S. Counties, 1950–1969,* Department of Health, Education, and Welfare Publication no. (NIH) 75-780 (Washington, D.C.: U.S. Department of Health, Education and Welfare, 1975).

13. The nonwhite population was too small in many counties for a nationwide treatment. But a year later, the National Cancer Institute published a nonwhite counterpart that omitted symbols for areas with small nonwhite populations; see Mason et al., *Atlas of Cancer Mortality among U.S. Nonwhites, 1950–1969,* Department of Health, Education, and Welfare Publication no. (NIH) 76-1204 (Washington, D.C.: U.S. Department of Health, Education, and Welfare, 1976): v.

14. Mason et al., *Atlas of Cancer Mortality* (1975), quotation on 5.

15. See William J. Blot et al., "Lung Cancer after Employment in Shipyards during World War II," *New England Journal of Medicine* 299 (1978): 620–24; William J. Blot and Joseph F. Fraumeni

Jr., "Geographic Patterns of Lung Cancer: Industrial Correlations," *American Journal of Epidemiology* 103 (1976): 539–50; William J. Blot and Joseph F. Fraumeni Jr., "Geographic Patterns of Oral Cancer in the United States: Etiological Implications," *Journal of Chronic Disease* 30 (1977): 745–57; and Deborah M. Winn et al., "Snuff Dipping and Oral Cancer among Women in the Southern United States," *New England Journal of Medicine* 304 (1981): 745–49. All cite the 1975 Mason *Atlas*. In addition, a 1996 mortality atlas credits the Mason *Atlas* with revealing two "previously unnoticed clusters of high-rate counties" in which field investigations "uncovered . . . the links between shipyard asbestos exposure and lung cancer and [between] snuff dipping and oral cancer." See Linda Williams Pickle et al., *Atlas of United States Mortality*, Department of Health and Human Services Publication no. (PHS) 97-1015 (Hyattsville, Md.: U.S. Department of Health and Human Services, 1996), quotations on 1.

16. Ibid.

17. For examples, see Cynthia A. Brewer et al., "Mapping Mortality: Evaluating Color Schemes for Choropleth Maps," *Annals of the Association of American Geographers* 87 (1997): 411–38; and Cynthia A. Brewer and Linda Pickle, "Evaluating Methods for Classifying Epidemiological Data on Choropleth Maps in Series," *Annals of the Association of American Geographers* 92 (2002): 662–81.

18. For a concise assessment of May's contributions, see Wilma B. Fairchild, "Jacques M. May (1896–1975)," *Geographical Review* 66 (1976): 236–37; also see "Dr. May and Wife, Nutritionists, Die," *New York Times*, July 3, 1975, 34. May described his approach and plans in Jacques M. May, "Medical Geography: Its Methods and Objectives," *Geographical Review* 40 (1950): 9–41.

19. May's books include *The Ecology of Human Disease* (New York: MD Publications, 1958), *Studies in Disease Ecology* (New York: Hafner Publishing Co., 1961), and several regional works on malnutrition, for example, *The Ecology of Malnutrition in the Far and Near East* (New York: Hafner Publishing Co., 1961). For an example of small-area map of presumed causal relationships, see the map of yaws in Haiti, in *Ecology of Human Disease*, 218.

20. James Stevens Simmons et al., *Global Epidemiology: A Geography of Disease and Sanitation*, 3 vols. (Philadelphia: J. B. Lippincott, 1944–54).

21. Ibid., 1:483. Army medical intelligence staff apparently assembled the data, but did not draft the finished maps. Simmons's preface attributes the cartographic artwork for the worldwide disease maps to Elon Clark, at the Duke University School of Medicine. See ibid., 1:viii. Clark's name appears at the bottom of the larger map in the History of Medicine historic prints collection.

22. Maurice C. Hall, *Control of Animal Parasites: General Principles and Their Application* (Evanston, Ill.: North American Veterinarian, 1936), diagram opp. 156.

23. See, for example, the diagrams describing "parasite forces" and a more focused strategy for the "war against trichina" in ibid., 11 and 88, respectively.

24. Ibid., 51.

25. For discussion of the importance of using size symbols, not graytones, to show geographic variation in magnitude data, see Mark Monmonier, *How to Lie with Maps*, 2nd ed. (Chicago: University of Chicago Press, 1976), 22–23.

26. Vernon Bennett Link, *A History of Plague in the United States of America*, Public Health Monograph no. 26 (Washington, D.C.: U.S. Government Printing Office, 1955).

27. Theodore J. Bauer quoted in ibid., iii.

28. Ibid., 42.

29. Citizens' Association of New York, Council of Hygiene and Public Health, *Report of the Council of Hygiene and Public Health of the Citizens' Association of New York upon the*

Sanitary Condition of the City (New York: D. Appleton and Co., 1865), folded version of the lithographed, hand-colored map tipped in between pages xx and xxi. A reprint edition of the report published by Arno Press in 1970 attests to the report's significance. Also see Daniel Cark Haskell, *Manhattan Maps: A Co-Operative List* (New York: New York Public Library, 1931), 67; and I. N. Phelps Stokes, *The Iconography of Manhattan Island, 1498–1909: Compiled from Original Sources and Illustrated by Photo-Intaglio Reproductions of Important Maps, Plans, Views and Documents in Public and Private Collections*, 6 vols. (New York: Robert H. Dodd, 1915–26), esp. 3:777–78.

30. Egbert Ludovickus Vielé, *The Topography and Hydrology of New York* (New York: R. Craighead, 1865).

31. The report's index (360) calls attention to Vielé's 1860 study of sanitary conditions in Boston (xcviii) and to his observation, as president of the city's Board of Engineers, that "[i]t is folly to suppose that when the city is fully built upon, and the valleys filled up, no water will find its way into the beds of its original streams. I know to the contrary; and my own experience, during a residence in a southwestern city while an epidemic was in progress, taught me that in all localities where there were original depressions in the topography, the disease raged with the greatest violence, although there was no apparent presence of water or even of moisture in the ground" (206).

32. All references to "The Public Health: The Fever and Ague Districts of New York," *New York Herald*, November 3, 1865, 8.

33. "The Substratum of New York," *New York Herald*, November 3, 1865, 4.

34. George Rosen, "Public Health Problems in New York City during the Nineteenth Century," *New York State Journal of Medicine* 50 (1950): 73–78, esp. 77; Wilson G. Smillie, *Public Health: Its Promise for the Future* (New York: Macmillan Co., 1955), 292–95; James J. Walsh, *History of Medicine in New York: Three Centuries of Medical Progress* (New York: National Americana Society, 1919), esp. 1:240–56; and Israel Weinstein, "Eighty Years of Public Health in New York City," *Bulletin of the New York Academy of Medicine* 23 (1947): 221–37. For a comparatively detailed description of the sanitary survey, see Stephen Smith, *The City That Was* (New York: Frank Allaben, 1911; Metuchen, N.J.: Scarecrow Reprint Corp., 1973). For obituaries of Vielé, see "Death of Gen. E. L. Viele," *New York Times*, April 23, 1902, 9; and "Egbert L. Viele [obituary]," *Bulletin of the American Geographical Society* 34 (1902): 184.

35. For a list of association publications, see George Gould, "Does Your State Need New Social Hygiene Laws?" *Journal of Social Hygiene* 28 (1942): 536–47, esp. 547.

36. Ibid., map on 544.

37. George Gould, "Twenty Years' Progress in Social Hygiene Legislation," *Journal of Social Hygiene* 30 (1944): 456–78; map on 463.

38. Ibid., map on 459.

39. For the descriptive article accompanying the map, see T. R. Ponton, "Survey Reveals Need for Increased General Hospital Service in U.S.," *Hospital Management* 56 (August 1943): 17–19, 38.

40. Ibid., 18.

41. For information on the Hill-Burton Act and its benefits to rural counties, see "News from Washington: Congress Approves $375,000,000 a Year for 5 Years for Hospitals," *Hospital Management* 62 (August 1946): 41; and Lister Hill, "Health in America: A Personal Perspective," in *Health in America: 1776–1976*, Department of Health, Education, and Welfare Publication no. (HRA) 76-616 (Washington, D.C.: U.S. Department of Health, Education, and Welfare, 1976): 3–15. Ponton died two years after enactment of the Hill-Burton bill. His obituary in the journal he had edited noted that Ponton "developed unusual ability in line

drawings and was able to do all his work with meticulous accuracy which was a great advantage in setting up charts of organization, flow or functional charts and the like." See Malcolm T. MacEachren, "Dr. T. R. Ponton Dies in California Hospital April 2," *Hospital Management* 65 (April 1948): 18, 70–72; quotation on 70.

42. "The Eradication of Smallpox" is a series of three small-scale world maps showing areas in which smallpox has been eradicated, as of 1966, 1972, and 1977. Source unknown; possibly from the World Health Organization. From the Historic Photo and Prints Collection, History of Medicine Division, National Library of Medicine.

43. "Europe against Cancer" is a full-color poster with province-level map for deaths from breast cancer in women, 1970s. "Map compiled for the European Commission by the International Agency for Research on Cancer." Published by the "Office for Official Publications for the European Communities." Text note: "Mortality is particularly high in Northern Europe, Denmark, United Kingdom, Ireland, Netherlands. Among the reasons given are *excessive weight* and a diet too rich in animal fats. However, these hypotheses need to be confirmed. Conclusion: avoid being overweight." From the Historic Photo and Prints Collection, History of Medicine Division, National Library of Medicine.

44. For additional discussion of the traffic-light metaphor, see Mark Monmonier and George A. Schnell, "Natural Hazard Mapping: Status and Review," in *Natural and Technological Disasters: Causes, Effects, and Preventive Measures,* eds. S. K. Majumdar et al. (Easton: Pennsylvania Academy of Science, 1992), 440–54.

45. Diverse phenomena have been identified or suggested as risk factors for breast cancer. For recent assessments of suspected personal and environmental factors in breast cancer, see Graham A. Colditz, "Cancer Culture: Epidemics, Human Behavior, and the Dubious Search for New Risk Factors," *American Journal of Public Health* 91 (2001): 357–59; and "Your Cancer Risk: Breast Cancer: Risk List," online at the Harvard Center for Cancer Prevention Web site, http://www.yourcanderrisk.harvard.edu. Some supposed causes, like electromagnetic fields, appear irrelevant; see, for example, E. R. Schoenfeld, E. S. O'Leary, and K. Henderson, "Electromagnetic Fields and Breast Cancer on Long Island: A Case-Control Study," *American Journal of Epidemiology* 158 (2003): 47–58. A recent essay in *Lancet* suggests that epidemiologists might have prematurely downplayed the role of saturated fat; see Sheila A. Bingham, Robert Luben, and Ailsa Welch, "Are Imprecise Methods Obscuring a Relation between Fat and Breast Cancer?" *Lancet* 362 (July 19, 2003): 212–14.

46. EPA Map of Radon Zones (1993) accompanied a brief explanation, issued as EPA document 402-R-93-071.

47. For discussion of radon's variability and a critique of the EPA radon program, see Mark Monmonier, *Cartographies of Danger: Mapping Hazards in America* (Chicago: University of Chicago Press, 1997), 174–86.

48. The 4 pCi/l action level is based on the mortality experience of uranium miners, who apparently not only worked longer hours than reported but also were heavy smokers. See ibid., 177–78; and Philip H. Abelson, "Mineral Dusts and Radon in Uranium Mines," *Science* 254 (1991): 777. The EPA recommends mediation of some sort for homes with a measured concentration higher than this level. By contrast, Canada uses a 20 pCi/l action level.

49. See Peter Gould, *The Slow Plague: A Geography of the AIDS Pandemic* (Oxford, U.K.: Blackwell Publishers, 1993), and Peter Gould, "Sources of Error in a Map Series, or Science as a Socially Negotiated Enterprise," *Cartographic Perspectives* no. 21 (Spring 1995): 30–36.

50. Alan M. MacEachren and David DiBiase, "Animated Maps of Aggregate Data: Conceptual and Practical Problems," *Cartography and Geographic Information Systems* 18 (1991): 221–29.

51. See "Inexorable March," *Time* 140, August 31, 1992, 20; "People with AIDS," *Forbes* 154, September 12, 1994, 250; and "The Self-Cleaning Oven," *Playboy* 41, February 1994, 44–45. *Forbes* ran a horizontal sidebar with maps for 1982, 1988, and 1990, with a caption; *Playboy*'s short article used maps for 1986, 1988, and 1990; and *Time* used maps for 1982, 1986, 1988, and 1990 in a vertical sidebar, with a caption.

52. See, for example, the dot map of cancer cases on Long Island described in Linda M. Timander and Sara McLafferty, "Breast Cancer in West Islip, NY: A Spatial Clustering Analysis with Covariates," *Social Science and Medicine* 46 (1998): 1623–35. Statistical analysis of household data suggested that conventional risk factors (family history of breast cancer, age at first pregnancy) accounted for the apparent clusters.

53. Maps are as indispensable in medical surveillance as they are in warfare and military defense; for a concise discussion of the use of maps and geospatial data in coping with epidemics (human and animal) and bioterrorism, see Mark Monmonier, *Spying with Maps: Surveillance Technologies and the Future of Privacy* (Chicago: University of Chicago Press, 2002), 155–68.

7. *"Some One Sole Unique Advertisement"*
Public Health Posters in the Twentieth Century

WILLIAM H. HELFAND

WHILE THERE HAVE BEEN broadsides on public health issues posted by local and state governments for several centuries, there were but few illustrated posters for such events before the late nineteenth century. These were largely notices for fundraising events, sponsored either by the Red Cross or by hospitals, beginning in the 1890s. A good example of the earliest public health posters was the *Croix Rouge du Congo* by Allard L'Olivier. Published as a supplement in a Belgian newspaper in 1891, it presented a realistic scene of physicians and nurses at work in a field hospital tent. A more striking image was an 1895 advertisement by Ramón Casas for a Barcelona sanitarium specializing in the treatment of venereal disease. Its design, similar in layout to L'Olivier's in that it separated words from image, included an asp on the back of the woman's dress as the only indication that she might indeed have an illness that would require treatment in the sanitarium. Somewhat later came two posters for hygiene exhibitions. One was an iconic poster by Franz Van Stuck for an exhibition in Dresden in 1911 with a haunting monster eye to greet the viewer. The second, by Adolph Hohenstein (1854–1928), a German artist long active in Italy, was commissioned for a 1900 exhibition in Milan. Hohenstein's poster uses the image of an idealized family drinking from a pure mountain stream—identified as the *fons vitae,* the fountain of life—which offers the four requisites of good hygiene: light, air, water, and exercise (Figure 7.1).

Other than these images and several others, public health posters prior to the First World War were scarce. Beginning in 1917, however, with battles raging across Europe, serious issues concerning the alarming increase in tuberculosis cases as well as the chronic history of alcoholism in France, and the growth in venereal disease rates among service men, created a need for educational campaigns to warn about these dangers, and not surprisingly posters were included as part of the tactics that were employed. The appearance of these images inaugurated a source of powerful propaganda that continues to this day. Posters had to be sufficiently persuasive to enable the reader, who only had brief seconds to get

Figure 7.1. Adolf Hohenstein, "Expositione d'Igiene" (*Hygiene Exhibition*), Italy, circa 1900. Created for the 1900 exhibition in Naples, this poster uses an image of an idealized family drinking from a pure mountain stream to emphasize the four traditional requisites of good health: light, air, water, and exercise. Courtesy of the William H. Helfand Collection, Philadelphia Museum of Art.

the message, to accept the need to change. In the case of tuberculosis, early treatment, sleeping with open windows, or increased research funds were the themes; in the case of public health concerns in later years, a variety of messages were similarly promoted. In the main, the integrated words and illustrations were designed to persuade the viewer to change certain behavior patterns.

In July 1917, even before governments began to do something more serious about the alarming increase in tuberculosis cases, the Rockefeller Commission for the Prevention of Tuberculosis in France arrived to provide public education medical and nursing services. Among its varied programs, the organization commissioned more than a dozen posters, about twenty postcards, and a series of large broadsides announcing meetings, programs, and health-care services to be provided in several locations in Paris as well as in smaller cities around France. The Commission's posters were the first such sustained campaign anywhere to attack a severe public health problem, and several of the posters created as part of the campaign are vivid models of what an effective poster can be.

Of course, defining what makes an effective poster is not a simple matter. Like any piece of propaganda, a poster is designed to persuade the viewer to react, either by buying the product advertised or by modifying or eliminating destructive habits. The public health poster admonishes us to stop smoking, lose weight, use condoms, not share needles, breast-feed our babies, and send money; if it can do these things, it is deemed worthwhile. At the minimum, however, it must make the passer-by stop, if only for a few seconds, to absorb its message. In general, it does this by presenting a forceful image accompanied by hard-hitting words. These qualities were best summarized by James Joyce in his *Ulysses,* when he described Leopold Bloom's quest for ". . . some one sole unique advertisement to cause passers to stop in wonder, a poster novelty, with all extraneous accretions excluded, reduced to its simplest and most efficient terms not exceeding the span of casual vision and congruous with the velocity of modern life."[1] In the earliest public health campaigns, the Rockefeller Commission chose artists who could create large images that would be mounted in appropriate places where they were likely to be noticed. In the main, the resulting posters, with strong imagery and a short text reduced in importance, were the type that would have stopped Bloom in his tracks.[2]

The posters created by the French artist Georges Dorival (1879–1968), who was asked to develop four posters for the Rockefeller Commission, had forceful images that met these criteria. One shows an eagle impaled on a sword, linking tuberculosis with the German enemy as two plagues, both of which will be destroyed. The sword has the word *tuberculosis* on it, perhaps the first instance the word itself was used in an image placed before the public, for at the time the word *tuberculosis* was rarely used in public statements.[3] Another of Dorival's images, published by the commission after World War I, pointed out that the French could not rest on their laurels as tuberculosis remained a prevalent public health issue. In a third poster, a snake serves as a metaphor for tuberculosis similarly to the way the

poster for the Barcelona sanitarium used an asp for syphilis.[4] This concept was again repeated in a later image by Leonetto Cappiello (1875–1942), one of the more prolific and popular poster artists, in which a mother, holding her child high above her head, stamps on a frightening reptile.

If the commission's first objective was to capture the public's attention, its second objective was to provide information on both the causes of and the methods to prevent the spread of tuberculosis. *Un Grand Fléau* (A Great Plague), by F. Galais, shows some of the many conditions that promoted the spread of tuberculosis among the urban poor as a result of crowded and unhealthy environments. The Angel of Death holding his scythe hovers over the scene as refuse is thrown from windows, food is taken from piles of trash, men are spitting and drinking, and a basket of food is left unprotected. In addition, an American artist, A. M. Upjohn, was commissioned to create a series of four posters pointing out proper habits to keep children from being affected by the cause of tuberculosis. These small posters were reproduced on postcards as well; they showed the importance of playing games, sleeping with open windows, and holding classes in the open air, and the value of the visiting nurse in treating patients.

In the overall campaign, the Rockefeller Commission stressed the provision of health care, especially as supplied by visiting nurses. The title of an arresting image of a visiting nurse by Auguste Leroux (1871–1954) sums up the message they wished to convey: "The visiting nurse is the aide of the physician and of social activities in the crusade against tuberculosis and infant mortality." In the poster, the nurse holds a young patient as she resolutely stands high above a crowded city (Figure 7.2). Leroux's poster set the tone for what has been a recurring necessity throughout the twentieth century, especially in wartime, and which still continues today: the need to continually recruit nurses to join the profession. Following the Rockefeller's lead, the Red Cross and local and federal agencies in the United States assigned well-known artists—including important commercial illustrators such as Haskell Coffin, Jon Whitcomb, John Falter, Thomas Tryon, and Harrison Fisher—to create public health posters, and the attractive and uplifting images of handsome young women have become a staple in the poster world.

By contrast, the Rockefeller Commission often turned to better-known artists to produce their posters because this would ensure a more effective result. Louis Raemakers (1859–1956), for example, was a Belgian artist who published many battlefield views and political caricatures that were ultimately collected into commemorative volumes when the war was over. Raemakers's nursing poster asks the tuberculosis patients to have confidence, but its impression is rather routine, not at all typical of the power of other images that he was capable of creating. One of these, which was not commissioned by the Rockefellers, was *Hecatomb, Syphilis,* one of the most compelling examples in the group of posters calling attention to the dangers of sexually transmitted diseases, one of the central public health concerns during both world wars (Figure 7.3). The smiling

Figure 7.2. Auguste Leroux, "La Visiteuse d'Hygiène Vous Montrera le Chemin de la Santé. Elle Mène une Croisade Contre la Tuberculose et la Mortalité Infantile. Soutenez-La!" (*The Public Health Nurse Will Show You the Path to Good Health. She Leads a Crusade against Tuberculosis and Infant Mortality. Support Her!*), Paris, circa 1917. Marching across the urban landscape like a Parisian Athena in a fashionable hat and overcoat, the public health nurse strikes a military pose and offers protective care for the republican child nestled in the crook of her left arm. Leroux's poster stresses her importance to the nation and asks for her support. Courtesy of the History of Medicine Division, National Library of Medicine, Bethesda, Maryland.

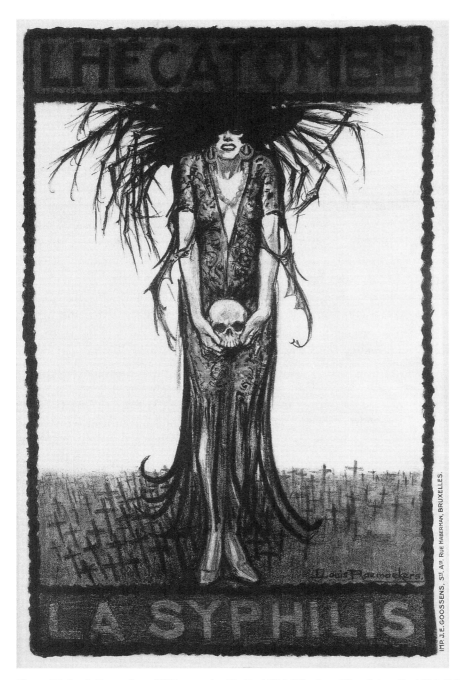

Figure 7.3. Louis Raemakers, "L'Hecatombe / La Syphilis" (*The Great Slaughter—Syphilis*), Belgium, circa 1917. A poignant warning, a *momento mori*, on the dreaded disease, embodied by a frightening emaciated woman with spider-like hair and black cloak, captures the ways in which syphilis was typically represented to the public. Courtesy of the William H. Helfand Collection, Philadelphia Museum of Art.

woman with spider-like hair, holding the skull of one of her victims in a position that appears to equate death with sex, stands above a cemetery containing many other victims. The image is sufficient to make its point with only the two words of the title. A second dramatic statement on the same subject was made in the 1918 poster by Theophile-Alexandre Steinlin (1859–1923), in which the artist issues a dramatic appeal to those fighting on the battlefield to maintain strength for their country and to resist those "seductions of the street" that carry with them the risk of exposure to an illness that is as "dangerous as war" and may lead to a "useless death without honor." The contrast between life, represented by a healthy soldier surrounded by laurel leaves and his country's flags, and death, symbolized by skull and crossbones among withered branches and thorns, is reinforced by a gravestone-like tablet on which the impassioned warning is written. Reflecting the sensibility of the times, as was also the case with tuberculosis, neither the word *syphilis* nor *gonorrhea*, nor even *venereal disease*, appears in the text.

Tuberculosis and venereal disease were major public health concerns during the early part of the twentieth century, as was alcoholism. Excessive drinking had long been a chronic problem in France, even before the period of World War I, and both public and private groups were created to do something about it. For example, the Union des Françaises Contre l'Alcool (French Temperance Union) sponsored three posters by B. Chavannez, each with a frightening domestic scene in which drunkenness is the ruination of a family. In *Oh, When Are They Going to Outlaw Alcohol,* a crying mother and cowering daughter attempt to wrestle the tightly held bottle from an alcoholic husband. In another poster with a similar title, a soldier observes a drunkard hanging on a lamppost. Eugene Burnand (1850–1921) published a poster for another organization, the National League against Alcoholism, with a similar scene and the brief statement, "L'Alcool Tué" (Alcohol Kills).

During the 1920s, public health posters echoed earlier ideas and visual metaphors, with continued emphasis on tuberculosis, sexually transmitted disease, and alcoholism. Basilio Cascella (1860–1950), an Italian artist, published two fund-raising posters in the early 1920s for the Italian Red Cross with identical titles, showing tuberculosis as a huge spider in the first and as a serpent encircling the earth in the second (Figure 7.4). *The Next to Go,* a poster designed for the American Red Cross, depicted tuberculosis as an evil ghost-like figure being pushed out the door, while an Italian image by Tito Corbella (1885–1966) echoed the sentiments of these images, suggesting that such means as rest, good hygiene, and temperance, among others, would be sufficient to eradicate the disease.

The skeletal figure of Death lends itself to representation for any disease for which there is no known cure. Not surprisingly, it is an image that has come back with some frequency in the contemporary visual imagery of AIDS. But in the 1920s,

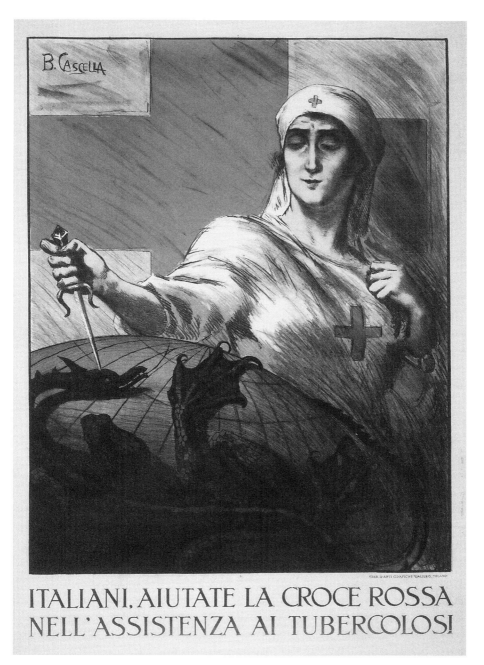

ITALIANI, AIUTATE LA CROCE ROSSA
NELL'ASSISTENZA AI TUBERCOLOSI

Figure 7.4. Basilio Cascella, "Italiani, Aiutate la Croce Rossa Nell'Assistenza ai Tubercolosi" (*Italians, Help the Red Cross to Cure Those with Tuberculosis*) Italy, circa 1920. The globe-encircling monster, a visual metaphor for tuberculosis, is contrasted with the pure white dress of the nurse. Fundraising efforts by the Red Cross and other health agencies have been a recurring trope of public health posters since the late nineteenth century. Courtesy of the William H. Helfand Collection, Philadelphia Museum of Art.

it was employed as a symbol for venereal disease. Two posters dating from the late 1920s show this theme. In the first, by Theodoro, Death sneers behind the kissing couple in a poster; in the second, by the prolific Achille Mauzan (1883–1952), an artist whose long career produced posters in Italy, France, and Argentina, two figures representing Death stand with an unsuspecting bridal party.[5] A similar concept, substituting Satan for the figure of Death, appears in a poster by an unknown artist, showing a blindfolded couple walking under the advice-giving headline, *N'allez pas en aveugles vers l'amour,* (Don't fall in love blindly). The versatile symbol of Death also appeared in an anonymous Italian poster in which the figure appears piloting a plane that is releasing huge insects dropping bombs of microbes on a frightened population. The title of the poster, *Guerra alla Mosche,* called for a war against this frightening evil.

By the 1930s, the basic structure and purpose of earlier public health posters began to change in both Europe and the United States, although it was still maintained under the Communist government in Russia. There, bold posters with powerful graphics continued, and examples of public health posters that addressed smallpox, breast-feeding, and blood donations, among other topics, demonstrate iconography and design that was not too far from the hard-hitting posters done in the West during World War I. Such Russian posters in the period before the revolution are unknown. In the 1930s, posters generally became smaller in size and less confrontational in their presentation, relying on simple graphics to carry their message. Economic conditions forced a reduction in advertising expenditures and thereby curtailed the production of posters in most countries. In the United States, however, the development of the Federal Art Project (FAP), one of the many divisions of the Works Progress Administration during the New Deal, managed to develop a considerable body of impressive work in the service of public health. Posters produced for not-for-profit agencies became a major component of the large-scale effort to provide jobs for unemployed artists, and before the FAP's functions were transferred to the Defense Department in 1941, when the country entered World War II, more than thirty-five thousand designs had been developed.[6] The majority of these used the newly developed silkscreen process, a printmaking technique pioneered by the FAP in 1935 that was ideal for Depression years because it used inexpensive materials and portable equipment. Silk-screened posters were generally twenty-two by fourteen inches, smaller in size than the majority of earlier posters. According to Christopher DeNoon, FAP posters generally used flat screen-printed colors and lots of diagonals, and reflected "the 'synthetic cubism' of the School of Paris, the geometric abstraction of Kandinsky and de Stijl, and the efforts of Stuart Davis and American abstract artists—particularly those in New York—to make aesthetically revolutionary design principles the basis of a socially revolutionary art."[7] They also reflected the contemporary Art Deco style, and as a result are

often considerably milder in impact than their predecessors. Two venereal disease notices, *Shame May Be Fatal* and *Don't Wait, 70% Are Doomed,* are typical of those produced during the second half of the 1930s.[8] Others, prepared by federal, state, and local health groups, provided similar messages warning against quackery, emphasizing early medical attention for cancer, and endorsing blood tests before marriage.[9]

European posters in the 1930s displayed some of the same characteristics, less immediate impact, and less compelling graphics, and in addition, were generally wordier than their silk-screened contemporaries from the United States. One of the few dated specimens from this period is a French anti-alcohol poster, *L'Intemperance provoque . . .* , which depicts the dramatic as well as ubiquitous episode in which a young child attempts to extract his father from a saloon. An Art Deco poster by Leo Fontan (1884–1965), *La Syphilis Est Curable,* uses blocks of lettering that become major elements in the overall design (Figure 7.5). European artists, in contrast to their American counterparts, were still as concerned with strong images as they were in earlier years. Cancer posters showed wraith-like figures rising from cancerous cells under a microscope, crustaceans, or even a skeletal arm held in a vise-like grip to depict the disease and the need for funds to finance research.

The advent of World War II in 1939 revived the need to combat public health concerns of the previous global conflict twenty years before. One would normally expect consistently strong propaganda efforts in wartime, and this was indeed the case for many of the graphics issued by the major players in World War II. Posters for wartime needs such as bond sales, enlistment, victory gardens, and encouraging secrecy among civilians and industrial workers demanded strong messages, and resulted in many memorable examples. For public health advocates, however, the key effort was to prevent sexually transmitted diseases among those in the armed forces. Late in the war, when adequate supplies of penicillin were available, the message changed to show that gonorrhea and syphilis could be cured. For the most part, posters warning against venereal disease echoed those published by the FAP. Service men were continually warned about the dangers of unorthodox treatments, and especially the hazards of loose women, or even of the girl next door who, as one widely distributed American poster suggested in its title, *She May Look Clean–But. . . .* In 1942, the American pharmaceutical firm John Wyeth & Brother solicited the services of a popular illustrator, Arthur Szyk (1854–1951), whose remarkable images were also used to publicize the dangers of venereal disease (Figure 7.6). Harkening back to the early tuberculosis poster of Dorival, which coupled the German enemy with tuberculosis as two evils to be eradicated, Szyk created three posters designed to make the same connection between venereal disease and the Axis powers. In addition, comic books, one of the most favored reading materials of American service men, were also employed

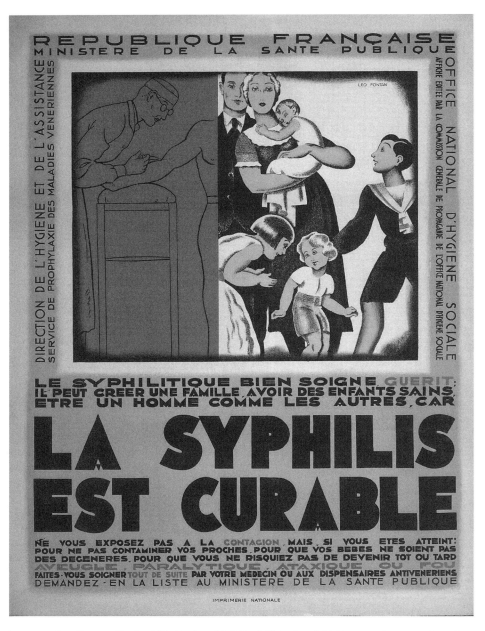

Figure 7.5. Leo Fontan, "La Syphilis Est Curable" (*Syphilis Is Curable*), France, circa 1935. Long before the military's mass production of penicillin in the mid-1940s, the drug was used as an effective treatment for syphilis, as this Art Deco poster from the mid-1930s emphasizes. A note at the bottom of the text offers a list of special dispensaries where patients with venereal disease can seek medical treatment. Courtesy of the History of Medicine Division, National Library of Medicine, Bethesda, Maryland.

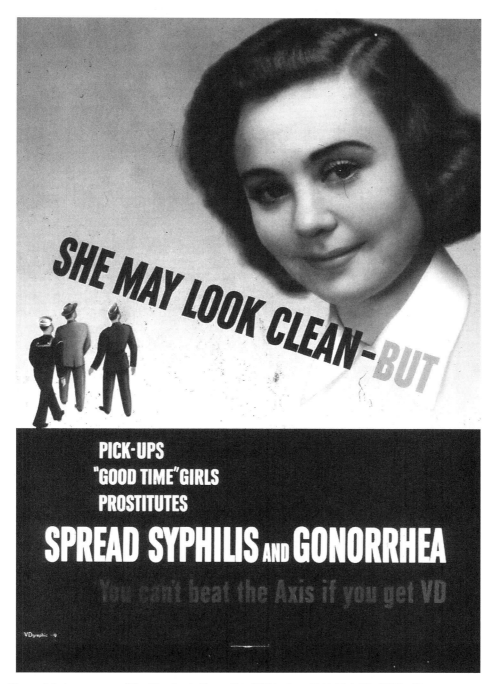

Figure 7.6. Anonymous, "She May Look Clean–But," USA, circa 1943. This World War II–era poster moves beyond the usual misogynist stigma attached to the "loose woman" by targeting the so-called girl next door as a possible source of venereal infection. Courtesy of the History of Medicine Division, National Library of Medicine, Bethesda, Maryland.

for the first time for the same purpose.[10] While mainly providing fantasy and entertainment in an easily digestible form, they also served as useful vehicles for historical and biographical information, and could also be employed as effective sources of propaganda.[11]

Public health posters produced for the British public were mainly developed by Abram Games (1914–1996), a respected poster artist who in 1940 was appointed Official Poster Designer for the War Office. His lithographs warning against the dangers of mosquitoes and flies and for the need for blood donations adroitly mixed words and images to convey important messages. Another British graphic designer, Reginald Mount (1906–1979), developed two posters warning against venereal disease, one of which repeated the skeletal death image. In their designs, the poster images of both Games and Mount echo the sensibility of the American silkscreen posters first seen in the FAP of the 1930s.

With the war's end, public health posters began to stress concerns other than sexually transmitted disease and insect carriers, but they still reflected many of the design conventions that were prevalent before the war. Regarding the advances in polio research as described in two public health posters of 1949 and 1950 by Milton Ackoff and Herbert Matter, it seemed that they reflected the 1950s, with their angled type, bands of color, and greater use of white space. The Austrian typographer Herbert Bayer (1900–1985) was one of a number of European poster artists who immigrated to the United States and became an influential graphic designer. His 1949 poster to raise funds for polio research built upon the type of imagery that Bayer had developed at the Bauhaus, the influential art, design, and architecture school founded in Germany in 1919. Two French posters of the same period for the fight against cancer use similar symbols: in one by the French graphic designer Guy Georget (1911–1992), a sword cuts the heads of a hydra-like monster, while in a poster by Bernard Villemot (1911–1989), a club is used to beat a huge crab into submission. Other public health posters of the period immediately following World War II were rather weak, offering a pale reflection of their former force and appeal. But this mild approach to public health fears has changed radically in more recent years as major campaigns have been mounted throughout the world to combat addiction to tobacco and narcotics, the continuing worldwide problem of alcoholism and, since the mid-1980s, the scourge of still-incurable HIV infection.

These major global public health issues, addiction and the dangers of unprotected sex, have been the focus of continual propaganda campaigns focusing on their causes and on effective solutions. In the United States, the evils of cigarette smoking were clearly stated in the 1964 report issued by a committee under the chairmanship of the Surgeon General, Luther L. Terry.[12] As the first widely publicized official recognition that smoking was a leading cause of cancer and other serious illnesses, the report spawned a host of measures to sensitize the public to

the habit's high cost. Similar drives to curtail substance abuse, despite some forceful posters as part of propaganda programs, have been less successful. Such campaigns have only been in existence since the 1970s, despite the fact that narcotic addiction is hardly a new problem. There had always been reticence to use popular media to discuss addiction, either because posters were not thought to be effective or because the subject was too coarse to permit public airing. Today, this has changed, considerably aided by the need for dramatic warnings about the use of shared needles and, more recently, pointing out the dangers of crystal methamphetamine.[13]

Almost all of the posters for both smoking and narcotic use have been commissioned from graphic designers; their images are rarely signed and rarely dated. The same can be said of the thousands of AIDS posters that have been issued by countries all over the world over the last twenty years, but which were more prevalent during the years between 1985 and 1995. Their creation has slowed considerably since then as the development of different classes of pharmaceuticals has arrived, at least in the developed world, to enable many patients to survive for longer periods. But AIDS, as we know, has in no way been eliminated, and public health programs will be necessary as long as it remains incurable. The vast majority of the thousands of posters promoting AIDS and HIV education and prevention are not in the tradition of earlier, more powerful images. Because individual AIDS and HIV posters are normally created to address the perceived needs of specific groups such as young people, women, racial and ethnic groups, and men who have sex with other men, each category bases its appeals in specific ways.[14] Frequently, these make use of rather shocking imagery because, as an executive with the New York City Department of Health noted, "Adolescents, in particular, demand and accept candor and choose not to accept abstractions."[15] The admonition could probably be applied to all viewers as well.

The graphics used in many AIDS posters provoke the viewer to pay attention to their messages, such as encouraging drug users to avoid sharing needles and practice safe sex through the mandatory use of condoms. Activist groups such as ACT UP, which began its use of graphic design as a form of political propaganda in New York City in 1987, played a prominent role in stimulating strong response.[16] AIDS posters by the design collective Gran Fury used cartoons, humor, and even tabloid-style photographs of prominent political and religious figures, but rarely the work of famous artists and illustrators.[17] Occasionally contemporary posters will appropriate iconic images by well-known artists such as Norman Rockwell and Pablo Picasso and, by adapting them for an AIDS poster, may well succeed in getting passers-by to look at them. *Aids Prevention* (Figure 7.7), for example, a poster that shows the image of a snake curled around an apple by the well-known California artist David Lance Goines (b. 1945),

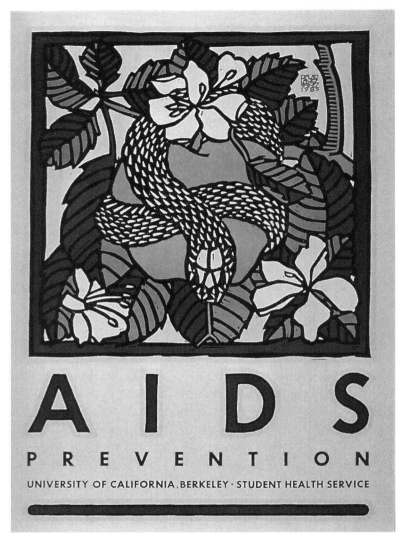

Figure 7.7. David Lance Goines, "AIDS Prevention," USA, 1985. Goines's image of a snake curled around an apple aroused controversy because of its implicit equation of AIDS with sinful behavior. Other HIV and AIDS posters produced in the mid- and late-1980s made a concerted effort to emphasize that HIV infection occurred through multiple vectors, such as shared needles and blood transfusions, rather than only through sexual contact. Courtesy of the History of Medicine Division, National Library of Medicine, Bethesda, Maryland.

aroused some controversy among those who felt that it implied an association between the disease and the concept of sin.[18]

Recognizing that it is extremely difficult to generalize about the huge body of European and American public health posters of the last century, at a minimum their design has had to be attention-getting in order to be effective, for unless the

poster is noticed, it cannot communicate at all.[19] Dramatic posters were more the rule than the exception in the early years of the twentieth century, but in many ways contemporary designs have gotten away from the more forceful images that greeted passers-by when public health campaigns first began. Partly because of the development of less costly offset production methods in place of earlier lithographs, quantity has replaced quality. Posters being just one medium in a mix of many propaganda efforts, and rarely the sole means, it is always hard to tell if they alone have been an effective method of sensitizing men and women to the dangers posed by epidemics, endemic diseases, and other chronic public health problems. Clearly, they are a helpful means, but can never hope to singly modify habits and behavior patterns that need to be changed. And finally, in addition to their effectiveness at the time of publication, in many ways their designs and cautions provide a lasting body of images for us to better understand public health concerns in earlier years.

Notes

1. James Joyce, *Ulysses* (New York: Modern Library, 1934), 705. Bloom's comment is a response to the question "What were habitually his final meditations?"
2. The commission distinguished which posters were to be used outdoors and which were to be used inside buildings and offices, with the latter designed to be factual. See Herman Biggs, Rockefeller Commission report on early work of the commission, December 1, 1917, Rockefeller Archives, Box 28, Dayton Ave, Sleepy Hollow, New York 10591, 3.
3. "[T]he Americans . . . wanted to tell the patient what was the matter with them—a thing that was never done. The word 'tuberculosis' was never used; to tell a patient that would be to kill him." See Lionel Murand and Patrick Zylberman, "Seeds for French Health Care: Did the Rockefeller Foundation Plant the Seeds between the Two World Wars?" *Studies in the History and Philosophy of the Biological and Biomedical Sciences* 31, no. 3 (2000): 471.
4. The Red Cross, with whom the Rockefeller Institute worked closely in France, was also listed as publisher of this poster.
5. Alain Weill, ed., *Affiches Mauzan, Achille Mauzan* (Paris: Musée de la Publicité, 1983), 42.
6. Christopher DeNoon, *Posters of the WPA* (Los Angeles: Wheatley Press, 1987), 13.
7. Ibid., 9.
8. Ibid., 118–19.
9. Rules developed by federal agencies for the Federal Art Project prohibited the posters from being sold and from being signed, thus creating continual problems for future investigators.
10. Bert Hansen, "Medical History for the Masses: How American Comic Books Celebrated Heroes of Medicine in the 1940s," *Bulletin of the History of Medicine* 78 (2004): 149–91.
11. Hansen notes that "the power of resonance and reinforcement of common themes in a wide mass culture should not be discounted." Hansen, "Medical History for the Masses," 190.
12. *Report of the Advisory Committee to the Surgeon General of the Public Health Service* (Washington, D.C.: U.S. Department of Health, Education, and Welfare and Public Health Service), 1964.
13. William H. Helfand, *To Your Health: An Exhibition of Posters for Contemporary Health Issues* (Bethesda, Md.: National Library of Medicine, 1990), 12.

14. William H. Helfand, "Art, Science and Politics in the Service of Public Health," *Caduceus* 4, no. 2 (Summer 1990): 18–23.

15. Ann H. Sternberg, assistant commissioner of the New York City Department of Health, quoted in Mireya Navarro, "Group Begins New AIDS Ads in Subways," *New York Times*, January 14, 1994, Region Section.

16. AIDS Coalition to Unleash Power. See Liz McQuiston, *Graphic Agitation* (London: Phaidon Press Ltd., 1993), 128.

17. Iceland published a series of three posters showing that condoms are everyday items, using a variety of men and women playing with them and holding them in various ways; one of the more than one hundred people photographed in the posters was John Major, then the prime minister of the country.

18. Helfand, "Art, Science and Politics in the Service of Public Health," 19.

19. Sound principles for effective communication are discussed in Andy Goodman, *Why Bad Ads Happen to Good Causes* (Santa Monica, Calif.: Cause Communications, 2002), 52. The first of the principles is "Capture the Reader's Attention like a Stop Sign and Direct It like a Road Map."

8. *Nursing the Nation*

The 1930s Public Health Nurse as Image and Icon

SHAWN MICHELLE SMITH

IN 1937, THE NATIONAL ORGANIZATION OF PUBLIC HEALTH NURSING (hereafter NOPHN) celebrated its twenty-fifth anniversary, an accomplishment that inspired the organization to take stock of its past and future rather self-consciously. In the two and a half decades since its advent, the NOPHN had undergone important structural changes. From an organization of less than two hundred members in 1912, it had grown to one of eight thousand, claiming a larger community of twenty thousand public health nurses in the United States, capable together of making twenty-nine million visits each year. Increasingly, its practitioners viewed their main object as "health," and emphasized preventive medicine over bedside care. In the words of one of its early historians, Annie Brainard, the NOPHN would be known "not only for the relief of the sick, but for the preservation of the public health as well."[1] She goes on to say, "No longer is [the public health nurse] content to give only passing relief; she aims to give permanent cure; no longer does she confine her attention to the individual and the poor; she takes the whole community under her care."[2] The organization expanded its purview to include patients of all economic levels and, under the auspices of the Social Security Act of 1935, it continued to systematize health care services nationally, through the increasing coordination of state and local health units.[3] In general, over the course of twenty-five years, the work of public health nurses had shifted location from private agencies to tax-supported city, county, state, and national public agencies, including health departments and boards of education.[4] Deeming this "one of the most conspicuous changes in the status of public health nursing," Brainard declared, "No longer can the public health nurse be called the 'Servant of the Poor,'—she has become a 'public servant.'"[5]

As health became the NOPHN's object, nurses took on new roles as managers of national welfare. Called upon to study and protect the population in general, their work required new methods of measuring and mapping, of creating "health" by establishing and enforcing its norms. The public health nurse saw her role

increasingly as that of instructor and supervisor. According to Brainard, "If her training as a nurse is essential, her ability as a teacher is equally so."[6] In her role as teacher, the public health nurse was to predict and provide for the future health of the nation. In this task, she defined the "public" she served, the "health" to be achieved, and herself as a new kind of public health ambassador who instructed, supervised, and managed a national body.[7]

In this essay, I examine how a visual historical record registers and proclaims these fundamental changes in the scope, mission, and meaning of public health nursing in the 1930s. The early NOPHN was quite interested in what we would now call "visual culture"; indeed, the journal *Public Health Nursing* is filled with calls for visual education aids, such as charts, posters, photographs, exhibits, window displays, demonstrations, skits, plays, pageants, puppet shows, and motion pictures. Examining photographs especially, I assess how images announce and crystallize a new modern identity for public health nurses. My analysis suggests that photographs were employed to manage new anxieties (for nurses themselves and a wider public audience), scripting responses to the public health nurse's new roles, and claiming new prerogatives for her. I propose that the photographs function not simply as documentation, but as argumentation. The images constitute sites through which we can see the NOPHN negotiating changes in its aims and ambitions—making new claims on national health, and making a new image of the public health nurse visible to nurses themselves and to the nation.[8]

The shifts celebrated during the NOPHN's anniversary were symbolically manifested in its new uniforms. These new outfits were called upon to represent the public health nurse's professionalism and efficiency—to announce the new standardization of her education, procedures, and practices. Indeed, several writers mark the public health nurse's "new look" as a sign of her modernity. Comparisons to older uniforms abound. In a 1937 article entitled "What's Changed?" one writer notes: "The nurse of 1912 entered the home in long full skirts and a large hat. She often gave nursing care with her hat on—an amusing picture as she looks back on herself. Her bag was heavier, its equipment less efficiently simplified. Perhaps she rode to work on a bicycle. Her meager records were made at night on scraps of paper."[9] In contrast to this historic figure, the nurse of 1937 is characterized by "the streamlines in today's dress and transportation, the meticulously efficient bag and systematic record-keeping."[10] The new uniforms were characterized by their comfort, easy care, simplicity, and efficiency. Typically blue, the dresses were generally made of washable cotton or silk, and accented with white collars and cuffs, and a "mannish tailored tie" or "Windsor tie." Coats, hats, shoes, bag, and tie were typically dark blue or black.[11]

Repeated comparisons to her forebears, in the form of "before" and "after" images, symbolically mark the distance that the modern public health nurse has traveled. While initially designed as a washable garment to protect nurses who

tended to the sick from being contaminated, the uniform was adopted by other public health nurses, including those who did not perform bedside service, for a variety of other considerations. According to the National Organization for Public Health Nursing in 1934, "some reasons for wearing uniforms, besides protection, are to give publicity to the organization, to protect the nurse in difficult situations, and to regulate wearing apparel for the sake of personal appearance."[12] In her new uniform, nationally sanctioned by the NOPHN, the public health nurse begins to resemble other public servants, such as military personnel and scouts. As she enters "difficult situations," her uniform identifies her purpose and clarifies her mission for potentially suspicious viewers. Donning her new garb, she becomes a member of a public health army, each nurse equivalent—in knowledge, training, and appearance—to her peers in public health work. Putting on her uniform, the public health nurse becomes part of something bigger than herself, and she works for something broader than the care of individuals—her task, after all, is to secure the health of families, communities, and ultimately, the health of the nation. In her crisp uniform, the public health nurse becomes the professional arm of the state, and an official icon of the nation.

The salient signs of the public health nurse's "new look" were distilled and concretized in a popular silhouette image. In the 1930s, the journal of *Public Health Nursing*'s most prominent "filler image," used to decorate the blank space left at the end of a column, was a small silhouette of a public health nurse with her efficient bag, sporty hat, sturdy black shoes, and striking white collar and cuffs (indeed, the silhouette is identifiable *as* a public health nurse only because of the presence of these visual clues) (Figure 8.1). This figure marches across the pages of the NOPHN's official journal, the swing in her skirt marking her brisk pace.[13] Her persistent advance recalls the contemporary words of C. E. A. Winslow, a prominent professor of public health at Yale University: "Can you not hear the footsteps of the thousands of nurses all over this country, passing through the streets approaching waiting doors, to bring their skill and knowledge to those who live within?"[14] Seizing upon the silhouette image for broader national publicity, the NOPHN raised this ubiquitous figure to the exalted level of "poster lady," using it to represent the national organization in a variety of public venues.[15] Indeed, the NOPHN was so pleased with this image that in 1937 it sponsored a silhouette contest to secure another "poster lady" to represent the organization.

The choice of a silhouette as representative emblem of the public health nurse is an interesting one. The silhouette is entirely symbolic—literally a shadow figure. It functions as a kind of cipher, representing no one and yet everyone. This, of course, is the basis of its appeal; even as the icon might represent anyone, so anyone might project herself into this image, as emblematic public health nurse. The silhouette takes the strategies of standardizing and equalizing, as enacted by the nurse's uniforms, one step further toward abstraction. The dark figure allows any

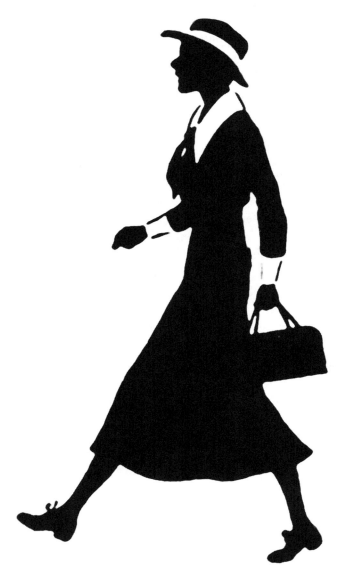

Figure 8.1. Silhouette of public health nurse, *Public Health Nursing* 26, no. 10 (October 1934): 517. Reproduced with permission from the National League for Nursing.

viewer imaginatively to fill in the details of the image with the particularities of her own face, to imagine herself into the image, as a representative nurse, as a member of a group distilled to its most basic signs—the props of bag, hat, tie, collar, cuffs, and shoes.

As the image of the public health nurse was being standardized, her work was increasingly to standardize a national population—to bring people of diverse racial, ethnic, regional, economic, educational, and religious backgrounds up to

the same standards of national health. Even as the public health nurse carefully attended to such differences in the population, her aim was to make these diverse individuals equivalent in terms of health and, through conformity to health standards and practices, to make them citizens of the same nation. According to feminist cultural historian Barbara Melosh, "Nurses portrayed domestic and personal hygiene as 'American,' and used individuals' 'health habits' as a measure of their assimilation."[16] The public health nurse taught health habits, nutrition, and hygiene; she supervised pregnant women through maternity, giving prenatal, delivery, and postpartum care; she monitored the health and hygiene of infants and children; and she managed the prevention of communicable diseases, including tuberculosis, syphilis, and gonorrhea.[17] Through the work of the public health nurse, "health" became an official means of nation-building.

How was the public health nurse to accomplish this new and overwhelming task? By educating and transforming the populace family by family. As one commentator observed, "The family is the unit with which she deals."[18] And the primary exchange through which this transformative work on the family was to take place was the home visit. According to Edith Bryan, vice president of the California State Nurses Association in 1935, "The personal visit of the nurse to the home is the heart of the entire plan of public health nursing."[19]

The results of the *Public Health Nursing*'s 1937 silhouette contest attest to the importance of the home visit in the NOPHN's self-conception and self-representation. In the contest's winning image, as in the third-place contender, we find a nurse, outside a home, knocking at the door, waiting to enter a home and render her services. These images represent a threshold; the nurse as public servant is about to enter the private space of the home. Broadly construed, the nurse's mission is to bridge or mediate between public, professional, and private colloquial spheres. According to Dorothy Deming, general director of the NOPHN in 1937, the public health nurse is responsible for "translating the findings of the laboratory and desk into the language of the man in the street, and teaching through precept and demonstration in the homes of our people what is meant by healthful living. The public health nurse . . . is the connecting link between hospital and home, health department and home, school and home, and industry and home."[20] As another public health professional puts it, the public health nurse is "the vital link between the scientific laboratory and the home in which its discoveries must be applied. She is the 'Minister of Healing and the Messenger of Health.'"[21] Ultimately, the public health nurse's goal is to bring the private home into conformity with the health of the larger community, to inscribe the independent family into the healthy community of the nation.

The scene of a nurse on the threshold to a home is also salient in the archives of the National League for Nursing. Indeed, it is one of the most often reproduced scenes in the League's visual archives. While the recurrence of such images can

be explained by the importance of the home visit in the national plan for securing public health, I would suggest that the repetition of these images helped both nurses and the general public to negotiate and manage anxieties surrounding the nurse's home visit in this period. As Lillian Jeffers, RN, notes in a 1939 article on maternity care in the home:

> Some twenty years ago when the first bill providing for federal aid to states in preserving mother and child health was being debated in Congress, an eminent senator stormed: "Shall the Government, for the first time in America, enter the home, thrust its official nose into family affairs, and assert a right of interference in the holiest, tenderest, most tragic thing that ever occurs upon this earth—the birth of a child?"[22]

In the 1930s, through the figure of the public health nurse, the government was indeed "thrusting its official nose into family affairs." The images of nurses conducting home visits (and delivering babies, as we shall see), script such encounters as friendly meetings; they work to instruct the public and nurses themselves in the proper conduct and feelings to be accorded the home visit.

There are several variations on this theme in the archives of the National League for Nursing, but the nurse's approach to or departure from the home stands out in its photographic collections. We find a young public health nurse knocking at the front door of a home in Marion, Indiana. There is almost a kind of suspense in the image. We do not yet see any of the inhabitants of the house, none of the people the nurse has come to engage. The home appears impoverished, with makeshift, unpainted siding, and uneven, broken planks in the porch. We do not know what scene the nurse is entering, what ailment she has been called upon to help rectify, what lessons she might impart to the inhabitants of this house.[23] In other photographs, family members, especially children, are presented greeting the nurse or seeing her off. An image of a visiting nurse in New Brunswick, New Jersey, shows a nurse ascending brick steps, smiling at the children who greet her. The image promises a happy encounter, perhaps between people who are already well acquainted. Another image shows a friendly departure—a nurse is posed in front of a suburban home, with private brick walkway and gardening beds, seen off by a smiling young girl (Figure 8.2). Finally, we have a group picture posed on the walkway in front of an urban residence. The family is divided by a fence, a boundary that the nurse has already crossed with three of the children who see her off. She is having some kind of humorous exchange with the eldest boy, and the other family members lean in to see their expressions and catch their remarks. The images document encounters in rural, urban, and suburban areas, but while the setting changes, the scene does not.

In all of these images, we do not see the nurse from the point of view of those being visited, nor do we see patients from the point of view of the nurse; instead,

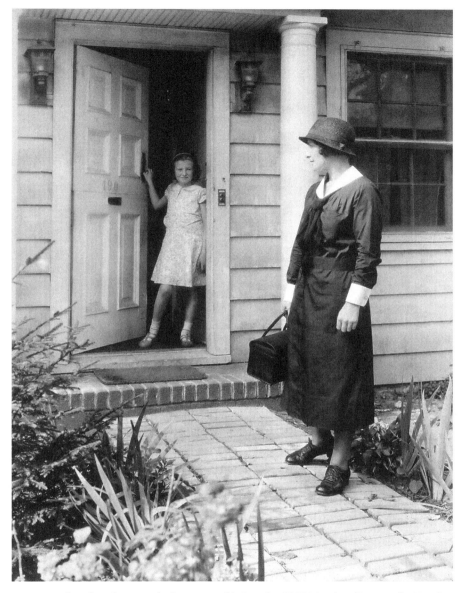

Figure 8.2. Paul Parker photograph, "Home Health Care," NOPHN, National League for Nursing Archives, MSC 274, History of Medicine Division, National Library of Medicine. Reproduced with permission from the National League for Nursing.

we see these scenes from an outside, third position. We are witness to these exchanges and encounters, but we are not part of them. The photographs, then, become performances for an outside gaze. They encourage nurses as well as a wary public to see themselves in these happy pictures, instructing the curious and suspicious in the beneficence of state surveillance and intervention. The

repetition of such images works to make these scenes knowable, ordinary, and even enjoyable.

Such images were made during a historical moment in which the public health nurse could not be certain she would be welcomed in the homes she visited. No longer did she arrive only at a moment of illness and crisis, to render aid to the acutely sick, and to relieve exhausted family members from care. In her new role, especially as agent of the health department, she arrived as both teacher and policer. In a number of health departments in the 1930s, the task of posting and removing quarantine placards fell to the public health nurse.[24] In other words, the public health nurse's job was to evaluate, regulate, and police the home according to state and national standards, laws, and sanctions. In her role as public health instructor, her aim was to teach new practices and to transform personal habits. Writing in 1935, Edith Bryan explained that "The public health nurse makes her approach to her community as an *educator* to teach the subject of health; as an *advisor* to assist in establishing health habits; as the *servant* of the public to actually nurse or serve in certain forms of bedside care or emergency service; and as the *enforcer* of certain rules and regulations in which she has been deputized to express authority in matters such as control of communicable disease, birth registration and supervision of the care of dependents or deficients."[25] In these multiple roles, the public health nurse might be perceived with considerable anxiety by those she served. No longer simply a saving angel, she was newly authorized by the state to survey and discipline the populace. Bryan cautioned: "The nurse or social worker, who may think glibly enough of the 'problem' she is going into the home to solve, should realize to its fullest extent that *she is herself a 'problem' to that home*."[26] The public health nurse "is an *outsider intruding* into the privacy of . . . personal or family life."[27]

Repeated images representing the public health nurse's "home visits" aim to transform an encounter laden with anxieties on both sides of the door into scenes of happy exchange and willing conformity. For the nurse, such images shrink the unknown that may be looming behind the door. For those she visits, the images transpose the nurse from intruder into pleasant professional. In this sense, the photographs teach a broader public what to expect in an encounter with the public health nurse. Additionally, the images also instruct the nurse in how she is to behave; they remind the nurse that she must learn to embody traits that will be welcomed. According to Bryan, one of the "absolutely essential prerequisites for this service is a pleasing personality."[28] The public health nurse's "work is done in every grade of economic life, in every race and nationality, among vastly differing moral and esthetic standards. . . . A keen tact, a calm judgment, a versatility in method . . . and a beauty of adaptation are demanded."[29] The nurse's demeanor, deemed by the NOPHN as her "approach," was considered one of the most important aspects of her work on the home visit, to be evaluated along with

her technique, teaching, the adequacy of her care, and her apparent awareness of an individual patient's place within larger community groups.[30]

If we see the public health nurse first perched on the threshold between public and private spaces, we then find her ensconced in the "inner recesses" of the home. In another of the often-repeated images in the archives of the National League for Nursing, a nurse tends mother and newborn in their home. In these scenes of nurse with mother, it is always the nurse who holds or tends the baby, while the mother or other children, or simply the photographer and later viewer, look on. It is the uniformed woman who nurses the nation.[31]

The repetition of these scenes of nurse with newborn emphasizes the importance of the nurse's relationship to the infant, and also serves to assuage tensions and anxieties surrounding the nurse's new role as educator. According to Bryan, when the parent views the infant as "a much prized, beloved possession," that parent "frequently considers his own opinion concerning the care of the child as the final word not to be questioned or disputed by any outside influence, either personal or official. Such a parent frequently considers the nurse's proffered influence as *intrusive, impertinent* and *vicious*."[32] How the nurse seeks entrée with such a hostile audience is a delicate matter, and if she is not present at the birth, she is encouraged to seek contact with the mother soon after this event, when "the mother feels *weak* and *inadequate*."[33] Here the nurse will find a more willing and malleable student, one more likely to feel grateful and trusting in the future.

In the photographs of nurses tending newborns, then, we have an attempt to get an important set of relationships started off on the right foot. In an image provided by the Henry Street Visiting Nurse Service, for example, the newborn and nurse hold one another in their gazes, and all other eyes are focused on this point.[34] The curve of the nurse's arm encloses the newborn in the sphere of her gaze. They are a little unit unto themselves. While the caption suggests that the nurse is engaging the mother—"The public health nurse demonstrates infant care to the mother"—her entire attention seems concentrated on the infant itself. The intensity of the nurse's focus on the newborn, her relationship to the infant, is the subject of numerous photographs in the National League for Nursing Archives. Indeed, a cropping suggestion on the back of an image from the Ottawa Order of Nurses for Canada would reduce an interesting photograph of five individuals to "baby and nurse" exclusively. Such cropping would extract the ambiguity from this image, excising the somewhat perplexing looks of the other children to focus solely on nurse and infant.

Examples of such "cropped" images abound. In two such photographs, oiled and wrapped infants seem to look out at viewers, while adoring nurses, with soft smiles, bend over in their care (Figure 8.3). The nurse figures saliently in the representation of twins and triplets, reminding us of the dangers of pregnancy and

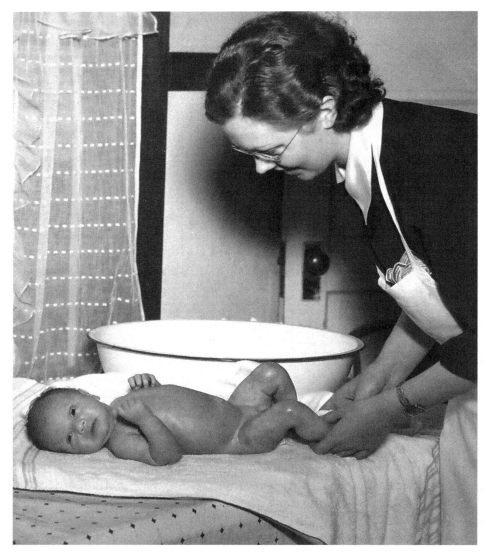

Figure 8.3. "Nurse Bathes the Baby," PHNA, Tacoma, Washington, 1936, NOPHN, National League for Nursing Archives, MSC 274, History of Medicine Division, National Library of Medicine. Reproduced with permission from the National League for Nursing.

birth, and emphasizing the nurse's role as enabler and, perhaps, even as savior. In a 1936 photograph of Miss Finch, of the Visiting Nursing Service of Hackensack, New Jersey, Nurse Finch confidently and comfortably holds the two babies she has presumably helped to bring safely into the world. The image is entitled, simply "TWINS," and the two infants are displayed as the proud nurse's offerings.

The photographs of nurses with babies function as another kind of threshold image. The images document an infant's entry into a life in which children will be

cared for not only by parents but also by an increasingly systematized phalanx of public health professionals. Indeed, a poster for the Children's Bureau visually encapsulates this thesis: "Health Protection for Every Child" presents happy, healthy children playing in a field. This sunny vignette is framed on one side by mother and father figures, and, on the other, by doctor and nurse. Mother and father look remarkably like their professional counterparts, and this visual coincidence, along with their parallel positions, lend the figures equal weight. The poster suggests that the child's health is protected only through this doubled guidance and care. The nurse and doctor, as professional surrogate parents, share the same responsibility as Mom and Dad for raising the nation's children. And as professional parents, nurse and doctor transform mother and father in their own image, training and holding them to new scientific standards of parenting.

The photographs of nurses in home birthing rooms, acting the part of professional parents, also work to replace and supplant the cultural images of midwives in these intimate scenes. In the first decades of the twentieth century, particularly in the South, African-American midwives continued to deliver many of the babies born in rural communities. Tending predominantly to African-American women, they nevertheless also delivered babies for white women, crossing social, economic, and racial boundaries in ways that few other individuals did or could.[35] In the National League for Nursing's photographs of young, white, uniformed nurses proudly holding the white babies they have helped bring into the world, licensed professional white women now assume roles that were traditionally held by African-American women. The images register a transitional phase in the transformation of delivery across the nation. As birthing was increasingly medicalized in the first decades of the twentieth century, physician-attended deliveries in hospitals became the ideal, especially for middle-class white women.[36] But until such an ideal could become a reality, especially in rural areas, the trained public health nurse served as the physician's surrogate, and many public health nursing agencies and associations continued to offer delivery services as part of their maternity programs.[37] The white public health nurse was posed as the next best thing to the white doctor, a forward step in medical care away from the African-American midwife, deemed "ignorant," "untrained," "dirty," and "superstitious." Thus, in the National League for Nursing Archives, the process of professionalizing, regulating, and managing birth is also represented as one of "whitening" birth.

As photographs of the white nurse in the home birthing room challenged the presence of the African-American midwife in these spaces, white professional women also assumed a greater portion of responsibility for regulating racial separation through birth registration. As Gertrude Jacinta Fraser has argued in her study of African-American midwifery in Elizabeth City, Virginia, midwives themselves were accorded an important position in racial regulation after 1924, when the Virginia state legislature passed a set of laws for the "'preservation of

racial integrity.'"[38] During the 1920s and early 1930s, the height of the eugenics movement in the United States, midwives were required to report the race of each child they delivered, transforming the birth certificate into a document of racial delineation. In accordance with "one drop" identity laws, the midwife was to record the exact racial makeup of all babies in order to prevent the passing of light-skinned infants. Misrepresentation of an infant's race was considered a felony, and carried a penalty of one year in the state prison.[39] As Fraser has perceptively noted, such regulations put the African-American midwife in a difficult position, particularly when biracial babies were born to white women, the supposed biological protectors of imagined white racial purity. Such cases of interracial reproduction, if recorded, could easily be manipulated by white supremacists as "evidence" of rape, and invoked as the justification to terrorize African-American men in the community.[40] In this complicated racial framework, the white public health nurse represented in the white woman's birthing room, holding and caring for a fat white baby, is posed as a racial regulator with the "proper" cultural investments and racial loyalties.

As the public health nurse was newly charged with regulating birth in the delivery room, she was also newly tasked with regulating the African-American midwife herself. Once again, while many held physician-attended births in hospitals as the ideal, public health practitioners nevertheless realized that such an ideal was unreachable for many in the South and Southwest in the 1930s. According to Elizabeth Ferguson, RN, a nurse-midwife for the Maryland Department of Health, "In the ten states from Virginia south to Florida, and west to Arizona, midwives delivered at least 174,000 babies in 1936."[41] While state health departments had been licensing, regulating, and instructing midwives for years, the Social Security Act placed more public health nurses in rural areas after 1935, and these tasks increasingly fell to them.[42] Nurse instruction of midwives emphasized the use of clean linens, or newspapers where linens were scarce, practices for cutting and caring for the umbilical cord, and drops for the babies' eyes. Many nurses also held their most important job to be that of dispensing essential supplies to midwives at reasonable prices.

"The bag" played a central role in the public health nurse's regulation of midwives. Indeed, the "meticulously efficient bag" was fundamentally important to the nurse's own professional self-image. The streamlined, boxy bag is pictured as the constant companion of the snappy nurse in the photographs of the National League for Nursing Archives. Along with coats and hats, it is consistently marked as a status symbol in the journal of *Public Health Nursing*'s slim advertising section. In a Stanley Supply Company ad of 1936, the New York business promotes "The Miracle Bag": "It is no mere flight of fancy that causes so many patients to refer to the Visiting Nurse's Bag as 'the miracle bag' . . . 'the magic bag.' For when the nurse calls on the sick, to them her bag seems a symbol of hope. Your V. N. Bag

goes a long way toward inspiring real confidence, when it's a genuine STANLEY—with each detail refined to high professional standards, and sturdily built for extra rugged wear."[43] We see a further illustration of this "magic bag" concept in a 1937 photograph by Paul Parker, entitled "Nurse Opening Bag—Little Girl Watches" (Figure 8.4). In this lovely image, the nurse is lit from both inside and out; window

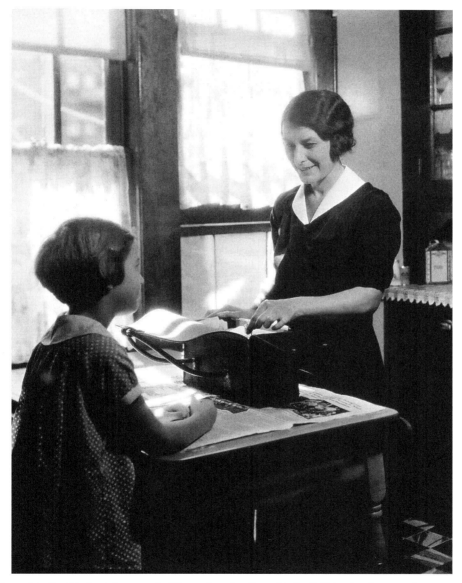

Figure 8.4. Paul Parker Photograph, "Nurse Opening Bag—Little Girl Watches," 1937, NOPHN, National League for Nursing Archives, MSC 274, History of Medicine Division, National Library of Medicine. Reproduced with permission from the National League for Nursing.

light touches her right side, which we just barely glimpse from our vantage deeper inside the room; her left side is illuminated by an inside light, focused solely upon her. The light ennobles the nurse as a kind of glowing angel, entering a home ebbing into shadow. Her bag is the gift she brings to this family, and it is posed as an intermediary between herself and the child, who appears happy to see her, and curious about her means and methods. As her fingers touch the bag and its wares, the nurse looks not down, but into the eyes of the child whose posture and curled hands nearly approach a pose of reverence.

So fundamental was the nurse's bag to her professional self-image, that one visiting nurse referred to herself and her colleagues as those who "carry the bag," and the bag itself figured as main character and, indeed, as the *narrator* of a humorous story for *Public Health Nursing* in 1936. In "The Black Bag," a "little tale of a day in the life of a black bag," the bag/narrator proclaims: "Without a doubt you have noticed me before and wondered just what I contained. . . . Although I am quite an ordinary black leather bag, my contents are far from being ordinary. Standing like soldiers against the length of one wall are, first, the stately green soap bottle, its solution being used to clean the two thermometers you see standing as sentinels on the opposite wall." Launched in this strangely militarized language, the black bag's soliloquy continues to list, in minute detail, its contents, and then goes on to tell humorous anecdotes about the patients it visits with the person it calls "my nurse."[44]

The bag also served as a disciplinary site in the public health nurse's training and licensing of midwives. In the frequently racialized, and often racist, depictions of "unlettered but faithful," "old 'granny'" African-American midwives, the suitability of the midwife, her knowledge and professional competence, is measured by the contents of her bag, "its cleanliness and neatness." Addressing nurses called upon to train and supervise midwives, Laura Blackburn, RN, District Supervisor of Maternal and Child Health for the State Board of Health in Columbia, South Carolina, advises: "A ruthless hand is needed to cast out of the bag such things as pipes, tobacco, spectacles, and other foreign objects."[45] As Fraser has argued, "Because there were not enough nurses to monitor the private relationships between midwife and client, the bag inspection and the immediate threat of sanctions provided the public health nurse with a visible symbol of her authority. The bag inspection became, therefore, the site of the struggle between the nurse professional and the African American midwife."[46] And this struggle was not one-sided; indeed, Valerie Lee has called the midwifery bag a "bag of resistance," and has suggested that many "grannies" may have kept two bags—"one for inspection and one for delivery."[47] Knowing that she must pass the nurse's inspection in order to keep her license, the midwife may have kept all and only those medically "approved" items on view while nevertheless refusing to discard her own tried and true teas and balms when it came time to actually deliver a baby.

The public health nurse's monitoring of midwives extended beyond the bag. In an article describing the midwife program in Florida, Jule O. Graves, RN, explains that "the state is now trying to educate and control and replace . . . old midwives, . . . aged granny women who are still in a stage of primitive medicine."[48] Outlining various efforts made in midwife education and replacement, the article provides photographic models of an "old granny" midwife (the midwife of the past), "a midwife of today," and the "midwife of the future," situating the three women along a timeline of "progress." "Granny" is depicted standing in front of a worn house. She leans upon a cane, wearing a floppy bonnet and the "long skirts" public health nurses associated with a somewhat humorous past of their own. The "midwife of today," "Ida Whitfield," is shown giving a demonstration in infant care. Sitting outdoors on concrete steps, this apparently middle-aged, heavyset woman exhibits a white baby doll in a handmade baby bed, along with baby clothes and other articles of baby care. A detailed caption tells us that she has formed a "mothers' and infants' club" that offers supplies and volunteer cooking and cleaning services to needy new mothers. Finally, the "midwife of the future," "Ethel May Jones," a slim young woman, with notably lighter skin than her predecessors, stands erect in a formal interior setting (Figure 8.5). Her uniform, shoes, and bag very closely resemble those of the public health nurse. Indeed, it would appear that the "future midwife" of Florida will not only be modeled on the public health nurse, she will herself be a nurse, for as Graves notes, "It is hoped that in time the old illiterate midwife will be replaced by the nurse midwife. . . . The plan is to have a nurse midwife in every county health department."[49]

African-American women worked not only as midwives, but also as public health nurses in this period. Despite discrimination and limited educational opportunities for graduate study in public health, African-American women pursued careers in public health nursing beginning in 1900 with Mrs. Jessie Sleet Scales's work with the Tuberculosis Committee of the Charity Organization Society in New York City.[50] Other early leaders include Mrs. Elizabeth Tyler Barringer, who worked for Miss Lillian D. Wald, pioneer of public health nursing in the United States, at her famous Henry Street Settlement in New York City.[51] Yet, in the mid-1930s, there were only about six hundred practicing African-American public health nurses.[52] The NOPHN actively encouraged and supported African-American women's entrance into the field of public health nursing in this period, arguing that "Negro nurses should replace white in attending to the needs of their own race."[53] While such statements of support resonate with segregationist overtones, they also acknowledge that the white nurse was not always trusted by African-American communities.[54] Throughout the 1930s, at a time when the American Nurses Association allowed its southern state affiliates to deny membership to African-American nurses,[55] the NOPHN was an advocate for African-American public health nursing and supported the efforts of Mabel K. Staupers

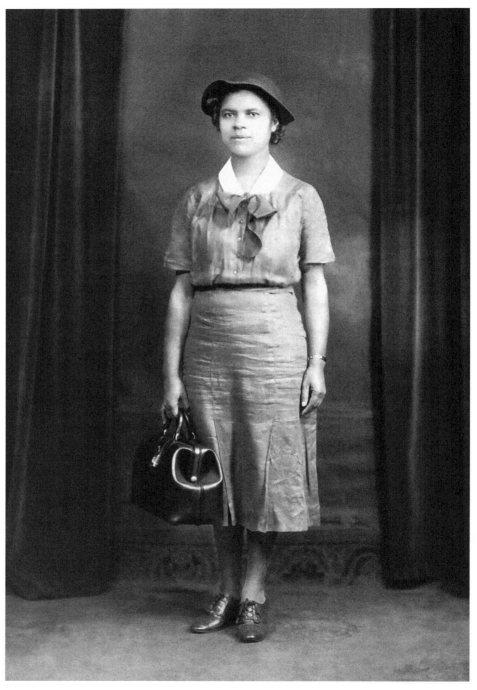

Figure 8.5. "Ethel May Jones—Midwife of the Future," NOPHN, National League for Nursing Archives, MSC 274, History of Medicine Division, National Library of Medicine, reproduced in *Public Health Nursing* 31, no. 10 (October 1939). Reproduced with permission from the National League for Nursing.

and Estelle Massey Riddle to reinvigorate the National Association of Colored Graduate Nurses.[56]

Visual representation of African-American nurses is rather slight in *Public Health Nursing,* and generally confined to specific articles on "Negro Health" issues. But there is at least one salient exception to this general rule. In the 1930s, the journal ran a "Nurse-of-the-Month" column, celebrating the work of the NOPHN's members, and illustrated with portraits of the individuals so honored. In July 1936, the "Nurse-of-the-Month" was Sarah Brooks, a public health nurse in Alabama (Figure 8.6). Like many of her peers, Brooks is photographed in her uniform, smiling, standing by her car. The brief biographical sketch that frames and introduces her own epistolary essay announces her racial identity in rather coded terms. The biographical note, written in the third person, begins:

> Thirty-one years ago on February 7, in the wee hours of the morning, a country doctor delivered a girl baby in Wilsonville, Alabama. She was named Sarah Elizabeth by her parents. A five-year-old cousin thought she was very nice, but "awfully sunburned." Less than one year later the proud father left the beautiful young mother all alone with the task of fitting this small but energetic piece of humanity for some sort of service to the world.[57]

Brooks's life history begins with a tale that most fiction writers of the time would have ended as a tragedy, with the "beautiful young mother" killing herself,[58] or an African-American man being lynched for the crime of having sexual contact with a white (or seemingly white) woman. And while Brooks's father does abandon mother and child, her mother nevertheless sees her child graduate from college, attend graduate school, receive a nursing diploma, and dedicate her life to serving others.

In her essay, Brooks describes her work in Talladega County, Alabama, a county in which "over one-third of the population is colored." She discusses her group teaching experiences with "'ole granny women" midwives, in colored health centers giving classes in prenatal and infant care, and her work "among the white people" with health classes and home demonstration clubs. Noting that she often encouraged participation in such events by advertising that she would also play a few songs on the violin for the audience, Brooks tells of "a little sooty-faced, tow-headed six-year-old" who "piped up with, 'Miss Brooks, when are you gonna 'diddle that fiddle?'"[59]

Given the attention that nurses, doctors, and midwives were meant to give to the racial differentiation of infants at birth and the eugenicist overtones of such surveillance and documentation, Sarah Brooks's position as the mixed-race arm of the state is especially interesting. As her story clearly demonstrates, she moves easily across the color line, and finds poor white children at least as amusing as "granny" midwives, reproducing their speech in dialect for humorous effect. She has the mobility, freedom, and independence of the public health nurse, and

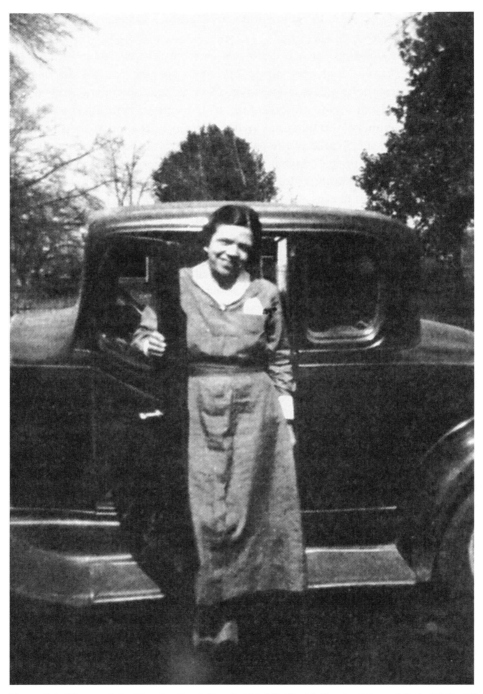

Figure 8.6. "Nurse-of-the-Month—Sarah Brooks," *Public Health Nursing* 28, no. 7 (July 1936): 475. Reproduced with permission from the National League for Nursing.

functions as the state's representative to educate, serve, and monitor a diverse rural population.

Even as she was celebrated as a new kind of professional parent, the public health nurse was situated at the center of conversations about race and propagation in several different ways. Some voiced concerns about the infrequency with which these modern young women became birth mothers themselves in the eugenical language that characterized many public discussions about reproduction. For some, especially for eugenicists, the nurse's social role as a parent teacher who was not a parent in her own right was a serious dilemma. Paul Popenoe, General Director of the Institute of Family Relations in Los Angeles in 1936, deems "the low marriage rate of educated women" a "special problem" in maintaining the family life of the nation. "Nurses offer a good illustration of this almost universal tendency. It appears that little more than one half of the graduates of the average school of nursing ever marry. Yet they represent a highly selected group in physique, in intelligence, and in emotional normality, not to mention the fact that they have an education that fits them for motherhood much better than does the education of most women. Socially and eugenically, there is no excuse for such a situation."[60]

The story of nurse Sarah Brooks poses special problems for the eugenicist. Although Popenoe might have been happy if this particular public health nurse did not have children (as eugenicists always feared mixed racial ancestry), he might also have been troubled by the fact of a woman of mixed racial ancestry professionally "mothering" the nation. Brooks's mobility as a public health nurse demonstrates the extent to which public health nurses in general claimed a new kind of social space in the 1930s. These professional, independent, and dynamic young women were newly authorized to be the face and functionaries of the state. The public health nurse was newly charged not only with producing national health but also with producing the nation itself in new ways. Through her work in millions of homes, she outlined healthy habits for citizens and defined communities in accordance with national standards of health. The members of her imagined communities could be measured, charted, and graphed; they also could be disciplined and transformed. And yet, as her work as professional parent and public health teacher encouraged her to establish norms of healthy behavior for others, her own performance as the state's representative enabled her to side-step other national duties, namely the traditionally gendered roles of wife and mother. As professional parents and educators, public health nurses were situated at the center of a new kind of nation-building—they reproduced the nation through the standards of systematized health care, not through their own bodies. As professional parents, they need not themselves be birth parents. Like the silhouette marching across the pages of the NOPHN's journal, the public health nurse, in her snappy new uniform, could remain mobile, crossing the thresholds of private and

public in both directions and moving both into as well as out of the home. As official agents of the state and practitioners of a new kind of nation-building, these modern young women could choose not to nurse their own babies, but instead, to nurse the nation.

Notes

1. Annie M. Brainard, *The Evolution of Public Health Nursing* (1922; repr., New York: Garland Publishing, 1985), 333. Brainard was at one time the president of the Visiting Nurse Association of Cleveland.

2. Brainard, *Evolution of Public Health Nursing*, 419.

3. According to nurse and professor M. Louise Fitzpatrick, "Undoubtedly the most important event which took place during the nineteen-thirties was the passage of the Social Security Act. . . . Its promotion of health and social services under government auspices gave a permanency to the idea of tax-supported public health nursing service and encouraged development of these where they had not existed before." Title V of the act gave special "provisions for maternal-child health and crippled children's services." M. Louise Fitzpatrick, RN, EdD, *The National Organization for Public Health Nursing, 1912–1952: Development of a Practice Field* (New York: National League for Nursing, 1975), 121. In 1933, the Federal Emergency Relief Act, under Rules and Regulation number 7, made it possible for those offering bedside nursing care to the poor to make a claim on public relief, and the Civil Works Administration established relief projects for unemployed nurses. Fitzpatrick, *National Organization for Public Health Nursing*, 110.

4. In 1930 one-third of public health nursing agencies were still privately administered, such as visiting nurse associations and Red Cross nursing services. National Organization for Public Health Nursing, *Survey of Public Health Nursing*, ed. Katharine Tucker (New York: The Commonwealth Fund, 1934), 8.

5. Brainard, *Evolution of Public Health Nursing*, 393. Brainard also states: "That public health nursing is gradually being looked upon more and more as a public function, to be paid for by the state, county, city, or even federal taxes, and made available for all, is certain" (402).

6. Ibid., 420.

7. Barbara Melosh and Susan Reverby both note the autonomy and independence of public health nurses relative to other nurses working more directly under the supervision of physicians in hospitals or as private-duty nurses. Barbara Melosh, *"The Physician's Hand": Work Culture and Conflict in American Nursing* (Philadelphia: Temple University Press, 1982), 114; and Susan M. Reverby, *Ordered to Care: The Dilemma of American Nursing, 1850–1945* (Cambridge, Mass.: Cambridge University Press, 1987), 110.

8. Rima D. Apple has studied photographs of nursing from the 1890s and early 1900s, suggesting that photographs provide a unique kind of historical evidence, disclosing "physical details and textures only implied in written and oral sources," and showing "relationships among people and between people and institutions not discussed explicitly in other types of sources." Rima D. Apple, "Image or Reality? Photographs in the History of Nursing," *Images of Nurses: Perspectives from History, Art, and Literature*, ed. Anne Hudson Jones (Philadelphia: University of Pennsylvania Press, 1988), 40–62, 40. While I agree with Apple, I would like to suggest that we can take our reading of photographs a couple of steps further as well, to understand them as rhetorical and political representations that make claims in contested cultural conversations. In other words, photographs do not simply nuance our

understanding of history, they also make claims on history, functioning as sites through which a particular historical narrative is proposed or challenged, functioning as propaganda for a particular *vision* of history.

9. E. M., "What's Changed?" *Public Health Nursing* 29, no. 6 (June 1937): 341. See images in *Public Health Nursing* 29, no. 1 (January 1937): 23, and *Public Health Nursing* 29, no. 4 (April 1937): 210.

10. E. M., "What's Changed?," 341.

11. "Uniforms Keep Up to Date," *Public Health Nursing* 30, no. 2 (February 1938): 105–6. See images such as: Henry St. nursing costumes of 1893 and the 1930s in the National League for Nursing Archives MSC 274 HMD/NLM; "Henrietta Hoffman, the public health nurse of 1937, and Lulu St. Clair, representing the public health nurse of 1912," *Public Health Nursing* 29, no. 5 (May 1937): 291; "Mrs. S. I. Bolton, Nashville's first public health nurse, appointed in 1911, and Sara Sprouse, Nashville's public health nurse appointed in 1936," *Public Health Nursing* 29, no. 3 (March 1937): 156; "New York pageant participants Katherine Payne, the Public Health Nurse of 1912, and Florence Badorf, the Public Health Nurse of 1937," *Public Health Nursing* 29, no. 10 (October 1937): 568; and finally as represented by two dolls in a Connecticut State Health Department exhibit entitled "Yesterday and Today in Public Health Nursing" *Public Health Nursing* 29, no. 2 (February 1937): 124.

12. NOPHN, *Survey of Public Health Nursing*, 110–11.

13. The silhouette image itself undergoes a change between the years 1933 and 1934. The image used prior to 1934 is less streamlined overall: it is thicker, the nurse's skirt fuller, her bag larger, the accents of her uniform a bit more flouncey, her tie blowing behind her, her back arched and her step extremely wide. I imagine she is meant to be depicted running, or nearly so. Compared to the later image, the 1933 silhouette would seem to depict a nurse slightly out of control.

14. C. E. A. Winslow made these comments regarding the dedication address of Dean Annie W. Goodrich for the new building of the Henry Street Nursing Service. C. E. A. Winslow, "National Health Challenges—How the Public Health Nurse Is Meeting Them," *Public Health Nursing* 27 (March 1935): 120–24.

15. Attesting to the ubiquity of this image, an announcement in the magazine declared: "You are probably all familiar with the silhouette of the nurse who so often strides across these pages." For "Poster Lady," see Providence, Rhode Island, District Nursing Association exhibit in "Gleanings" *Public Health Nursing* 29, no. 1 (January 1937): 53.

16. Barbara Melosh, *"The Physician's Hand,"* 135. Melosh and Susan Reverby also describe the public health nurse's work in terms of class. According to Reverby, public health nursing "provided the predominantly lower- and working-class patients with lessons in proper middle-class health behavior." See Reverby, *Ordered to Care*, 110. Melosh similarly states: "Good health could become a code for middle-class standards and practices, and, like other types of reform, public health could become a vehicle for social control." Melosh, *The Physician's Hand*, 134. Daniel Walkowitz has made a similar argument about social workers: "The heart of the social workers' job as gatekeepers of public and private relief aid has always been patrolling the boundaries of class." According to Walkowitz, however, the social worker actually produced and reproduced class *divisions*, shoring up her own status as middle-class by determining the "dependency" of her less-privileged clients. Daniel J. Walkowitz, *Working with Class: Social Workers and the Politics of Middle-Class Identity* (Chapel Hill: The University of North Carolina Press, 1999), 10.

17. See chapter 10, "The Nursing Program," in NOPHN, *Survey of Public Health Nursing*, 146–91.

18. Winslow, "National Health Challenges," 122.

19. Edith S. Bryan, *The Art of Public Health Nursing* (Philadelphia: W. B. Saunders, 1935), 35.

20. Dorothy Deming, RN, "The Function of the Public Health Nurse," *Public Health Nursing* 29, no. 4 (April 1937): 246–47.

21. Winslow, "National Health Challenges," 122.

22. Lillian Jeffers, "Maternity Care in the Home," *Public Health Nursing* 31, no. 12 (December 1939): 661–67.

23. Marion, Indiana was the site of one of the most infamous lynchings in U.S. history. On August 7, 1930, two young African-American men were dragged from jail, murdered, and hung from a tree in the courthouse lawn, while thousands of white men, women, and children looked on. Dora Apel and Shawn Michelle Smith, *Lynching Photographs* (Berkeley: University of California Press, 2007). See also James H. Madison, *A Lynching in the Heartland: Race and Memory in America* (New York: Palgrave, 2003).

24. NOPHN, *Survey of Public Health Nursing*, 169.

25. Bryan, *Art of Public Health Nursing*, 15, emphasis in original.

26. Ibid., 35–36, italics added.

27. Ibid., 226, italics added. As M. Louise Fitzpatrick notes, however, the Depression of the 1930s was also a period in which the extreme needs felt by so many actually opened doors to the public health nurse. She quotes Mary Gardner, a board member of the NOPHN in the 1930s, who proclaimed: "'We have gained something almost inestimable in its importance; everywhere a ready entrance into the homes of the people.'" Fitzpatrick, NOPHN, *1912–1952*, 109.

28. Bryan, *Art of Public Health Nursing*, 16.

29. Ibid., 14.

30. NOPHN, *Survey of Public Health Nursing*, 194.

31. According to Barbara Melosh, "maternal and infant welfare programs were the most common activities of public-health nursing agencies throughout the 1920s and 1930s." Melosh, *"The Physician's Hand,"* 120.

32. Bryan, *Art of Public Health Nursing*, 118, emphasis in original.

33. Ibid., 122.

34. This photograph is reproduced in *Public Health Nursing* 29, no. 2 (February 1937): 77.

35. Gertrude Jacinta Fraser, *African American Midwifery in the South: Dialogues of Birth, Race, and Memory* (Cambridge, Mass.: Harvard University Press, 1998), 186.

36. According to Gertrude Jacinta Fraser, "Public health officials hoped that only a few 'properly' trained women would remain during the transition phase and that eventually all midwives would be replaced by physicians." Fraser, *African American Midwifery in the South*, 118.

37. NOPHN, *Survey of Public Health Nursing*, 147.

38. Fraser, *African American Midwifery in the South*, 72.

39. Ibid., 74.

40. Ibid., 74–75.

41. Elizabeth Ferguson, RN, "Midwifery Supervision," *Public Health Nursing* 30, no. 8 (August 1938): 482–85. Valerie Lee notes that while "the greatest numbers of practicing grannies were from the turn of the century through the mid 1920s," as late as the 1940s "grannies" continued to assist in more than 60 percent of the childbirths by African-American women in the South. Valerie Lee, *Granny Midwives and Black Women Writers: Double-Dutched Readings* (New York: Routledge, 1996), 6–7.

42. Ferguson, "Midwifery Supervision," 482.

43. *Public Health Nursing* 28, no. 10 (October 1936): inside back cover.

44. Helen Snow, RN, "The Black Bag," *Public Health Nursing* 28, no. 4 (April 1936): 222–23.

45. Laura Blackburn, RN, "Searchin' the Midwife's Bag," *Public Health Nursing* 29, no. 2 (February 1937): 119–21. The photograph of a young nurse knocking on the door of an impoverished home, from the Health Center of Marion, Indiana, was used to illustrate this story, and given the caption "A Bag and Its Owner."

46. Fraser, *African American Midwifery in the South,* 114.

47. Lee, *Granny Midwives and Black Women Writers,* 43–44.

48. Jule O. Graves, RN, "The Midwife Program in Florida," *Public Health Nursing* 31, no. 10 (October 1939): 527–31.

49. Ibid., 531.

50. Mabel Keaton Staupers, RN, "The Negro Nurse in America," *Opportunity: Journal of Negro Life* 15 (November 1937): 339–41, 349, 125. Reprinted as Document 19 in Darlene Clark Hine, ed., *Black Women in the Nursing Profession: A Documentary History* (New York: Garland, 1985), 125–27.

51. Ibid., 126.

52. Dorothy Deming, RN, "The Negro Nurse in Public Health," *Opportunity: Journal of Negro Life* 15 (November 1937): 333–35. Reprinted as Document 13 in Hine, *Black Women in the Nursing Profession,* 97–99.

53. Ibid., 99.

54. Barbara Melosh has argued: "Especially in rural districts, public-health agencies used black nurses for their black clients with an alacrity that seemed to come more from white nurses' reluctance to cross color lines than from an enlightened appreciation for black colleagues." Melosh, *The Physician's Hand,* 124.

55. Darlene Clark Hine, *Black Women in White: Racial Conflict and Cooperation in the Nursing Profession, 1890–1950* (Bloomington: Indiana University Press, 1989), 109.

56. Hine, *Black Women in White,* 110–18. In 1930 the NOPHN conducted a study of Negro Public Health Nursing sponsored by the Julius Rosenwald Fund. Fitzpatrick, *NOPHN, 1912–1952,* 117.

57. "Nurse-of-the-Month: Sarah Brooks, Alabama," *Public Health Nursing* 28, no. 7 (July 1936): 475–77.

58. I am thinking of Kate Chopin's "Desiree's Baby" here.

59. "Nurse-of-the-Month: Sarah Brooks, Alabama," 475–77.

60. Paul Popenoe, ScD, "The Family in Society," *Public Health Nursing* 28, no. 9 (September 1936): 567–72.

PART III *Building New Public Spheres for Public Health*

9. *Visual Imagery and Epidemics in the Twentieth Century*

ROGER COOTER AND CLAUDIA STEIN

THERE CAN BE FEW BETTER PLACES to begin thinking about public health and visual imagery than Oliviero Toscani's wonderfully irreverent poster on the death of the American AIDS activist, David Kirby (Figure 9.1). First released as a press photo in November 1990 entitled "Final Moments" and reconceived by Toscani as a part of an advertising campaign for the United Colors of Benetton in 1992,[1] it was greeted with howls of protest and prohibitions. The Germans took it to court, French bill-stickers refused to post it, and, in Britain, *The Guardian* (the first newspaper to run it as a full-page advertisement) was inundated with letters of complaint.[2] Even

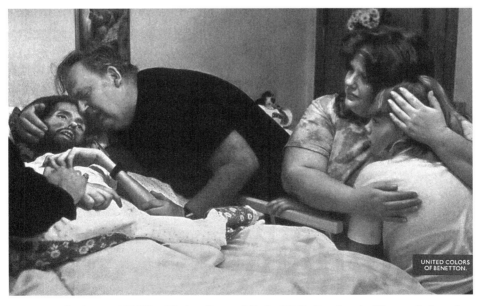

Figure 9.1. "Dying on AIDS" by Oliviero Toscani (Italy, 1990). Reprinted with permission of United Colors of Benetton, copyright 1998 Benetton Group S.p.A. Photograph by Therese Frare, concept by Oliviero Toscani.

some of those in the world of advertising worried over its ethics.[3] What had the world come to that an "immoral" victim of "unnatural" sex should be depicted Christ-like and comforted by an overweight Mary Magdalene in drag with a (Pietá-like) Virgin Mary and child looking on, all cross-dressed in the vestments of modernity?[4]

It is not, however, the poster's multiple transgressions of religious, moral, and gender orders that suits it for the concerns of this essay. Rather, what makes it noteworthy is what seemed at the time its impertinent exploitation of a tragic medical circumstance simply to sell fashion knitwear. Audaciously, Toscani's image publicly profaned the private space for death, dying, and disease made sacred by the medical profession, and in so doing violated the humanitarian sensibilities and proprieties that had customarily been granted to that profession. Like anatomist Gunther von Hagens's sensationalist public displays of "plastinated" human bodies,[5] Toscani's poster deliberately confused the conventional distinction between commercial marketing and medical humanitarianism by blurring the normative boundaries between public art and private anatomy/medicine. As such, it raises interesting questions about the history and nature of medicine's visual representation, about who owns and controls such images, and about how any complicity with them may have been established.

Toscani's image also remains heuristically useful in confounding the authority of modern medicine in general. It harkens to a death in postmodern times as great as Christ's in premodern times—the death, one might hazard to say, of nothing less than the all-embracing, all-powerful secular grand narrative of scientific medicine. In the face of the AIDS epidemic this narrative was stripped of its pretensions, and modern scientific medicine exposed as helpless. Indeed, Toscani's poster might be read to joke that since biomedicine could offer no answers to the new plague, one may as well put one's faith in God.

This essay is not the place to rehearse the history of the impact of AIDS on Western medicine in the late twentieth century. Suffice it to say that the epidemic seriously compromised what was until then one of medicine's triumphant ruling paradigms, that epidemical disease could be understood in terms of monocausal agents. Hitherto, for the best part of a century before AIDS, the Henle-Koch postulates—three independent criteria that have to be satisfied before an agent can be causally related to a disease—provided a seemingly objective scientific basis for Western medicine.[6] But from the late 1980s, especially around the debate over whether HIV caused AIDS, all this that seemed so solid began to melt into air. Like the hold of the living upon the dying in Toscani's tableau, medicine was losing its grip. Books like Jad Adams's *AIDS: The HIV Myth* (1989),[7] drawing on the research of dissenting retrovirologists, called into question the sufficiency of the notion that a single agent could be responsible for the epidemic, and seeded doubt that the medical profession was capable of effecting anything like a cure. Undermined

was medicine's status-enforcing claim that it could eradicate epidemic disease. Moreover, increasingly, public claims and counterclaims over the cause of AIDS steadily eroded the premise that medical research had a microbelike single objective scientific method. As the sociologists of science Joan Fujimura and Danny Chow were quick to point out in 1994, the debate over whether HIV caused AIDS hastened a relativist understanding of scientific statements, theories, and facts (at the same time as it highlighted the importance of politics and big money in biomedical research). Consequently, scientific truth was increasingly to be seen as "true" only to "a set of self-authenticating techniques based within particular styles of scientific practice."[8] Compromised was the idea that science uttered universal and eternal truths based on disinterested objective research.

Connected to this were changes wrought in the social relations of medicine. As Steven Epstein observed in 1996, AIDS caused the boundaries between scientist "insiders" and lay "outsiders" over research and treatment to crisscross to an unprecedented degree. Individual patients were encouraged "to seek new ways of relating to their health-care providers and vice versa."[9] A variety of organized challenges to biomedicine were inspired, some of which developed into full-fledged social movements. AIDS activists began to command a voice in political and scientific circles sufficient to shape government funding for research. Last, but not least, AIDS served to undermine preexisting notions of individual sickness. Once multifactoral explanations for AIDS came to be accepted by the medical establishment, the syndrome developed into and confirmed a more-or-less individualized view of sickness and health. AIDS victims, in not being "diseased" as such, died in uniquely individual ways from nonuniform causes that were governed by the peculiarities of their immune systems.

It would be difficult to maintain that medicine (re)turned to a nonstandardized early modern humoral-like understanding of the body as ruled by its very own nature. While there is some evidence that hitherto uniformly applied medical procedures and protocols began to be challenged and destabilized,[10] on the whole, medicine did not noticeably move in the direction of neohumoralism. Indeed, it could be argued that biomedicine became committed more than ever to a new reductive paradigm, DNA sequencing. At any rate, by the new millennium, there was agreement in medicine that HIV *was* the cause of AIDS.

Nevertheless, even if, ultimately, AIDS was scientifically tamed and faith was restored in biomedical research and its capacity to produce universal truth, the AIDS epidemic signalled a departure from the "mass medicine" of the "golden age of medicine" in which all bodies were construed as essentially the same in terms of their response to disease agents and would-be countervailing "magic bullets." It is this return of the patient to a premodern world of individuated suffering in the face of biomedicine's message of universality that Toscani's image of David

Kirby's last moments appears to symbolize and celebrate through no less a unique body than that of Christ.

However, we do not draw attention to it here simply as a means to access the historical significance of AIDS for modern medicine. Apart from its epidemical subject matter, our primary reason for focusing on it is precisely because it is a *poster*—a large, mass-produced advertisement intended for print media or displayed on walls and billboards for the purposes of selling something to a general public.[11] As such it does as much for forcing us to think about this particular genre in visual culture as for reflecting on modern (Western) medicine as a whole from a post-AIDS perspective and, crucially here, for contemplating the relations between them. For the history of this twentieth-century pictorial genre (and in relation to epidemic-related public health posters, in particular) it operates in the same destabilizing way that it does for medicine's golden age as a whole: that is, through transgressions that render it novel and strange. It lifts to the surface unspoken conventions and implicit assumptions that compel us to ask questions about the how, when, where, and why of this type of visual representation. Moreover, because Toscani's poster is *not* a public health poster but a commercial advertisement, it smudges the boundary between, on the one hand, what is professional (in medicine) and therefore ostensibly in the public interest, and, on the other, what resides in and serves private enterprise in contemporary Western culture. Furthermore, in focusing on a sexually transmitted disease, it raises to a fine point the permissible boundaries between the public and the private and therefore prompts questions about how these boundaries were established and authenticated in the first place.[12] Finally, in appearing only five years after the first public health posters for AIDS were created,[13] Toscani's poster-advertisement encourages reflection on the fate of public health posters in the time of AIDS. It is this above all—the nature of the public health poster as it enters the twenty-first century, which Toscani's image captures so succinctly—that drives this essay.

A few caveats are necessary before we begin. The first is that in concentrating on the visual history of public health posters dealing with epidemical subjects, this essay does so with the consciousness that posters are material objects that function in a discursive world. We do not therefore hold with the belief of some commentators, that the visual must be interpreted only *from* the visual.[14] Admittedly, "looking practices" are not the same as "reading practices"; but images need to be regarded as constitutive of discursive realms rather than serving, as historians often deploy them, as mere reflections of a "reality" perceived as something other.[15] In this sense, "discourse" refers not to language as separate from a "real" material world but to organizing sets of signifying practices that cross the boundary between "reality" and language and convey meaning through form as well as content.[16] Ideally, a history of public health posters would be written according to

two methodological registers made seamless: one concerned with the conditions of possibility for discursive objects of thought, and one (more conventionally historical) concerned with contingent material and political conditions of possibility for transient visualizations. Practically, however, this seamlessness proves to be next to impossible to achieve, especially for an object like a public health poster that is by definition ephemeral and assumed to be capable of "speaking for itself." It is also an object that has received little serious attention either from historians or from students of visual culture.[17] This essay therefore weaves between these two registers in its effort both to *problematize* the public health poster as a particular artifact of visual culture and *historicize* it as a particular artifact of the history of medicine—albeit in a provisional exploratory manner, with little contextual specificity, and under the constraint of limited scope for illustration.

Second, although public health posters might be said to operate by evoking a controlled form of fear and anxiety for purposes of rational governance over personal and/or national life, the degree to which any emotional response to them can be generalized, either in terms of the intent to instill it by producers of posters, or in terms of viewers' reactions, remains an open question. Fear and anxiety, like pain, are not "natural," transhistorical phenomena but reactions culturally shaped and publicly registered, as well as, in the case of diseases, conditioned by real or fantasized epidemiological memory. Add to this the multiple configurations of individual health experiences; microbelief systems; social, political, and economic circumstances; and locally learned ways of viewing (among much else), and it is only too apparent why the question of measuring a poster's "effects" is difficult to answer, historically or otherwise. Like trying to gauge the impact of reading or listening on an audience, the attempt to measure for visual impact (or even define "impact," for that matter) is among the most obdurate aspect of poster history in general.[18]

Third, and finally, it needs pointing out that in a practical sense public health posters are difficult objects to deal with historically. As disposable defaceable pieces of public media intended to make an impression and then disappear (or at the very least be pasted over), the things themselves often do not survive.[19] Where they do, in museums and archives, they usually do not carry any additional information about who designed them, the size of print runs through which they were circulated, or records of the negotiations that went on (sometimes involving psychologists, sociologists, and market and media professionals) between the commercial agencies who produced them (also usually unknown) and their clients—be the latter voluntary health organizations, the state, or international agencies. Nor is there much information on the legal and ethical boundaries surrounding their "public" posting. The fact that health posters (today at least) are as likely to be found on a train platform as in a doctor's office means that, unlike the study of other visual technologies in medicine (X-rays for example), they offer no fixed abode (comparable to the X-ray clinic) where their so-called representational practices might be studied.[20]

This leaves us, then, with the images themselves, and the task of comprehending what may have lent them discursive coherence. Typically, it is only when such images arouse protest that we can place ourselves in the position of the proverbial Martian (or epistemologist)[21] and inquire into the sense-making rules and regulations that govern their viewing at a particular time or place. In what follows, informed by the resistance to Toscani's image and by our reading of that image's dislocations, we explore how the public health poster's image-text form of knowledge delivery was aesthetically assembled; how this can be regarded as constitutive of the perception of modern medicine and its corporeal object; and how, during the "Age of AIDS," it came to be reconstituted.

Envisioning a History of Public Health Posters

Public health posters were not the first visual means for the popular dissemination of authoritative medical knowledge and instruction. Precautionary information in printed notices and warnings had been available for centuries, especially during outbreaks of epidemics. More recent and very different in purpose were pictorial advertisements for patent medicines, which we will discuss later. Another important vehicle was cartoons in nineteenth-century magazines such as *Punch* and *Harper's Weekly*. However, in these, as in advertisements for proprietary products, the imparting of medical knowledge was largely incidental. An example is a turn-of-the-century cartoon from *Puck* in which the new knowledge of bacteriology—literally spelled out in the image—is put to the purpose of dress reform since long dresses were perceived as vehicles for sweeping microbes into the private sphere of the home.[22] But the image on its own is ambiguous, requiring both a caption ("The Trailing Skirt: Death Loves a Shining Mark"—itself fairly obscure) and an accompanying editorial. How seriously the viewer was meant to take the ostensible supportive microbial information is unclear. The ambiguity was almost certainly deliberate, for in popular American culture well into the first decade of the twentieth century the idea of microbes was as much a joke and source of scepticism as it was a wondrous discovery.[23]

Twentieth-century public health posters were very different in form and content, especially in the relationship between those two aspects. But it was some time before they became so. In early public health posters, such as those designed to expose the dangers of alcohol or to combat tuberculosis, the preventive message was rarely invested in a single image, as it would be in many public health posters by the 1920s. Rather, it was told through a series of didactic lessons, somewhat in the manner of Hogarth's famous series of prints illustrating the devilish downward spiral of drink.[24] These multiple images were often accompanied by an abundance of text, spelling out causes, consequences, and preventive measures. Such text-reliant presentations were deemed necessary to minimize

any ambiguity of message among a public whose gaze had yet to be trained by health educators. Although steps at reducing what came to be regarded as "sensory overload" were pioneered in displays at hygiene exhibitions from 1911,[25] textually and imagistically crowded public health posters continued to be produced well into the interwar period and beyond.

Commonly, part and parcel of the narrative clutter of early public health posters was their inclusion of more-or-less realistically portrayed human subjects set within social environments of ill health. This is well illustrated in a 1917 public health poster depicting the interior of a nursery being watched over by the figure of Death poised in front of an industrial cityscape (Figure 9.2).[26] Drawn by Alice Dick Dumas for France's Bureau des Enfants, Croix-Rouge Americaine, which collaborated with the Rockefeller Commission for the Prevention of Tuberculosis until the early 1920s,[27] the poster instructs mothers to save their babies: "Death lies in wait. By your intelligence and care you can stave off his hands." Posters such as this did not exclude knowledge of bacteriology, but it was not essential to them, nor a part of what they necessarily took for granted or sought to preach. Instead, they drew on the familiar language of environmental public health and hygiene to propagate the emergent ideology of "Preventive Medicine" (invariably capitalized at the time) in which the responsibility for health was laid firmly at the door of individuals.[28] Clearly, in this Dumas poster, the intended viewer of the

Figure 9.2. "Save Your Baby!" targets new mothers by citing the high incidence of tuberculosis among infants. Designed by Alice Dick Dumas for the Children's Bureau of the American Red Cross (France, circa 1925).

message is not an infant (microbiologically reduced or otherwise), but a mother whose would-be standardized response—"good parenting"—is built around the moral aspiration on the part of the ideologues of preventive medicine for mothers to overcome their "defective knowledge" and thereby reduce infant mortality.[29] The environment is medicalized, but it remains pluralistically so inasmuch as it is a source of potentially different diseases and individual disease responses.

Similar is the framework and *modus operandi* of one of the most common Anglo-American types of public health poster produced in the 1910s and 1920s, which focused on danger of flies.[30] In these often remarkably uncluttered posters, the flies might seem to us to function more or less as microbes writ large; and indeed, in some cases, these posters were used to teach bacteriology. But this is an anachronistic reading on at least two counts. First, although these images are monocausally explicit in terms of presenting a single-vector source of illness, their reduction is not to a single disease, but (as in the Dumas poster) to a variety of *potential* illnesses, the specificities of the causation of which are left undefined. These posters inculcate not corporeal uniformity through microbiological reductionism, but the "scientific" logic behind it of single cause and effect. And second, far from eclipsing the role of environment, such posters celebrate it: the fly is the exemplar of the "dangerous" environment that it inhabits. The primary logic here is sanitarian, though now personalized in the mode of preventive medicine. What the fly poster literally embodies is the transference and transport of the environmental causes of disease to the individual body. The standardization that the poster promotes requires killing flies in order to obtain a morally idealized healthy environment for an individualized body.

Such representations, historians have claimed, made it relatively easy for the public to comprehend and accept germ theory.[31] More important to note here, however, is that in early public health posters it was possible for the two stories or two logics (the bacteriological and the environmental) to exist in complementary fashion[32] in the service of standardizing preventive (but not necessarily biologized) responses. A revealing example of this cohabitation is Roméro Dumoulin's poster of circa 1910 for the Bacteriological Institute of Namur in Belgium (Figure 9.3).[33] Like other public health posters of its time, it is heavily narrativized and subjectivized. Unlike posters focused on venereal disease and alcoholism, however, this one is not filled with personalized messages of blame and shame. Familial relations under realistic conditions of dire poverty are presented in graphic detail, and the message, "TB enters where there is no air or sun," speaks first and foremost the language of environmental public health. Unusual for its time, however, is its visual display of invisible bacteriological evidence. The image-insert affirms the authority of the laboratory and the new scientific medicine in general, but the knowledge is literally disembodied in that it has no organic place in the picture as a whole. As a

Figure 9.3. "Tuberculosis enters where neither fresh air nor sunlight enters. So open a window!" One of a series of posters designed by Roméro Dumoulin for the Bacteriological Institute of Namur (Belgium, circa 1910).

result, the viewer receives at least two fields of connotation, the emergent bacteriological one being, literally, the less domesticated.

Well into the interwar period, public health posters continued to exploit these two fields with their very different conceptions of disease causation. Indeed, the bacteriological one was increasingly made "self-evident" by being built upon the earlier moralized environmental one. Thus two ways of viewing melted into one dominant one, and often it was impossible to tell which discourse was being drawn upon. Consider, for example, a 1935 poster by the British pioneering minimalist graphic designer, Abram Games—"Where There's Dirt There's Danger / Cleanliness is the First Law of Health"—commissioned by the United Kingdom's Health and Cleanliness Council.[34] Here the image, as an entirely verbal address, assumes the public's familiarity with germ theory and enables the identity of the infective agents themselves to be dispensed with. The scientific worldview is so embedded and effaced that, so far as the message goes, it almost stands as a simulacrum of prebacteriological images of the epidemiological dangers of dirt. It might as easily be read as referring to the overtly moralized hygienic discourse on

the dangers of dirty environments as to the visually emergent bacteriological one. In contrast to the Dumas and Dumoulin posters, however, it effaces the environments of and the relationships between "dirt" and poverty, and suffering and disease, by stripping out the human subject. Literally and metaphorically, the field of vision is restricted and disembodied at the same time as the visual (text) message is democratized, thereby pathologizing the whole of society, not just the poor (or poor mothers). In this way, bodies became increasingly standardized in their perceived reaction to specific agents of disease rather than through variable environments that potentially induced different kinds of moral and illness responses.

Later health posters, while similarly denuding images of environmental and social relations of disease as well as narrative clutter, embedded the bacteriology-grounded monocausal epistemology of laboratory medicine at the same time as they removed it from view by burying it in the body itself. As literally spelled out in a 1946 poster on venereal disease (also designed by Games), "disease is disguised [in the body]" (Figure 9.4).[35] By this time the public health poster was structured by what was doubly invisible and fantastical: the substantive epistemology of modern scientific medicine that informed the surface message, *and* the invisible microbe that informed the science.[36] Without the viewer's complicity in the logic and the knowledge of bacteriology, the association between the image and the behavioral message would make no sense. (The viewer also requires *blind* faith in the capacity of white-coated experts to see the invisible agents of disease upon which the scientific medicine rests.) Although the nature of what is not to be "gambled with" remains unseen, its logic is perfectly understood. Thus, reductively, as the worldview of laboratory medicine became more socially invested, the aesthetics of the public health poster came more fully to mediate and naturalize that worldview.

To be sure, not all "modernist" public health posters submitted to the extreme minimalism and abstraction of the Bauhaus School—a school deeply influenced by the themes of modern physics and scientific medicine.[37] As in advertising, a wide variety of graphic designs were always evident, especially if considered internationally. Some, photograph-like, bore explicit statements about "germs" and remained overtly didactic as well.[38] But the trend was toward seeing less and imagining more of the monocausal epistemology of modern medicine, thus consigning all bodies to the same rules wherever those bodies might be physically located.

Moral messages did not disappear, of course. The public health poster by its very nature moralizes behavior, guiding the viewer to a clear notion of what is or is not socially acceptable. Unattainable at any time is the ideal, promoted by Susan Sontag, that modern medicine would be value free if stripped of its moral metaphors.[39] Such a view only serves to support the myth that modern medicine itself is neutral in and of itself and therefore culturally transcendent. Public health posters, whatever their surface messages and metaphors, were embedded with this myth of modern medicine. Only by escaping from it could they act other

Figure 9.4. This frightening poster combines an exotic espionage image with the more common-place (and widespread) image of women as vectors of venereal disease. Designed by Abram Games (Great Britain, 1946).

than as agents for its epistemology. Of course, if they did that, they would not be public health posters as we know them, all of which serves to challenge those commentators of visual culture who insist that vision has been denigrated in the twentieth century and become merely an empty "surface show." This antiocular notion (itself sometimes cast in medical metaphor as the "cancerous growth" of

visual culture)[40] holds that you see only what you get, and what you get are "simu-lacrums of nothing."[41] This is sometimes compared to the early modern period where what was seen was not only what was seen (or what we moderns would only see) but also was what was not seen—that which lies outside the frame yet suf-fuses the whole.[42] In modern secular images, however, with this excision, you only see what you get—or so the argument goes.

Cheap and disposable public health posters would seem likely candidates to support this line of argument. But, in fact, as we have suggested, the viewer requires an enormous amount of knowledge and understanding to decode these posters, even if that action is performed almost instantaneously. Thus, while it is true that the public health poster became more "surface" over time through the shedding of its narrative clutter, and eventually in some cases through adopting the shared cultural symbols of scientific medicine (white coats, stethoscopes, microscopes, and so forth), it only became so in relation to its ever-increasing reliance on its own invisible God to inform and define the whole—standardized and reductive laboratory medicine. By World War II the apparent—or, more fre-quently, *un*apparent—biomedical God had become the basis of the epidemical public health poster. Like the surface message that warned viewers that "disease is disguised," the substantive work of the public health poster was also disguised through the mediations and mystifications of its imagery. In short, just as the Almighty is to the religious painting, the epistemology of modern medicine is to the epidemical public health poster, informing, regulating, and rationalizing its view.

That the public health poster has not been comprehended in this way only testifies to the invisible cultural codes and conventions that govern its viewing. By necessity, health posters must go with the cultural flow, both visual and medical. Their complicity with the rules of viewing becomes apparent only when suddenly we see them as ceasing to do so—more or less as Toscani's image of David Kirby's death from AIDS functioned in the world of commercial advertising through its blatant medico-corporeal transgressions. How did such rules get formulated in the first place, and what were the political circumstances under which the public health poster and its viewing became naturalized? The conditions for its possibil-ity may not have *constituted* the epidemical public health poster in any deep sense, but they certainly conditioned the possibilities for its being seen.

The Politics of Becoming Seen

To assume that medicine itself was responsible for creating the public health poster would be a half-truth at best. Medical science was fundamental to shaping the message, but the medical profession had little influence on or control over the production of such posters, nor over the material and visual culture through

which these objects were called into existence in the early twentieth century. What evidence there is suggests that before World War II none of the several sectors of the medical profession had much corporate interest in health posters. Indeed, to a much greater extent than opponents of political posters before World War I,[43] the medical fraternity had intellectual and practical reasons to be resistant to the idea of them. Even if the legacy of whole-person medicine (the pre-"clinical gaze") was threadbare by the turn of the century, there was still a great deal of self-interested market wisdom in flattering the individualism of private patients, long after the universalizing notions of Koch and Pasteur had reduced illness to germs. Doctors, as educated rationalists, probably also shared the thinking of some nineteenth-century educationalists and social reformers that the visual stimulated the passions and thereby clouded scientific objectivity and rational thought.[44] During his travels in Paris in the 1880s, for example, Sigmund Freud recoiled in horror at the "ghastly posters and the serialized novels they announced," and therewith framed his first thoughts on "psychic epidemics" and mass psychology.[45] As the increasing use of the poster in early twentieth century politics confirms, its appeal was directly to the emotions of the masses.[46] To a profession aspiring to be "rational" and be seen as above politics, that association alone might have been enough to warn them off.

Above all else, though, was the predominant place of the poster in the world of advertising patented medicines. If the pictorial poster belongs to a revolutionary shift away from verbal language, then it was in this realm (and not at Parisian stage doors or as part of election cycles) that its import was greatest. Commercial posters and signs were regarded by many doctors and other members of the middle and upper classes as "an unsightly and undignified method of sales promotion used only by manufacturers of patent medicines" to reach the illiterate.[47] But the matter was about more than merely "bad taste"; it was fundamentally economic, hinging on the advantages that patent medicine advertisements conferred on "quack" competitors for the patient-consumer's body. For this reason, from as early as the 1840s in the United States, doctors had attacked "nostrum posters" for, among other things, despoiling the urban landscape.[48] As if to add insult to the pocketbook injury threatened by the nostrum mongers, qualified practitioners by the late nineteenth century witnessed colorful patent medicine posters appropriating their own (dress-coded) image in bids to lend authority to the products advertised.[49] This was but one of the many ways in which the patent medicine vendors of the late Victorian "golden age of advertising" extended what Thomas Richards has identified as the "spur to the medicalization of life" that had always been a part of the oral and printed promotion of patent medicines. As Richards points out, commercial vendors were in many ways more alike than different from medical regulars: they believed in specific cures for specific illnesses through the use of therapeutic restorative commodities; they believed that experts know best; and

they believed that the symptoms of disease are manifestations of individuality.[50] Ironically, among the wares displayed in their poster advertisements was that which ultimately played to the victory of the medical regulars and corporeal standardization: bacteriology. Posters on commercial billboards, such as William Radam's "Microbe Killer" (1890), probably did far more for the popularization of bacteriology than anything issued elsewhere, including cartoons in magazines.[51]

Although bacteriology was incidental to the disinfectant products being sold, as evidenced in the cartoon from *Puck* described earlier, the promoters clearly had some reason to believe that there was still some commercial kick left in Koch. And it might also be said of the viewers of these advertisements (never mind the consumers) that they were "sold" something of which the real disinfectant contents were unknown. In presenting microbes as the agents of disease, older, multifactoral, and environmental understandings of disease causation, already bending under the weight of the new public health, were further strained. But general practitioners, so far as we can tell, were as unaware of this dimension of the advertisements as the public were. They did not strive to (re)appropriate the microbe to their own professional interests; they merely ranted and raved at the marketing strategies of their competitors and negatively associated pictorial posters with them.

Somewhat more surprising, perhaps, is the lack of enthusiasm for posters among professionals in public health, which was the case at least in Britain. Although there is evidence from British medical journals from as early as 1905 that many of these professionals believed that commercial "posters do have a great effect in influencing the public mind,"[52] acting upon that faith with regard to public health was long delayed. Significantly, in 1910, it was not public health officials but the Association of British Advertisers and Bill Stickers who, looking for a worthy cause to improve their image, ran an antituberculosis campaign that granted free space for thirty thousand large posters that could "[draw] attention to the ravages of this disease."[53] The limited scale of and funding for public health among local authorities in Britain before the 1929 Public Health Act doubtless did little to encourage the production of health posters. Whether by "nature" or because of lack of resources, British Medical Officers of Health saw themselves at this time as "sedate and undemonstrative" in their methods of health propaganda when compared to their American counterparts.[54] Even *The Times* of London was moved to observe in 1925 that in Britain "poster art has not yet been utilized to any great extent in health work."[55] Telling, too, perhaps, is that some of the earliest posters advertised in the journal the *Medical Officer* were referred to as "Pictorial Methods of Health Teaching," and "Cartoons" rather than "public health propaganda" or "public health education," as such posters would be denominated between the mid-1920s and 1930s.[56] Their intended audience, one might add, was not the adults on streets, buses, and underground trains, but children in schoolrooms, a group whose attention was little coveted by general practitioners. This

also seems to have been the case in the United States, where leading physicians strongly opposed all other forms of action by health propagandists as threats to their livelihoods and authority.[57]

A further constraint on the take-up of posters by public health officials was the dominant role of voluntary bodies in health and welfare education. It was these organizations who in fact pioneered the health poster, notably in campaigns against tuberculosis (from as early as 1909) and in traveling welfare exhibitions.[58] Indeed, as public health posters became increasingly common in the interwar period, by far the largest proportion of them (in Britain and the United States at least) continued to be produced by these nonstatutory agencies. What their attitude may have been toward commercial advertising (especially of medical products and services) is difficult to establish; however, it is clear that they maintained an ambiguous relationship at best toward biomedical authority. Despite the single focus of their campaigns, they were not predisposed to monocausalism. Even the antituberculosis lobby, which could point to Koch's illustrious bacillus, retained a broad constitutional and environmental understanding of disease etiology, largely because it afforded more scope for social and moral interventions. Thus antituberculosis health posters produced long after the achievements of Koch had become familiar continued to be filled with holy images of whiteness and innocent children frolicking in radiant nonurban, nondegenerative landscapes suffused with fresh air and wholesome breezes.[59] Koch, of course, had arrived at no effective cure for tuberculosis, which might partly account for the continuance of this therapy-reflecting and environmentally attached imagery. But that doesn't account for it wholly, for even where specific pharmaceutical cures were known, as was the case with syphilis after 1917, the campaigns run by voluntary bodies remained visually structured around "the wages of sin." As in a 1926 poster for an antisyphilis movie, death hovers over the heads of those who would fall for fashionable flappers, just as it had previously hovered over the heads of soldiers and sailors (and would again).[60] And why not? The voluntary bodies campaigning against venereal disease and tuberculosis had as much of a moral stake in the surrender to reductive scientific medicine as they had in the ideological surrender of health education to the state and/or the medical profession. For this reason, too, relatively few health posters (as opposed to advertisements for proprietary products) deployed the familiar symbols of modern medicine. Far more common were religious icons, especially the nurse/ nun figure that appears in a wide variety of public health posters.

As a genre with its own recognizable conventions, public health posters did not come into their own until during (and mostly after) World War I,[61] and then mainly in France, Belgium, the Netherlands, and the new Soviet Union. Although the war was hardly the cause of the epidemical public health poster, the authoritarian conditions of wartime and the extensive use of posters for recruiting were favorable to it. It is no coincidence that during the war the military largely

embraced scientific medicine as a cheap means to deal with the unproductive sick. For once all bodies could be understood as essentially the same in disease; like the product in the factory or the soldier in the platoon, they could be managed in standardized ways. What was good for one soldier was good for all, never mind that there were few cures before the 1940s. Inoculations against smallpox and typhoid, and the antitoxin for diphtheria, had proven this worth of "scientific" medicine to the military, and the further discovery (made during the war) of the causal connection between the body louse and typhus was added confirmation. A poster produced in Moscow in 1919 is illustrative of this visual translation of the militarization-cum-scientization of the diseased body (Figure 9.5).[62]

Strikingly reductive in its attribution of death from the Rickettsial typhus louse, the poster neatly effaces the underlying social, political, and material circumstances (mainly from war and famine) behind the decimation of several million Russians from this disease.[63] The poster is also interesting for its assumption that viewers will understand the causal link it makes between the bug and the disease, a connection that had been only recently established. Although we don't know where such a poster was displayed, it is worth noting that during both world wars governments were able to legislate the physical space for the public posting of such posters. In effect, the wars turned the world into army camps, as did the Civil War in Russia where the health of the new society itself was deemed dependent on health agitprop. "Either socialism will defeat the louse, or the louse will defeat socialism," Lenin told the Seventh Congress of Soviets in 1919.[64] Public health posters were also more routinely viewed during wartime as a result of the reining-in of commercial billboard advertising.

The Muscovite typhus poster is typical of the image effect of wartime, and of state health-welfare regimes in general on public health posters. During and after World War II, these objects became firmly embedded in state-sponsored preventive medicine, which was premised on the implicit bacteriological assumption that everyone is epidemiologically the same. In effect, the collusion of the state with biomedical monocausalism appropriated the moral space made visible in the earlier public health posters by the voluntary organizations, although in most Western countries this appropriation was slow to commence and was never complete due to the continued vitality of the voluntary bodies responsible for producing health posters. Eventually, though, even in the latter's posters, the overt moral space was leeched away by the invisible laws of science and by the biomedical authority built upon it and harnessed by the medical profession.

Interpreted this way, the "golden age" of the epidemical public health poster was not during the interwar period when many of them were produced, but during the Cold War when the universal monocausal truth of the bacteriological paradigm was everywhere reinforced—not least by analogy with the medical profession's newfound truth that "Smoking Causes Cancer" and the poster campaigns

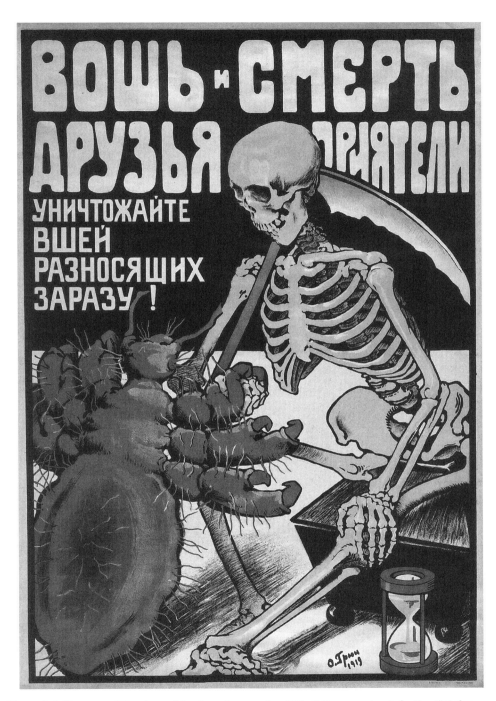

Figure 9.5. "Louse and Death are friends and comrades. Kill all lice carrying infection!" Color lithograph designed in Moscow by O. Grin (Soviet Union, 1919).

that went with that. Although the West experienced few major epidemics during this time (polio in the 1950s being the exception) and public health and health education were duly marginalized, the epistemology of Cold War medicine was widely reproduced through the dissemination of public health posters to the "third world" via the World Health Organization and other international agencies.[65]

And Then There Was AIDS

It would be incorrect to say that AIDS changed everything. Certainly, AIDS shook the conceptual and social foundations of the "Cold War body" (especially through the controversy over whether HIV caused AIDS), but that didn't mean either that health posters could no longer paint their messages monocausally or that AIDS posters couldn't deploy biomedical imagery. Initially, in fact, many AIDS posters relied on images of viruses, for example.[66] As for monocausalism, the basic message of all AIDS posters is that unprotected sex can result in AIDS. Between the late 1940s and the early 1980s, everything around the health poster changed and, consequently, the health poster changed too. New digitized means of production, and the fact that poster art in general underwent a revival in the 1960s and 1970s as well as a revolution in design, all bore upon the object's production and consumption.[67] The most crucial change, however, was in the socioeconomic context for this manufacture and viewing in the 1980s and 1990s. Especially in health campaigns undertaken by the state, but increasingly among the voluntary sector, too, their production came to be orchestrated by highly professional international advertising corporations. The AIDS campaign begun in Sweden in 1987, for instance—amounting to the country's biggest poster campaign in over thirty years—was launched by the pioneer American TV advertising firm Ted Bates Worldwide Inc., a branch of the self-proclaimed world's largest advertising firm, Saatchi & Saatchi Plc.[68] Although dictated by different and changing pedagogical strategies aimed at their clients,[69] the advertising agencies were conscious above all of operating in an intensely competitive visual marketplace—much of it the result of their own making. Thus striking images and metaphors—from shark's fins, icebergs, and life-saving rings (for condom advertisements) to highly eroticised and idealized male bodies—competed against each other.[70] What matters most here are not the images themselves, but the fact that, as never before, such images became indistinguishable from the advertisements used for other commodities.[71] Hitherto, as we have suggested, public health posters had occupied a somewhat ambiguous moral space between the "vulgar" (and often supposedly "deceitful" and "manipulative") world of commercial advertising, on the one hand, and the would-be exemplary "humanitarian" world of medicine and public health, on the other. Now, however, that tension, or ambiguity, or in-betweenness—assigned subsequently by medical professionals as much as by art historians—was dissolved.

In turn—or, rather, hand in hand—the *experience* of viewing of health posters, and AIDS posters in particular, came to be regarded differently than it had been in the past. No longer were public health topics bracketed from the rest of commodity culture; they now became fully a part of it. In overt ways they took up the same visual sales pitch as other commercially spun desires and lifestyle identities. And they did so at a time when, simultaneously and inextricably, medical welfare was falling under the thickening blanket of privatization[72] while the individual physical body was increasingly appropriated by the visual marketing skills of giant Madison Avenue advertising agencies. Thus was inaugurated the age of global corporations unfettered by the ideological promotion of the "open market"—the age, that is, of Tommy Hilfiger, Nike, Calvin Klein, and, not least of all, Benetton.

Toscani's poster-advertisement of David Kirby's death produced as part of Benetton's "Shock of Reality" campaign[73]—signifies all this and more. At one level we can regard it as speaking to a world in which, in some quarters at least, the hitherto reigning medical discourse came to be seen as but another religious myth; a world in which the reductive certainties and epistemological specificities of laboratory medicine were destabilized; and a world in which the would-be standardized and universalized body of preventive medicine was localized and subjectivized. For AIDS at least, public health posters often came to be produced by intimate neovoluntary groups and pasted up in specific localities targeted at specific audiences, rather than corporeally undifferentiated masses of all bodies *any*where *any*time.

In retrospect, however, Toscani's poster advertisement is less important as an illustration of the medico-epistemological moment in which it was produced than as a marker on the road to the dissolution of the old ambiguity between the world of advertising and the world of medicine and the body. Insofar as the outrage against it in 1992 was based on a sense of the violation of medical humanism by commercial interests, that outrage was the last significant gasp in the former's defense. Thereafter, the boundary that had come to separate the health poster from the commercial advertisement, and which over time was consolidated through its imagery, ceased to exist. The medicalization of life was now as fully commercialized in the visual assemblage of the health poster as in the promotion of proprietary medico-lifestyle products. Indeed, increasingly little distinction is to be made between medically approved television commercials for health lifestyle products (direct-to-consumer) and the promotion of health. Thus reconstituted, the public health poster was to live on, though within a more fractionated and commercialized "public." But far from continuing to sell the epistemology of modern medicine through its imagery as something separate from the world of commodity culture, it was to live on—imagistically and otherwise—as constitutive of that culture.

Notes

For inspiration, references, sound criticism, and much encouragement we are indebted to Julie Brown, David Cantor, Flurin Condrau, Anne Hardy, Rhodri Hayward, William Helfand, Thomas Hill, Bill Luckin, Anna Mayer, Sybilla Nikilow, Dorothy Porter, Michael Rhode, Walton Schalick, William Schupbach, Jim Sellers, David Serlin, Bertrand Taithe, James Thompson, and Elizabeth Toon. For his close critical reading we are particularly grateful to Mike Sappol. For providing forums for discussion, we thank the National Library of Medicine, the Wellcome Trust Centre for the History of Medicine at UCL, the London School of Hygiene and Tropical Medicine, the History Department at the University of Essex, the Centre for the History of Science, Technology, and Medicine at the University of Manchester, and the Department of Anthropology and History of Health at the University of California at San Francisco. For opening their archives and poster collections to us, we thank the Deutsches Hygiene-Museum, the National Library of Medicine, the U.S. National Archives and Records Administration, and the Wellcome Library. For much good-spirited technical assistance along the way we are grateful to our colleague Adam Wilkinson. As ever we are indebted to the Wellcome Trust for their generous support.

1. Reproduced in Jürgen Döring, ed., *Gefühlsecht: Graphikdesign der 90er Jahre* (Hamburg: Museum für Kunst und Gewerbe; Edition Braus, 1996), 128, and in Margaret Timmers, ed., *The Power of the Poster* (London: V & A Publications, 1998), 228. The photo, by Therese Frare, appeared in *Life* magazine.

2. The reactions are overviewed in "Benetton—Advertising History," entry for 1992 (http://www.newterritoryfuerteventura.com/deborah/benetton.htm#ADVERT). See also Döring, *Graphikdesign*, 128–29. *The Guardian* was forced to defend itself in an editorial of January 24, 1992; see Lorella Pagnucco Salvemini, *United Colours: The Benetton Campaigns* (London: Scriptum Editions, 2002), 92–93.

3. John Hegarty, "Selling the Product," in Timmers, *Power of the Poster,* 228.

4. On the image as "worthy of a 17th-century Pieta," see Salvemini, *United Colours,* 91, and for Toscani's own explicit reference to this, see his *Die Werbung ist ein lächelndes Aas,* trans. Barbara Neeb (Mannheim, Germany: Fisher Taschenbuch Verlag, 2000), 58.

5. Gunther von Hagens, *Prof. Gunther von Hagens' Body Worlds: The Anatomical Exhibition of Real Human Bodies: Catalogue on the Exhibition* (Heidelberg, Germany: Institut für Plastination, 2002).

6. Guenter Risse, "History of Western Medicine from Hippocrates to Germ Theory," in *The Cambridge World History of Human Disease,* ed. Kenneth Kiple (Cambridge, Mass.: Cambridge University Press, 1993), 19.

7. Jad Adams, *AIDS: The HIV Myth* (London: Macmillan, 1989).

8. Joan H. Fujimura and Danny Y. Chou, "Dissent in Science: Styles of Scientific Practice and the Controversy over the Cause of AIDS," *Sociology of Science and Medicine* 38 (1994): 1017.

9. Steven Epstein, *Impure Science: AIDS, Activism, and the Politics of Knowledge* (Berkeley: University of California Press, 1996), 12.

10. See, for example, Stefan Timmermans, *Sudden Death and the Myth of CPR* (Philadelphia: Temple University Press, 1999).

11. Maurice Rickards, "Posters," in *The Encyclopedia of Ephemera,* ed. Michael Twyman (London: British Library, 2000), 250–51; John Barnicoat, "Poster," in *The Dictionary of Art,* ed. James Turner (London: Macmillan, 1996), 25: 345–55; and Harold F. Hutchinson, *The Poster: An Illustrated History from 1860* (London: Studio Vista, 1968).

12. A fuller history of health posters would reveal that this particular boundary has been drawn differently in different locations at different times, depending on the sensibilities engendered by different notions of public space, different histories of advertisement, design, or education (medical and general), and, crucially, different valuations of the use of the visual in education, public health, and critical theory. This is a part of our larger project, "Biopublics and the Politics of the Visual: German and British Medicine and Visual Culture in the 'Century of the Eye'."

13. William Helfand, *To Your Health: An Exhibition of Posters for Contemporary Public Health Issues* (Bethesda, Md.: National Library of Medicine, 1990), 12.

14. A view challenged in Suzannah Biernoff, *Sight and Embodiment in the Middle Ages* (London: Palgrave, 2002), 3.

15. As Francois Delaporte has noted of this practice, historians overlook that the "reality" that they thereby reconstitute is nothing other than a discourse about appearances: "The History of Medicine according to Foucault," in *Foucault and the Writing of History*, ed. Jan Goldstein (Oxford: Blackwell, 1994), 140. On the "documentary fallacy" involved in historians using visual images, see Ludmilla Jordanova, "Medicine and the Visual Culture," *Social History of Medicine* 3 (1990): 90–93.

16. On this view for language, see Mary Fissell, "Making Meaning from the Margins: The New Cultural History of Medicine," in *Locating Medical History: The Stories and Their Meanings*, eds. Frank Huisman and John Harley Warner (Baltimore: The Johns Hopkins University Press, 2004), 364–89.

17. A partial historical exception is Mariel Grant, "Health Publicity, 1919–1939" in her *Propaganda and the Role of the State in Inter-War Britain* (Oxford: Clarendon Press, 1994), 123–93.

18. See Elizabeth Toon, "Managing the Conduct of Individual Life: Public Health Education and American Public Health, 1910–1940," (PhD thesis, University of Pennsylvania, 1998), 20. Some experts in visual studies claim the recognition of nonuniversal responses to the visual is precisely that which makes the field of visual studies possible. See Margaret Dikovitskaya, *Visual Culture: The Study of the Visual after the Cultural Turn* (Cambridge, Mass.: MIT Press, 2006), 14.

19. Roger Cooter, *"Public Health Posters," Encyclopedia of Pestilence, Pandemics, and Plagues,* ed. Joseph P. Byrne (Westport, Conn: Greenwood Press, 2008) 2:578–79.

20. As we argue elsewhere this feature in fact methodologically advantages health posters over the study of other visual objects and technologies in the history of medicine. See Cooter and Stein, "Coming into Focus: Posters, Power, and Visual Culture in the History of Medicine," *Medizinhistorisches Journal* 42 (December 2007): 180–209.

21. See Arnold Davidson, "On Epistemology and Archaeology: From Canguilhem to Foucault," in *The Emergence of Sexuality: Historical Epistemology and the Formation of Concepts,* ed. Arnold Davidson (Cambridge, Mass.: Harvard University Press, 2001), 192–206 at 193.

22. Reproduced and discussed in Bert Hansen, "The Image and Advocacy of Public Health in American Caricature and Cartoons from 1860 to 1900," *American Journal of Public Health* 87 (1997): 1798–1807. A cropped version of the cartoon also features on the dust jacket of Nancy Tomes, *The Gospel of Germs: Men, Women, and the Microbe in American Life* (Cambridge, Mass.: Harvard University Press, 1998).

23. For instance, "Microbes," a hit song of 1905, sneered at the idea, as illustrated on the dust jacket for the sheet music. Reproduced in David L. Cowen and William H. Helfand, *Die Geschichte der Pharmazie in Kunst und Kultur* (Cologne, Germany: Dumont Buchverlad, 1991), 195.

24. Williams Hogarth, *A Rake's Progress* (1733–35) on display at the Sir John Soane Museum, London.

25. See Erin H. McLeary and Elizabeth Toon, "'Here Man Learns about Himself!': The American Museum of Health and the New York World's Fair, 1939–1940," paper delivered at the American Association for the History of Medicine, Bethesda, Maryland, May 21, 2000. The pioneer in uncluttered exhibition display was Karl Lingner, the organizer of the 1911 Dresden International Hygiene Exhibition; see *Offizielle Monatsschrift der Internationalen Hygiene Ausstellung Dresden 1911*, vols. 1 and 2 (1911). On the rationalization of exhibition display, see Evart and Mary Routzahn, *The A B C of Exhibit Planning* (New York: Russell Sage Foundation, 1918).

26. Wellcome Library, photo no. V49892; reproduced in Cyr Voisin, *La Tuberculose, Parcours Imagée*, vol. 2: *Regards Images de la Tuberculose en France de 1900 à nos jours* (Lycee Lavoisier: Auchel, 1995), 55.

27. See Lion Murard and Patrick Zylberman, "Seeds for French Health Care: Did the Rockefeller Foundation Plant the Seeds between the Two World Wars?" *Studies in the History, Philosophy, Biology and Biomedical Sciences* 31 (2000): 463–75. On the *Bureau des Enfants*, see Fisher Ames Jr., *American Red Cross Work among the French People* (New York: Macmillan, 1921). Alice Dick Dumas was born in Paris in 1878 and first exhibited in the Salon des Artistes Français in 1903. Her posters for the American Red Cross were internationally distributed and were also widely reproduced as postcards.

28. George Newman, *An Outline of the Practice of Preventive Medicine (a memorandum addressed to the Minister of Health)* (London: HMSO, 1919), and idem, *Public Education in Health* (London: HMSO, 1925).

29. See H. R. Kenwood, "Public Health Propaganda and Social Work," *Journal of the Royal Sanitary Institute* 39 (1918–1919): 158.

30. For visual examples, see *The Medical Officer*, July 31, 1920, x. Posters for "The Campaign against Flies" were advertised in (and purchasable from) *The Medical Officer* as early as April 21, 1917 (viii). For a Dutch example from 1915 see Stephen Prokopoff, ed., *The Modern Dutch Poster: The First Fifty Years, 1890–1940* (Urbana: Krannert Art Museum, University of Illinois at Urbana-Champaign, ca. 1987), 74, plate 39. For an American example from 1917 see Naomi Rogers, *Dirt and Disease: Polio before FDR* (New Brunswick, N.J.: Rutgers University Press, 1990), 51.

31. This is precisely the point made by Naomi Rogers, "Germs with Legs," *Bulletin of the History of Medicine* 63 (1989): 599–617. See also Tomes, *The Gospel of Germs*.

32. See Sabine Marx, "Rethinking the Rise of Scientific Medicine: Trier, Germany, 1880–1914" (PhD thesis, Carnegie Mellon University, 2002).

33. Reproduced in Marine Robert-Sterkendries, *Posters of Health* (Brussels: Therabel Pharma, ca. 1996), 352. The poster was one of a series of five that Dumoulin (1883–1944) produced for the *Institut Bacteriologique de la Province de Namur Service d'hygiene sociale*.

34. Wellcome Library, photo no. L23774; reproduced in Naomi Games, C. Moriarty, and J. Rose, *Abram Games, Graphic Designer: Minimum Meaning, Minimum Means* (Aldershot, U.K.: Lund Humphries, 2003), 16, Figure 9.

35. Wellcome Library, photo no. L34083. Games may well have been influenced by contemporary psychology with its commitment to revealing the hidden or repressed in the human psyche.

36. On making bacteria visible, see Christine Brecht and Sybilla Nikolow, "Displaying the Invisible: *Volkskrankheiten* on Exhibition in Imperial Germany," *Studies in the History, Philosophy, Biology and Biomedical Sciences* 31 (2000): 511–30.

37. See Peter Galison, "Aufbau/Bauhaus: Logical Positivism and Architectural Modernism," *Critical Inquiry* 16 (1990): 709–52.

38. See, for example, "Don't Be Your Own Doctor. If you're sick report sick" with the picture caption: "Never give a germ a break," issued by the U.S. War Department in 1944. Copy in the collections of the History of Medicine Division, U.S. National Library of Medicine.

39. Susan Sontag, *Illness as Metaphor* (New York: Farrar, Straus & Giroux, 1978).

40. Michel de Certeau, *The Practice of Everyday Life* (Berkeley: University of California Press, 1984), xi. On antiocularism, see Martin Jay, *Downcast Eyes: The Denigration of Vision in Twentieth-Century French Thought* (Berkeley: University of California Press, 1993).

41. Jean Baudrillard, "Simulacra and Simulations," in *Jean Baudrillard: Selected Writings*, ed. Mark Poster (Stanford, Calif.: Stanford University Press, 1988), 169–87.

42. Biernoff, *Sight and Embodiment*, 2.

43. See James Thompson, "'Pictorial Lies'? Posters and Politics in Britain, ca. 1880–1914," *Past and Present* 197 (2007): 177–210.

44. See Anne Secord, "Botany on a Plate: Pleasure and the Power of Pictures in Promoting Early Nineteenth-Century Scientific Knowledge," *Isis* 93 (2002): 28–57.

45. Freud to Minna Bernays, December 3, 1885, quoted in J. Andrew Mendelsohn, "The Microscopist of Modern Life," *Osiris* 18 (2003): 156.

46. Thompson, "Posters and Politics in Britain," 188–90.

47. Ralph M. Hower, *The History of an Advertising Agency: N. W. Ayer & Son at Work, 1869–1939* (Cambridge, Mass.: Harvard University Press, 1939), 99, quoted in William H. Helfand, "Advertising Health to the People: The Early Illustrated Posters," in *Right Living: An Anglo-American Tradition of Self-Help Medicine and Hygiene*, ed. Charles Rosenberg (Baltimore: The Johns Hopkins University Press, 2003), 171.

48. William Euen, *A Short Expose on Quackery* (Philadelphia, Pa.: 1840), 6, quoted in Helfand, "Advertising Health," 180–81.

49. See, for example, "Dr. Pierce's Golden Medical Discovery is a Doctor in your home: Stomach-Liver-Blood," Lithograph, New York, ca. 1910. Wellcome Library, photo no. L30550.

50. Thomas Richards, "The Patent Medicine System," in *The Commodity Culture of Victorian England: Advertising and Spectacle, 1851–1914* (Stanford, Calif.: Stanford University Press, 1990), 89–105.

51. Reproduced in William H. Helfand, *Quack, Quack, Quack: The Sellers of Nostrums in Prints, Posters, Ephemera & Books* (New York: The Grolier Club, 2002), 109, plate 55. On the vogue for disinfectants by the early 1880s, see "Disinfectants at the Health Exhibition," *Lancet*, September 6, 1884, 430: "A few bear fancy titles such as 'sanitas,' 'Jeyes' 'perfect purifier,' 'affinitan,' and 'antimicrobe.'"

52. E. H. Snell, "Instruction by Poster," *Lancet* (December 23, 1905): 1864.

53. *The [British] Poster Advertising Year Book and Directory, 1930* (London: BPAA, 1930), 4.

54. "Health Propaganda," *The Medical Officer*, February 25, 1922, 79.

55. "Health Posters," *The Times*, April 21, 1925, 20, col. C.

56. See, for example, "Health Teaching by Pictures," *The Medical Officer,* November 28, 1914, 249, and January 4, 1919, vii, which illustrates the posters for "Pictorial Methods of Health Teaching."

57. Toon, "Managing the Conduct of Individual Life," 276.

58. For a description of 150 posters used by the Durham Travelling Welfare Exhibition (established in 1917) see H. S. Cooper Hodgson, "Public Health Propaganda Work," *Journal of the Royal Sanitary Institute* 43 (1922–1923): 315–16.

59. See, for example, *"Achetez le Timbre Antituberculeux"* (ca. late 1920s), reproduced in Robert-Sterkendries, *Posters of Health*, 359.

60. Reproduced in ibid., 325. In being issued jointly by the Ligue Nationale Française contre le Peril Vénérian and endorsed by the Ministère du Travail de l'Hygiene, de l'Assistance et de Prévoyance Sociales, this Theo Doro poster was relatively unusual, at least outside of France and during peacetime.

61. Helfand, *To Your Health*, 5.

62. Wellcome Library, photo no. L32923. Color lithograph by O. Grin, 1919. The caption reads: "Louse and Death are friends and comrades. Kill all lice carrying infection."

63. Hans Zinsser, *Rats, Lice, and History* (1934; repr., New York: Black Dog, 1963), 299.

64. Quoted in Frances L. Berstein, "Envisioning Health in Revolutionary Russia: The Politics of Gender in Sexual Enlightenment Posters of the 1920s," *Russian Review* 57 (1998): 191–217.

65. See, for example, "Avoid Smallpox—Be Vaccinated," issued by the Nigerian Federal Ministry of Health, ca. 1950. Wellcome Library, photo no. L30552, artist G. A. Okiki.

66. See, for example, "Combattre Lutter pour, ca la vie" reproduced in Döring, *Graphikdesign*, 142). See also the AIDS posters reproduced in Paula Treichler, "AIDS, Homophobia, and Biomedical Discourse: An Epidemic of Signification," *Cultural Studies* 1 (1987): 263–305.

67. Jeremy Myerson and Graham Vickers, *Rewind: Forty Years of Design and Advertising* (New York: Phaidon, 2002), 105–15.

68. We are grateful to David Thorsén for this information.

69. See Charles R. Garoian, "Art Education and the Aesthetics of Health in the Age of AIDS," *Studies in Art Education* 39 (1997): 6–23.

70. Many of the latter are reproduced in Sander Gilman, *Picturing Health and Illness: Images of Identity and Difference* (Baltimore: The Johns Hopkins University Press, 1995). For the others, see *Poster Collection: Visual Strategies against AIDS: International AIDS Prevention Posters* (Zurich: Museum fur Gestaltung Zurich and Lars Muller Publishers, 2002) and Hugh Rigby and Susan Leibtag, *HardWare: The Art of Prevention* (Edmonton, Canada: Quon Editions, 1994).

71. This is well exemplified in the latest, most visually slick—and allegedly most successful—poster campaign against AIDS and other STDs staged by the Terrance Higgins Trust, the leading British voluntary organization in this area. In imitation of Calvin Klein underwear advertisements, the campaign features chiseled males strutting their stuff with computer-generated sores on their skins while wearing underwear on which the designer logos have been replaced by warnings of sexually transmitted diseases.

72. Mike Davis, *City of Quartz: Excavating the Future of Los Angeles* (London: Verso, 1990), 304.

73. See Joan Gibbons, "Reality Bites," in *Art and Advertising* (London: I. B. Tauris, 2005): 43–62.

10. The Image of the Child in Postwar British and U.S. Psychoanalysis

LISA CARTWRIGHT

PSYCHOANALYSIS, WITH ITS FOCUS ON THE INDIVIDUAL in the therapeutic setting, would seem to present little of value in a discussion of public health or the determination of policy and the management of child social welfare on a national, much less a global, scale. If we look to the definitive work of child psychoanalysts such as Melanie Klein or her followers, we find little evidence of commitment to public or macrolevel issues. Although her work has become the historical standard in child psychoanalysis, Klein was far from the only prominent child psychoanalyst of the postwar period, and in fact there were a number of psychoanalytically informed infant and child psychiatrists and psychiatric social workers in the United States and Great Britain after the war who exerted considerable influence on public policy globally, most notably Anna Freud and René Spitz. After the Second World War, high-profile practitioners of child psychotherapy engaged in the care of children undergoing what Spitz called "emergencies of survival." A term typically reserved for medical emergencies and circumstances brought about by immediate disaster, emergencies of survival were in this case generated by the loss of a primary caregiver by infants and young children. This was the outcome not only of war but also of economic and social crises that left parents without resources to care for a child, and who either gave up their child to the state in hopes of thereby getting them better care, or who lost their parental role to the state due to charges of neglect or abuse or incarceration. A major concern of child psychoanalysis during the postwar era, then, was the "social orphan," the child who had become the charge of the state but whose primary caregiver was neither dead nor unknown to the state. The refugee measure in which nine months prior to the outbreak of war Britain and other countries took in almost ten thousand predominantly Jewish children from Germany and other Nazi-occupied countries, placing them in foster homes, nurseries, hostels, and farms, preceded the wave of transnational adoptions in necessitating attention to the issue of child rights outside the purview of their nation origin, and the need for transnational discourse and policy.

In this essay, I consider the work of transnational infant and child psychoanalysts, students and followers of Freud who in the mid-twentieth century adapted the classical techniques of psychoanalysis to work with institutionalized social orphans. The social context of the practices I discuss is the postwar milieu of the British welfare state and, more broadly, a spirit of global humanitarianism shared among professionals throughout Europe and North America in fields including public health, social work, psychiatry, and education engaged in domestic and international discourses of infant and child welfare. The psychoanalytic work I consider was based largely in public institutional contexts, and was performed in keeping with the sentiment that human rights, when extended to the child, required global action and public consciousness at the level of schools, hospitals, clinics, orphanages, prisons, and institutions involved in their management. This sentiment was articulated in the 1948 United Nations Universal General Assembly Declaration of Human Rights, a document that included the stipulation that "[m]otherhood and childhood are entitled to special care and assistance. All children, whether born in or out of wedlock, shall enjoy the same social protection."[1] The 1948 declaration inaugurated an era of escalating attention to child welfare globally that culminated in the drafting of the Convention on the Rights of the Child, an international treaty entered into force in 1990 that put forward not simply new forms of child protection but, in UNICEF's interpretation of it, "a new vision of the child."[2] The convention defines children as autonomous subjects in a global milieu that supersedes the state, as neither solely the charges of their parents nor the objects of charity. The first legally binding instrument to grant children civil, political, economic, social, and cultural rights in an international framework, the convention remained unratified in 2009 by two countries: the United States and Somalia.[3] In the postwar era, professionals who engaged in matters of child welfare proceeded with confidence and believed that, although children were rightfully citizens, the matter of how a government managed them on its own soil would no longer be solely the nation's private business. The convention thus marks a turning point after which children gained the special status of global subjects, with recourse to protections outside the boundaries of the nation-state. This shift in the status children from charges of the state to citizens of the world had enormous implications for the life of the social orphan as a potential subject of transnational adoption.

The psychoanalysts and psychiatric social workers considered in this essay were among those practitioners who concerned themselves with infants and young children in medical and psychological crises that resulted from parental loss, temporary or long-term, and the psychological development and outcomes of these children as it became a matter of public health and global conscience. The practices that concern me here are those of infant psychiatrist René Spitz and his professional partner, the psychologist Katherine Wolf (the collaboration was

cut short by her untimely death[4]), who were leaders in the study of the impact of institutionalization on infants; psychoanalysts Anna Freud and Dorothy Burlingham, founders of the Hampstead Nurseries, who worked with war orphans and, later, with blind children; and psychiatrist John Bowlby and psychiatric social worker James Robertson and his wife and collaborator Joyce Robertson, participants in the British Child Guidance Movement. The Robertsons' findings concerning the experience of young children separated from an attachment figure through hospitalization grounded Bowlby's theoretical claims about attachment. Their work influenced generations of thinking about children deprived of primary caregivers in fields including psychology, social work, education, and neuropsychiatry. The work of these psychoanalytically trained child professionals falls, for the most part, outside the realm of Klein's object relations theory, in that it considered non-normative circumstances: early conditions of caregiver privation (never having a primary caregiver) and deprivation (having a primary caregiver taken away) in early life experience. While this work had implications for understanding infant and child development and ego formation among subjects who did not undergo these conditions, it made a crucial contribution to the understanding of the growing numbers of children being raised in residential schools, nurseries, and orphanages around the industrializing world. Their empirical findings and subsequent theories influenced practice outside the profession of psychiatry proper, making its impact most visibly in the psychology, medicine, law, and social service practices dedicated to the care of the social orphan—practices that had escalated in number and become foundations of the child study field by the end of the twentieth century.[5]

In the following pages I closely consider a few of the films of two of these psychoanalytic teams as instances of psychoanalytically transgressive interventions in childhood states of emergency: Spitz and Wolf, and the Robertsons. These teams produced motion picture films that gained international professional audiences, forging a climate of compassionate consternation with regard to children experiencing psychic and developmental "emergencies of survival" due to circumstances of war, family trauma, or illness. The term I use to describe this response of compassionate consternation on the part of an international psychiatric community is *moral spectatorship,* a concept borrowed from sociologist Luc Boltanski and developed more fully in my book of that title.[6] The material I describe here is drawn from published sources, films, and unpublished interviews with Anna Freud, Bowlby, and James Robertson (conducted by psychiatrist Milton Senn), and the private papers of Spitz. Although they did not make films, Freud and Burlingham actively engaged with and reviewed the films devoted to child study and understood the importance of film to empirical visual observation, notably in their work with blind children, in which they emphasized the place of sight in ego development. Visuality was a key mode in their repertoire of studying

child development in circumstances not only of crisis but also of physical and sensory difference. In including this team of practitioners, my concern is to show the place of visuality in their postwar reorganization of the concept of the child as *global* subject and the contribution of this important team of child study workers to a global professional discourse on behalf of this new vision of the child. I do not discuss the work of other notable psychiatrists and child study experts who used film during this period, such as the American psychologist Arnold Gesell who had much to say about adoption but who primarily studied and filmed infants and children raised in normative family conditions. Margaret Mahler, the Jewish émigré psychiatrist and peer of Spitz's who worked on infant psychosis, is a notable exception here, as is Mary Ainsworth, who worked with Bowlby and the Robertsons on early separation through the Tavistock Clinic. I consider their work in film elsewhere.[7]

When and how infants begin to use vision to organize their world has been a perennial concern of psychoanalysis. For Freud and Burlingham, Spitz and Wolf, and Bowlby and Robertson, how an infant looks—meaning not just how the infant appears but also how it mobilizes its gross physical capacity to apprehend the world through sight—is a key indicator of an infant's mental health and development in the absence of indicators in speech and motor control. Film was a useful tool not only for acquiring visual knowledge about infant and child health and development but also for apprehending the minute details of the infant's looking practices and the spatial and visual systems through which it organizes its world. Visuality was thus central not only to study the child empirically, but also to understand the child's own way of organizing its world.

The infant and child subjects studied by these teams were understood to have experienced "emergencies of survival" on two levels: institutionalization was both a product and a cause of crises in the lives of these children; and developmental processes as basic as ego emergence were negatively impacted (arrested or even reversed) by institutional living. Several factors united the experiences of these infants and young children: the removal of the primary caregiver; emotional deprivation resulting from loss of a caregiver; and institutionals providing no adequate consistent substitute for this care for a prolonged period of time. Because these factors were identified as the products of complex environmental circumstances including war, hospitalization, parental incarceration, abandonment, or mandated removal of the child from the home, practitioners shifted their focus away from individual or family clinical treatment based on the child living in a private home to treatments that took into account conditions in group public health and child welfare settings like hospitals, orphanages, and nurseries. National and global policy-making was in turn shaped by the fact that professionals in child study were now looking closely at the institutionalized child, and not only at the child in the private home as the model for policy. This

was strongly the case for the World Health Organization, which turned to Bowlby to draft recommendations of practice and policy regarding the care of infants and children globally. For the teams of Spitz and Wolf and Bowlby and Robertson, filmmaking was an important means of data gathering, study, and professional presentation and persuasion. Their modified psychoanalytic methods demonstrate a turn toward visual observation as well as a turn toward interpretation of the role of visual perception both in psychoanalysis and in child study. And most importantly, their practices helped to turn attention among professional caregivers and policy makers on an international scale to the institutionalized child, and especially to the social orphan, the child placed in the hands of the state.

These teams modified and perhaps even violated some of the cornerstones of psychoanalytic protocol in this process of focusing on the institutionalized child. They engaged in visual practices in ways that transgressed traditional psychoanalytic methods, which were based in speech and language. Their practices took a double visual turn that will be at the crux of my discussion. The first was a turn to visual means of therapy and the visual as an object of study. This turn was made by necessity. Visuality was understood to be crucially linked to ego formation in the child. Moreover, visual media provided crucial evidence of the trauma experienced by prelinguistic infants observed over time after the departure of its mother or primary caregiver. The visual turn was an obvious necessity in this context. Still, visual methods and a focus on visuality in the child ran counter to classical psychoanalytic technique, which favored analytical listening. The phrase "the talking cure" captures the centrality of oral speech and listening as both the chief medium and the defining metaphor of classical psychoanalysis. The dynamic of the "talking cure" involves different relationships of the analysand and the analyst to speech as activity. As psychoanalyst Ida Macalpine pointed out in 1950, psychoanalysis is not exactly a relationship that puts analyst and analysand on equal discursive footing: the patient speaks, the analyst listens.[8] For the patient, then, to speak is to enter the world of social discourse, to take his or her place as a subject in the world that is played out on the "psychic screen" that takes shape in the organizing presence of the analysis. For the analyst, to listen passively is to occupy the neutrally supportive or reflective space in which the subject can constitute a world in speech. While this may be accurate, it is important to note that analytic passivity does not connote a position of weakness. For the transference to be successful, the analysand must experience the analyst's position as a powerful one. Analytic passivity is, powerfully, a mediating activity—a position through which the activity of speech is channeled, organized, and transformed into new meanings. In psychoanalytic transference, the position of mediation carries none of the negative connotations of neutral passivity, but rather situates the analyst at the coordinating locus of meaning.

Because of the professional emphasis on speech and language in classical psychoanalysis, it is important to consider the role of visuality in the classic understanding of the transference relationship. Citing a publication of analyst Phyllis Greenacre (1954), Spitz proposed that the matrix of transference comes largely from the original infant–mother quasi-union of the first months of life, a preverbal period.[9] "Psychoanalytic technique," concludes Spitz, "creates an infantile setting. Transference readiness requires 'a new edition' of this infantile setting and the stages in the formation of the object relations to which the adult must regress, step by step."[10]

Spitz notes that Anna Freud cautioned him that the objectless first stage of infancy does not appear in the transference in adult psychoanalysis.[11] To regress to a stage of nondifferentiation with the mother would set the patient back to conditions prior to ego formation and prior to language, thus eliminating the very grounds, speech and language, on which an analysis could take place. Spitz responds that while Freud is quite right, the analytic setting nonetheless reproduces many elements of this first infantile phase. Spitz postulated that the patient is pulled "funnel-like" back toward the objectless phase. The "infantile setting" that Spitz describes is organized very much in visual terms, but in a manner that *restricts* visuality, by thwarting the patient's attempts to be active in the registers of sight and physical movement and channeling them into the realm of inner thought and outward speech. He explains:

> We frustrate the patient's visual participation of the object; tactile participation is precluded by the conditions of the analytic situation. We frustrate his auditory perception by responding sparely and rarely to his manifestations. We force the patient to recline and restrict his "acting out" to the verbal register, limiting physical and eye contact.[12]

In the classical analytic set-up Spitz describes, the patient's outward sensory reception is limited to a narrow visual field with the analyst seated out of range of sight. The analysand's action is redirected away from looking (restricted) and touching (understood to be prohibited) and into the register of speech, where virtually nothing is barred. In this classic (though perhaps not typical) relationship, a discourse of looks is off-limits; looking and touch both fall into the realm of prohibited action. This state of visual and tactile sublimation and motor incapacitation is akin to infantile helplessness in all registers but speech. Spitz emphasizes the role of visuality in this setting:

> Though activity is redirected away from it, sight and the visual remain crucial: they motivate speech. What cannot be seen or touched sets the grounds for desire and fantasy, centered in part on the figure of the analyst whose organizing presence is imagined, situated out of the line of sight. Prohibition against visual and tactile contact makes the analyst's private life as mysterious as the parent's.[13]

It is not only the analysand whose visual and motor activities are restricted in this setting, of course. The analyst's perceptions and action are perhaps even more strictly circumscribed to attain the mediating position. In his discussion of his infantile setting theory, Spitz recommends that the analyst perform diastrophically (supportively), resisting the impulse to "act out" on any register himself. However, as Spitz is quick to acknowledge, this is not always the case in practice. In fact, he proposes that there can be benefits to a situation where the analyst does not remain in his or her place: "The analyst's acting out can lead to a therapeutic interpretation" and, moreover, "when acting out replaces interpretation, the results will sometimes be spectacular."[14]

We might wonder what sort of spectacle might result from the analyst "acting out"—what might lie beyond interpretation to constitute, in Spitz's terms, a spectacular cathartic therapeutic intervention. Throughout this discussion, I will follow the thread of this peculiar remark about the results of the analyst's "acting out" by tracking the analysts' own performances, that is, their instances of spectacular "acting out," not only with their patients but also on and through film and in public forums on behalf of infants and children, the class of "emergent" subjects they visually document and analyze. It is in the realm of preverbal subjects that Spitz earned a reputation for making such "spectacular interventions" on an international scale in psychiatry and psychology, "acting out" in relationship with his subjects, and acting out on film with them for public evidence, dramatizing these children's unthinkable emergencies of survival inside the walls of prison nurseries and orphanages for a global professional audience. The Robertsons would follow Wolf and Spitz's precedent, using the mode of film to transform analytic professional passivity into overt public expression and intervention on behalf of children, in Britain and globally. These instances of analytic "acting out" involve a type of countertransference that becomes the grounds for these practitioners to stage a narrative of rescue and social transformation, taking the analytic professional position from passivity to dramatic action through the medium of film.

Spitz: The Moral Witness of Infant Grief

René Spitz was widely hailed for his work on infant psychoanalysis and, in particular, his work with preverbal infants institutionalized during the first year of life. It is on this work that, in all probability, he bases his observations about the adult therapeutic setting as being like an "infantile scene." Preverbal infant subjects pose certain obvious problems for psychoanalytic practice. With its focus on therapeutic intervention through speech, psychoanalysis would seem to offer little potential insight into the meanings of preverbal infant behavior. Spitz referred to this as a "poverty of symptomatology" in infant psychiatry. In its pre- and early

linguistic phases, analysis would seem to be precluded for lack of its fundamental object, symptomatic speech. In his work with infants, Spitz shifted his focus from speech to appearance and his stance from listener to observer. These shifts entailed dramatically foregrounding sight and the visual, the very registers so tightly restricted in the conventional analytic setting. He and Wolf generated analytic interpretations of visual, observational data, much of which was compiled on film or through charts and textual records. The information they gathered was largely based on physical observation of the body of the infant that included movement, gesture, gaze, expression, behavior, and growth. In their observations of and interaction with the infant and young child, looking and physical performance (gesture, touch) supplement or replace oral speech as both analytic technique and as the primary objects of analytic attention. Perceived behavior, including the infant's social activity of looking—receiving looks, returning them, or not—become key indicators of a child's developmental health.

The observational platform on which Spitz organized his work with infants was by necessity constituted as a visual field in which everything revolved around relays of looks and touching as stimulus. In this, Spitz went against at least two of the analytic tenets: the prohibition against physical contact, and the tendency not to engage the patient through eye contact and bodily signals. For infant psychoanalysis to be cathartic, the analyst needed to foster a reciprocity that broke the codes of analytic neutrality and passivity. Moving away from Macalpine's "one-sided" model of the psychoanalytic relationship, Spitz engaged in reciprocal visual "dialogs" with infants. He did not simply look and observe. He interacted with the infants he studied. These interactions were spectacular for their methodological transgressions of the hands-off standards of psychoanalytic practice and diversions from the "blind" observational strategies of child psychology of the period, which kept the observer unseen by the child.[15] They were also spectacular for their broad effects internationally in changing public sentiment and policy globally concerning child and family health, education, and welfare, influencing professionals to recognize the plight of children in institutions.

Like the Freuds, Spitz was among the wave of psychoanalytically trained Jewish psychiatrists who moved to England and the United States in the 1930s to escape Nazi persecution. Born in Vienna in 1887, Spitz earned his first medical degree under Sandor Ferenczi in Budapest and underwent a didactic analysis with Freud in 1910 and 1911. He became one of the foremost proponents of Freud's work in the United States, where he lived from the 1930s until his death in 1974. Infants in the first year of life, which he studied from the early 1930s in Vienna until the end of his life, were the subjects in the work that earned Spitz international recognition after the Second World War. Based on silent film records made in institutions around the world with Wolf from the 1930s forward, he produced a series of well-received and internationally celebrated publications and films that

documented and theorized the emergence of object relations and the ego in infants who were either without a primary caregiver from birth or deprived of their caregiver after attachment had begun to form.[16] Influenced by Sigmund Freud and Georg Simmel, Spitz looked at the mother-child dyad to observe the nascent ego's formation. With Wolf, Spitz conducted a study between 1936 and 1940 of 164 children in the first year of life. Wolf was codesigner with H. Durfee in Austria in 1933 of a test used in Spitz's study to assess the psychiatric consequences of institutional care of infants in their first year.[17] Their test included a quotient for intelligence and quantifiable development data. Durfee and Wolf found that children institutionalized for less than three months showed no demonstrable impairment, but children institutionalized for more than eight months showed such severe psychiatric disturbances that they could not be tested.[18] Subsequent studies indicated that after three years, the psychosomatic damage was irreversible. The original studies by Spitz and Wolf were done at two sites, and each set of studies was extensively documented on film. The first was conducted in Casa de Cuna, a rural orphanage in Mexico, while the second was conducted in the nursery of an urban prison for female juvenile offenders in Argentina. Both groups included control subjects, infants in private homes in the respective surrounding communities. The orphanage and the nursery both provided more than adequate nutrition, hygiene, medical, and material care for their infants. Privation or deprivation—that is, absence or removal of a consistent, trusted primary caregiver—were the major differences in circumstance from those of the infants studied by the psychologist Arnold Gesell, who observed and filmed in his laboratory setting the behaviors of infants who otherwise lived in private family homes.

The theories Spitz and Wolf put forth on the basis of these studies[19] are regarded internationally as paradigm shifting in infant and child psychiatry and psychology.[20] Their first contribution was to refine and revise hospitalism, a concept that entered the North American medical literature through an *Archives of Pediatrics* editorial of 1897. The author of that editorial made it clear that the phenomenon was widely recognized, even commonplace, in turn-of-the-century hospitals, and subsequent usage referred to children in nurseries and orphanages as well.[21] Of the children Spitz and Wolf followed at the orphanage, 37 percent died within two years. The twenty-one surviving children are described as "extraordinarily retarded" mentally and in weight and height despite adequate nutrition and care. In the three and a half years of study at the nursery for one full year each, not one child died. Most children remained in the nursery for a year only, or slightly more, and then were returned to their mothers.

Published in 1945 and 1946, Spitz's classic papers on hospitalism refer to conditions where infants undergo continuous institutional care and have no deficit of food and shelter. Deprived of a consistent primary caregiver in the first year of life,

the infants experienced severe developmental delays and setbacks; they exhibited emotional withdrawal and heightened susceptibility to infection; and they died in startling numbers in cases where the caregiver was not restored, despite adequate food and more than adequate hygiene. Spitz and Wolf proposed, on the basis of their observations, that absence of a consistent primary caregiver and inadequate sensory stimulation froze and even reversed development. This was not exactly a disease of the ego, they postulated; the ego was barely formed in the first year. Rather, this was an outcome of deficiencies in the factors needed to nurture the emergence of an ego that would sustain the child, providing it with an internal will to survive.[22] Their findings were reinforced by other studies of institutionalism, including those of Durfee and Wolf, Bender and Yarnell, Goldfarb, and Lowrey who separately found that after three years of institutionalization the changes effected by the experience of maternal deprivation were irreversible.[23]

The importance of the publications on hospitalism has been widely debated, for others had studied hospitalism, and Spitz's conclusion regarding cause (which he attributed to maternal separation or absence) was challenged.[24] But until Spitz and Wolf, none had studied institutionalized infants from birth through the first year, in that critical prelinguistic ego-formative stage, and none had worked with a sample this size. And certainly none of this had, until the Spitz and Wolf studies, been documented on film, in graphic visual form and in detail, over time. The essay about Hospitalism was regarded with consternation and surrounded by controversy. Crucial to this essay's fraught reception, I propose, was its coincidence with the worldwide climate of consternation in response to the atrocities of the Holocaust and concern over the fate of child war refugees and children living in states of poverty and abandonment to the state—a situation that would be replicated, if differently and on a different scale, in Eastern and Central Europe after the fall of the Soviet Union. Spitz, as an immigrant from Hungary working in the context of postwar United States, occupied an emblematic place as a spokesperson for child welfare as an international cause and as an outspoken and engaging student of Freud. Spitz's publication, based on research conducted in the 1930s, was well-timed to coincide with the same global moral human rights sentiments that motivated the 1948 UN Declaration of Human Rights, initiating decades of discussion and policy reform concerning children as global subjects culminating in the UN Convention on the Rights of the Child a half century later—a convention that coincided with the economic and child crisis that ensued with the end of the Cold War.

The second major contribution made by Spitz and Wolf was their 1947 paper proposing that infants deprived of their primary caregiver for an extended period of time experienced infant anaclitic depression. They described this condition in infants as sharply distinct from adult anaclitic depression, and they distinguished

their concept from other, currently better-known theories such as Klein's concept of infant depression as a fundamental basis of development.[25] "In contrast to Melanie Klein and her group," Spitz wrote, "we do not consider depression as an integral element of the infantile psyche . . . We speak of depression as a specific disease in infants arising under specific environmental conditions."[26]

The anaclitic depression paper was based on observation of 123 unselected infants in the nursery of the penal institution where in nineteen cases they observed a clear-cut syndrome they described in terms of this concept. Characteristics of the anaclitic depression syndrome included weight loss, weepy behavior giving way to withdrawal, indifference, frozen stare or watchful countenance, weeping or screaming in response to the approach of experimenter whereas previously the child had smiled and interacted, insomnia, greater susceptibility to infection, and a decline in developmental quotient.[27] Observations were conducted over three and a half years on each child for one year each from the fourteenth day of life. Observations were recorded on film and in charts and records at weekly intervals totaling approximately four hundred hours per child.[28] The children were divided into two racial groups: "white" (77 children) and "colored" (46 children), and were classified according to severe, mild, no depression, and no diagnosis.[29] All of the prison nursery children in whom the syndrome of anaclitic depression was identified shared one factor: the mother was removed from the child somewhere between the child's sixth and eighth month, "for unavoidable external reasons."[30] No equivalent caregiver substitute was provided. Over the course of this prolonged separation, the infants regressed, withdrew, and became unresponsive. Growth ceased and even reversed itself. The manifestation of depression, Spitz wrote, is "unmistakable to the practiced eye"[31] and so obvious that "even the lay person with good empathy for children has no difficulty in making the diagnosis, and will tell the observer that the child is grieving for his mother."[32]

Although the melancholic, mother-starved infants did not die at the same high rates as those cases noted in the orphanage studies, the psychiatric syndrome of anaclitic depression in prison nursery infants gave Spitz ample material in which to observe the dejected look, the turning away of the infant's gaze from the approach of the researcher, and the absolute withdrawal and apathy in previously cheerful infants whose mothers had disappeared from their lives as strikingly alike to those of the orphanage infants who had never had the maternal figure in place. These studies gave him reason to look back upon the orphanage deaths and conjecture that there might exist a suicidal tendency in infants who would starve themselves in the presence of food out of grief over the loss of a loved one.[33] The gaze of the infant whose mother's absence lasted more than three months was described as progressing toward end-stages in which the infant in essence lost

movement and affect altogether. They exhibited "frozen, affect-impoverished" faces, assuming poses of "stuporous catatonia."[34] The deep grief of the nascent ego, without the restoration of the mother by the third month, could lead eventually if not to physical death then to the developmental arrest or regression, physical illness, or the psychic death of psychosis. The therapeutic measure proposed was simple: restitution or substitution of the primary caregiver.[35]

Spitz and Wolf used motion picture films as a means of data collection and analysis in their orphanage and prison nursery studies, and the films they produced with this footage showed devastating evidence of this condition. Before World War II, Spitz and Wolf had been active with Anna Freud in placing Jewish refugee children, so they were no strangers to the everyday circumstances of maternal-infant separation under conditions of international crisis. After the war, Spitz began to use the footage he'd shot with Wolf prior to this experience in his lectures and professional presentations, once he had settled in the United States—and after he had experienced firsthand the forced exile of the Holocaust. He edited and composed the research footage that had supported his earlier essays into eight didactic films. Some of these films were acquired by the World Health Organization (WHO), the United Nations, and the British Film Institute in the early 1950s, and by hundreds of universities and social service organizations around the world from the late 1940s through the 1970s. Spitz went to great lengths to try to get the WHO to act as global distributor for his films, and invoices and request letters demonstrate that Spitz's films circulated broadly among a disparate range of institutions, from rural child guidance centers to the Jewish Board of Guardians, to intellectuals including Bruno Bettelheim and Margaret Mead, to the American Medical Association, the U.S. Public Health Service, and the National Institutes of Mental Health. One of these titles, *Grief: A Peril in Infancy* (1947), acquired by the WHO, continued to be used in some psychology classes into the late 1990s. It re-emerged as an important piece of documentation about institutionalization for the social orphan when the world's gaze turned to the plight of the institutionalized child in former Soviet states after 1989. The film is a devastating document of the demise of a child on the basis of a psychic trauma that no measures were available to alleviate.

Grief (1947) is a direct companion film to the essays on hospitalism and anaclitic depression. The film begins with Jane, an eight-month-old child who intertitles tell us is well cared for by her mother in the prison nursery. A stranger (Spitz) enters the frame as Jane reclines in her crib. He leans over her, nodding and smiling. She smiles into his eyes. Intertitles warn us that if a baby is separated from its mother at this point it will respond like a child "dumped on another continent, in an alien environment, where nobody speaks its language and customs and food are foreign." We might wonder if Spitz and Wolf remembering their own

immigration experience, or his work with Freud's war orphans when they made this analogy. We are then shown Jane a week after separation from her mother. An intertitle prompts us to note Jane's depressed expression, her bewildered gaze, and her passive countenance. When approached by the stranger (Spitz) again, Jane weeps. Spitz's attempts to reassure Jane make her weep all the more. Jane rocks and slams her feet against the crib. Another intertitle pronounces that this is "Jane's expression of grief."

The next child to whom we are introduced, Anna, at eight months gleefully receives the stranger (Spitz). Spitz offers the smiling baby his hand, scooping her up from her cot and posing with her for the camera as she prods his face and inserts her fingers in his mouth as he speaks to her (the film is silent, however, we can see him mouth words). We are then informed that Anna was separated from her mother shortly after this scene. The following shot gives us Anna gazing despondently out at the stranger. She fails to respond to his offer of a toy. Finally, we are prompted that we will see Anna at eleven months, still separated from her mother. Spectators are warned that at the approach of the observer the baby's "grief finds vocal expression and it will be difficult to assuage it." Anna appears thinner. As predicted, at Spitz's approach her mouth opens wide to expel a wail that appears not to cease during Spitz's physical ministrations. He lowers the bars of the crib and lifts out the child, holding her close to his body as he strokes her and speaks consolingly to her, looking down into her face. His eyes then turn outward to look beseechingly into the camera, into the eyes of the audience at this moment of Anna's inconsolable grief and his own helpless empathetic compassion. His face, with its gaze cast down at the child, echoes backward and forward in time. Spitz first looks downward in sadness and shame. He then turns his gaze up and out to meet the camera lens directly with an imploring gaze, a gesture that is without question both borne of his own grief and intended to evoke compassion in the spectator.

As a climax of *Grief*, the film displays an emaciated Anna cowering in the corner of her crib, wailing inconsolably. This shot is repeated throughout a few of the films, and in publications as a still frame. She is shrunken and withdrawn. Her face is a mask of pain. "Emotional deprivation," an intertitle concludes, "can become as destructive as physical starvation by arresting development and lowering resistance to disease. The only response is the helpless marasmic[36] smile and the equally helpless wailing." The cure, an intertitle proclaims, is to restore the mother.

Despite its undoubtedly shocking impact to professional audiences to whom the film was distributed, Spitz recommended showing the film not once but twice: once before a lecture, then afterwards in slow motion on an analytic projector that would allow for close scrutiny of individual frames.[37] He used film in part to document in close detail the movements and expressions of infants with the

intent of arriving at an interpretation of the distinct features of infant affect and drive in ego development. He was in favor of withholding interpretation of documented bodily movement, separating appearance from meaning in order to allow for a new lexicon of expressive movement specific to infant subjects to emerge. On the basis of these intentions alone, his work is relevant to theories of scientific representation and spectatorship. On a formal level, Spitz refused commonly held correspondences between expression and meaning to open the door for new findings in the interpretation of "obvious" expressions such as smiling. In this regard, his work is congruent with that of Béla Bálazs and other early film theorists who have focused on the encoding and reception of bodily and facial movement and expressive meanings, except that in this case Spitz focused on spontaneous and not dramatic simulation of expression.[38] Spitz's followers stressed the importance of having detailed knowledge of facial anatomy and musculature in infancy for any psychologist or psychiatric social worker that sought to interpret infant expression; this was a subject near to Simmel's heart, but which Simmel oddly never investigated deeply in the case of the infant and the development of empathy.[39]

Following Spitz, a wave of psychologists including Silvan S. Tomkins attempted to devise ever-more precise instruments for measuring increments of movement in the face as a means of better understanding the expression of affect.[40] The developmental moment Spitz analyzes in these films is relevant to theories of representation and spectatorship on another level as well.

In tracing visually the emergence and then the regression of the ego, *Grief* documents the infant's nascent ability to itself "read" other bodies for expressive movement. Spitz himself performed for the child in order to elicit responses he could observe and analyze in the child's reciprocal response.

The "acting out" of the analyst is powerfully demonstrated in the film *The Smiling Response* (aka *The Smile of a Baby*, 1948). *Smiling* stands opposite *Grief* in its presentation of a situation that invokes not sadness but play. This film is a series of research vignettes produced and performed by Spitz and Wolf. A baby in a crib is approached by a series of adults: a white baby is approached by a white man (Spitz) and a white woman (Wolf), who nod and smile, eliciting a return smile from the baby; a black woman approaches the white baby; and a black baby is approached by a white man and woman (Spitz and Wolf). The team then introduces props—including a doll, a mask, and a scarecrow—to observe the baby's response to representational substitutes—a project that precedes and resonates with Harry Harlow's famous studies of surrogate and mechanical mothers in his primate infant studies. The Spitz and Wolf smiling studies are of central concern here because they allow us to witness Spitz and Wolf studying the place of visual recognition in infant development, and performing actively in the visual field of the infants they study, precisely to elicit a reaction. The white baby responds smilingly to the mask, for

instance, leading Spitz to conclude that the human quality of movement was enough to signal human contact to the baby. His own physical presence continues to be invoked even when he introduces human substitutes. He substitutes for his own body a scarecrow whose features are, amusingly, modeled on his own. The baby smiles at the scarecrow, except when it appears in profile. Spitz then presents himself to the baby in profile, generating no response. Babies black and white, he concludes, will smile at men and women, black and white, indiscriminately. However, there are certain basic features, such as two eyes and physical movement, that the body must have for the child to recognize it as human.

The role of the gaze and the psychoanalyst as overt elicitor of looks is explicit in *Smiling*. Spitz and Wolf ham it up for the viewer as well as for the baby, grinning

Figure 10.1. Spitz mugging for the baby, in René A. Spitz and Katherine M. Wolf, "The Smiling Response: A Contribution to the Ontogenesis of Social Relations," in *Facial Expression in Children: Three Studies,* ed. Ruth Wendell Washburn (New York: Arno Press, 1972), 78.

Figure 10.2. Spitz appearing for the baby in a mask, from Spitz and Wolf, "The Smiling Response," 82.

and grimacing on film like children at play. Spitz constructs a double of himself in the scarecrow he makes to show the baby: the straw man is bald with severe brows wearing a black turban matched to the beret we see Spitz sporting in a number of his other filmed interactions with babies. Indeed, a photograph of a smiling Spitz wearing the scarecrow's turban appears in the typescript and publication of the smiling response project.[41]

Object relations in the infant involve the understanding of self and other and the development of empathetic responses both to live others and to constructed representations of human bodies or faces. Empathetic response—involving identification and mimicry—are at the core of spectator identification with characters on film. Spitz and Wolf's film about infants' reception of human bodies and faces demonstrates the importance of this link between ego emergence and the

emergence of representational schemes, of which Spitz regards the face to be the first. In this sense, the film is reflexive insofar as the researchers are searching not only for how to read the correspondence between stimulus and affect in infant expression but also for the ability of the human body to project affective meaning outwardly to the child. In other words, *The Smiling Response* is a text in which Spitz struggles to gain control over the legibility of his own body in the eyes of his spectator, the infant. The infant's struggle with the series of faces presented to it mirrors the analyst's own struggle to interpret infant faces and their representations.

These two films, *Grief* and *Smiling*, present an interesting problematic in scientific representation. The researchers, Spitz and Wolf, engage in an observational protocol that, by its own design, prohibits interference in the filmic process. They engage with their subjects as a stimulant to reaction, as one can see during Spitz's face-making throughout the film on the smiling response. He does not, however, interrupt the process he documents as it unfolds in the experimental setting, except in ways pre-designed to elicit information. In the film documenting infant depression, however, we do see Spitz increasingly engaging with his subjects outside the terms of the experiment in order to interrupt the process he is appalled to see unfolding before his eyes: the withdrawal and regression of the child.

The researcher responds to this unfolding scene of grief by introducing care, compassion, and empathy. Indeed, the pity response provoked by these children in Spitz and Wolf become a feature in the numerous films in which they show separation and grief, making these films documents not only of the unfolding processes of depression in the infant that Spitz wishes us to observe but also the process of the interjection of the analyst as observer, the moral agent who mourns the process that he or she is observing and therefore acts out spectacularly to intervene. *Grief* and *Smiling* act as mirrors insofar as the researchers themselves model compassionate interaction and the very processes of introspection and empathy so stunningly lacking in the care of the infants who wasted away in the full presence of institutional caregivers in the contexts they studied.

Yet the moral imperative to intervene with compassion went against the expectations of objectivity and distance built into both the film process and the scientific process of observation, and is ruled out by institutional policies that leave no time for individual care. To be clear, I am not making the claim that all scientific observation is coldly dispassionate and detached. Rather, I want to highlight the fact that the infant who loses his or her ability to progress toward human connection, toward identification, and toward empathy, and thus to emerge as a social subject, elicits exaggerated displays of researcher identification and empathy.

One possible strategy for explaining how facial images are inscribed with meanings relative to pity is by examining Luc Boltanski's analysis of Adam Smith's

moral spectator, and Boltanski's own theory of media spectatorship of distant suffering. Boltanski's work is unique among theories of spectatorship in its attention to situations in which viewers observe representations of present suffering in strangers at a distance, and subsequently are moved to charitable and perhaps even risky action on behalf of that subject. Their action on the individual's behalf, which may take the form of speech or payment, such as, for example, a charitable donation, is likely to impact "a host of replacements," if not the subject who inspired the action. Just as Spitz cannot halt or reverse the demise of the infant who mourns its lost mother but can help a host of others by implementing a theory of intervention, the spectator of distant suffering can change the course of experience for others even if the tragedy witnessed can never be redressed. Few theories of spectatorship have addressed the relationship between distanced, reasoned responses to sequelae of trauma and the fantasies borne of desire to change the course of action, particularly in relationship to the moral spectator's assumption of responsibility and action. Boltanski notes that in this relationship "it is action that is above all the problem,"[42] for given the distance factor "no one would suggest that the spectator of distant suffering should drop everything and rush to the unfortunate's side."[43]

Boltanski interprets Smith's *The Theory of Moral Sentiments*[44] as a model of a relationship wherein the political order incorporates pity as a chief element.[45] Smith's moral spectator is a bystander who observes a suffering individual at a distance. The spectator imagines the suffering observed but does not become involved, does not identify with the victim or even imagine himself or herself in the position of a kinship bond with the unfortunate. In Boltanski's words, the spectator is a "split subject" insofar as he or she watches himself or herself, acting as impartial moral guide to the self as bystander from a distance. On the one hand, the assertion of suffering as a "fact" rather than as an opinion is the morally acceptable form for the spectator to take in speaking about the misery observed for, as Boltanski writes, "it is inhuman for children to die for want of maternal care." It is precisely this inhumanity that Spitz was forced to endure in taking on the humane task of documenting the impact of institutionalization on the social orphan. In Boltanski's text, there is the assumption of a universally shared acceptance of this statement insofar as no viewer would dare to admit feeling that an infant's lack of maternal care is somehow "not my concern" or argue neutrally that "the value of study made their suffering worthwhile." In the model of spectatorship described by Boltanski, there is a prohibition against detached reporting. For Boltanski, the detached, observant spectator of distant suffering must be, however, introspective, recognizing and describing his or her own feelings in any account of the suffering observed, and it is precisely this sort of introspection that is apparent in Spitz's film *Grief*. But

ironically, introspection is precluded for the infant who regresses back to a near egoless state, who seems to shrink and crumble cradled in the arms of the compassionate witness, the psychoanalyst who can no longer be of help. In the absence of a parental caregiver, the helpless infant's fate lies in the also helpless hands of the observer, whose proximity is for the purpose of witnessing the spectacle so as to preclude its eventuality for others.

Spitz's *Grief* calls upon viewers to reform institutional practices as well as psychological theories of infant care and maternal responsibilities. Cultural difference is traversed in a humanitarian response that helps a "host of substitutes"—not Anna and Jane, the two children documented by the film, but children like them who constitute the anaclitically depressed infant inhabitants of prison nurseries and orphanages around the globe, hidden behind the walls of institutions until the news media exposed their conditions at the end of the Cold War. Spitz's *Grief* is not only the grief of his infant subjects, then, but also the grief generated in the professional adult viewers drawn in by Spitz's films to see anew situations they had become inured to every day in their institutional work, or which they were not privy to in their research careers. These intertitled silent films were his and Wolf's silent call for professional empathy, a call made on a global scale through his efforts to market the films via the international organizations such as the WHO and the United Nations. His viewers were the psychologists, psychiatrists, and social workers who fanned out globally after 1945 to institute reform in prisons and orphanages from New York to Athens to India to Mexico, and back to the Europe they had been forced to leave.

There was considerable consternation in response to Spitz's film. While Spitz does not address this in his writing, the child psychiatrist Robert Emde, in a commemorative speech given after Spitz's death, commented that:

> The story is told that when Spitz first showed *Grief* to a group of New York psychiatrists a number became teary and expressed agony because of a compelling empathetic response to the suffering infants. In recent years . . . we have found that a more common experience is for viewers seeing these films to become anxious. Furthermore, if the viewers are not prepared for what they see, they may struggle to avoid feelings of sadness by "making light" of the films by focusing on inappropriate details, or by not paying attention.[46]

Spitz's title *Grief,* then, refers only partly to the mental state of his infant subjects who grieve their primary loss, staring out at the camera in a vacant and uncomprehending gaze. It is also the grief generated in professional adult viewers of these children, captured in the figure of Spitz. The suffering he witnesses and brings to the screen serves as a powerful call to moral action.

Figure 10.3. Spitz comforts a grieving baby in the film *Grief: A Peril in Infancy* by René A. Spitz and Katherine M. Wolf, 1946.

Bowlby, Robertson, and the Reform of Institutional Space

How does professional consternation and denial or professional despondency and grief transform into social action, drawing the analyst out of his or her passive listening mode and into the spheres of national and international policy concerning the rights of the child? John Bowlby and James and Joyce Robertson's 1952–1958 film observations of children experiencing withdrawal and depression in London hospitals spurred a set of procedural and architectural hospital reforms similar to those attempted by Spitz, effectively reorganizing looking practices among children and caregivers as a means of circumventing the trauma experienced by the institutionalized child separated from its primary caregiver. In 1940, Scottish laborers James and Joyce Robertson worked in the East End of London where the docks were the first targets of the Nazi bombings. The working poor who lived near the docks were killed in great numbers. The Robertsons helped in the evacuation to the countryside of orphaned children and children whose parents opted to move their children out of danger. James Robertson writes,

> Anna Freud was setting up a place in [northwest] London which gave working mothers, themselves bombed out and sleeping in shelters, easy access to the children. Joyce and I were attracted to the idea of protecting the children against the certainty of psychological damage that would result from the total separation of evacuation, while giving

them the best possible physical protection in a residential part of London. To keep children in London was against the Government's evacuation policy but we liked the considered balance of risks in Anna Freud's approach.[47]

The nurseries consisted of two houses in Hampstead near the Freud home where Sigmund Freud had died one year earlier. This was understood to be safe from the bombing that was concentrated in the working-class areas near the docks and factories. They had to look after air-raid precautions and, when the daytime raids encroached upon the residential areas, to get the children into the shelters below the nurseries. The Robertsons performed this work with five other pacifists under Anna Freud and Dorothy Burlingham. From Anna Freud the Robertsons received informal but intensive on-the-job training in the psychoanalytic method.

The Robertsons came to film practice through their work with Bowlby, one of the most influential figures in British child psychiatry and a major voice in post-war global child health policy, most notably through his work for the WHO. Bowlby had interrupted his early psychiatric training to work with juvenile offenders in an educational setting. His work in this context is legendary, for it transformed his medical views, motivating him to see child mental health and the development of child psychopathology in the broader context of the family and community, and as a matter for social welfare policy. His concept of maternal-child attachment would come, in the late twentieth century, to define a generation of neuropsychiatry and psychology devoted to the rehabilitation of the postinstitutionalized social orphan. However, his influential theories were based largely on the fieldwork and findings of his colleagues, most notably the Robertsons and Mary Ainsworth, and not his own direct observations of institutionalized children. The films and documentation of these field workers provided essential channels through which Bowlby's perceptions were mediated.

The Robertsons tend to be viewed as supporting characters in the story of Bowlby's major theoretical contributions to child study. Here I will be turning the focus to the Robertsons in part to give credit where credit is due for the sustained research that grounded some of Bowlby's major findings, but also to underscore the role of motion picture film in the Robertsons' groundbreaking findings about maternal-child separation.

In 1944, Parliament passed an Education Act that mandated, among its many far-reaching features, a provision for child guidance clinics throughout Britain. One of the professional outcomes of this act were that educational psychologists, psychiatrists, and social workers were distributed into interdisciplinary working groups rather than separated into distinct professional offices. Bowlby was selected to head up the psychiatric division of the child guidance clinic at the London Tavistock Clinic, and he soon afterward invited James Robertson to join him as social worker in the Separation Research Unit he was establishing at this now legendary clinic.

Robertson's project was to study child and infant experience in pediatric wards of hospitals for the National Health Service. What he encountered was a situation in which the child in the crisis of illness was shut off from parental care and isolated for purposes of checking the spread of infection. This triggered in the child a sequence of responses that Robertson studied in detail and depth, and documented on film. He labeled the stages of the sequence protest, despair, and denial. This theory of Robertson's was later written up and popularized by Bowlby. Robertson witnessed a disturbing professional nonchalance about the children's plight in hospitals, a response not unlike the lack of attention paid by caregivers in orphanages. This professional response "was not witting cruelty," Robertson explains. The staff was so accustomed to seeing children in states of despair that either they had become inured to what lay before their eyes every day or they were so disturbed by it that they needed to establish psychological distance in order to withstand the witnessing of the psychological pain over parental loss they witnessed each day. Wishing to force this issue to attention, Robertson rendered the familiar sight strange by producing a sort of *cinema verité* documentary film that demonstrated in graphic detail the psychological impact of separation on the hospitalized child.[48]

In the 1952 film *Two-Year-Old Goes to Hospital*, Robertson documents eight days spent at the hospital by Laura, a child of middle-class parents who undergoes surgery for a herniated umbilical cord. We first encounter Laura with her mother in a garden shot accompanied by Robertson's voiceover telling us that "it takes a lot to make Laura cry." Upon entry to the hospital, Laura is tricked and is separated from her mother with the promise of a rocking horse. She seems not to understand that her mother will not be present with her on the ward. She asks repeatedly for her. Footage recorded at the same time each day over the eight-day intervals takes us into the hospital ward, where the camera is trained on Laura behind the bars of her crib. We see an increasingly withdrawn and sullen Laura. On day three, Robertson tells us

> She has been very subdued all morning. It is easy to believe she has settled in. She does not cry or demand attention. This is the picture seen by the busy ward staff. But see what happens when the nurse comes. It takes longer to make contact and Laura does not respond.

"I want my mummy!" Laura cries, her back turned on the nurses and the social space of the room as she clutches her teddy and doll-blanket. In subsequent shots, taken at five-minute intervals, we can see Laura's efforts to regain control. Robertson's voiceover affirms this: "[Laura] is controlled and unresponsive, then her feelings appear, and then again she regains control." "Control," in this context, entails being unresponsive to her surroundings, blocking out what she sees and

hears in the social space of the ward. "Why is that boy crying?" Laura demands. The sight of another child crying incites in her empathetic identification. She immediately loses control and bursts into tears herself, demanding for the hundredth time her "mummy" as the camera moves in to an extreme close-up on her crying face.

Laura's states of control entail a combination of averted gaze and watchful vigilance. When her mother does return to the ward to visit, Laura is somewhat responsive at first but ultimately turns her gaze away, progressively becoming less and less responsive to her parents' daily visits as if in response to their admonitions, "Don't cry, Laura." Laura turns her back to the nurses, too, but glances back at them every so often and just slightly over her shoulder as if needing to monitor the presence of their activity behind her, as if in watchful vigilance, to make sure they are still there. She faces the camera but does not seem to notice its presence after the first day. Her face begins to take on the apathetic stare, the slightly paranoid vigilance of the anaclitically depressed child described by Spitz. At this stage, when she is visibly moved to feeling she expresses consternation and rage.

Laura's is not the only rage at stake in this film. When *Two-Year-Old Goes to Hospital* premiered at the Royal Society of Medicine before an audience of three hundred pediatricians, nurses, and administrators, the response to the film replicated the professional response to Spitz and Wolf's film *Grief* when it was shown to medical professionals in 1947. Robertson reported that "it was as if we had dropped a bomb in the hall. There was an enormous reaction of resistance and rejection . . . from most members of the audience. . . . I had slandered the professions." This was not, he explains, "because what I had shown was untrue but because . . . my film had torn away some of the defenses and had exposed pediatricians and nurses to the anxieties that they had become defended against." Robertson describes one viewer's letter expressing anger for including in the film a shot of the girl's fingers twitching, a sign of her anxiety, which "had moved him." Yet "he and others would not recognize," he explained, "that the emotion was inside themselves, repressed, and not in my editing." Robertson compared this general hostility to the film among British pediatricians to the international response the film garnered upon distribution: "the Americans, the Australians, the New Zealanders, the European reviewers—all were positive."[49] On the basis of this film, the WHO invited Robertson later that year to New York to bring his observational skills to pediatric wards there.

As was the case for Spitz and Wolf's *Grief,* professional consternation did not shut down reception of the film, but rather drew professional viewers into the social function of political action in an international sphere where, congruent with Boltanski's observations, they could respond to political suffering with the distance required for a spectatorial response of moral action. As Robertson explains it, the film awakened latent anxiety, motivating previously passive,

inured professionals situated at a distance to act. Recalling Spitz's words quoted earlier on the analyst's "spectacular acting out," we might view this action as a kind of transgression performed on the first level by Robertson himself, who was after all commissioned by the Public Health Service only to observe and not change hospital procedure. By bringing his film to a professional audience, Robertson drew others into a position of identification not only with Laura's feelings, but with his own outrage on her behalf.

On a local level, the response to the film began with a phase of consternation over Robertson's audacious spectacle, his unprofessional acting out in simply showing the film. But this consternation revealed itself to be, as Robertson explains, displaced anxiety about the situation depicted, a situation too close to home to accept. We might compare this response with that of the child who first experiences denial about the parent's disappearance. This denial was in certain cases followed by consternation about the conditions witnessed, and then action. One of the doctors who left the Royal Academy in a state of anger later put on record in the Royal Society's Proceedings the fact of his anger. But, he explained in a subsequent response, he was also moved to reform the environment and practice in his hospital pediatrics ward, instituting accommodations that would allow mothers to accompany and care for their children in the hospital. These reforms initiated sweeping changes throughout British hospitals in policies regarding child visitation.

In the 1958 film *Going to Hospital with Mother,* Robertson documents this doctor's reforms at Amersham Hospital. Whereas *Two-Year-Old Goes to Hospital* was titled "a scientific film by James Robertson," *Going to Hospital with Mother* was promoted as a humanitarian response to the former film and titled "a documentary film by James Robertson." Might this small but significant change in classification signal Robertson's own new understanding of his work as social activism, not merely scientific observation? In *Going to Hospital,* we see a dramatic change not only in the hospital's regard for the feelings of the child, but also in the organization of vision and the place of visuality within the ward. The newly organized space of the pediatrics ward is structured to allow the child to see, hear, and touch its mother continually. It also allows mothers and other primary caregivers, especially nurses, to continually observe not only the child but also one another engaging in the routines of caregiving. Glass partitions were installed to make cubicles that allow for the mother-child unit to have some semblance of privacy, but they are small enough to preclude private conversation, and they allow for heightened visibility. One can of course be seen through glass, but one also becomes more aware of the act of looking when one is looking through a wall of glass, and not simply across an open space. Throughout the film, mothers work alongside nurses, bathing and feeding their children under the watchful gaze of the nurses and of other mothers in neighboring cubicles. The humane pediatrics

ward is structured, in effect, like a friendly version of Bentham's Panopticon, where lack of privacy for the mother-child unit can be interpreted as a means of fostering community among mothers who may "peek in" on one another and share their experience and knowledge, knowing too that they may be observed by the nursing staff even if nobody is looking at any given moment. Nurses and mothers form a self-regulating managerial network in a magnified field of looking in which care is reduplicated and modeled cubicle by cubicle. The new hospital pediatrics ward thus constructs the gaze very much along the lines of the observational child study film, with its one-way windows and mechanisms for the careful control and study of visual interaction.

I will conclude this essay by saying a few words about Anna Freud's place in this international ethos of moral spectatorship through the visual language of film. Unlike Spitz and Bowlby, Freud did not make films. However, she and Burlingham took a special interest in sensory differences that impacted development. In 1965, Burlingham published an influential article on ego development in blind children that evolved into a book. Burlingham based her essay on observations at the Hampstead Nursery for Blind Children where she worked through the mid-1970s. She considered problems of communication and pleasure, both from the side of the mother and the side of the child: "Blind infants need more than the usual stimulation from the mother to respond to her," she noted, adding that "acoustic and tactile sensations do not seem to have the same arousing effects on the infant as visual ones."[50] Her point was not the stereotypical one about the primacy of vision or the lack of vision among the visually impaired. Rather, her concern was about synesthesia, the concept that vision stimulates the other senses. But vision is also identified as a problem for sighted subjects interpreting the actions of the blind child. Blind children's expressions, Burlingham explained, can be hard to read because they are not confined to the face, as would be expected, but rather are dispersed all over the body: "The blind child uses his body and musculature to express pleasure . . . in a manner which is more appropriate for the toddler stage, before communication of affect is confined to facial expression."[51] U.S. physician Vann Spruiell, in an unpublished paper recounting his experiences at the Hampstead Nursery for Blind Children, emphasized that the Hampstead analysts were especially taken with the question of narcissism among the blind children. "By thinking about congenitally blind children," he explained, "we might come to think new thoughts about normal narcissism." And "by thinking about narcissism we might 'see' blind children in new ways." Spruiell went on to explain that what they learned was less about narcissism than about the inadequacy of the concept of narcissism to describe ego formation. In these children, he wondered, "was there any self at all—[any] self to love?"[52]

Spruiell's question is a potentially naïve one, and indeed Anna Freud's reception of his view of blindness in children is less than generous. But it underscores a

fundamental point about the power of visuality within mid-twentieth-century psychiatric theory and the daily application of the visual in psychiatric social work. The stage on which the psychoanalyst at mid-century constructed the world of the child was fundamentally a sensory and visual one, so much so that to imagine a child without sight is to consider the prospect of a subject who fails to form an ego. Without sight, according to these psychoanalysts, there is no self. Perhaps what made these films so gruesome to watch is not just grief that they inspired in viewers but also fear at the prospect of the failure of subject formation on the basis of sensorial, affective deprivation. Such images of children go beyond the heart-rending melodrama of the social problem film to enter the domain of the obscene in that they show a most private grief, and one that should have been prevented by any means possible, and was not. One could argue that it is precisely this "out of bounds" quality that motivated psychoanalysts to move their discipline out of the sphere of clinical practice and into the realms of education, law, and international policy. It was to this domain that Anna Freud's psychoanalysis moved; by the time of her death she was fully engaged in the social work of law and policy with regards to the child. I propose that in order to better understand the implications and problems of the new vision of the child that underpins our approach to child welfare work in the twenty-first century, we consider this particular Freudian legacy that has remained in the shadows of the history of psychoanalysis.

Notes

1. United Nations General Assembly, resolution 217 A (III) of December 10, 1948. Quotation from Article 25 (2); http:/www.un.org/en/documents/udhr/index.shtml (accessed August 2010).

2. The Convention on the Rights of the Child was adopted and opened for signature, ratification, and accession by General Assembly resolution 44/25 of November 20, 1989. It entered into force September 2, 1990, in accordance with article 49. http://www.2.ohchr.org/English/law.crc.htm (accessed August 2010).

3. In November 2009, Somalia announced plans to ratify the convention. The United States remains in conflict on the issue. Although President Barack Obama has expressed embarrassment about this failure to ratify, conservatives continue to voice opposition on grounds that signing could mean that international law could trump state and national laws and parental rights in decision making, a view that psychologist Harold Cook characterizes as "narcissistic sovereignty" (quoted in Penny Starr, "'Narcissistic Sovereignty' Has Kept US From Ratifying U.N. Treaty of Children's Rights," cnsnews.com, http://www.cnsnews.com/public/content/article.aspx?RsrcID=39799, [accessed August 2010]). See also the Human Rights Watch's position statement, "US: Ratify Children's Treaty," at http://www.hrw.org/en/news/2009/11/18/us-ratify-children-s-treaty (accessed August 2009).

4. Born in Vienna in 1907, Katherine M. Wolf conducted research with Spitz in Vienna and New York before joining the Yale Child Study Center, where she was promoted to associate professor of psychology in 1953, four years before her death. She was author and collaborator on numerous child studies including work on children's perceptions of racial stereotyping in comics (See Patricia L. Kendall and Katherine M. Wolf, "The Analysis of Deviant Cases in Communications Research," *Communications Research*, 1948–1949: 152–79).

5. Although I do not have the space to pursue this issue here, their work has exerted an enormous and unacknowledged influence on adoption psychology and medicine after the Cold War.

6. Lisa Cartwright, *Moral Spectatorship: Technologies of Voice and Affect in Postwar Representations of the Child* (Durham, N.C.: Duke University Press, 2008).

7. On Margaret Mahler (1897–1985) see *The Memoirs of Margaret S. Mahler*, ed. Paul E. Stepansky, (New York: The Free Press, 1988); and Margaret S. Mahler, M.D., in collaboration with Manuel Furer, *On Human Symbiosis and Vicissitudes of Individuation* (New York: International Universities Press, 1968). Her films can be rented through the Margaret Mahler Foundation at http://www.margaretmahler.org/foundation/projects.html (accessed August 2010). On Ainsworth (1916–1999), see Ainsworth, Mary D. Salter, "The Development of Infant-Mother Interaction Among the Ganda," in *Determinants of Infant Behavior*, ed. B. M. Foss (New York: Wiley, (1963), 67–103; Ainsworth, Mary D. Salter, *Infancy in Uganda: Infant Care and the Growth of Love*, (Baltimore, Md.: The Johns Hopkins University Press, 1967); and Ainsworth, Mary D. Salter, and S. M. Bell, "Attachment, Exploration, and Separation: Illustrated by the Behavior of One-Year-Olds in a Strange Situation," *Child Development* 41 (1970): 49–67.

8. Ida Macalpine, "The Development of the Transference," *Psychoanalytic Quarterly* 19 (1950): 502–39, cited by Spitz in *René A. Spitz: Dialogues from Infancy*, ed. Robert N. Emde (New York: International Universities Press, 1983) 410.

9. Spitz in Emde, *Dialogues from Infancy*, 409

10. Ibid., 410.

11. Ibid., 413.

12. Ibid., 414.

13. Ibid., 414.

14. Ibid., 422.

15. Arnold Gesell (1880–1961), the American psychologist who founded the Yale Child Study Center, is the most widely known practitioner of the psychology of infants and young children during this period. Unlike Spitz, his focus was the normative development of infants and young children being raised in private homes. He enlisted parents to bring in children to his study center, which was equipped with play areas. While his assistants played with subjects, he observed through methods including the use of windows and a room-size glass dome outfitted with one-way glass, equipped with tracks for sliding a motion picture film camera over its arc to maximize documentation from all angles. For a full record of Gesell's work see the Archives of American Psychology. A film documenting Gesell's film work can be seen at http://www.thoughtequity.com/video/clip/49312061_014.do (accessed August 2010).

16. Emde's *Dialogues from Infancy* includes a full Spitz filmography.

17. The Durfee and Wolf research article is "Anstaltspflege und Entwicklung im ersten Lebensjar," *Zeitschrift fur Kinderforschung* 42, no. 3 (1933).

18. Ibid.

19. René A. Spitz, "Hospitalism: An Inquiry into the Genesis of Psychiatric Conditions in Early Childhood," in *The Psychoanalytic Study of the Child*, 1:53–74 (1945), 54. See also René A. Spitz, "Hospitalism: A Follow-Up Study, *The Psychoanalytic Study of the Child*, 2:113–17 (1946).

20. One of many examples of evidence of the broad international impact of the theory expounded in this paper: psychiatrist Joseph Stone wrote to Spitz referring to Dr. Spyros Doxiadis, the pediatrician who heads Metera, an orphanage in Athens, Greece, where he conducted a study: "It is a very interesting institution which I think is succeeding in providing appropriate

affection and stimulation for infants in the first six months or so, but it becomes more and more baffled with the older ones who remain on because of disabilities or legal barriers to adoption." He also refers to plans for collaborative research between Metera and psychiatrist Reginald Lourie's group at Children's Hospital of the District of Columbia. In a previous correspondence, Stone refers to giving a copy of Spitz's book to Metera. Letter dated December 15, 1964, Joseph Stone, René Spitz Papers, Box M, Folder 2112, Archives of the History of American Psychology, Akron, Ohio.

21. Floyd M. Crandall, MD, "Hospitalism," *Archives of Pediatrics* 14, no. 6 (June 1897), 448–54. For another reference to hospitalism from this early period see John Zahorsky, MD, "The Baby Incubators on the 'Pike': A Study of the Care of Premature Infants in Incubator Hospitals Erected for Show Purposes," Part 2, *St. Louis Courier of Medicine* 32, no. 1 (January 1905), 1–13 (Part 1 appeared in December 1904).

22. René A. Spitz and Katherine M. Wolf, "Anaclitic Depression: An Inquiry into the Genesis of Psychiatric Conditions in Early Childhood," *The Psychoanalytic Study of the Child"* (1946) 2: 313–42.

23. See H. Bakwin, "Loneliness in Infants," *American Journal of Diseases in Children* 63 (1942), 30–40; L. Bender and H. Yarnell, "An Observational Nursery: A Study of 250 Children in the Psychiatric Division of Bellevue Hospital," *American Journal of Psychiatry* 97 (1947), 1158–74; William Goldfarb, "Effects of Early Institutional Care on Adolescent Personality," *Journal of Experimental Education* 12 (1944), 162–67; William Goldfarb, "Effects of Early Institutional Care on Adolescent Personality: Rorschach Data," *American Journal of Orthopsychiatry* 14, no. 3 (1944), 441–47; and L. G. Lowrey, "Personality Distortion and Early Institutional Care," *American Journal of Orthopsychiatry* 10, no. 3 (1940), 576–85. Spitz notes the results of the Child Welfare Research Station of the State University of Iowa that conducted extensive research on the nature vs. nurture controversy, comparing either children in foster homes or children over one year of age, for example children in orphanage preschools (Spitz, "Hospitalism: An Inquiry," 55). The Iowa studies results were published in H. M. Skeels, R. Updegraff, B. L. Wellman, and H. M. Williams, "A Study of Environmental Stimulation: An Orphanage Preschool Project," *University of Iowa Studies in Child Welfare* 15, no. 4, (1938), 129–45. See also H. M. Skeels, "Some Iowa Studies of the Mental Growth of Children in Relation to Differentials of the Environment: A Summary," 39th Yearbook, National Society for the Study of Education II (1940), 281–308.

24. A letter of November 9, 1955, from Spitz to Lawrence Joseph Stone refers to the experimental psychologist Samuel Richard Pinneau's critique of Spitz's hospitalism thesis for failing to specify in more detail the children's background, the precise location of the studies, and his methods, published in the *Psychological Bulletin* in 1955. In this letter Spitz indicates that Ashley Montagu told him that Stone wanted to set up a public discussion between Pinneau and Spitz, but Spitz said no. He expressed annoyance that Pinneau's critique caused him to have to stop his current work and dig out old documents to refute "falsifications" (though he did respond to Pinneau's charges in a dialog that went back and forth in the *Psychological Bulletin* in the same year). "As Ashley remarked in his letter to me, the syndrome of hospitalism is now so firmly established that nothing anybody could say, be it Pinneau or myself, could alter the fact." He writes, "It has been experimentally proved on rats by Lewis Bernstein in Denver." (L. Joseph Stone Papers, Box M712, Folder: Spitz, Archives of the History of American Psychology, Akron, Ohio).

25. Spitz and Wolf, "Anaclitic Depression."

26. Ibid., 324.

27. Ibid., 313.

28. Ibid., 317.

29. Ibid., 318.

30. Ibid., 319.

31. Ibid., 326.

32. Ibid., 328.

33. Ibid., 320.

34. Ibid., 313.

35. Ibid., 338.

36. *Marasmus,* a term first used in 1656, describes the infant's extreme state of malnutrition and emaciation. It is from the Greek expression "to pass or die away." The term continues to be used, especially to describe children who starve. Its use to describe the wasting away of children who have access to food took root with the rise of hospitals and the placement of children in institutional homes where the phenomenon became apparent in children with access to food.

37. René Spitz, "The Films of the Psychoanalytic Research Project on the Problems of Infancy, General Introductory Notes," undated manuscript, René Spitz Papers Box M2137, Folder 83, Archives of the History of American Psychology, Akron, Ohio. See also Mary S. Fisher and Lawrence Joseph Stone, "Explanatory Notes on the Series of Films, Studies of Normal Personality Development," undated pamphlet, Department of Child Study, Vassar, 8, René Spitz Papers, Box M2137, Folder 777, Archives of the History of American Psychology, Akron, Ohio.

 The UN (Geneva) purchased the films *Grief* and *Somatic Consequence*s in 1951, according to a handwritten anonymous note in the René Spitz Papers, Box M 2137, Folder 78, Archives of the History of American Psychology. In this general correspondence Spitz goes to great lengths in letter writing to attempt to get the WHO to act as universal distributor.

38. Béla Balázs "The Visible Man (1924)," in *Béla Balázs and Early Film Theory*, trans. Rodney Livingstone (London: Berghahn Books, 2010).

39. Georg Simmel, "The Aesthetic Significance of the Face," in *Georg Simmel 1858–1918*, ed. K. H. Wolff (Columbus, Ohio: Ohio State University Press, 1958), 276–81.

40. Paul Ekman, Wallace Friesen, and Silvan S. Tomkins, "Facial Affect Scoring Technique: A First Validity Study," *Semiotica* 3 (1971): 37–58.

41. René A. Spitz and Katherine M. Wolf, "The Smiling Response: A Contribution to the Ontogenesis of Social Relations," *Genetic Psychology Monographs* 34 (1946): 57–125.

42. Luc Boltanski, *Distant Suffering: Morality, Media and Politics*, trans. Graham D. Burchell (New York: Cambridge University Press, 1991), 17.

43. Ibid.

44. Adam Smith, *The Theory of Moral Sentiments.* (London: Henry G. Bohn, 1966 [1759]).

45. Boltanski *Distant Suffering*, 17.

46. Emde, *Dialogues from Infancy*, 426–27.

47. James Robertson, interviewed by Milton J. E. Senn in 1977, typescript, American Child Guidance Clinic and Child Psychiatry Movement Interview Collection, Oral History Collection, Modern Manuscripts, History of Medicine Division of the National Library of Medicine, National Institutes of Health, Bethesda, Md.

48. Robertson, Senn interview.

49. Robertson, Senn interview.

50. Dorothy Burlingham, "Some Problems of Ego Development in Blind Children," in *Psychoanalytic Studies of the Sighted and the Blind* (New York: International Universities Press,

1972), reprinted from *The Psychoanalytic Study of the Child* 20 (1965), 194–208. Citation from page 327 of the 1972 reprint.

51. Burligham, "Some Problems of Ego Development in Blind Children," 333.

52. Vann Spruiell, MD, "Thinking Blind," unpublished research paper based on observations at the Hampstead Nursery, 1974, http://www.analysis.com/vs/vs84b.html (accessed August 2010). Spruiell relates that "Miss Freud chuckled" about his idealizations in this paper. Burlingham herself never uses the word *narcissism* to describe the state of the blind children she worked with, though she did describe autoerotic "blindisms" (masturbation, nail-biting, rocking, and other forms of self-stimulation) and the inwardness of these subjects, whose behaviors she elsewhere compares to the behaviors of children with autism.

11. *Performing Live Surgery on Television and the Internet since 1945*

DAVID SERLIN

HISTORIANS OF VISUAL CULTURE and of communication technology have often described the period from the late 1940s through the late 1950s in the United States as the "Golden Age" of broadcast television.[1] The rough-hewn, often experimental, and unusually rich years associated with live series like the *Kraft Television Theater* and *Playhouse 90* and early visionaries like Paddy Chayefsky, Ernie Kovacs, and Rod Serling are routinely lauded as examples of the height to which the new medium of television had soared though barely a decade old. Yet such nostalgically rendered projections of quality and taste are often considered anachronistically in a cultural vacuum with little or no relationship to other programs, most of them forgotten, which took shape on broadcast television in the immediate postwar years.

The possibilities inherent in television as a tool for shaping and disseminating public health information, for instance, was readily apparent to many by the early 1950s. Large and medium-sized hospitals and medical schools throughout the United States began to broadcast surgical procedures live to physicians and, later, to mass audiences to whom such programs were pitched as medically relevant documentaries. Indeed, the degree to which the medical establishment had a hand in developing postwar television technology for mass rather than specialized audiences has been characteristically underplayed and even ignored by canonical histories of the medium.[2] Advances in recording, transmission, and storage technologies in the 1940s and 1950s, which included magnetic videotape, closed-circuit broadcasting, two-way long-distance communications, remote-control cameras, special lenses for close-ups and magnification, and technical effects, were regularly underwritten by pharmaceutical firms, medical laboratories, medical schools and colleges, and professional medical organizations. Indeed, the first colored or "tinted" television broadcast in the United States was arguably conducted at the 1949 annual convention of the American Medical Association (hereafter AMA) to demonstrate the power and efficacy of closed-circuit television in the operating theater.[3]

Scholarly discussions of the interface between the medium of television and the practice of medicine have been largely confined to the technological development of telemedicine—the use of telecommunication networks in promoting individualized opportunities for medical diagnosis and treatment.[4] Although telemedicine easily fits within the visual regimes of twentieth- and twenty-first-century public health, this essay will shift away from medicine within clinical practice and toward medicine within cultural practice in order to examine the broadcast history of live surgery, from televised surgical events beginning in the late 1940s through contemporary manifestations of live surgical phenomena as broadcast on the Internet.

In this essay, I deliberately distinguish live as well as recorded display from other types of medical diagnostics or imaging techniques that have been substantively analyzed by scholars who study visual representations of medicine in the public sphere. As scholars of visual culture and history of medicine such as Lisa Cartwright, Joel Howell, Bettyann Holtzmann Kevles, and José van Dijck have argued, techniques of visualizing and representing the human body, whether through X-ray and MRI penetrations of its "subjective" exterior or through microcinematic excursions within its "objective" interior, have crystallized the relationship between technological modernity and medical authority, which emerged concurrently with the prophylactic use of hormones, vitamins, and antibiotic agents to stave off illness or the need for invasive surgery.[5] Since the late 1940s, however, the use of closed-circuit television for surgical procedures was greeted with enormous professional enthusiasm, especially as it emerged with other visualizing technologies, such as echocardiography and electroencephalography, used for diagnostic and training purposes in hospitals, medical schools, professional meetings, and military installations.[6] As Colonel Hugh R. Gilmore, Jr., of the Army Medical Corps observed in 1955, "As a tool the position of television in medicine today may be compared to that of the microscope in the days of Leeuwenhoek."[7]

Among those scholars who have written about cultural representations of medicine on television, Robert S. Alley and Joseph Turow have limited their discussion to the evolution and impact of medical dramas of the postwar period such as *Medic* (1954–1956), *Ben Casey, M.D.*, and *Dr. Kildare* (both 1961–1965). In particular, these scholars have argued that the storylines offered by these programs' producers and writers—attempts to show the authoritative triumphs of medical technology, or the unimpeachable character of doctors—were narrative strategies devised to promote the image and reputation of the contemporary physician in particular and the medical industry in general. In the case of a program like *Medic,* storylines were developed in tandem with the Los Angeles County Medical Association as a way to raise public consciousness about contemporary health topics such as hemophilia, mental illness, brain injury, and

even an aborted episode on homosexuality.[8] As Alley has argued, in the 1950s such shows proved how "medicine was the profession most closely allied to the popular culture of those that imbibed the heady knowledge of science . . . [and] an idealization of physicians and particularly surgeons bordering upon worship."[9] Turow interprets these medical dramas more critically as direct reflections of the controlling interests of organized medicine during the 1940s and early 1950s, when doctors and hospitals in the United States fought against a perceived crisis of professional authority. "Physician organizations [such as the AMA]," Turow argues, "were interested in making sure that programs about doctors showed health care settings, characters, and patterns of action that matched the values that organized medicine was fighting to protect."[10]

By focusing only on dramatic narratives and what Turow calls "medical storytelling," however, neither Alley nor Turow account for the initial interest in the interface potential between television and medicine produced in the immediate postwar period that included a wide range of live-action features, medical documentaries, and closed-circuit experiments aimed at both large and small audiences. These programs were not, as one critic cynically called them, mere "stethoscope operas," but were instead programs for which the very act of visualizing the body in a medical context—through live surgical intervention, disease diagnosis, or even physician-patient interaction—generated a visual image quite distinct from that typically created by televised melodramas.[11] Furthermore, Turow and Alley do not consider the evolution of television technology within its various medical and economic contexts, since by the mid-1950s television served as a much-touted tool of medical modernity as well as a space-age innovation aimed at American consumers.

Medical programming on commercial broadcast television ran the gamut from local and national broadcasts of live surgical operations and documentary series such as *The March of Medicine* and *Medical Horizons* to sophisticated medical dramas that focused almost exclusively on contemporary health issues and the diagnosis and management of chronic illness. By examining a range of primary materials from the period—popular and professional sources, as well as surviving artifacts from the individual television broadcasts—I will explore the complex ways in which assumptions to medical authority and control over health information pulsed just below the surface of these programs like the undulating representation of a heartbeat on an electrocardiograph machine.

Although this essay examines the technological and ideological status of television in the postwar period in its promotion of medical authority and public health imperatives, the visual component through which this authority was exercised—that which Karal Ann Marling has called the "visual culture of everyday life" in postwar America—was hardly a new phenomenon.[12] As William Graebner has written, "Although the arrival of commercial television, the Polaroid Land

camera . . . and xerography . . . would seem to make a strong case for the late 1940s as a newly visual culture, other elements of the period's heightened visual sensibility, including *Life* magazine and *The March of Time* newsreels, date to the mid-1930s."[13] Graebner correctly distinguishes between the previous influence of visual media as early as the 1930s and the arrival of a new "sensibility" after 1945. By the mid-1950s, however, television technology became linked rhetorically to postwar discourses surrounding medical technology as a form of scientific superiority that symbolized America's capacity to alter the future of health care. Writing about the uses of color television in medicine in 1954, for example, Dr. Alfred N. Goldsmith, a chief consultant at RCA, commented with noticeable aplomb that

> By thus radically shrinking time and space, and even freezing the momentary picture, color television can bring to [physicians] and their colleagues everywhere all the scientific facilities and capabilities which members of so noble a profession as medicine fully deserve. Color television can thus become one of the latest and greatest gifts of electronic technology to those practicing the healing arts.[14]

Because the majority of these surgical broadcasts were transmitted live and rarely recorded for posterity, we can only reconstruct them through indirect sources and contemporary observations. The ephemeral nature of these live medical images notwithstanding, their historical existence attests to the visual potency and popularity of other live television spectacles in the 1950s—such as news programs and quiz shows—that spanned the education-entertainment nexus. At the same time, early live televised surgery was more like the contemporary Internet than we might expect, especially for the ways it sustained corporate sponsorship while promoting medical services to an increasingly prosperous clientele eager to purchase these services as consumer amenities. This essay thus moves beyond the uses of television in postwar culture as education or even mere entertainment in order to explore television technology's contribution to the peculiar contours and "heightened visual sensibility" of postwar medical science and the ways in which such sensibilities made possible a visual culture of public health that was unprecedented in the public sphere.

Bringing the Operating Theater to the Home Theater

The desire to perform surgical procedures live on broadcast television, beginning in the late 1940s, emerged in response to medical concerns that were particular to the United States after World War II.[15] The increasing incidence of chronic illnesses such as cancer, diabetes, obesity, and stress—regarded ironically by some as hallmarks of postwar success and prosperity—had for the most part supplanted the epidemiological crises that still dominated the public health

bureaus and local health care practices of many nations in the postwar world. In an American context, chronic health anxieties were, to a large degree, ripe for artistic expression and economic exploitation by the expanding market and institutional growth of television, which was still regarded by some as a rich person's toy as late as the early 1960s when they became affordable to all but the poorest consumers.

In September 1947, operations performed at New York Hospital were successfully transmitted to delegates at the annual conference of the American College of Surgeons at the Waldorf-Astoria Hotel.[16] Technicians suspended one standard Image Orthicon camera, with the lens blocked into a rectangular frame directly above the operating table through the use of masking tape. Meanwhile, a standby operator waited in the viewing gallery with a camera equipped with a telephoto lens. Within a few months, fifteen different medical schools across the United States applied to RCA for consultation and equipment; by 1959, twenty-four medical schools had installed on-site television production units.[17]

The use of closed-circuit television for surgical procedures and consultation grew concurrently with other visualizing technologies, such as echocardiography and electroencephalography, used for diagnostic and training purposes in hospitals, medical schools, professional meetings, and military installations.[18] Dr. Alfred Goldsmith of N.B.C. Laboratories explained in 1954 that "television . . . can readily be converted into a *two*-way procedure such that two physicians, or two groups of physicians can see and hear each other at any desired distances. Thus the world becomes one vast auditorium—or perhaps one might say operating theater."[19] Television cameras and color receivers promised to transform hospitals and teaching facilities radically into gleaming beacons of modernity in much the same way that sophisticated medical technologies promised to transform doctors and surgeons into modern medical messiahs (see Figure 11.1).

Many pundits, however, seriously pondered the effect of this new technological intervention. In the years following World War II, many older and/or non-hospital-affiliated physicians resented their more technology-driven colleagues whose offices and surgeries were crowded with a plethora of expensive new machines. Moreover, the appearance of television in this milieu formalized for many the increasingly accepted gulf between dependent patient and omnipotent physician. Indeed, the surveillance potential of television seemed to capture the process by which scientific medicine reduced the whole body to anonymous, isolated, and more manageable units. An undated cartoon by popular illustrator Constantin Suozzi published during the early 1950s demonstrates how humorous depictions of television technology mocked the impersonal state of modern medical care (see Figure 11.2).[20] In the cartoon, a man bolts upright from the operating table and hams it up before the television camera as if caught spontaneously at a live sporting event or making a cameo appearance on Steve Allen's

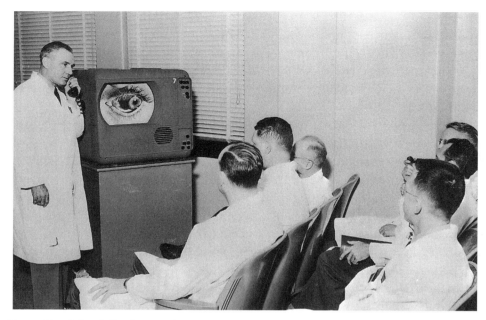

Figure 11.1. Colonel Charles Moseley instructing medical students at the Army Medical Services Graduate School in Washington, D.C., while watching the broadcast of an eye operation in progress. According to the original caption, "At any time students may interrupt and address questions directly to the surgeon by using [the] telephone apparatus beside the TV monitor." Photograph taken January 11, 1955, copyright Bettmann/Corbis. Reprinted with permission.

"Man on the Street" segment of *Tonight,* the mid-1950s precursor to NBC's long-running series *The Tonight Show.* The patient's enthusiastic "Hi, Mom!" gesture, which seems particularly American, is conveyed primarily by his amateur delight in appearing on television. The iconic "Americanness" of this gesture is expressed knowingly by the lack of a verbal caption (with the notable exception of the word *television* prominently inscribed on the camera) and the appearance of an array of impressive-looking technological accoutrements. The patient's delight, however, is juxtaposed with the professional consternation of the attending surgeons, who appear unfazed by the patient's actions.

In response to myriad critiques of the impersonal nature of modern health care, regional affiliate television stations around the country began broadcasting live and filmed operations—and, later, more interactive public health–oriented news programs—that were targeted specifically at local audiences. By the early 1950s, home viewers around the United States could experience a wide range of both live and prerecorded programs from local hospitals, many of which were pitched as educational documentaries for commercial television. Unlike the more familiar medical dramas of the early 1960s, these were live programs for which the very act of exhibiting the body was an active attempt to dramatize the public health dimensions of the broadcast image.

Figure 11.2. Cartoon by artist Constantin Suozzi (circa early 1950s) of male patient on the operating table waving to a television camera suspended above him. Originally published in *Stag Magazine*, reprinted in Henry Felsen, *Medic Mirth* (New York: Ace Books, 1956). Courtesy of the artist.

Audiences in large and small metropolitan areas surprised local broadcasters in their outpouring of interest for live medical programs that featured graphic surgical procedures, thus challenging many of our assumptions about 1950s public culture as squeamish about inappropriate public topics or else as inherently prudish and reactionary. In 1952, for example, local television station WPTZ in Philadelphia broadcast for public view the last ten minutes of a two-hour gall bladder surgery performed by famed surgeon Isidor Ravdin at the University of Pennsylvania Hospital. University administrators intended the segment as the inaugural feature of Penn's projected television series, *In the American Tradition*, which would promote impressive spectacles, such as televised surgery, in order to bolster the university's reputation as a forward-looking institution. Despite initial fears that the broadcast would be offensive, the mainstream press celebrated the event, while one approving Philadelphian wrote to WPTZ and exclaimed, "This is the television we've been waiting for!"[21]

Live medical programs enabled regional stations to transcend the geographical and technical limitations imposed by network broadcasts. Smaller regional stations could make ingenious use of nearby resources—such as teaching hospitals and clinics, local physicians' clubs and medical organizations, ladies' auxiliaries, and private physician-citizens—in order to provide public health

information to their constituents. In December 1954, for example, when WRGB in Schenectady broadcast a local news program, *Medically Speaking,* in which local physicians from the Albany Medical College spoke about recent developments in modern medical diagnosis and therapeutics, one commentator observed that "[t]he potentials of television for public health are great, but they will be more completely realized when developed regionally as well as nationally."[22] In April 1955, KSTP in Minneapolis started a daily medical news feature, "Public Health Is People," hosted by popular local personality, Bee Baxter, a journalist who had won national awards during World War II for her "salute to the nursing profession."[23] In April 1958, WSYR in Syracuse, New York, devoted an entire episode of *Ladies Day,* its morning news program aimed at women, to the topic of cancer. A panel of local oncologists introduced the hour-long special, which followed a female patient from her first diagnosis to actual filmed footage of removal of her cancer at Syracuse General Hospital.[24]

Local programming such as this implied a progressive, democratic approach to television technology, especially by providing public access to health information tailored to local audiences. Yet the commercial impulse to represent medical topics in a dramatic context was extremely alluring, giving way to programs that focused on those most socially vulnerable, especially women and young children. A live cancer operation, for example, performed on an unidentified female patient (described on the program enigmatically as "Patient X") broadcast in April 1954 from WKRC in Cincinnati drew approximately 700,000 viewers and an additional 1.3 million viewers from nearby Ohio affiliates in Dayton and Columbus.[25] During the same month as the Cincinnati spectacle, station WHAS in Louisville, Kentucky, broadcast live lung surgery from Louisville General Hospital, a program that was awarded *Variety*'s "Outstanding Citation" for 1954. Sherly Uhl, a staff journalist for the *Louisville Times,* observed wistfully, "If TV holds a mirror to life, this was a supreme example of this function. For an hour human life hung in the balance as modern medicine's skilled battle against a stubborn killer was photographed—not on film but as it actually happened."[26]

Often, national and international medical equipment and pharmaceutical companies, such as Johnson & Johnson, Ciba, and Squibb, served as corporate sponsors and promoted medical programs as popular dramatic spectacles rivaling other live televised events. In June 1952, surgeons at Wesley Memorial Hospital in Chicago performed the first operation to be broadcast live coast-to-coast to an estimated thirty million viewers.[27] Capitalizing on the novelty of transmitting live surgery to a captive audience, the six-minute event (excerpted from a three-hour ulcer operation) was included in an hour-long documentary about medical breakthroughs sponsored by pharmaceutical giant Smith, Kline & French under the positivistic title *The March of Medicine.* Although one journal affirmed that the program "[stood] high among the season's accomplishments," The *New York Times*

critic William Laurence assured those who missed it that the visual impact of seeing medicine practiced on the small screen was "not much different from what has already been made familiar in motion pictures and popular magazines."[28] Indeed, the conventions of realism appeared self-evident to one reviewer who quipped that, "the fact that the first operation ever beaming on a national TV network had to do with ulcers, is believed to be purely coincidental."[29]

Such off-handed comments suggested that the familiarity with which middle-class viewers watched surgical treatment for ulcers was not very different from their familiarity with other public health concerns, such as stress, that were among the many badges of honor earned by what William H. Whyte called the "organization men" of the 1950s. For many, however, television's appeal to some version of medical "realism" merely recapitulated the themes of theatrical presentations or countless Hollywood wartime films in which actors—and, increasingly, make-up artists—simulated extensive wounds and their subsequent repair with exactly realistic detail.[30] Television critic Jack Gould questioned the broadcast's claims to realism by distinguishing between fictionalized and "real" depictions of surgery: "In the theater, the scene in the operating room is, after all, make-believe and fiction, the handiwork of a dramatist. But last Tuesday television showed reality . . . [t]hat is vastly different."[31] Gould's comments implied that the technical objectivity, and stark realism, offered by televised surgery transcended any generic claims to "realism" by theater or standard Hollywood fare.

Watching a live representation of a life hanging precariously in the balance was obviously not the same as watching someone play a role in a well-rehearsed performance—though what, exactly, it was that distinguished one form of bodily presentation from another remained vague. Yet this distinction, however inarticulate, could be perceived as a powerful point of contention in the cultural climate of the 1950s. As critics realized, televised surgery was a modern public event that blurred the boundaries separating the "symbolic" from the "real."[32] Television was already a staple part of a sensationalized mass culture diet of horror films, comic books, and dystopian science fiction stories. But these depictions, however graphic or violent, were typically understood as fictions, and in most cases were understood as shocking only for shock's sake. Without a clearly defined ideological trajectory, comics and horror films were regarded as mere "entertainment," even if members of the public questioned these media's moral values or their influence on young people. Such productions were clearly distinct from "real" events, such as those images of war to which American audiences were introduced during the 1940s through *Life* photojournalism, Hollywood soldiers' stories, propaganda films, and *March of Time* newsreels. During World War II, these "real" events were necessarily deployed as symbolic acts to mobilize and disseminate nationalistic values. They helped to form a visual vocabulary in which an American body—or a body that epitomized some essential or inexorable quality of Americanness, such

as that of a soldier or veteran—was the crucible upon which patriotic integrity was forged in the popular imagination. Thus, by the mid-1950s, recurring criticism of televised surgery did not occur simply because the procedures themselves were too viscerally graphic. Without direct reference to any "real" event, such as war, televised surgery questioned the necessity of making such depictions visible in the public sphere, especially with regard to their influence on women, children, and those perceived to have sensitive medical conditions (see Figure 11.3).

By the mid-1950s, programs such as *The March of Medicine* and *Medical Horizons* began to exploit dramatic opportunities inherent in the live medium of broadcasting that, they believed, would demonstrate for the public the speed at which the ingenuity of modern health care might travel. On June 5, 1955, NBC broadcast an episode of *The March of Medicine* that was developed in conjunction with the annual AMA convention held that year in Atlantic City.[33] After initial broadcasts from the scientific exhibits on the convention floor, the broadcast switched live to the Walter Reed Army Medical Hospital in Washington, D.C.,

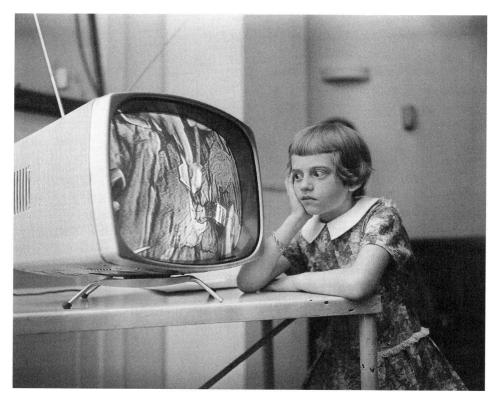

Figure 11.3. Nine-year-old Rosemary Muller of Roslyn Heights, Long Island, watching a transmission of a heart operation similar to the one from which she's recovering as it is being performed live at Bellevue Medical Center of New York University Hospital. Photograph taken May 7, 1958. Copyright Bettmann/Corbis. Reprinted with permission.

where surgeons took a biopsy of breast tissue from a female patient. They then sent the tissue sample via high-speed pneumatic tube to laboratories at the Armed Forces Institute of Pathology (AFIP), just over one mile away from the hospital. By means of two-way audio and video relays, the surgeons and pathologists conferred about the biopsy from their respective institutions. Within the hour—and with seconds ticking—the tissue sample was ultimately diagnosed as benign, much to the collective relief of the diagnostic team and the viewing audience.

This particular episode of *The March of Medicine* was an artificially dramatized re-creation of closed-circuit television collaboration between the AFIP, the University of Pennsylvania, the Johns Hopkins University, and the National Naval Medical Center that originally had taken place six months earlier in January 1955. The differences between the two broadcasts, however, suggested that, in the short space of half a year, NBC deliberately manipulated the original project in order to present it as a sensationalistic, albeit futuristic, medical spectacle. The June version, designed self-consciously to approximate the feel of a 1950s quiz show, exploited both the technical possibilities inherent in the new communication technology as well as the theatrical tensions surrounding the diagnosis given to the unidentified female volunteer. At the initial event in January, University of Pennsylvania surgeon Isidor Ravdin consulted electronically from Philadelphia with pathologists in Washington, D.C., and Baltimore to "illustrate certain capabilities of the television medium in medical activities" while a small group of medical educators and electronics engineers from these various institutions watched a small screen.[34] By contrast, the live June version of the event followed each step of the diagnostic process in slow and agonizing detail: from close-up shots of the surgeons taking a tissue sample from an exposed, though discreetly covered, breast to an on-screen time-lapse clock measuring the delay of laboratory results during the consultation. The visual allusion to the quiz show, whether perceived to be in bad taste or not, was not lost on media pundits. Writing in the *New York Times* the following day, television critic J. P. Shanley observed, "Objections have been raised before about a tendency toward sensationalism on medical programs on television . . . [This program] went beyond the bounds of discretion. It included the sight of scalpels, clamps, and raw flesh."[35] The only thing that remained undisclosed and hidden during the broadcast, it seemed, was the identity of the patient herself, who was never shown during the episode except as an anonymous female specimen draped by white sheets, under the surgical scalpel. In performing the rituals of medical expertise on a supine and unidentified female body, the male surgeons and laboratory researchers rendered the patient's subjective experience of the medical encounter completely silent.[36] Indeed, as if to add insult to biopsy, only forty-two national NBC affiliates carried the broadcast of this particular episode of *The March of Medicine*. By contrast, over 340 national ABC affiliates broadcast the inauguration of Dr. Elmer Hess, the

incoming president of the AMA, later that same day.[37] In the short space of an hour, television trained the "medical gaze" on the anonymous female body awaiting her laboratory results as well as the transcendent male physician awaiting—and receiving—his moment in the public spotlight, suggesting that health concerns still operated within a hierarchy of values wedded primarily to the (male) authority of the profession rather than to the (nonmale) needs of its citizenry.

In May 1958, WABD in New York City broadcast a two-hour special simply called "Heart Surgery." The program featured Dr. Jere Lord, surgeon at New York University–Bellevue Hospital, performing a delicate heart operation on Mabel Chin, a three-year-old Asian American girl whose parents had recently emigrated from China to the ethnic enclaves of the Lower East Side of Manhattan (see Figure 11.4).[38] However one reads the photograph of Chin for its complex racial overtones—the sight of the tiny, vulnerable Chinese American girl who seems to be succumbing passively to the weight of what might be called the medical-televisual gaze of the anonymous white physicians attending to her—it is a powerful reminder that in these settings the expertise of doctors, and not necessarily the healing of patients,

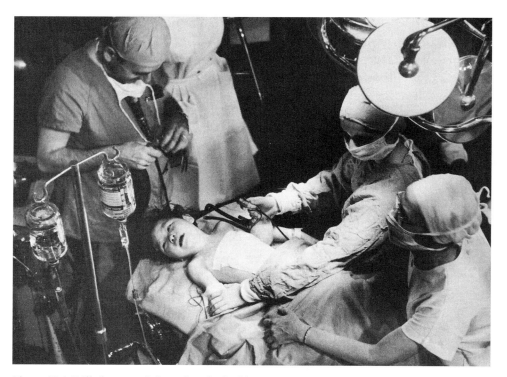

Figure 11.4. Still photograph from the televised heart operation performed on three-and-a-half-year-old Mabel Chin of Manhattan at the New York University Hospital and broadcast live by local channel WABD. Given the historical coincidence of broadcasting and spectatorship, is it possible that Chin's operation is being watched by Rosemary Muller in Figure 11.3. Photograph taken May 7, 1958. Copyright Bettmann/Corbis. Reprinted with permission.

was often projected as the central subject of live medical programs. Producers at WABD later edited a kinescope recording of the program and presented it, along with news of Mabel's progress, for national broadcast in the summer of 1958 under the Orientalist title "Chin Up."

In June 1958, on the other coast, KPIX in San Francisco broadcast an hour-and-a-half segment of live open heart surgery performed on eight-year-old Tommy Hunter to an estimated 1.25 million viewers in the greater Bay Area, beating out the popular Western *Cheyenne* in the ratings by many points.[39] Unlike the broadcast of Mabel Chin's operation, the Hunter program brought KPIX an unprecedented level of public attention for which the station was inundated with sympathetic telephone queries about Tommy's postoperative condition. In response to the outpouring of concern for Hunter, Pacific Telephone & Telegraph installed a phone number at KPIX with an automated message system that provided regular medical updates on Tommy's condition to callers. The station received fifty-nine thousand calls within the telephone line's first twenty-four hours of operation, anticipating by forty years the public desire for the kind of audience-participation technology that has become a staple of reality TV programming on both network and cable television. Clearly, by the end of the 1950s, live medical displays had become one of the most provocative proving grounds on which the terms of medical modernity were represented and negotiated in the newly engaged public sphere made possible by television.

The Fall (and Rise) of Live Medical Spectacles after 1960

Beginning in the early 1960s, the popular spectacle of live surgery on television began to decline as a result of two interrelated factors. Producing and broadcasting live medical shows from hospitals and clinics had been initially an inexpensive way to fill empty blocks of airtime (or "fringe-time," as one physician put it in 1959) between first-run television series and local programming.[40] In the mid-1950s, for example, when corporations like Ciba and Smith, Kline & French sponsored both live and prerecorded medical programs like *The March of Medicine*, the industry pressure to keep viewers perpetually tuned in that is such a staple of contemporary commercial media either did not exist or was not technologically feasible. By the end of the decade, however, the reduced cost of television production and inexpensive film and, later, videotape enabled local stations and national networks to broadcast an inexhaustible supply of prerecorded television programs for daytime and prime-time viewers. By the mid-1960s, live prime-time programming in any format was forced to the margins with the obvious exceptions of live news reports, sporting events, and occasional variety shows that relied upon, and were authenticated by, new global communication technologies.

Another reason for the decline of live surgery on broadcast television might be explained by the commercially driven shift away from live medical spectacles and toward "stethoscope operas" recorded on film and videotape. In the early 1950s, James Moser, the man responsible for *Dragnet*, became the executive producer for television's first prime-time medical drama, *Medic* (1954–1956). Moser researched storylines and hospital protocol at Los Angeles County General Hospital, and his devotion to "realism" in the name of medical science won *Medic* a critical and popular following, even when the program made excursions beyond the hospital to explore social or health-related issues that many deemed questionable choices.[41] By 1961, popular series like *Ben Casey, M.D.* and *Dr. Kildare* (the latter of which featured Richard Chamberlain as television's prototype physician-hunk) had replaced the technological focus on live surgical broadcasts with the more familiar terrain of soap opera drama. Viewers saw highly constructed plots, more often based on the conventions of melodrama than on current health topics, that depicted the health conditions of frail women and innocent children. Furthermore, the recurring popularity of television series about the "human side" of the institution of medicine and its practitioners—from programs like *Medical Center, Marcus Welby, M.D.*, and *M*A*S*H** in the 1970s through *Trapper John, M.D.* and *St. Elsewhere* in the 1980s, *ER* and *Chicago Hope* in the 1990s, and *Gray's Anatomy, House*, and *Scrubs* in the first decade of the twenty-first century—suggests that, in the nearly six decades since *The March of Medicine*, the medical drama has become one of the formative cultural sites at which complex representations of medical knowledge and romantic beliefs about medical professionals collide.

However one interprets the rise and, ultimately, the decline of live surgery on mainstream network television broadcasts, the increasingly dramatic display of the body in the mass media after the 1960s attests to the unintentional resonance that live televised surgery may have had with contemporary cultural politics. Carefully crafted documentary newsreels and static photographs taken during World War II or the Korean War could hardly compare to the live, instantaneous images provided by global telecommunication systems, such as satellite television, that network television had standardized by the late 1960s. This was especially true as televised coverage of the Civil Rights Movement, the Vietnam War, student activism, and other contemporary incidents came into full swing before a media-transfixed public. These were not passive images of anesthetized patients underneath the white lights of a hospital operating theater, but active images of bodies under duress in Berkeley, Birmingham, Dallas, Hanoi, London, Memphis, Oakland, Paris, Prague, Saigon, and Washington, D.C., Satellite transmissions from the other side of the world brought with them profound and disturbing visual images, such as the infamous broadcast of the point-blank execution of a Viet Cong soldier shown on American television in 1968.

Yet live surgery did not entirely disappear from the media landscape in the 1960s. For the most part, its didactic power meant that live surgery could migrate to the realm of health documentaries on noncommercial television, such as PBS, which bolstered the public dimension of such programming during the 1970s and 1980s where surgical realism became synonymous with education. The popularity and freedom accorded to cable television from the late 1970s onward and, later, to the Internet in the early 1990s, however, as well as the proliferation of commercial Web sites by the end of the decade, made live surgery a viable prospect again as the convergence point of medical authority and technological novelty put, more often than not, in the service of public health awareness. In August 1999, for instance, singer and former talk show host Carnie Wilson reportedly "made history" when she allowed video cameras to broadcast her stomach surgery live on the Internet. Wilson had agreed to undergo the procedure, known as laparoscopic gastric bypass surgery, as a last-resort attempt to gain control over her weight. The venue Wilson chose for her surgical debut, the now-defunct ADoctorinYourHouse.com, was one of several prominent Web sites created in the pre-dot.com bubble of the mid-1990s that was devoted to health topics as introduced by celebrities, albeit ones with quickly diminishing cultural capital.[42] The full spectacle of Wilson's appearance as a live patient-performer actually unfolded over the course of several months in the run-up to her operation. In early June 1999, Wilson, her surgeon, Alan C. Wittgrove, and interested parties held preoperative online chats about Wilson's failed attempts at dieting, her loss of self-esteem, and her expectations for the surgery. In November 1999, Wilson and Wittgrove participated in postoperative online chats in order to champion the surgery's success after Wilson had reportedly lost sixty pounds in less than three months (see Figure 11.5).

Since the gastric bypass procedure first gained popularity in the United States in the 1980s, Frances Berg and Paul Ernsberger, two specialists in eating disorders research, have catalogued the dangerous and damaging postoperative consequences of the operation.[43] Despite these persuasive data, which seem to have caused not a dent in public consciousness, many U.S. surgeons continue to promote the procedure as "The Solution" for so-called morbid obesity, the heavily chronicled *bête noire* of contemporary public health issues in the United States and, increasingly, in resource-rich nations around the world. The confessional quality of Wilson's Internet broadcasts, rhetorically constructed as a celebrity feature story about the triumph of the will over adversity, was designed to serve as a powerful incentive for those considering the procedure. On August 10, 1999, a tiny laparoscopic video camera took the broadcast beyond the conventions of the maudlin heart-tugging celebrity narrative and actually brought viewers *inside* Wilson's stomach, thereby transforming Wilson's traumatic battles with her weight into a dramatic, if manipulative, exhibition of Wittgrove's surgical prowess.[44]

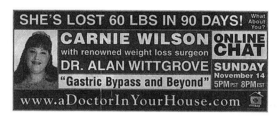

Figure 11.5. Advertisement promoting online chat with singer and celebrity surgical subject Carnie Wilson on the now-defunct Web site ADoctorInYourHouse.com. Newspaper clipping circa early November 1999. Author's collection.

Wilson's performance, including the maudlin build-up to the operation, was hardly unique among surgical broadcasts on the Internet in the late 1990s. In August 1998, for example, the now-defunct America's Health Network (ahn. com) broadcast quadruple bypass coronary surgery to a combined cable television and Internet audience of over 11 million people.[45] In December 1999, amazingsurgeries.com—the Web site that promised to give "what you need, when you need it"—broadcast what was promoted as the world's first online sex reassignment surgery, fulfilling its mission as the Web site "designed to show you how skilled surgeons are challenging nature, destiny and sometimes even god, to change a human body or save a life."[46] More than a decade later, such broadcasts—complete with high-resolution audio and video streaming and interactive e-mail chat features—remain evidence of the ways in which public health information has been transformed by the visual conventions of a techno-logical medium whose rules of engagement, while seemingly formalized, are still very much in development as electronic media attract the attentions of demographic groups and shape institutional values.

In May 2009, the *New York Times* reported that Methodist University Hospital in Memphis, Tennessee, had produced a video Webcast for YouTube featuring Shila Renee Mullins, a patient with a malignant tumor, undergoing brain surgery.[47] Hospital administrators claimed that they were providing an educa-tional service to the public and the thousands of Web sites and blogs that inevi-tably would distribute a link to the YouTube clip. Jill Fazakerly, the hospital's marketing director, observed that the goal of such Webcasts was "to further [the hospital's] reputation as well as to educate the community, who will ask their physicians about our care." Yet whatever aspirations surgeons and hospital administrators have for using the online surgery as a method for demystifying surgery for prospective patients, it is difficult not to see the historical parallels between the contemporary moment and the postwar moment when live surgery was transmitted into American homes by television technology. Indeed, both postwar television and contemporary Web sites function openly as part of a com-mercial, for-profit network of health care providers and institutions nurtured by marketers, promoters, shareholders, and trustees. Such institutions deliberately

exploit the educational and even performative potential of their broadcasts in order to target a growing base of consumers willing to pay big bucks for surgical procedures, including many elective surgical amenities, which can often be purchased on credit card plans if health management organizations and for-profit insurance carriers continue to restrict what can or should be covered by their patients. For many of these individuals, watching visceral displays of live surgery is no more or less surprising than browsing on Amazon.com or bidding on eBay.[48] In onlinesurgery.com's cosmetic procedures archive, for example, viewers watch films of patients undergoing facelifts, liposuction, nose jobs (rhinoplasty), breast lifts (mastoplexy), breast augmentation (mammoplasty), and a procedure known euphemistically as vaginal rejuvenation. In one recorded session of mammoplasty surgery, a thin, blonde, tanned patient lays prostrate on an operating table and makes casual presurgery conversation with the camera operators and anesthesiologist. Her lethargic monotone offers a predictable combination of privilege and ennui. The drama of waiting for the intravenous drip to take over gives the broadcast the unmediated feel of *cinema verité*. The steady and unblinking video eye, which supplies a surveillance image not unlike that of a convenience store camera, records the supine woman's body as it descends slowly into unconsciousness.

Web sites that broadcast medical procedures often argue that they have succeeded in bringing a living, immediate component to displays of the body that simply did not exist before the Internet. On cable television and the Internet, broadcasting surgical procedures has become a commonplace occurrence, though the vast majority of such programs are edited from hundreds of hours of available recordings and streamlined to fit the tastes of a visually literate (though increasingly nonplused) public. Clearly, however, contemporary Internet sites—not unlike those programs produced during the 1950s—also recognize the opportunity to broadcast surgical and diagnostic techniques as analogues to domestic and international discussions of public health while promoting particular forms of medical intervention as the cutting-edge tools and economic benefits of an expanding free market and liberal public sphere.[49] In the early twenty-first century, the efflorescence of media that present such materials for public consumption—Web-based archives on the Internet that feature surgical procedures as well as network television programs like *Extreme Makeover* and the profusion of cable television programs, such as those broadcast on the Learning Channel, that are focused on repairing disabled bodies, liposuctioning fat bodies, or both—demonstrates how the lines that demarcated public health concerns such as chronic obesity from cosmetic procedures such as liposuction have become permanently blurred as increasingly more consumers are persuaded to believe that narratives of health can merge seamlessly with narratives of personal transformation. Television series like Fox's *House* and F/X's *Nip/Tuck*—many of which are consumed by loyal fans not only during commercial broadcast but through DVD boxed sets, rental

distribution systems like NetFlix, and online channels like Hulu—have success-
fully merged the glamour of the nighttime soap opera with elements of the medical
documentary genre, pushing the envelope of graphic medical display as a profes-
sional and aesthetic corollary to the central characters' romantic escapades and
moral conundrums. On these programs, public health concerns often take a back-
seat to the allure of the rare or exotic (or, in the case of *Nip/Tuck,* the cosmetic),
so much so that what is presented visually as health care and what is presented
visually as public health information are distorted beyond recognition and
often beyond the possibility of disentanglement, thereby canceling out whatever
public health ambitions such shows might have had in the first place, if they had
them at all.

Procensorship conservatives, family advocacy groups, and self-appointed
public defenders of social values often try to argue that the proliferation of delib-
erately provocative content on Web sites like YouTube and reality television pro-
grams like *Extreme Makeover* or *The Biggest Loser* demonstrates the corruption of
public morals, as evidenced by the zeal through which commercial broadcasters
have rushed to make available previously taboo, or at least private, subjects to
mass audiences.[50] One could extend such a critique to the decay of a public
health sphere in which the distinctions between surgical interventions for life-
threatening health conditions and those for cosmetic amenities have apparently
disappeared or have been made interchangeable for a large portion of the view-
ing audience. Libertarian champions of television and the Internet, on the other
hand, see the broadening of broadcast topics as an inevitable social good, let
alone a healthy economic good that embodies the principles of the free market.
Such an argument supports the contention that the broad range of medical topics
as filtered through popular and professional media reflects a collective desire for
unrestricted access to health care in the public sphere, whether one determines
that health care is delivered equally for "deserving" cases (for example, gastric
bypass surgery for the morbidly obese) as well as for "undeserving" ones (for
example, breast augmentation for the morbidly narcissistic).

The pervasiveness of live surgical broadcasts on early broadcast television,
however, revises both of these positions as imprecise and misinformed. Surgical
broadcasts in the 1950s were in fact evidence of a highly experimental zone of
engagement for producers and viewers alike. Early television broadcasts pre-
sented graphic surgical procedures not as titillating social "taboos" but as educa-
tional models, even if those models ultimately appropriated the tools of advanced
technology to promote the interests of corporate sponsors and professional
organized medicine. In other words, television viewers in the 1950s who were
bombarded regularly by live images of surgery and public discussions of chronic
illnesses did not experience an uncomplicated "Golden Age" free of dissonant
images, no matter how much historians of the medium or conservative critics of

contemporary television endeavor to portray it as such. On the other hand, part of the unintended irony of the libertarian model of television history is that medical dramas even today—from surgery-based reality series on network television like *Extreme Makeover* and cable television documentaries like *Plastic Surgery: Before and After* to scripted episodes of long-running popular medical series like *ER* or *House*—are often obliged to meet public demand for realism by including regular snippets of actual filmed surgery (or, in the case of *House*, highly stylized recreations and super-realistic computer animations) in order to raise their authenticity quotient. Such claims to surgical authenticity—or at least some semblance, however mediated, of surgical realism—have the unintended consequence of mystifying the very process by which network television supposedly has become more liberalized. The so-called freedom often imputed to post-1960s television and Internet broadcasts with respect to graphic depictions of surgery is a kind of overstated wishful thinking, an unrecognized revisionist history of popular media and of the history of postwar visual culture in general.

Notes

1. See, for example, Erik Barnow, *Tube of Plenty: The Evolution of American Television*, 2nd edition (New York: Oxford University Press, 1990); Lynn Spigel, *Make Room for TV: Television and the Family Ideal in Postwar America* (Chicago: University of Chicago Press, 1992); Gary Edgerton, *The Columbia History of American Television* (New York: Columbia University Press, 2009); and Michele Hilmes and Jason Jacobs, eds., *The Television History Book* (London: British Film Institute, 2008).

2. David Fisher's *Tube: The Invention of Television* (New York: Mariner Books, 1997), 313–14, briefly discusses the American Medical Association's relationship with early television technology, but very much in passing and without any sustained acknowledgment that professional medical education and medical practice played a significant role in the technological development of television.

3. "The Operating Theater Becomes a Theater Indeed," *TV Guide*, January 3, 1959, 28–29.

4. While an extensive technical literature about telemedicine exists, I am interested here primarily in recovering the historical contexts in which early precedents for telemedicine debuted, which I identify in the late 1940s and early 1950s. For an inconsistent though interesting overview of the early history of telemedicine, see Warner V. Slack, *Cybermedicine: How Computing Empowers Doctors and Patients for Better Health Care* (San Francisco: Jossey-Bass, 1997), esp. 7–26. For its historical development, see Rashid L. Bashshur and *Gary Shannon, History of Telemedicine: Evolution, Context, and Transformation* (New York: Mary Ann Lambert, 2009).

5. For more on this phenomenon, see Lisa Cartwright, *Screening the Body: Tracing Medicine's Visual Culture* (Minneapolis: University of Minnesota Press, 1995); Joel D. Howell, *Technology in the Hospital* (Baltimore: The Johns Hopkins University Press, 1997); Bettyann Holtzmann Kevles, *Naked to the Bone: Medical Imaging in the Twentieth Century* (New Brunswick, N.J.: Rutgers University Press, 1997; and José van Dijck, *The Transparent Body: A Cultural Analysis of Medical Imaging* (Seattle: University of Washington Press, 2006).

6. See, for example, Stanley Joel Reiser, *Medicine and the Reign of Technology* (New York: Cambridge University Press, 1978).

7. Hugh R. Gilmore, "Television in Medicine," press release probably early February 1955: 4. Photostat manuscript in the WRAMC-TV (1950s) folder, Otis Historical Archives, National Museum of Health and Medicine, Armed Forces Institute of Pathology, Walter Reed Army Medical Center, Washington, D.C.

8. See Steven Capsuto, *Alternate Channels: The Uncensored Story of Gay and Lesbian Images on Radio and Television, 1930s to the Present* (New York: Ballantine, 2000), 96–97.

9. Robert S. Alley, "Medical Melodrama," in *TV Genres: A Handbook and Reference Guide,* ed. Brian G. Rose (Westport, Conn.: Greenwood Press, 1985), 73. See also Robert S. Alley, "Media, Medicine, and Morality," in *Understanding Television: Essays on Television as a Social and Cultural Force,* ed. Richard P. Adler (London: Praeger, 1981), 231–46.

10. Joseph Turow, "James Dean in a Surgical Gown: Making TV's Medical Formula," in *The Revolution Wasn't Televised: Sixties Television and Social Conflict,* eds. Lynn Spigel and Michael Curtin (New York: Routledge, 1997), 186. See also Turow, "Television Entertainment and the U.S. Health-Care Debate," *The Lancet* 347 (1996): 1240–43; and Turow, *Playing Doctor: Television, Storytelling, and Medical Power* (New York: Oxford University Press, 1989).

11. Review of September 5, 1955, broadcast of NBC's *Medic, Variety* (September 7, 1955).

12. Karal Ann Marling, *As Seen on TV: The Visual Culture of Everyday Life in the 1950s* (Cambridge, Mass.: Harvard University Press, 1995).

13. William S. Graebner, *The Age of Doubt: American Thought and Culture in the 1940s* (Boston, Mass.: Twayne Publishers, 1991), 17.

14. Alfred N. Goldsmith, "Color Television and Medicine," (paper delivered at the Armed Forces Institute of Pathology, probably 1954), 13. From the WRAMC-TV (1950s) folder, Otis Historical Archives, National Museum of Health and Medicine, AFIP, Walter Reed Army Medical Center, Washington, D.C.

15. For further elaboration on the political and social context of televised medicine in the 1940s and 1950s, see David Serlin, "Built for Living: Imagining the American Body through Medical Science, 1945–65" (PhD dissertation, New York University, 1999), especially Chapter 1, "Medical Futurism, Early Television, and the American Body."

16. See "Now 'Dr. Kildare' Must Be OK for Television," *Variety* (March 5, 1947).

17. See James W. Ramey, *Television in Medical Teaching and Research: A Survey and Annotated Bibliography* (Washington, D.C.: Government Printing Office, 1965), 11–12.

18. See Reiser, *Medicine and the Reign of Technology,* esp. 196–226.

19. Goldsmith, "Color Television and Medicine," 2.

20. Undated cartoon (ca. early 1950s) by Constantin Suozzi; reprinted in Henry G. Felsen, *Medic Mirth* (New York: Ace Books, 1956), 44.

21. "Open TV Network Carries Surgery: Philadelphia Station Shows Portion of Major Operation — Viewers 'Thrilled'," *New York Times* (March 17, 1952), 23.

22. Review of December 1, 1954, broadcast of WRGB (Schenectady, N.Y.) program, "Medically Speaking," *Variety* (December 8, 1954).

23. Review of April 1, 1955, broadcast of KSTP (Minneapolis, MN) program, "Public Health is People," *Variety* (April 6, 1955).

24. Review of April 13, 1958, broadcast, "WYSR-TV Picks Up Cancer Operation," *Variety* (April 23, 1958).

25. Joe Kolling, "Cincy Telecast of Cancer Operation Gets Record Audience, Viewer Approval," *Variety* (April 14, 1954).

26. Uhl, quoted in "Citations: '53–'54," *Variety* (April 21, 1954), 18.

27. William L. Laurence, "Major Operation to Save a Life Put on Network TV for First Time," *New York Times* (June 11, 1952), A1.

28. Laurence, "Major Operation," 20.

29. Review of June 10, 1952, broadcast of NBC's *March of Medicine, Variety* (June 18, 1952).

30. For an interesting discussion of surgeons and surgery in popular culture, such as in the 1930s Broadway drama *Men in White,* see Daniel M. Fox and Christopher Lawrence, *Photographing Medicine: Images and Power in Britain and America since 1840* (New York: Greenwood, 1988), 246.

31. Jack Gould, "First Televised Surgical Operation Draws Mixed Reaction: Its Value as Education Is Weighed," *New York Times* (June 13, 1952), 31.

32. Like other contemporary cultural productions, such as footage from the frontlines of the war in Korea, televised surgery was described repeatedly as an objective, unvarnished, natural spectacle. See Abercrombie, et al., "Popular Representation: Recasting Realism," in *Modernity and Identity,* ed. Scott Lash and Jonathan Friedman (Cambridge, Mass.: Blackwell, 1993), 115–40.

33. See "TV and Radio Balm to Nation's Medics," *Variety* (June 15, 1955).

34. *First Inter-Agency Symposium on the Application and Scope of Television in Medicine.* Pamphlet for conference, held January 17–19, 1955, at the Armed Forces Institute of Pathology, Walter Reed Army Medical Center. In the WRAMC-TV (1950s) file, Otis Historical Archives, AFIP, Walter Reed Army Medical Center, Washington, D.C.

35. J. P. Shanley, "Surgery: Channel 4 'March of Medicine' Brings an Operation into the Living Room," *New York Times* (June 8, 1955), 59.

36. For a near-contemporary historical parallel, see Lisa Cartwright, *Screening the Body,* esp. Chapter 6, "Women and the Public Culture of Radiography," 143–70.

37. See "TV & Radio Balm to Nation's Medics."

38. Review of May 6, 1958, broadcast of WABD (New York, N.Y.) program "Heart Surgery," *Variety* (May 14, 1958), 22.

39. "KPIX Heart Operation Thumps Through with Walloping 38.6 ARB," *Variety* (July 2, 1958), 21.

40. Marion B. Sulzberger, "Summary of Discussion of Plan 1," in Institute for the Advancement of Medical Communication, *Report of the First Meeting of the Council on Medical Television, Held at the National Institutes of Health, Bethesda, MD, October 15–16, 1959* (New York: IAMC, 1960), 32.

41. For a complete discussion of the developmental history of *Medic,* see Joseph Turow, *Playing Doctor,* 54–55. For a discussion of *Medic's* controversial topics, see Steven Capsuto's chapters on television in the 1950s in *Alternate Channels,* 96–97.

42. Spotlighthealth.com, which is now defunct, had as its central advertising slogan, "Combining healthcare expertise and celebrity experiences in a caring supportive community." For early commentary of this trend, see Nancy Haas, "Now on the Web: Plastic Surgery for Voyeurs," *New York Times* (November 19, 1999), 9:1.

43. See, for example, Frances M. Berg, "Health Risks Associated with Weight Loss and Obesity Treatment Programs," *Journal of Social Issues* 55, no. 2 (1999): 277–97, esp. 287–89, and Paul Ernsberger, "Surgery Risks Outweigh Its Benefits," *Healthy Weight Journal/Obesity & Health* 5, no. 18 (1991): 21–25.

44. For an entire site devoted to laparoscopic surgery, see http://www.laparoscopy.com.

45. The operation was performed by Dr. Denton A. Cooley, the pioneer cardiologist who completed the first successful human heart transplant three decades earlier in 1968. See

"Dr. Cooley Performs Open Heart Surgery Broadcast Live on Internet and Cable TV," press release from the Texas Heart Institute (http://www.tmc.edu/thi/ahnheart.html), August 20, 1998.

46. "The Internet's First Sex Change Operation," performed December 10, 1999; the Web site's manifesto can be found at http://www.amazingsurgeries.com. According to Net legend, so many people went online to watch the operation that the Internet was effectively "shut down" for nearly half an hour.

47. See Pam Belluck, "Webcast Your Brain Surgery? Hospitals See Marketing Tool," *New York Times* (May 25, 2009), A1.

48. See Bob Kurson, "Surgery to Go Up for Auction on Web Site," *Chicago Sun-Times* (January 9, 2000), 6A.

49. For further discussion of the relationship between medicine and liberal values in the postwar period, see David Serlin, *Replaceable You: Engineering the Body in Postwar America* (Chicago: University of Chicago Press, 2004), esp. 3–20. See also Kirsten Ostherr, *Cinematic Prophylaxis: Global Public Health Films* (Durham, N.C.: Duke University Press, 2005).

50. For a larger discussion of this tendency among conservative critics, see Joshua Gamson, *Freaks Talk Back: Tabloid Talk Shows and Sexual Nonconformity* (Chicago: University of Chicago Press, 1998).

12. *Imagining Mood Disorders as a Public Health Crisis*

EMILY MARTIN

AMERICANS LIVING UNDER THE DESCRIPTION of manic depression today are often encouraged to keep a "mood chart" in order to manage their manias and depressions. The practice is part of a long tradition dating back to the eighteenth century, when charts were used to manage the daily ups and downs of moods. The Philadelphia physician Benjamin Rush devised a "moral thermometer," published in a popular health magazine in 1833, that enabled people to register changes from "unfeeling," "cold," or "sullen" on the low end to "hot," "passionate," or "ungovernable" on the high end (Figure 12.1). Rush intended the moral thermometer to regulate people's "tempers" in accord with the dictates of the temperance movement of that time.

At the end of this essay, I will return to Rush's chart for comparison with the multitude of contemporary charts I came across in my fieldwork. One example is "Amy's Self-Rated Mood Chart," found in a popular contemporary handbook on managing bipolar disorder.[1] The chart features a grid on one page, with a line for

Figure 12.1. Benjamin Rush's 1833 "Moral Thermometer" showing a range of mental states as hot and cold temperatures. Copyright 1833 Benjamin Rush, "Moral Thermometer." *Journal of Health and Recreation* 4, no. 1 (1833): 5. Courtesy of National Library of Medicine.

each day of the month. The left part of the chart is devoted to records of medication and the right part to mood. There are columns for daily notes such as "friend's wedding," or "dog got sick; went to hospital," and columns to indicate "irritability," "anxiety," and hours of sleep. The range of moods is from "elevated" to "depressed," and, strikingly, times when one is "able to work" or "not able to work" are distinguished for both elevated and depressed moods. This chart connects working and not working, productivity and nonproductivity, with the individual's moods.

In the U.S. economic system, there is a premium on measuring and tracking any valuable resource, and that includes moods. The activities of charting and recording moods make moods and their potential benefits or detriments visible and quantifiable. Norms for moods have gone up the scale from "moderate" toward "hot." Anyone living under the description of manic depression—as well as anyone who partakes in the powerful aura of a manic style—learns they have the capacity to be "hot" and the potential to parlay this capacity into a valuable commodity in the market.

Filling out a mood chart—a small act of individual discipline—can have dramatic effects. When many people fill out the same charts or register their moods on a numerical scale, they make their distinct experiences comparable. When people assign a number to a mood, they are paving the way for statistics that describe the moods of a population and their changes over time. Through the social technology of the mood chart, manic depression emerges from the psychology of individuals onto the scene of national and global concerns with the rationality and productivity of populations.

The mood chart takes concrete form as a template. Looking at a blank mood chart, planning to fill it in, focuses one's attention visually on the information one is about to add. But the chart itself has already shaped one's visual perceptions to allow inclusion of only certain aspects of one's moods: how high or low are they? At what times do they shift? What medications affect them? The mood chart is like a map on which the roads are already laid out in advance. The user is likely to accept the given roads without question, and simply note where he or she has traveled over the given pathways.

Mood charts such as Amy's encourage people to manage their psychological states rationally so they can work productively. The conviction that psychological management is rational came out of the early history of the disciplines of psychiatry, psychology, and psychoanalysis. Scholars working within these disciplines came to think that individuals could achieve desirable goals such as authority, tranquility, sanity, virtue, or efficiency by governing their own subjectivity. To govern themselves, individuals would need to collect information about their subjectivity in any number of forms, from written reports to drawings, from charts to statistics.[2] As the individual scrutinized and recorded various inner

states he or she would become more aware that he or she was a separate individual who bore the responsibility for self-government.[3] Today, a person who keeps a mood chart is bringing information out from the interior, subjective realm to the exterior, social realm.[4] The practices of introspection and record-keeping we have come to take for granted build a strong identity at the individual level, both general (I am a self-regulating, calculating, rational person) and specific (these are my mood patterns, and this is how I respond to my specific medications).

Once a person writes his or her subjective information down in some form, he or she can manage it in new ways. If a person collects information on a chart with categories that are widely used, the individual can compare inner states to those of another person. The chart promotes the perception that everyone experiences the same kinds of moods, just in different combinations and intensities. Comparisons on a common scale not only are invited, they rush to the forefront as charts proliferate. It is as if moods have been thrown into what Marx called the "great social retort."[5] The "retort" boils out particular flavors and leaves only measurable abstract qualities, such as degrees of sanity, modernity, or rationality.

If a person collects his or her information on a chart that has a numerical scale, still more elaborate forms of management open up. The individual can now track moods numerically over time and ascertain whether, by the year, month, or day, his or her moods are averaging higher or lower. As moods become represented by a numerical value, they become commensurable with the moods of others.[6] If the person provides numerical information about his or her moods to the doctor or a public health specialist, he or she may contribute to statistical measures of the national or global mood. These forms of record-keeping create standardized measures for private, interior states, standardized measures that enable new kinds of measurement of populations.[7]

To gain greater historical perspective on contemporary mood charts, I turn to Emil Kraepelin's charts of moods in *Manic Depressive Insanity and Paranoia*, originally published in 1921 and reprinted in color in a new 2002 English edition. For Kraepelin, there was a limited number of types of mood states within the general category of manic depression. Each type was marked with a special graphic or shade of color: mania, hypomania, raving mania, and manic stupor, all measured in shades of red; and light depression, heavy depression, depression with flight of ideas, and depressive excitement all measured in shades of blue.[8] But the many charts Kraepelin included in the book demonstrate that he recognized the immense variety of ways individuals with manic depression cycle through mood states. He argued that others' efforts to lump groups of individuals into subtypes of the illness were futile: "the multiplicity of the courses taken by manic-depressive insanity . . . is absolutely inexhaustible. The cases reported only show that there can be no talk of even an approximate regularity in the course, as has

formerly been frequently assumed on the ground of certain isolated observations."[9] For Kraepelin, the time scale was in years (numbered on the left side of the chart), subdivided only into months and portions of months (labeled across the top of the chart). So compact was the chart that the entire lifetime of a person could be contained on one single page. Doctors familiar with patients in a clinical setting compiled the condensed information in Kraepelin's charts over many years. Patients themselves had no role in noting down their symptoms; rather, doctors kept careful records of patients' health, from how much they weighed to how neatly they could write.

Kraepelin saw manic-depressive insanity as a disease that had a natural, inevitable progression. He regarded it as a "natural disease entity,"[10] with characteristics he and his associate discovered through clinical record-keeping of "countless" patients.[11] He devised a special form called the *Zählkarten*[12] with which he could categorize information about each patient. Although masses of data were collected and studied, there is no evidence that Kraepelin quantified this data to present it in the form of graphs or charts summarizing many patients. Nor did he use mathematical forms of representation to show, say, the rise and fall of mood in individual patients over time. His charts showed only the many ways subtypes of moods succeeded one another in different individuals.

According to Kraepelin, although the progression of manic-depressive insanity could be charted, ordinarily no cure would be possible for patients admitted to institutions; he said most were "forever lost."[13] The only hope would come from prevention. In Kraepelin's view, at least one-third of all mental illnesses had causes he regarded as preventable, such as alcoholism, syphilis, traumatic injury, or addiction to morphine and cocaine.[14] In spite of the gloomy prospects for his patients, Kraepelin's charts, as well as his descriptions, showed the possibility for patients to enjoy prolonged and frequent disease-free periods. Kraepelin called these remissions "long lucid intervals,"[15] during which patients were "able to reenter the family, to employ themselves profitably, and to return to their profession."[16] On his charts, these intervals are represented as white spaces.

In contrast to Kraepelin's time, individuals today maintain their own mood charts. The charts appear regularly in popular books, magazines, doctors' offices, and on the Web. Many groups interested in manic depression explicitly encourage their use. For example, the Web site for the Harvard Bipolar Research group provides a sample chart already filled in and a blank chart that you can download and print out for your own use. The Web site for the Depression and Bipolar Support Alliance, a patient advocacy group, provides a sample chart, a chart for downloading, and a page of detailed instructions. The pharmaceutical company Lilly gives consumers a Web page with a pull-down menu to register where one is in the range of moods and a button to click if one wants to see one's moods over time

as a graph. The federally funded National Institutes of Mental Health Web site presents visitors with a complex chart accompanied by extensive instructions.[17]

In addition, various kinds of charts have been developed for parents and teachers to use in home and classroom environments. With one device, children can color in the cartoon face that best represents their moods, from sad to frantic; with another device, children place plastic stickers on a "mood tree," at the bottom, labeled "no self, suicide" or the top, labeled "frenzy, all self." These techniques are explicitly marketed to the parents of children who display behavior problems in the home or classroom. More recently, *The Judy Moody Mood Journal*, a spin-off from a series of popular books about a temperamental third-grade girl, encourages children to keep track of their moods by following the character, "Judy Moody," who is "always in a mood." The diary has "Dial-a-Mood-Meter" spinner built into the cover with ten states such as "moody blues" or "mischievous" indicated around the circle.[18] As children are taught to keep records of their interior states, they are being taught to take individual responsibility for managing those states. The record-keeping of moods thus extends from children whose moods cause problems at school or home to (potentially) all children.

As in Kraepelin's charts, contemporary charts record a range of psychological states. But in contemporary charts, only simple, everyday feelings and behaviors are listed (for example, anger, sadness, irritability, tiredness, hunger), rather than technically defined complexes of traits (for example, Kraepelin's "manic stupor"). The traits charted, it is assumed, are knowable by the individual directly: Do I feel sadness? Elation? Do I experience energy? Fatigue? The charts do not call out for observations made by a trained observer of the sort Kraepelin relied on.

Compared to Kraepelin's charts, the contemporary mood chart has undergone a certain elaboration. In Kraepelin's case, an individual's entire life span could be described on one page; today, one page usually contains the details of only a single day. Each day, in turn, can be divided into periods of hours and minutes, and each quality or activity can be registered practically by the minute. Self-scrutiny and self-management can thus be carried out at a finer level of detail. I can record, and worry about, my mood variations minute by minute. From a *year per page* to a *day per page* is an increase of more than ten-thousand-fold.

The sharpest contrast to earlier charts is that contemporary charts invariably contain a place to record the means of ameliorating mood disorders. All charts I have seen include a section, often occupying nearly half of the chart, for recording what medicines the person takes as well as how much and when he or she takes them throughout the day. Medications are carefully plotted in relation to symptoms so that the mood pattern can be adjusted up or down. A software company has devised a program, Mood Monitor, which allows patients to fill out charts on their home computers while a doctor keeps tabs on their condition from a remote location. The program calculates summary data from moods

juxtaposed to medications, and doctors adjust medications as necessary. On the company's Web site, a doctor writes:

> I have used Mood Monitor in my clinical practice and am very impressed. I have long found that bipolar patients are unable to accurately measure their moods and other parameters between sessions. With Mood Monitor, I can see at a glance how their moods are varying as well as how the patient is sleeping. This allows me to make adjustments in medications with more confidence.

Even without a doctor's involvement, people in support groups frequently said that representing their moods on a chart over time allowed them to see more clearly exactly what differences medications make. A Web author who makes his mood chart available online agrees: "I've found that minor changes in medication can make big changes in how I felt, so tracking dosages was useful. And, embarrassing as it was, tracking when I didn't take medicines was useful too."[19]

Although the contemporary chart seems to offer more hope of improvement through medication than Kraepelin's, one effect of the detailed moment-by-moment scrutiny is to emphasize the abnormal. People are able to mark their moods and other states right along the middle axis of the chart, along "normal," but, in fact, this seldom happens. What counts as "normal" can occupy as little as one point on the chart—as on the Harvard Bipolar Research Program home page—and this point can be easy to miss. Also, as one charting regular asked me, "Who wants to be a zero?" While for some the zero of normality may be tinged negatively, for others the whole chart is negative territory. At a lecture I gave in 2003 at the University of Texas, Austin, I showed several slides of Kraepelin's mood charts, coded in shades of red for mania, shades of blue for depression, and white for lucid intervals. A woman in the audience who identified herself as a person from the Austin community living under the description of bipolar disorder commented, "Thank you for giving me the white spaces. I am going to go home and just be in a white space." This woman might have felt relief at being able to visualize "the white spaces"—a place where her moods were not disordered and she did not have to monitor them constantly.

In support groups in towns and cities in southern California and a large East Coast city, I observed directly how difficult it is to occupy the zero point as long as one has the diagnosis of a mood disorder. Groups often followed the practice of beginning each meeting by going around the room for brief introductions. Each person would state his or her first name and then, using a kind of oral mood chart, give a number on a scale from −5 to +5, indicating a range of moods from very depressed to very manic: "I'm Jan and I'm +3," "I'm Dave and I'm −2," and so on. Only people with a diagnosis of manic depression attended most meetings, and I never heard anyone choose zero. At one meeting, a woman who attended

regularly brought along her husband, who does not have the diagnosis of manic depression. He listened as each person gave his or her name and score. When it was his turn he said, uncertainly, "I'm Brad and I guess I must be zero." In sum, everyone can see himself somewhere on the chart and (unless he is a zero) he can see how his emotional state could be moderated by psychotropic medications. Being zero, being normal, placed Brad orthogonal to the chart and out of reach of its demand for self-surveillance.

Mood Hygiene

In a popular book about manic depression, keeping a mood chart is said to be part of "mood hygiene." Francis Mondimore includes a picture of Hygeia, the goddess of hygiene, who, in this context, stands for "[p]ractices and habits that promote good control of mood symptoms in persons with Bipolar disorder." In the context of the image of Hygeia, Mondimore points out that research shows just how important preventive measures can be for "improving symptom control in Bipolar disorder."[20] This is a powerful image because it is well known (and Mondimore emphatically reminds us) how efficacious hygienic practices (cleaning water, sweeping houses, and washing bodies) were in the reduction of mortality and morbidity that took place in the early twentieth century. But this is an odd image as well. If hygiene reduces physical disease by eliminating *pathogens*, then what is the hygiene of moods meant to reduce or eliminate? Are the surges and dips above and below the line of "normal" meant to be reduced? If this were to happen, would emotions, feelings, and sentiments in general be reduced? Would it be more "hygienic" if they were reduced to almost nothing? In Mondimore's book, the answers to these questions are left unanswered.

Why might "mood disorders" be considered a public health problem? In the 1978 book *Mood Disorders: The World's Major Public Health Problem*, Norman Sartorius *argues* that "[d]epression is a public health problem because it is frequent, causes distress and suffering for many patients and their families, and results in severe socioeconomic losses."[21] The link between mood and productivity in the workplace was well entrenched in North America by the end of World War II. An early 1950s public health education film produced by the Canadian Broadcasting Corporation makes clear the link between depression and lowered ability to work. In *Feelings of Depression*, the film tells the story of John, a young man who believes he is failing at his job, and more seriously, believes his company itself is on the brink of failure. This link between work and mood has been reiterated many times since, for example in a public health poster from 1991 captioned, "Not everyone who is depressed is this visible." In a scene of a contemporary open office space, several depressed workers are shown as immobile white plaster statues. Depression has, in this visual image, rendered its victims not only immobile,

but, because they are entirely made of plaster, it has rendered them both inanimate and dead. Now they are visible in their chalky ghostliness, but they also look frighteningly inhuman (Figure 12.2).

The original upsurge in interest in mood disorders as a public health problem was doubtless fueled by the development of a new form of anti-depression

Not Everyone With Depression Is This Visible.

Treat Depression Before It Becomes Obvious.

One in twenty Americans will suffer from depression this year. Unfortunately, this illness often goes untreated because the symptoms are not recognized.

If someone you work with has *changed,* this may signal a need for help.

In the workplace, depression can contribute to:

- Decreased productivity
- Problems concentrating
- Difficulty in making decisions
- Persistent sad moods
- Absenteeism
- Frequent accidents
- Alcohol or drug abuse

D/ART • DEPRESSION Awareness, Recognition, and Treatment

With early diagnosis and appropriate treatment, 80 percent of people with serious depression improve significantly in just a matter of weeks . . . with little time lost from work.

Learn more about depression and where to get help.

Write: DEPRESSION
Department 5
5600 Fishers Lane
Rockville, Maryland 20857

Call: 1-800-421-4211

U.S. DEPARTMENT OF HEALTH AND HUMAN SERVICES • Public Health Service • Alcohol, Drug Abuse, and Mental Health Administration • National Institute of Mental Health
DHHS Publication No. (ADM) 91-1872 Printed 1991

Figure 12.2. Public health poster for "Depression Awareness, Recognition, and Treatment." U.S. Department of Health and Human Services, Public Health Service, 1991. Courtesy of the U.S. Government Posters Collection, University of Iowa Libraries, http://digital.lib.uiowa.edu/gpc.

medication. Frank Ayd, coeditor of *Mood Disorders*, ran Merck's clinical trials for their antidepressant drug amitriptyline, marketed under the name Elavil. Merck bought fifty thousand copies of Ayd's book, *Recognizing Depression*, and distributed them worldwide. This played a significant role in Elavil's success. As David Healy writes, "Merck not only sold amitriptyline, it sold an idea. Amitriptyline became the first of the antidepressants to sell in substantial amounts."[22]

More recent stories in the media associate "moods," especially depression, with lack of productivity or inability to work. In 2001, the *Wall Street Journal* reported that Bank One, concerned about productivity losses because of depression among its employees, instituted programs to encourage education, screening, and treatment. But the outcome for the bank was that the number of employees taking disability leaves for depression skyrocketed.[23] In 2003, a widely reported study funded by Eli Lilly & Co., manufacturer of the antidepressant Prozac, on the "Cost of Lost Productive Work Time among US Workers with Depression," found that depression costs employers $31 billion per year in lost productive time.[24] Since this study also discovered that use of antidepressants among depressed workers was low, it made the dotted lines between taking antidepressants and increasing productivity much easier to connect. Similar lines were connected in the spate of articles in print media, the Internet, and on television looking at links between moods like depression and the inability to leave the welfare rolls by means of finding a job. In a *60 Minutes* story on welfare and depression, Lesley Stahl begins,

> One reason there are still five million people on welfare is that a huge number of them are depressed, not just suffering from a case of the blues, but seriously medically depressed. It's an epidemic of depression among America's poor. Dr. Kessler of Harvard's School of Public Health estimates between a third and a half of people still on welfare are clinically depressed.
>
> Dr. Carl Bell, of a mental clinic in Chicago: "The state of Illinois, bless their heart, finally figured out that maybe the people who were going to be left on welfare were people with psychiatric disorders, and so maybe somebody ought to be here screening for that and referring people for treatment."
>
> Stahl: So people come in for welfare, for their checks, to make their applications, and if somebody is there that perhaps spots these symptoms . . .
>
> Dr. Bell: You can screen them out—everybody can get a very simple screening form—find out who's got what, and then treat them.[25]

Concern for the control of mood disorders has even spread beyond the national borders of the United States to the rest of the globe. In 2001, the World Health Organization (WHO) declared mental illness to be the main global health crisis of the year. Chief among WHO's concerns were the loss of productivity to the world's economies because of depressed moods, and making effective pharmacological treatments more widely available. For their part, the pharmaceutical

industry, by the 1990s in possession of a greater arsenal of drug treatments, clearly envisioned the market for these drugs on a global scale, and began to speak of the "global Central Nervous System therapeutics market" estimated at approximately $44 billion.[26]

A number of factors are coming together here: dissemination of mood charts for individuals to track their moods on a daily or hourly basis; a strong link between mood and productivity; and interest in increasing the recognition and treatment of mood disorders across the globe. The modest technology of mood charting has had an important role to play in the claim, first made in 1978 and reiterated often since, that mood disorders are a threat to the health of populations, and that mood disorders constitute a serious public health crisis. For those people who feel compromised by their moods, this attention is welcome because it acknowledges the extent of the problem and legitimates its significant impact on life. My argument is that, in the process of coming into being, the public health crisis in moods has changed the way people experience their moods. Increasingly, we have seen the evolution of one universal set of mood categories that everyone experiences. Through the simple act of recording their moods in terms of these categories, people form the habit of thinking in terms of a standardized taxonomy of mood.[27] As they become more and more aware of their moods at a detailed level, they are likely to feel greater personal responsibility for practicing good mood hygiene. Thus, as subjectivity changes, new habits of recording moods in turn enable governments, public health agencies, and pharmaceutical corporations to compile national and global statistics.

Mood and Motivation

Whereas depression has become clearly linked to lowered productivity, mania has become linked to increased productivity. To understand why this should be so, we have to look back at the relationship between mania and two kinds of psychological states, mood and motivation, described previously, and explore more deeply how mood and motivation are related in the *Diagnostic Statistics Manual* (DSM), the so-called bible of the psychological profession. In the DSM-IV, both depression and mania are regarded as types of "mood episodes." Mood episodes "serve as the building blocks for the [mood] disorder diagnoses."[28] But the DSM-IV handles the building blocks of depression and mania quite differently. Whereas depressive episodes can combine into many types and subtypes of "depressive disorders," mania by itself cannot be the only building block of a mood disorder. As far as the DSM-IV is concerned, mania only occurs as part of bipolar disorder, where it alternates with depressive episodes. In other words, mania always exists as a part of a system of moods: manic highs, followed by depressed lows. According to the

DSM-IV, a manic episode is "[a] distinct period of abnormally and persistently elevated, expansive or irritable mood, lasting at least 1 week (or any duration if hospitalization is necessary)."[29] It includes three or more of these symptoms: "inflated self-esteem or grandiosity"; "decreased need for sleep"; "more talkative than usual"; "flight of ideas or subjective experience that thoughts are racing; distractibility (i.e., attention too easily drawn to unimportant or irrelevant external stimuli)"; "increase in goal-directed activity (either socially, at work, or school or sexually)"; "excessive involvement in pleasurable activities that have a high potential for painful consequences (e.g., engaging in unrestrained buying sprees, sexual indiscretions, or foolish business investments)."[30]

At first blush, mania in both its everyday and in its DSM-IV senses seems to involve pursuing one's interests passionately. Confirming this, whenever I have read the DSM definition of mania to audiences of undergraduates, graduate students, and faculty at universities and colleges, it has met with good-natured laughs and chuckles. When I asked why the definition was funny, people would tell me, "Because this level of activity sounds like me and a lot of the people I know." Even though the DSM-IV category endeavors to define the parameters of a major psychiatric disorder, people in this particular social setting enjoy recognizing themselves and their friends in mania's energy and passion.

How does passionate pursuit of an interest relate to a "mood"? Again, in the DSM-IV, mania is clearly categorized as a kind of "mood disorder," but there is not much explanation of why it should be called a "mood." The philosopher Gilbert Ryle gives us some markers to follow in the maze of terms used in ordinary English to designate mental states like moods:

> Moods . . . monopolize. To say that [a person] is in one mood is . . . to say that he is not in any other. To be in a conversational mood is not to be in a reading, writing or lawn-mowing mood.[31]

But to say that moods monopolize is not to say they are all equally intense. Clifford Geertz stresses the variation in intensity among mood states, some of which can "go nowhere." In contrast to moods, motivations are more enduring. Geertz explains, following Ryle, that motives "have a directional cast, they describe a certain overall course, gravitate toward certain, usually temporary, consummations."[32] Perhaps partly because they are directional, multiple motivations can coexist, sometimes in harmony and sometimes in conflict. A person can be motivated both to pursue a career and find a spouse and find these goals compatible; likewise, a person can be motivated both to pursue a career and nurture a family and find these goals incompatible. In sum, moods monopolize but can vary in intensity and duration; motivations can coexist but involve an enduring direction.

On this account, the mania people speak of in daily life and some of the manic elements described in the DSM-IV look something like motivations. They persist, they are directional, and they gravitate toward an ultimate consummation; indeed that is often their whole point, even if their duration may be short. In Amy's Mood Chart, mood and motivation are explicitly linked. And the DSM-IV's depiction of mania (in which it is always paired with depression) also seems to fit Ryle's characterization of a "mood" in certain ways: it is all-consuming when it appears, but comes and goes over time. Taken together, the various uses of the term *mania* share some properties with both the category of "motivation" and of "mood."

"Motivation" is the part of mania that our economic system places at a premium. Historian Elizabeth Lunbeck has suggested to me that the link between mania and enhanced motivation may be a "survival" of a much older way of distinguishing psychological states, on the basis of the "will."[33] Evidence of this is a psychological study, published in 1922, in which the author found *no* relationship between measures of mood and tests of performance *among* thirty-eight men and women. The reason posited is that moods are "distractions" that lead individuals to exert their will to "overcome resistance by increasing the output of energy."[34] In the early decades of the twentieth century, psychologists believed that the will led directly to performance: moods were minor annoyances that made people simply exert more will. Although not long ago mood and motivation were unconnected, today they surely are. The productivity of individuals and the vigor of markets hinge today on their ability to draw on manic energies. Mood and motivation have become strongly linked in the category of mania as the term is used in descriptions of the psyche and the market: this linkage means that the pathological category of manic depression now appears to contain a capacity that directly enhances both individual productivity and the energy of markets.

While mania cannot be had without depression, depression can be had without mania. The low end of the mood spectrum is often seen as simply a liability, as in the studies that find a correlation between people who remain on the welfare rolls and people who are depressed.[35] It goes without saying, of course, that welfare recipients should ideally be able to reap the same benefits of the latest medication and therapies for depression as economically better-off citizens. We need to understand the relationship between economic deprivation and psychological depression. How do we separate those who would be depressed whether rich or poor and those who are depressed *because* they are poor? Screening alone will not do the job.

In the *60 Minutes* scenario, the participants imagine that it would be best for depression to simply disappear. Of course, no one would wish to perpetuate the suffering caused by the despair and paralysis of depression, least of all pharmaceutical companies whose advertisements frequently imply that depression can be eradicated and that its eradication would be a good thing. On behalf of Prozac

and Serafem, Lilly urges you to "Get your life back" (from the depression that has taken it away) and, after treatment to remove the depression, declares "Welcome Back!" On behalf of Zoloft, Pfizer exhorts, "When you know more about what is wrong, you can help make it right." Taking Zoloft will correct the "chemical imbalance of serotonin in the brain," which, it is suggested, is the physical signature of depression. In *Against Depression*, Peter Kramer warns us not to romanticize depression as a form of "heroic melancholy," but instead treat it as a disease we can cure. Although I would agree that the suffering caused by depression should not be endowed with virtue, it is equally important to draw attention to the socially based reasons that we want to eliminate some moods but keep others. Kramer exempts mania and hypomania from elimination because "they may drive productivity in many fields."[36]

The practice of screening populations to detect undesirable mental states has now gone far beyond welfare offices. Heralded through the George W. Bush administration's "New Freedom Commission on Mental Health" and given a test run in Texas as the Texas Medical Algorithm Project (TMAP), systematic screening has already been instituted and remains official policy in more than ten states. The program is slated for national use. Pennsylvania has run into trouble because Allen Jones, a self-identified whistle blower, publicized the connections between the pharmaceutical industry—including the specific, brand-name drugs Pennsylvania placed on its formulary, the list of drugs physicians must choose from—and the financial interests of numerous state and federal officials. My point is not that we should deny the best mental health care—including drugs—for everyone, but that we should pay attention to the troubling way economic interests are tipping greater and greater numbers of people toward treatment with certain drugs.[37]

With depression eliminated, the way would be open to cultivate a kind of manic energy stripped of its nonfunctionality. Indeed, self-help experts have marketed explicit programs to help achieve this end. Through many best-selling books and television programs, for example, Barbara Sher advocates a program of self-improvement in which moods are considered a distraction. Moods are important to identify so they do not get in the way of the real goal: building motivation. "You can't ignore your emotions. They're strong and primitive and must be dealt with."[38] But moods and emotions are to be identified and swept away (as if by Hygeia's broom) so that your "hidden motivators" and "untapped energy sources" can be unleashed, even when, as Sher's Web site states, "you are in a lousy mood."

Although mood charts target people who are afflicted by their moods and need to know them in order to control them by practicing mood hygiene, the word *hygiene* should be a tip-off to us that *selections* are being made among mood states. Just as "unhygienic" behavior was discouraged and "hygienic" behavior was encouraged at the turn of the twentieth century, the notion prevails that, as depression

withers away altogether and the wild, raw mania of the manic-depressive can be tamed or optimized, individuals will be better able to succeed and economies to grow in the twenty-first century. Key agents in this picture are the growing numbers of psychopharmacological drugs. They are what allow contemporary doctors to give a patient a diagnosis of mood disorder and treat it, rather than, as in earlier historical periods, lay the patient's problems at the feet of his or her temperament or character.[39] This transformation has certain benefits, not least that drugs can be effective and patients can feel less personally responsible for their condition. A newspaper article by a doctor praises the transformation because it unmasks "cheerful character" as "hypomania" [a mild form of mania] and "gloomy temperament" as "hypomania's dark twin 'dysthymia' [a mild form of depression]."[40] In the unmasking, these conditions are rendered treatable. But they are also rendered as conditions that are greatly more susceptible to whatever cultural ideals are at play. It becomes thinkable to manage and adjust moods and motivations in directions that are apparently necessary for survival in the fierce economy of the present.

Evading Mood Charts

Sociologist Peter Miller has argued that rationalizing accounting schemes like mood charts are virtually impossible to resist. If people refuse to use one scheme, they will be provided with a new, improved version. Consultants and others will use their complaints to identify the shortcomings of the original calculating technology in order to develop a new one without those shortcomings. "The aspiration to render individuals and spaces calculable seems to engender a constant process of adjudication on the vices and virtues of this technique or that."[41] Rationalization, however, always has its Weberian "leftovers." In such "leftovers" we can find people evading calculating technologies in small ways. For example, since the publishing capacities of the Internet open the door to individual creativity, some individually designed mood charts might do more than reinscribe the calculations in a more efficient or effective form.

A chart on a Web site published by Jinnah Mohammed includes large amounts of information about his particular life, undercutting the depersonalized and abstract qualities of most charts. The more specific the information, the less readily it can be reduced to a number and compared to other individuals. Mohammed's chart also separates measures of mood from measures of functionality, opening multiple axes on which a person can compare different aspects of his or her condition. The additional axis could increase the surveillance of the chart over Mohammed's life, but at the same time it opens the possibility of challenging how standard DSM categories link moods and productivity. In the DSM, moods on either end of the manic-depression scale are abnormal. By charting functionality as well as moods, Mohammed discovers that he can be functional while his

moods are abnormal, thus opening a possible rejection of the DSM's assumptions. However, he does not go this way. Instead, he concludes he is never normal: "I have used the charts to show my family that when they thought I was normal (i.e., functional), I wasn't emotionally stable. It came as quite a shock to them often because they couldn't detect anything wrong with me . . . [The chart allowed me] to realize I had no periods of normality."[42]

Doing the accounting defined as self-management might be considered a strike in favor of one's capacity to be a rational person. Charting one's moods could be seen as demonstrating one's rationality—and this, in itself, could constitute a form of resistance to being categorized as irrational. Yet, compared to Kraepelin's charts, contemporary mood charts encourage self-monitoring because they are kept by patients, subdivided into many categories, liable to eliminate any space for the "normal," and oriented to the relationship between drugs and moods. They do, however, have something in common with the moral thermometer described by Benjamin Rush at the opening of this essay. Rush and his followers explicitly recommended that household members assiduously record information about themselves, though the matrix they provided was indeed less complex than today's charts. In the popular magazine that reprinted the chart, readers were exhorted to enter "in a journal every variation observed in their own tempers" and thus be able to look back over time "to see what measure of improvement has been gained in a given period."[43] Then as today, keeping a written record was a way of proving individuals a path to self-improvement.

> The inventor of the thermometer is persuaded that if ladies and gentlemen, young as well as old, were to use the instrument according to the directions which accompany it, they would find their own happiness increase, and their acquaintance more desirous at all times of their company; neither has he the least doubt, but husbands and wives, parents and children, masters and servants, would find their lives become gradually much more easy and happy by a proper attention to it. N.B. the scale had better be hung up out of reach.

A part of the early temperance movement in the United States, the intent of Rush's moral thermometer was to monitor the effects of consuming spirits and limit their consumption.[44] Although, like the mood charts of today, the moral thermometer gave individuals a set of categories they could use to describe their states of mind, it was not attached to broader kinds of summary measures. It had no numerical grid and therefore moods could not be graphed over time, nor could they be collected and compared statistically. The main contrast between then and now is the ideal temperature on the moral thermometer. For Rush, it was about being "temperate":

> An individual . . . was enabled to effect such a reformation in himself, that for many months on a stretch his temper and habits remained *temperate*, or rose only to the

degree marked *warm but reasonable*. A gentleman . . . effected so complete a change in his disposition, by an alteration of his food, that he assured the writer a variation in the moral Thermometer higher than warm or lower than cool was to him an uncommon occurrence.[45]

In contrast, as I have been arguing, for persons like Ted Turner, for CEOs of pharmaceutical companies, or for bipolar youth, the ideal temperature might be somewhere between "passionate" and "hot." And in this context, what, exactly, does a contemporary apparatus such as Amy's Mood Chart measure? What is the something that goes up and down, or gets a numerical designation: Moods? Feelings? Energy? Will? Whatever it is, it comes from a private, individual, and interior space. The chart converts specific experiences into abstractions through numeric measurement (Marx's "retort"), but it also makes these experiences social along the way.[46] When one is categorized as "mentally ill" and hence outside the realm of the fully human, having one's private experience count as part of the social holds great significance. The individual uniqueness of experience might be lost in the homogenizing process of abstraction, but in return the private moods of an individual take the form of their opposites, moods that are widely shared. For people with pathological mood disorders, this is a move toward feeling human.

Notes

1. See David J. Miklowitz, *The Bipolar Disorder Survival Guide: What You and Your Family Need to Know* (New York: Guilford Press, 2002), 156.
2. See Nikolas Rose, *Inventing Our Selves: Psychology, Power and Personhood* (New York: Cambridge University Press, 1998), 103.
3. Benjamin Franklin Miller and Ruth Goode, *Man and His Body* (New York: Simon and Schuster, 1960), 6.
4. This is similar to Bruno Latour's "action at a distance." See Bruno Latour, *Science in Action: How to Follow Scientists and Engineers through Society* (Cambridge, Mass.: Harvard University Press, 1987), 219. On accounting schemes, see Peter Miller, "Accounting and Objectivity: The Invention of Calculating Selves and Calculable Spaces," *Annals of Scholarship* 9, nos. 1–2 (1992): 61–86, and Theodore M. Porter, *Trust in Numbers: The Pursuit of Objectivity in Science and Public Life* (Princeton, N.J.: Princeton University Press, 1995).
5. The context of this phrase is: "Everything becomes saleable and buyable. The circulation becomes the great social retort into which everything is thrown, to come out again as a gold-crystal. Not even are the bones of saints, and still less are more delicate res sacrosanctae, extra commercium hominum able to withstand this alchemy." See Karl Marx, *Capital*, vol. 1 (1887; repr., New York: International Publishers, 1967), 132.
6. Otniel Dror has done important historical work on the ways emotions became numerically measured by technological devices in the late nineteenth century. When emotion was "numberized," it became knowable scientifically and became positioned inside the language of reason. See Otniel Dror, "Counting the Affects: Discoursing in Numbers," *Social Research* 68, no. 2 (2001): 357–78.

7. In a wide-ranging review of the history and social effects of the concept of commensuration, Espeland and Stevens trace the first formulation of how commensurability was paired with control, stability, and rationality, while incommensurability was paired with chaos, anxiety, and threat, to Plato's ideas from the fifth and early fourth centuries BCE. See Wendy N. Espeland and Mitchell. L. Stevens, "Commensuration as a Social Process," *Annual Review of Sociology* 24 (1998): 313–43. Espeland and Stevens draw on Martha Nussbaum's argument that Plato needed to make ethical values commensurate so that they could be ranked. Once people could rank their values, they could make rational choices among them and avoid following the pull of irrational passions. Aristotle, in contrast, questioned the goal of rendering value general and homogenous and preferred to retain the value of things and people for their own sakes. See Martha Nussbaum, "Plato on Commensurability and Desire," *Proceedings of the Aristotelian Society* 58 (supplemental) (1984): 55–80.

8. See Emil Kraepelin, *Manic-Depressive Insanity and Paranoia* (1921; repr., Salem, N.H.: Ayer Press, 1990), 140.

9. Ibid., 149.

10. Paul Hoff, "Kraepelin: Clinical Sections, I," in *A History of Clinical Psychiatry: The Origin and History of Psychiatric Disorders*, eds. German E. Berrios and Roy Porter (New York: New York University Press, 1995), 261–79.

11. Eric J. Engstrom, "Kraepelin: Social Section," in Berrios and Porter, *A History of Clinical Psychiatry*, 292–301.

12. German E. Berrios and R. Hauser, "Clinical Sections," in Berrios and Porter, *A History of Clinical Psychiatry*, 280–91.

13. Emil Kraepelin, *One Hundred Years of Psychiatry* (Cambridge, Mass.: Harvard University Press, 1962).

14. See Kraepelin, *Manic-Depressive Insanity and Paranoia*, 151.

15. Emil Kraepelin, *Clinical Psychiatry* (Delmar, N.Y.: Scholars' Facsimiles & Reprints, 1981), 151.

16. Ibid., 151.

17. At one time, the National Institute of Mental Health Web site solicited participation on ongoing NIMH studies of mood disorders.

18. Megan McDonald, *The Judy Moody Mood Journal* (Cambridge, Mass.: Candlewick Press, 2003).

19. I am focusing primarily on mood charts that people come upon or seek out on their own. There is another form of mood charting, in use for nearly a decade, used in large-scale studies of the efficacy of medications for mood disorders. In these studies, based on a retrospective or prospective "Life-Chart Method," patients are recruited and enrolled for the specific purpose of having their affective states charted, or learning how to chart them themselves.

20. See Francis Mark Mondimore, *Bipolar Disorder: A Guide for Patients and Families* (Baltimore, Md.: The Johns Hopkins University Press, 1999), 222.

21. Norman Sartorius, "Depressive Disorders, a Major Public Health Problem," in *Mood Disorders: The World's Major Public Health Problem*, eds. Frank J. Ayd and Irving J. Taylor (Baltimore, Md.: Ayd Medical Communications, 1978), 1–8.

22. See David Healy, *The Antidepressant Era* (Cambridge, Mass.: Harvard University Press, 1999), 76.

23. Elyse Tanouye. "Mental Illness: A Rising Workplace Cost—One Form, Depression, Takes $70 Billion Toll Annually; Bank One Intervenes Early," *Wall Street Journal,* June 13, 2001, B1.

24. Walter F. Stewart, Judith A. Ricci, Elsbeth Chee, Steven R. Hahn, and David Morganstein, "Cost of Lost Productive Work Time among Us Workers with Depression." *JAMA* 289, no. 23 (2003): 3135–44.

25. "Depressed and on Welfare." *60 Minutes,* CBS News, CBS Worldwide, Inc.

26. R. MacLennan, 2002. The Global Cns Therapeutics Markets: An Overview. In, www.frost. com/prod/serviet/market-insight.pag?docid=IKHA-5ALUC3&ctxht=FomCtx1&ctxixpLink =FomCtx2&ctxixpLabel+FomCtx3, (accessed December 1, 2003).

27. I am echoing Pierre Bourdieu's phraseology in which he describes how rationalization in the school system in France replaces "practical schemes of classification" with "explicit, standardized taxonomies." These typologies are deliberately taught and therefore fixed in memory as knowledge that can be "reproduced in virtually identical form by all the agents subjected to its action." See Pierre Bourdieu, *Distinction: A Social Critique of the Judgment of Taste* (Cambridge, Mass.: Harvard University Press, 1990), 67.

28. American Psychological Association (APA), *Diagnostic Criteria from DSM-IV* (Washington, D.C.: American Psychiatric Association Press, 1994), 356.

29. Ibid.

30. Ibid.

31. Ryle, Gilbert, *The Concept of Mind* (London: Hutchinson, 1949), 99.

32. See Clifford Geertz, *Religion as a Cultural System* (New York: Basic Books, 1973), 97.

33. Personal communication with Lunbeck, October 2003. For historical analysis of the concept of the will in the nineteenth century, see German E. Berrios, "The Psychopathology of Affectivity: Conceptual and Historical Aspects," *Psychological Medicine* 15 (1985): 745–58.

34. Elizabeth Teresa Sullivan, "Mood in Relation to Performance," *Archives of Psychology* 53, R. S. Woodworth ed. (New York: Archives of Psychology, 1922), 19.

35. See M.C. Lennon, J. Bloom, and K. English, *Depression and Low-Income Women: Challenges for TANF and Welfare-to-Work Policies and Programs* (New York: Research Forum on Children, Families, and the New Federalism/National Center for Children in Poverty, 2001), published on the Web: Lennon, M. C. B., Juliana//English, Kevin. (2001, April). "Depression and low-income women: Challenges for TANF and Welfare-to-Work policies and programs." Retrieved June 4, 2003, from http://nccp.org/dltanf.html.

36. Peter D. Kramer, "There's Nothing Deep about Depression," *New York Times Magazine* (April 17, 2005), 50–57.

37. Laura Dawn Lewis and the *Illinois Leader,* "Illinois Launches Compulsory Mental Health Screening for Children and Pregnant Women," *Illinois Leader* (July 19, 2004), reprinted at http://www.couplescompany.com/features/Politics/2004/OrwellianPregnancy.pdf (last accessed September 21, 2009); and "Texas Medication Algorithm Project Guidelines Produce Improvements in Patients with Major Depressive Disorder," *News-Medical.Net* (July 5, 2004). For information on other whistle-blowers who have filed charges that the pharmaceutical industry used inappropriate means to promote psychotropic drugs, see News-Medical.Net, http://www.news-medical.net/?id=3084 (accessed April 24, 2005). "Pharma Influence: Penn Psychiatrist Files Whistleblower Lawsuit: Investigation Confirms Medicare Chief Lied to Congress," *Philadelphia Daily News* (July 7, 2004).

38. See Barbara Sher, *Live the Life You Love: In Ten Easy Step-By-Step Lessons* (New York: Dell, 1997), 54.

39. Warren Sussman showed that late nineteenth-century advice books described the self as based on character, moral integrity that could be improved through hard work, moral behavior, and frugality. After the turn of the twentieth century, advice books focused on personality, a quality that one shaped by making oneself attractive to others. Francesca Bordogna analyzes William James's thesis about the temperament and its link to the physiological constitution of the individual. Francesca Bordogna, "The Psychology and Physiology of

Temperament: Pragmatism in Context," *Journal of the History of Behavioral Sciences* 37, no. 1 (2001): 3–25.

40. Richard Friedman, "When Bipolar Masquerades as a Happy Face," *New York Times* (February 17, 2004), F6.

41. See Miller, "Accounting and Objectivity," 4.

42. Jinnah R. Mohammed, *A Mood Chart System: Livingmanicdepressive—A Bipolar and Depression Website* (2003 [cited April 18, 2003]); available from http://www.livingmanicdepressive.com/D_030.html.

43. Benjamin Rush, "Moral Thermometer," *Journal of Health and Recreation* 4, no. 1 (1833): 5.

44. Another version of the Rush thermometer was divided into an upper section titled "Temperance" and a lower one called "Intemperance." Drinking only water and milk would lead to "health, wealth, serenity of mind, reputation, long life and happiness." Drinking anything more potent than strong punch would lead to vices (idleness, quarreling, anarchy), diseases (gout, melancholy, madness), and punishments (debt, hunger, workhouse, jail).

45. Rush, "Moral Thermometer," 5.

46. In an analogous process, when a specific form of labor is transformed through abstraction from something with use value into something with exchange value, it also becomes social. Marx explained how the specific labor of tailoring a coat could become equivalent to the very different specific labor of weaving linen. First, the concrete labor of tailoring becomes "directly identified with undifferentiated human labor," which is measured by labor time. This makes tailoring "identical with any other sort of labor," including the labor of weaving linen. Although tailoring, like all labor that produces commodities, is "the labor of private individuals . . . yet, at the same time, it ranks as labour directly social in its character . . . The labor of private individuals takes the form of its opposite, labour directly social in its form." See Marx, *Capital*, 1014.

Contributors

LIPING BU is a professor of history at Alma College in Alma, Michigan. She is currently writing a book on public health and modernization in twentieth-century China.

LISA CARTWRIGHT is professor of communication and science studies at the University of California–San Diego. She is the author of *Screening the Body: Tracing Medicine's Visual Culture* (Minnesota, 1995), *Moral Spectatorship: Technologies of Voice and Affect in Postwar Representations of the Child,* and *Images of Waiting Children* as well as coauthor, with Marita Sturken, of *Practices of Looking: An Introduction to Visual Culture.*

ROGER COOTER is a Wellcome Professorial Fellow at the Wellcome Trust Centre for the History of Medicine at University College London. He is author of *The Cultural Meaning of Popular Science: Phrenology and the Organization of Consent in Nineteenth-Century Britain* and *Surgery and Society in Peace and War: Orthopaedics and the Organization of Modern Medicine, 1880–1948,* and is editor of *Medicine in the Twentieth Century* and other volumes on child health, alternative medicine, accidents, and war and medicine. He is working on a history of the ethical in medicine and, with Claudia Stein, a collection of essays on the role of the visual in the creation of "biopublics" in Germany and Britain.

WILLIAM H. HELFAND, a retired pharmaceutical executive, is author of five books, including *The Picture of Health: Images of Medicine and Pharmacy* and *Quack, Quack, Quack: The Sellers of Nostrums in Prints, Posters, Ephemera, and Books,* the catalogue for a 2002 exhibition at the Grolier Club in New York. In 2003 he received the Lifetime Achievement Award from the American Association of the History of Medicine. He is a consultant to the U.S. National Library of Medicine and an Honorary Trustee of the Philadelphia Museum of Art.

LENORE MANDERSON is a medical anthropologist, social historian, and research professor in the School of Psychology, Psychiatry, and Psychological Medicine and in the School of Political and Social Inquiry at Monash University, Australia. She is the author or editor of sixteen books, including *Sickness and the State: Health and Illness in Colonial Malaya, 1870–1940; Sites of Desire/Economies of Pleasure: Sexualities in Asia and the Pacific;* and *Chronic Conditions, Fluid States: Chronicity and the Anthropology of Illness.* She is a fellow of the Academy of Social Sciences in Australia and the World Academy of Art and Science.

EMILY MARTIN is the author of *The Woman in the Body: A Cultural Analysis of Reproduction; Flexible Bodies: Tracking Immunity in America from the Days of Polio to the Age of AIDS;* and *Biopolar Expeditions: Mania and Depression in American Culture.* She has served on the Board of Directors of the Social Science Research Council and as president of the American Ethnological Society. Her research has been supported by Fulbright awards, a Guggenheim fellowship, and grants from the National Science Foundation and the Spencer Foundation. She has taught cultural anthropology at the University of California–Irvine, Yale University, The Johns Hopkins University, and Princeton University, and currently teaches at New York University.

GREGG MITMAN is William Coleman Professor of History of Science and Professor of Medical History and Science & Technology Studies at the University of Wisconsin–Madison. His most recent book is *Breathing Space: How Allergies Shape Our Lives and Landscapes.*

MARK MONMONIER is Distinguished Professor of Geography at Syracuse University's Maxwell School of Citizenship and Public Affairs. He received a PhD in geography from The Pennsylvania State University in 1969 and has taught at the University of Rhode Island and the State University of New York at Albany. He serves as editor of volume 6 (*The Twentieth Century*) of the *History of Cartography.* Monmonier is author of fourteen books, including *How to Lie with Maps* and *Coast Lines: How Mapmakers Chart Environmental Change.*

KIRSTEN OSTHERR is associate professor of English at Rice University. She is the author of *Cinematic Prophylaxis: Globalization and Contagion in the Discourse of World Health,* as well as numerous articles on science, animation, documentary, and medical films. She is completing a history of health education through mass media called "Medical Visions: Producing the Patient through Film, Television, and Imaging Technologies."

KATHERINE OTT is a curator in the Division of Medicine and Society at the Smithsonian's National Museum of American History and the author of *Fevered Lives: Tuberculosis in American Culture since 1870.* Her research focuses on the history of medicine, the body, disability, and bodily difference, among other things. She also teaches courses in material culture at George Washington University.

DAVID SERLIN is associate professor of communication and science studies at the University of California–San Diego. He is author of *Replaceable You: Engineering the Body in Postwar America,* which was awarded the 2005 Alan Bray Memorial Book Award Prize by the Modern Language Association, and the coeditor of *Policing Public Sex: Queer Politics and the Future of AIDS Activism* and *Artificial Parts, Practical Lives: Modern Histories of Prosthetics.* He is completing a book about the relationship between disability and architecture.

SHAWN MICHELLE SMITH is associate professor of visual and critical studies at the School of the Art Institute of Chicago. She is the author of *American Archives: Gender, Race, and Class in Visual Culture* and *Photography on the Color Line: W. E. B. Du Bois, Race, and Visual Culture,* and coauthor, with Dora Apel, of *Lynching Photographs.* She is also a visual artist and has exhibited her photo-based artwork in a number of venues in the United States.

CLAUDIA STEIN is associate professor in the Department of History at Warwick University in Coventry, England, and the author of *Negotiating the French Pox in Early Modern Germany.* She is working on "Breeding for Bavaria: Bodies, Population, and Politics in Eighteenth-Century Germany," a study of the emergence of biopower in eighteenth-century Germany, and, with Roger Cooter, a collection of essays on the role of the visual in the creation of "biopublics" in Germany and Britain.

Index

Page references in italics refer to illustrations